The DELAWARE RIVER

The DELAWARE RIVER

History, Traditions & Legends

FRANK HARRIS MOYER

Published by The History Press
Charleston, SC
www.historypress.com

Copyright © 2019 by Frank H. Moyer
All rights reserved

Front cover, top right image courtesy of Thinkstock. Front cover, top left, bottom images courtesy of Adobe Stock. Back cover, background image courtesy of Adobe Stock.

First published 2019

Manufactured in the United States

ISBN 9781467141154

Library of Congress Control Number: 2018963545

Notice: The information in this book is true and complete to the best of our knowledge. It is offered without guarantee on the part of the author or The History Press. The author and The History Press disclaim all liability in connection with the use of this book.

All rights reserved. No part of this book may be reproduced or transmitted in any form whatsoever without prior written permission from the publisher except in the case of brief quotations embodied in critical articles and reviews.

*Do not hesitate to enter fields despite the giants who may be your competition,
for it is the fresh analysis from a different vantage point
that often leads to important new insights.*
—Maurice Ewing, geologist,
one of a few tidbits of advice he offered to young scientists

…behind every legend lies an element of great truth.
—City of Mirrors, *The Passage Trilogy, Justin Cronin, 2016*

There is a God…

CONTENTS

Preface. Modern Geological Periods	11
Acknowledgements	13
Introduction. The Delaware River Basin	15
1. The Geologic History of the River	31
2. Legends and Myths	73
3. The Evolution of Ducks, Geese and Swans	93
4. A Living Tradition	117
A Chronological Human and Environmental History of the Delaware River and Estuary	143
Appendix I. Watershed/Stakeholder Groups and Partners	183
Appendix II. Islands of the Delaware River	191
Appendix III. The Bridges of the Delaware River	195
Appendix IV. Traditional Decoy Carvers	199
Appendix V. Contemporary Carvers	215
Appendix VI. Sources of Delaware River Decoys	219
Notes	221
Additional Sources Consulted	237
Index	245
About the Author	255

Geologic Time Scale

Eon	Era	Period		Epoch	MYA
Phanerozoic	Cenozoic	Quaternary		Holocene	0.01
				Pleistocene	1.8
		Tertiary	Neogene	Pliocence	5
				Miocene	23
			Paleogene	Oligocene	34
				Eocene	56
				Paleocene	65
	Mesozoic	Cretaceous			146
		Jurassic			200
		Triassic			251
	Paleozoic	Permian			299
		Carboniferous	Pennsylvanian		318
			Mississippian		359
		Devonian			416
		Silurian			444
		Ordovician			488
		Cambrian			542
Precambrian		Proterozoic			2,500
		Archean			3,800
		Hadean			4,600

Adapted from multiple sources.

Preface

MODERN GEOLOGICAL PERIODS

The Epoch of Man

The Holocene Epoch, instead of lasting millions of years, as preceding epochs had done, lasted only twelve thousand years. Earlier epochs have been characterized by the large-scale global changes such as the formation of supercontinents, volcanic activity lasting millennia, mountain-building events, mass extinctions, ice ages and, in the case of the end of the Cretaceous Period, a cataclysmic asteroid impact.

The Holocene Epoch followed the Pleistocene (1.8 mya[1] to 12,000 ya), distinct for its cyclic ice age and the rise of *Homo sapiens*. The Holocene provided a warm and stable environment that allowed humans to develop everything from agriculture to atomic energy and begin the exploration of space, "but that success remade the planet we live on through widespread deforestation, overfishing of the oceans, the extinction of countless species, and the altering of the planet's climate through the emission of greenhouse gases…[and] the spread of radioactive material across Earth since 1950."[2]

Human activity brought a premature end to the Holocene Epoch. On August 19, 2016, at a meeting of the International Union of Geological Sciences (IUGS) in South Africa, it was stated that since human activity was so potent a force in determining the future of planet Earth, a change in the geological calendar was necessary. The Holocene came to an end in 1950—the era of atomic bomb testing.[3] It was overwhelmingly recommended that the current geological epoch be designated the Anthropocene Epoch, characterized by ongoing human influences rather than long-term geologic processes. The destruction humanity has initiated is referred to as the Sixth Extinction.

ACKNOWLEDGEMENTS

A number of people have provided support and encouragement to the author in the writing of this book, but none more than the inspiration, support and encouragement given by my close friend Ginette Mirenna Reda, who additionally served as the "first reader," critic and proofreader in efforts to make me a better person and writer. I am very grateful to Gloria and Glenn Varga for their work and time as both readers and critics. Thank you to Allen Linkchorst and Bob White for support and suggestions.

I am extremely thankful for the word processing skills of Alicia Suzanne Ward and the artwork produced by her husband, Spencer Dwayne Ward.

In recognition of the debt I owe to all of you who provided suggestions and support in this endeavor, I must give special recognition to my editor, Idria Barone Knecht of Proof Positive, whose insight and editing skills brought this project to fruition, as well as to the photographic skills of her husband, Rick Knecht.

Delaware River decoys depicted in the text are part of the author's personal collection. Recognition must be given to Guyette & Deeter for providing permission to reproduce photographs from its auction catalogues.

Kudos to those dedicated but anonymous writers and researchers who work tirelessly to keep the Internet relevant.

Writing and publishing have been a labor of love and a personal challenge, and I give my heartfelt thanks to all who provided me with support and encouragement.

Introduction

THE DELAWARE RIVER BASIN

The headwaters of the Delaware River, the West Branch and the East Branch surging from the Catskill Mountains converge at Hancock, New York, known as the "Wedding of the Waters," forming the main stem of the Delaware River. The primary source of the river is the West Branch on Mount Jefferson, Schoharie County, New York, approximately one hundred miles north of Port Jervis, New York, near the secluded hamlet of Hobart. Here the Delaware River is a tiny trickle of a stream running down the mountain.[‡]

The Delaware River flows 331 (330.71) miles to its confluence with the Atlantic Ocean via the Delaware Bay. About 200 miles of the river from Hancock, New York, to Trenton, New Jersey, is non-tidal, while at Trenton, 134 miles from Cape May, New Jersey (Cape Henlopen, Delaware), the river becomes tidal. The river descends eight hundred feet in elevation on its journey to the sea. The river drains a watershed of 13,539 square miles, shared by the states of New Jersey, New York, Pennsylvania and Delaware, as well as an 8-square-mile section of Maryland. The Delaware River Basin includes the watersheds of 21 major tributaries that flow into the river and Delaware Bay. The mean annual flow at Trenton is 2.7 trillion gallons per year, a flow that can only be maintained by regular releases from reservoirs in New York State. Over the entire course of the main stem of the Delaware, 216 tributaries add their flow to the river. Of the 216 tributaries, 21 are rivers in their own right.

Introduction

River Tributaries of the Delaware River
(Source: www.nj.gov/drbc)

	Name	State	River Mile (Mouth)	Tidal/Non-Tidal
	Cape Henlopen (mouth of Delaware River)	DE	00.00	
1.	Mispillion River	DE	11.17	Tidal
2.	Maurice River	NJ	21.03	Tidal
3.	Murderkill River	DE	23.14	Tidal
4.	St. Jones River	DE	23.79	Tidal
5.	Little River	DE	27.80	Tidal
6.	Mahon River	DE	29.09	Tidal
7.	Simons River	DE	33.23	Tidal
8.	Cohansey River	NJ	37.80	Tidal
9.	Appoquinimink River	DE	50.88	Tidal
10.	Salem River	NJ	58.37	Tidal
11.	Christina River	DE	70.73	Tidal
12.	Schuylkill River	PA	92.47	Tidal
13.	Cooper River	NJ	101.58	Tidal
14.	Musconetcong River	NJ	174.60	Non-Tidal
15.	Lehigh River	PA	183.66	Non-Tidal
16.	Pequest River	NJ	197.80	Non-Tidal
17.	Neversink River	NY	253.64	Non-Tidal
18.	Lackawaxen River	PA	277.70	Non-Tidal
19.	Ten Mile River	NY	284.20	Non-Tidal
20.	East Branch Delaware River		330.70	Non-Tidal
21.	West Branch Delaware River		330.71	Non-Tidal

Introduction

Delaware River Basin

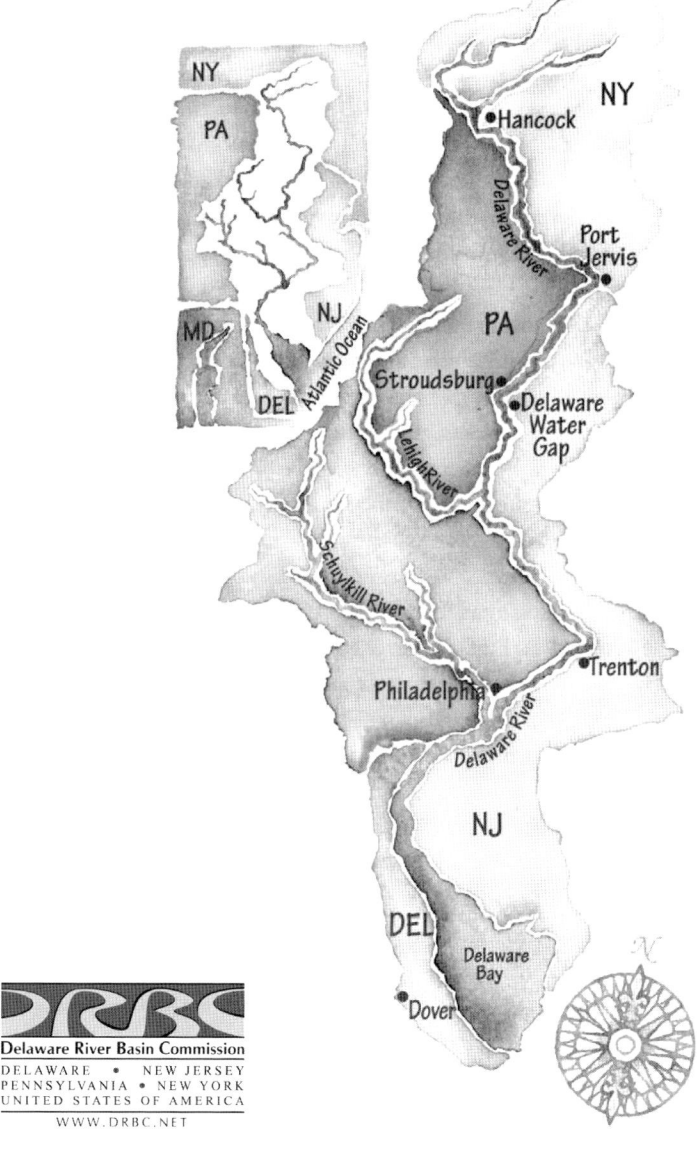

Introduction

Although the Delaware River Basin represents only 0.4 percent of the land area of the United States, the watershed provides water to almost 8 percent of the nation's population. U.S. Supreme Court decisions dating from 1931 and 1954 authorize New York City and central New Jersey to divert water out of the basin. New York City is allowed to divert an average of 800 mgd[5] of water from three reservoirs in the Catskill Mountains in the Delaware Basin to the Hudson River Basin, providing more than 50 percent of the drinking water to the city of New York. The Salem and Hope Creeks nuclear power plants, built on Artificial Island in Salem County, New Jersey, withdraw more than 3 billion gallons of cooling water per day from the estuary while providing 3,500 megawatts of electricity to the tri-state region. Additional water diversions/transfers amounting to nearly 100 mgd are made through the Delaware and Raritan Canal in New Jersey. By 2010, more than 1 billion gallons per day of drinking water and industrial process water were diverted from the rivers, streams and aquifers of the watershed to sustain the region's jobs and domestic, commercial and industrial economy. In addition to supporting a resident watershed population of more than 8 eight million (2010), the actual service areas of the Delaware River Basin sustain a population approaching 20 million people, including cities like Wilmington, Philadelphia, Allentown, Camden and Trenton. All or portions of 42 counties and 838 municipalities within the four-state region contribute to and benefit from the resources of the Delaware River Basin.

Delaware River Basin Facts (2017)
- Drainage Area: 13,500 square miles (0.4 percent of U.S. land area).
- Length: 331 miles, including Delaware Bay, with 200 miles of non-tidal river (Hancock, New York, to Trenton, New Jersey).
- Average Discharge of the Delaware River at Trenton: 11,750 cubic feet per second (thirty-third largest U.S. river in terms of flow). Maximum flow was 329,000 cfs on August 20, 1955. Minimum flow was 1,180 cfs on October 31, 1961. Typical summer low-flow is controlled at 3,000 cfs or higher.
- Population: 8,255,013[6] (a population greater than most states), a population increase since 2000 of 497,976, with a service area of 20 million (almost 5 percent of U.S. population).
- Average Rainfall: 44 inches (about 10 trillion gallons).

Introduction

- MILES IN NATIONAL WILD AND SCENIC RIVERS SYSTEM: 120 (one of the last major U.S. rivers without a dam on its main stem).
- LARGEST TRIBUTARIES: Schuylkill River (first) and Lehigh River (second).

Adapted from Richard C. Albert's Damming the Delaware *(1987).*

While the states retain autonomy, the Delaware River Basin is unique in governance. It is the only river basin with both an interstate-federal commission and a national estuary program. In 1961, JFK signed the Delaware River Basin Compact, which appointed the governors of Delaware, New Jersey, New York and Pennsylvania as commissioners to the first federal/state watershed agreement/accord based on a new concept of basin-scale water resource management. The Delaware River Basin Commission (DRBC) predates the first Earth Day, the establishment of the Environmental Protection Agency and the passage of the Clean Water Act. The national significance of the Delaware Estuary was acknowledged in 1988 when it became part of the National Estuary Program under Section 320 of the Federal Clean Water Act. In 2011, the DRBC celebrated the fiftieth anniversary of its founding.

The DRBC is charged with the responsibility for watershed-wide planning, including water quality protection, water supply allocation, regulatory review (permitting), drought management, flood loss reduction and recreation. The DRBC commissioners include the sitting governors of Delaware, New Jersey, Pennsylvania and New York, as well as the division engineer, North Atlantic Division, U.S. Army Corps of Engineers, who serves as the federal representative. Funding is provided by the signatory parties, project review fees, water use charges, fines and federal, state and private grants.

New York has constructed nineteen reservoirs in the Catskill Mountains and the headwaters of the Delaware River. These reservoirs divert high-quality water from the Delaware River Watershed and are a primary source of water for New York City and the environs. They are interconnected by a system of aqueducts and tunnels. The Delaware Aqueduct was completed in 1945 and taps the tributaries of the Delaware River in the western Catskills. There are two distinct water systems impounding and diverting the waters of the western Catskill Mountains and the upper reaches of the Delaware River Watershed. The Delaware Supply System includes reservoirs at Cannonsville, Neversink, Pepacton and Rondout, while the Catskill-Delaware Supply System impounds water at Boyd's Corners, Kensico and West Branch.

Introduction

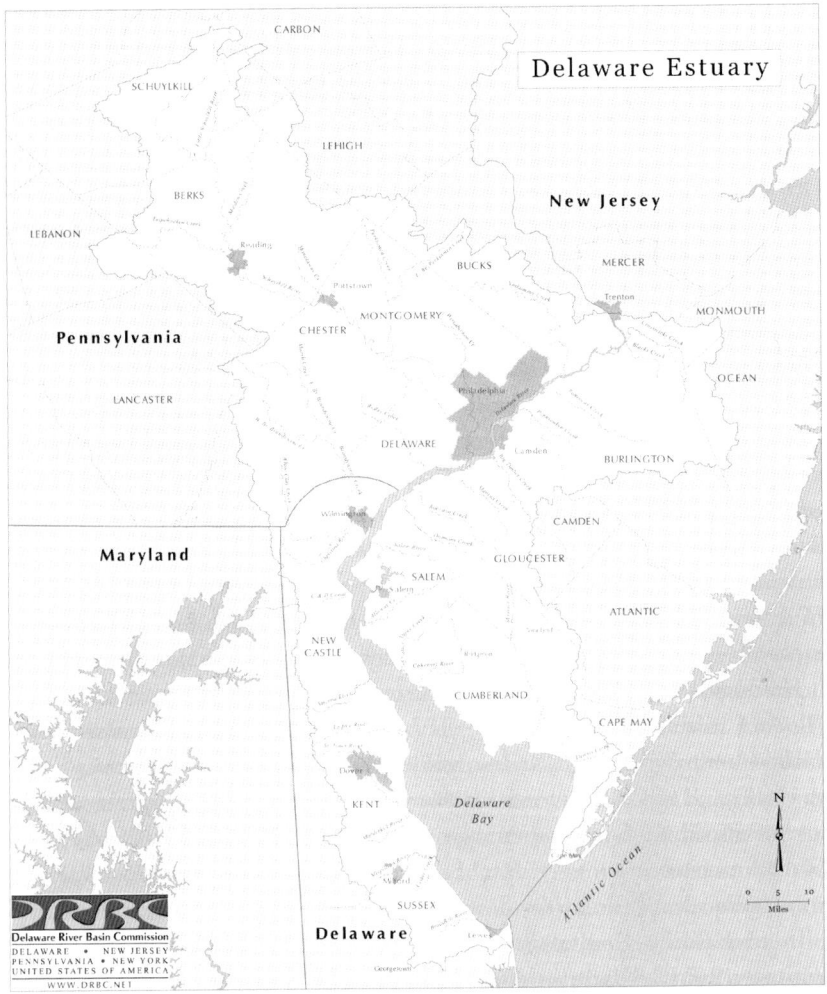

Henry Hudson, an Englishman sailing for the Dutch, "discovered" Delaware Bay in 1610. This minor distinction would have profound implications in the near future. A short time later, Samuel Argall, another Englishman, sailed into Delaware Bay, claimed the river for England and named what is now Cape Henlopen for Virginia's governor, Lord De La Warre. The Dutch and Swedes were the first to explore and exploit the bay and river as far north as present-day Trenton, where the falls in the river blocked passage. After the English wrested control of the region from the Dutch in 1664, the name De La Warre was applied to the bay and river.

Introduction

William Penn founded the "City of Brotherly Love" in 1681 while seeking refuge from religious persecution in Europe. By the eighteenth century, frugal yet prosperous Philadelphia Quaker merchants had established a triangular trade route between Europe, the Caribbean Islands and the port of Philadelphia. (As an aside, in 1790 Benjamin Franklin, America's first environmentalist, was so concerned about pollution in the Delaware River that he willed funds to Philadelphia to build the first municipal water system in the colonies to tap into the Delaware and Schuylkill Rivers for clean drinking water.[7])

The Delaware River played a significant role in the American Revolution. Washington crossed the Delaware three times between December 1776 and the summer of 1778. During the Revolution, Philadelphia was the largest city in the colonies and the third-largest seaport in the British empire. Only London and Liverpool had larger port facilities.

The discovery of anthracite coal in the Lehigh Valley in 1792 fueled the Industrial Revolution. By 1830, steam railroads were providing cheap transportation, fostering further industrial growth along the Delaware River. In 1802, the DuPont family established gunpowder mills along the falls of the Brandywine River above Wilmington, Delaware, one of the first industries in the Delaware Valley. During the 1800s, the extensive port facilities at Philadelphia, coupled with the advent of steam power, saw the growth of transatlantic shipping.

Beginning in the 1830s, three canals were built, primarily to carry anthracite "blue" coal from Northeastern Pennsylvania to urban areas, in competition with the expanding railroads. The Morris Canal was a 107-mile link between Phillipsburg, New Jersey, on the Delaware River and, eventually, Jersey City, New Jersey, on the Hudson River, which operated from 1831 to 1924. The Delaware Canal, joining Easton, Pennsylvania, to Bristol, Pennsylvania, a journey of sixty-two miles, was opened in 1831 and closed to canal traffic in 1931. The Delaware and Raritan Canal—consisting of a forty-nine-mile link between New Brunswick, New Jersey, on the Raritan River to Bordentown, New Jersey, on the Delaware River—was supported by a twenty-two-mile feeder canal between Bull's Island on the Delaware and Trenton and operated from 1834 to 1934. It exists today as a seventy-mile state park and a water supply link.

During the Civil War, the canals of the Delaware watershed were utilized for the transport of troops and war supplies, while Pea Patch Island, located in the estuary, was operated as a prisoner of war camp, receiving, in 1863, Confederate prisoners captured at the Battle of Gettysburg.

Introduction

By 1895, the Delaware River had been dredged to a depth of twenty-six feet from a natural depth of seventeen feet by the U.S. Army Corps of Engineers. Dredging would continue into the twenty-first century, when a channel more than forty feet deep from Philadelphia to the sea would be maintained to accommodate the increasing size of oil tankers and container ships.

During the latter half of the nineteenth century, the Delaware Water Gap along the Kittatinny and Blue Mountains to the north would develop into a resort/recreation area rivaling Atlantic City and Newport, Rhode Island. The resort grew in popularity as railroads from New York City and Philadelphia pushed into the forests of the upper Delaware.

Delaware River Basin Towns and Cities

After the turn of the century, by 1912, Philadelphia business and environs built or manufactured 5 percent of all the goods made in the United States. In 1914, the Panama Canal opened, providing the East Coast with access to Hawaiian sugar cane fields. Philadelphia became an important sugar refining and shipping center.

Delaware River ports, including both Philadelphia and Camden, were home to a premier shipbuilding industry by the beginning of the twentieth century. The Delaware River shipbuilding industries thrived through World Wars I and II. Many troop transport ships built during World War I saw service during World War II. The port economy boomed during the latter. The Philadelphia Navy Yard employed more than forty thousand workers, who built fifty-three ships during the war and provided repair services for more than five hundred vessels. After World War II, the "Arsenal of America" manufacturing industries and export businesses declined because of decreased demand for Lehigh Valley steel and Pennsylvania coal. In 1995, the Department of the Navy closed the Philadelphia Navy Yard and decommissioned the "ghost" fleet due to the evolving demands of the "new" navy.

The Delaware Valley saw the birth, maturation and eventual decline of numerous industries, including timber, horseshoes, gunpowder, leather, anthracite coal, slate, automobiles, glass, watches, silk, rubber, paper, cotton, grain, tobacco, iron and steel, mining equipment and even silent running pumps for nuclear submarines. Today, the growth industries are

Introduction

Delaware River Basin

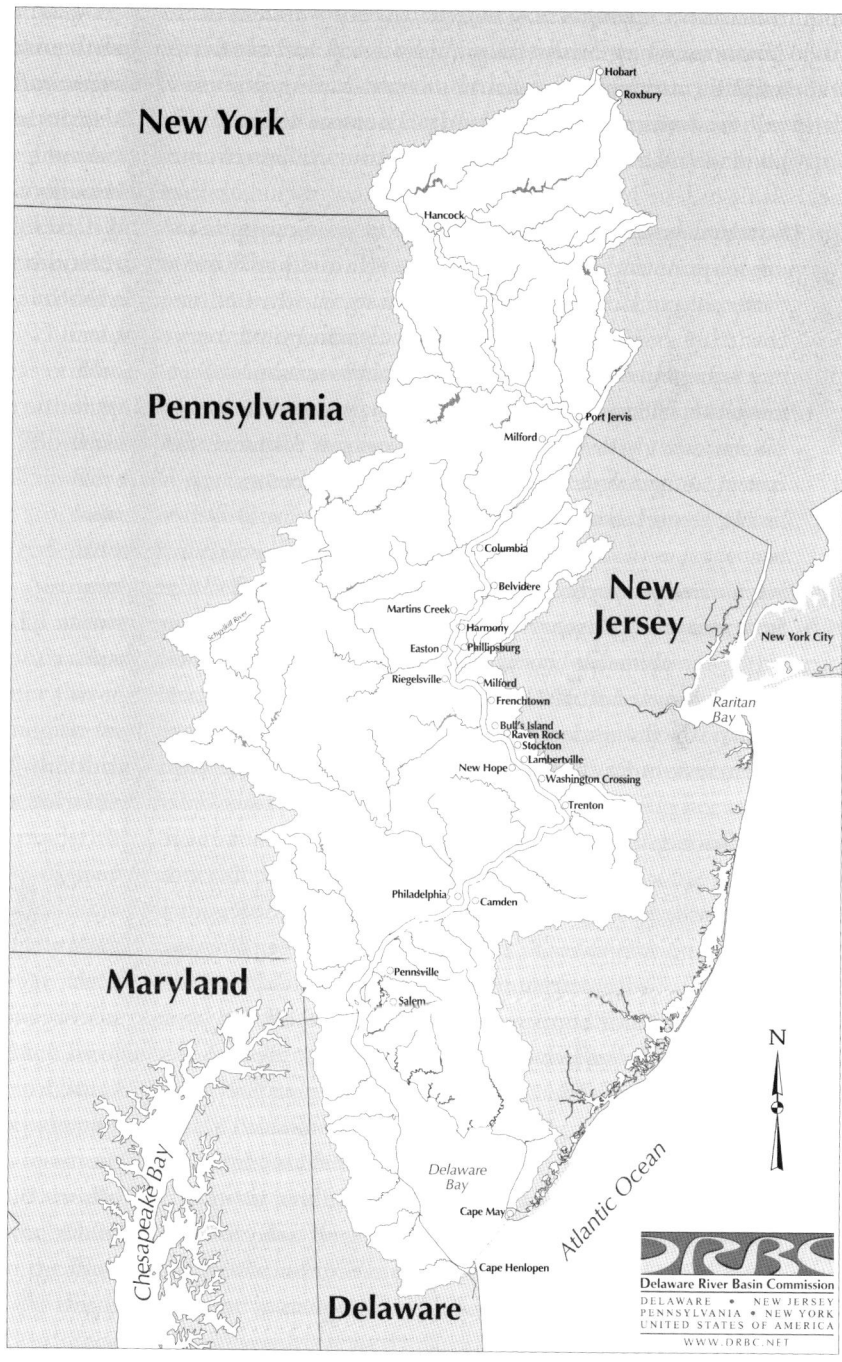

Introduction

pharmaceuticals, oil refineries and "fracking" for natural gas. Unfortunately, some of these industries are allowed to "legally" dump millions of pounds of pollutants into the Delaware River and estuary system annually in spite of the provisions of the Clean Water Act and the efforts of the DRBC and 110 volunteer-based environmental stakeholder groups.

By the end of the 1800s, the Delaware River supported the largest commercial American shad and sturgeon fishery along the Atlantic coast. The town of Caviar, New Jersey, was founded to process sturgeon and shad roe for worldwide export. By the 1880s, sailing vessels harvested 22 million pounds of oysters from Delaware Bay annually. In 1896, more than 14 million pounds of shad were caught with a value of $400,000 ($10 million in 2008 dollars). The commercial fishery has declined dramatically due to a four-hundred-year legacy of pollutants in the water. The Eastern Oyster fishery was hit hard from 1950 to 1980 by the disease MSX, originating in Asia, which caused dramatic declines in oyster populations. In 2010, the estuary's commercial oyster harvest was valued at $3.5 million. Oyster harvest quotas are closely managed, and limits are set based on annual population surveys. Since the early 1970s, an average of 6.4 million pounds of blue crabs have been hauled annually from Delaware Bay. Overharvesting concerns have led to licensing caps and the development of a fishery management plan between Delaware and New Jersey. Prior to 1930, freshwater mussels found commercial use. At least twelve species were native to the estuary. Today, freshwater mussels are the most imperiled of all animals and plants in North America, and of twelve species, only one is thought to be abundant.

In the 1800s and early 1900s, the river's Atlantic sturgeon population was decimated due to the high demand for their meat and roe (caviar). Since 1950, other factors have affected the sturgeon population: pollution, ship strikes and dredging. In 1998, a fishing moratorium was placed on all U.S. Atlantic sturgeon harvests, and in 2012, they were listed as an endangered species. American shad, the largest member of the herring family, grow to three to five pounds and migrate into freshwater rivers and streams to spawn, returning to their natural place of birth. Shad fillets and roe provide an appetizing treat in the spring. "Planked" shad is especially delightful. In the 1890s, shad harvests approached 19 million pounds per year. By the early 1900s, harvests had declined dramatically due to pollution, overfishing and the construction of dams on tributary streams and rivers. Since the passage of the Clean Water Act in 1972, some dams have been removed and fish ladders have been constructed; nevertheless, shad populations remain low.

Introduction

Sport fishing is an important economic and recreational activity throughout the Delaware River Basin. Smallmouth bass and brown trout are the most popular fish sought, followed by rainbow trout, walleye, American shad, white perch and channel catfish. Striped bass fishing in the estuary is very popular. Fishermen throughout the basin are advised to check with the appropriate state EPA departments for current fish consumption advisories, as even though great strides have been made in water quality since the "open sewer" days of the 1940s, when the mere smell of the river sickened people, pollution remains a problem. Eel should not be eaten under any circumstances.

Water quality is good to excellent north of Trenton but remains problematic in the tidal zone. In 1967, the DRBC adapted the most comprehensive water quality standards of any interstate river basin in the nation, including bacteria standards for primary and secondary recreational activities (swimming and boating). One year later, the DRBC adopted regulations for implementing and enforcing its new water quality standards. In 1972, the Federal Water Pollution Control Act Amendments, known as the Clean Water Act, was adopted. By the end of the 1980s, more than $1 billion had been spent on improving wastewater treatment plants in the Delaware River Basin, benefiting both people and fish. In 1989, the DRBC began its Delaware Estuary Toxics Management Program aimed at developing methods to control the discharge of toxic pollution from wastewater treatment plants in the estuary. In 1996, this program was expanded and strengthened. This program, by adopting stricter rules and adding many toxic substances to those that were originally regulated, cleaned up wastewater treatment plant discharge. Water quality in the tidal bay was improving, and water quality in the non-tidal Delaware River was better than the existing standards required. Nevertheless, in 1992, the DRBC launched its Special Protection Waters (SPW) program, which established regulations to "Keep Clean Water Clean" in the middle and upper sections of the non-tidal Delaware River. By 2000, the SPW program had been expanded to include all sections of the Delaware from Trenton north to the Delaware Water Gap. The federal government had designated a section of the Delaware River as part of the National Wild and Scenic River System in 1968.

During July and August 1955, two costly hurricanes struck the East Coast. Hurricane Connie was followed by Hurricane Diane one week later, from August 7 through August 10. Diane crossed the Delaware Valley, inflicting thirty-seven deaths at Brodhead Creek, millions in damage and record flooding. The flooding on the Delaware River and its tributaries was beyond

Introduction

record-breaking; the river crested at 40 feet above flood stage in Easton, Pennsylvania, and 38.85 feet above flood stage a few miles downriver at the Riegelsville, Pennsylvania river gauge. The storm caused a total of 184 deaths and $754.7 million in damage as it crossed the mid-Atlantic states into New England before dissipating. Rushing floodwaters destroyed 150 road and trail bridges, one constructed in 1831, and thirty dams in the Delaware watershed alone.

The record flooding of 1955 brought interest in flood control to the national agenda. Interest in building a flood-control/water storage dam (the idea seems to be at cross-purposes) six miles north of Delaware Water Gap at Tocks Island was reinvigorated. The U.S. Army Corps of Engineers became involved, because that's what it does best—build big dams wherever they are not wanted. The idea to build a dam at Tocks Island was in the works prior to the 1955 floods. The proposed earthen dam would have created a thirty-seven-mile-long lake with depths of up to 140 feet. The stated goals of the project were flood control; water supply for New York City, central New Jersey and Philadelphia; and the production of hydroelectricity at Sunfish Pond on top of Kittatinny Mountain. This latter goal would have destroyed Sunfish Pond, a favorite local hiking destination. This proposal only increased the controversy surrounding the dam project, angering and energizing environmental groups and increasing the angst of embittered local residents already in ill humor, since many thousands had been displaced by the U.S. Army Corps of Engineers' tactics of combining eminent domain with condemnation proceedings to acquire the sixty-thousand-plus acres necessary for the dam project. Fifteen thousand people were ultimately displaced, and more than three thousand dwellings and outbuildings were demolished to make room for an unwanted dam and recreation area.

National concerns, especially the cost of the war in Vietnam, as well as local political considerations, brought a judicious reconsideration of the entire project. In 1977, Brendan T. Byrne, governor of New Jersey, revealed that there were better and more economical options available to reducing future flood damage along the Delaware and of meeting the future water supply requirements of the metropolitan-urban area in the region. Sunfish Pond was quietly sold back to the State of New Jersey to become part of the Worthington State Forest. The Tocks Island project was "officially" reviewed in 1992 and then, ten years later in 2002, finally de-authorized.

The United States Congress approved legislation signed into law by President Lyndon Johnson on October 2, 1968, creating the National Wild and Scenic River System designed to protect the nation's rivers that possessed

INTRODUCTION

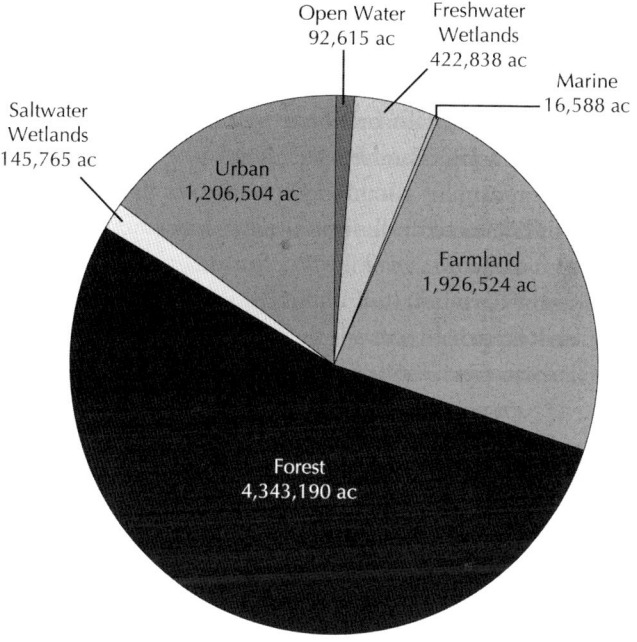

From Gerald J. Kauffman's "Socioeconomic Value of the Delaware River Basin in Delaware, New Jersey and Pennsylvania," University of Delaware, 2011.

remarkable scenic, recreational, geologic, fish and wildlife, historic, cultural and other similar values while, most importantly, preserving these unique rivers in a free-flowing condition.

In 1978, 64,791 acres, nearly 104 square miles, acquired for Tocks Island were transferred to the U.S. Department of the Interior's National Park Service for the establishment of the Delaware Water Gap National Recreation Area. This 40-mile section of the Delaware River, from the Delaware Water Gap to Port Jervis, New York, was granted protection under the National Wild and Scenic River System Act as the Middle Delaware National Scenic River.

An additional section of the Delaware River was added to the National Wild and Scenic River System by Congress and President Jimmy Carter

Introduction

on November 10, 1978. This section, seventy-three miles long, extends from the confluence of the East and West branches at Hancock, New York, downstream to Milford, Pennsylvania, as the Upper Delaware Wild and Scenic River.

On December 1, 1993, a 35.4-mile segment of the Maurice River in New Jersey and several of its tributaries were added to the National Wild and Scenic River System. In the fall of 2000, President Bill Clinton signed two bills: the first set aside a 38.9-mile section of the Delaware linking the Delaware Water Gap and Washington's Crossing, Pennsylvania, along the main stem of the Delaware as the Lower Delaware National Wild and Scenic River System, and the second designated White Clay Creek a tributary to the Christina River in Delaware as the White Clay Creek Wild and Scenic River System. On December 19, 2014, President Barack Obama signed into law a bill that added an additional 9 miles of White Clay Creek to the National Wild and Scenic River System.

On December 22, 2006, President George W. Bush added sections of another Delaware River tributary to the National Wild and Scenic River System. The Musconetcong Wild and Scenic River Act designated 24.2 miles of the Musconetcong River (New Jersey) a component of the National Wild and Scenic River System.

It is thought that the formation of the Delaware River Valley began during cycles of erosion and uplift approximately 30 to 50 million years ago. From Port Jervis to the Water Gap, the Delaware follows a valley of eroded shales and limestone. The unique S-shaped curve at Wallpack Bend is a meander of an early tributary stream eroded in antiquity. From the Water Gap to Trenton, the Delaware flows in a southeast course, and this is thought to be the original flow direction of the river. Below Trenton, the river closely follows its contact with the bedrock formations of the Piedmont. Why and how the Delaware River was diverted in a right-angle turn at Trenton, where softer sediments remain, is somewhat of a mystery. One possible explanation is that the ancestral river flowed southeastward through its entire length across New Jersey, as did the ancestral Schuylkill River. Both rivers eventually became the product of stream capture by smaller streams flowing parallel to the southwest valley, creating the existing structure of the Delaware River and Bay.

In spite of intensive human use, and in some instances abuse, the Delaware River remains one of the last undammed major U.S. rivers, as well as one

Introduction

of the most scenic. Of the 200 miles of non-tidal Delaware, 175 miles have been granted protection under the National Wild and Scenic River System. However, the Delaware is not entirely free-flowing. During times of low flow, reservoirs owned by New York and various private power companies contribute the majority of the water seen at Trenton to maintain the agreed-on minimal flow.

Twenty-five years of advanced water treatment and remediation technology have been applied to water resource problems in the Delaware River Basin. There have been improvements, especially in terms of water quality. Nevertheless, considerable work remains to be done. Our increasing ability to detect the presence of toxic compounds in our water in more minute quantities points to the need for more research and intervention. Continued fish consumption advisories for the estuary are an indicator of the significance of this problem.

The huge urban, industrial and recreational demands on the Delaware River Basin have meant facing and overcoming major water supply and water pollution problems. Remediation efforts have been highly successful on the Delaware because of the cooperation among various agencies between states and the activism of its concerned citizens.

Chapter 1
THE GEOLOGIC HISTORY OF THE RIVER

The Age of Earth

James Ussher (1581–1656) was the archbishop of Ireland from 1625 until his death in 1656. Archbishop Ussher was one of the most important biblical scholars of the seventeenth century, best known for his chronological analysis of the Old Testament that concluded that Adam was created on Sunday, October 23, 4004 BC. Solving the problem of the age of Earth and fixing the time of the creation event during 4004 BC meshed well with his deep interests in history, astronomy, geometry and math. Archbishop Ussher's analysis, based solely on the biblical record, places the current age of Earth at roughly 6,020 years. Ussher's life's work and careful analysis was originally published in the early 1640s, and his work, although ridiculed by some anti-creationists today, merits the highest respect. He died before his study of the Old Testament was completed.[8]

According to the Jewish calendar, the creation event happened in 3761 BC, while a Greek translation of the Old Testament, today known as the Septuagint, established the date of creation at 5500 BC. By the time of the Renaissance (1300–1600), the age of Earth was thought to be somewhere between five thousand and six thousand years old.[9]

It is interesting to note a revelation from antiquity. The Talmud is a massive collection of Jewish civil and ceremonial law, ethics, philosophy, customs, history, legend and lore that comes to us from between 200 CE[10] and 500

CE. The Talmud preserves the opinions and teachings of thousands of rabbis, including a prophecy that Earth will exist only for six thousand years!

Interest in just how old Earth is has been an enduring problem across history that at times defied the existing knowledge and capability of philosophers, scientists, mathematicians and churchmen alike.

During the seventeenth century, naturalists began to recognize that Earth's crust consisted of horizontal layers, or strata, of rock. The idea that these strata could be dated (i.e., the upper layers being younger than other rock layers at depth) would come later. In 1790, William Smith reasoned that if two layers of rock at widely differentiated locations contain the same fossils, it was very possible that the layers were the same age. Smith's nephew, John Phillips, later calculated that the age of Earth was 96 million years based on his uncle's theory.

In the mid-eighteenth century, Mikhail Lomonosov speculated that Earth had been created separately from and several hundred thousand years before the rest of the universe. The Conte du Buffon attempted to obtain a value for the age of Earth experimentally in 1779. His work led him to an estimate that Earth was seventy-five thousand years old.

In 1862, physicist William Thompson, 1st Baron Kelvin, calculated that the age of Earth was between 20 million and 400 million years. His work was based on the assumption that Earth formed as a completely molten sphere, and he attempted to determine the amount of time it would take for a molten Earth to cool to its present temperature.

Charles Lyell and other geologists and biologists had difficulty accepting early estimates of Earth's age; even 100 million years seemed much too short to be plausible, especially in light of Charles Darwin's theory of the evolution of life. In 1867, Thomas H. Huxley, Darwin's advocate, attacked Thompson's calculations, indicating that they seemed to be precise but were, in fact, based on erroneous assumptions. In 1856, physicist Herman von Helmholtz calculated the age of Earth to be 22 million years, while in 1892, astronomer Simon Newcomb entered his calculation of 18 million years into the controversy. The debate swirled. Charles Darwin's son, George H. Darwin, an astronomer, entered the fray. He hypothesized that Earth and the Moon had broken apart in the early days when they were both molten. He attempted to compute the amount of time it would have taken for tidal friction to give Earth its current twenty-four-hour day. He concluded that Earth was 56 million years old. This figure provided evidence that supported Thompson's earlier work. Thompson, now invigorated, provided a revised estimate of 20 million years but less than 40 million years in 1897. In 1892,

Thompson had been made Lord Kelvin in respect for his many scientific achievements. Thompson had utilized thermal gradients of Earth's crust to calculate the age of the planet. His estimate of 100 million years was later invalidated because he did not understand that Earth had a highly viscous fluid-like mantle. John Perry in 1895 used a model of a convective mantle and a thin crust to produce an age-of-Earth estimate of two to three billion years. Around 1900, John Jay calculated the age of the oceans at between 80 million and 100 million years based on the rate that salt has accumulated in the oceans caused by erosional processes.

The turn of the century brought tremendous advances in science. In particular, the discovery of radioactivity by Henri Becquerel in 1896 and the subsequent discovery of polonium and radium in 1898 by Marie and Pierre Curie would eventually lead to the development of techniques for accurately aging rock samples, which would lead to more precise age-of-Earth calculations.

In 1903, Pierre Curie and Albert Laborde found that radium produces enough heat to melt its own weight in ice in one hour. Geologists swiftly realized that this upset the assumptions underlying most methodologies existing for the calculation of the age of Earth. These methodologies had assumed that the original heat of Earth and the Sun dissipated steadily into space over time, but the heat caused by radioactive decay of certain elements meant that heat was being continually replenished. George Darwin and John Holy were the first to call attention to this phenomenon.

Ernest Rutherford and Frederick Soddy jointly continued their research on radioactive materials and concluded, in part, that a particular radioactive element decays into another element at a distinctive rate. This rate of decay is given in terms of a "half-life," or the amount of time it takes half of a mass of a radioactive element to break down into another element or "decay product." This suggested that it might be possible to measure the age of Earth by determining the relative proportions of certain radioactive materials found in rock samples.

Bertram B. Boltwood, a chemist, and Ernest Rutherford were the pioneers in the study of radioactivity. Boltwood conducted research on radioactive material, while Rutherford lectured at Yale University. In 1904, Rutherford began research that would lead toward the development of radiometric dating. The use of radiometric dating was first published in 1907 by Boltwood and is now the primary source of information about the determination of the absolute age of geological samples, including the age of Earth itself, and can be used to date a wide range of natural and man-made materials.

Sir William Ramsey, working with Soddy, developed a radiometric dating technique based on the decay of radium and dated a rock sample to an age of 40 million years. Boltwood continued his research and concluded that lead was the end product of the radioactive decay of radium. By the end of 1905, Boltwood, not to be undone, calculated the ages of twenty-six rock samples ranging from 95 to 570 million years old. By 1910, Boltwood had refined his calculations dealing with the half-life of radium and finally published his work, which was received with seemingly little interest by the geological community. Nevertheless, Robert Strutt showed continuing interest in Rutherford's work until 1910 and then abruptly ceased his research.

Arthur Holmes, a student of Strutt's and a physicist, developed an interest in radiometric dating techniques after everyone else had given up. Research continued through the 1930s. Isotope nuclei were found to have differing numbers of neutral particles, known as "neutrons." However, many geologists felt that these new discoveries made radiometric dating so complicated that it was essentially worthless.

Arthur Holmes's persistence finally began to pay off in 1921, when the members of the British Association for the Advancement of Science came to a rough consensus that Earth was a few billion years old and that radiometric dating was a credible technique for the dating of geological samples. In 1927, Holmes published *The Age of the Earth, an Introduction to Geological Ideas*, in which he estimated the age of Earth to be between 1.6 and 3 billion years.

Diehards in the geological community stubbornly resisted the push to embrace radiometric dating. As geologists, they really never cared for the attempts of physicists to intrude in their domain.

The National Research Council of the U.S. National Academy of Sciences appointed a committee in 1931 in order to investigate and resolve age-of-Earth controversy. Holmes was an obvious choice for membership on this committee, as he was one of only a few people in the world who was trained in radiometric dating techniques. In fact, he wrote the committee's final report, concluding that radiometric dating was the only reliable means of establishing geographical time scales.

Radiometric dating techniques have been tested and fine-tuned on an ongoing basis since the 1960s. Approximately forty differing dating techniques have been used to date a wide variety of both geological and anthropological samples. Evolving computer technologies since the 1980s have added both speed and accuracy to the application of radiometric dating technology.

The Geologic History of the River

The age of Earth is 4.567 billion years,[11] or from another source 4.55 billion years, plus or minus about 1 percent.[12] Young-Earthers (i.e., Creationists) would vehemently disagree,[13] but in an age of intellectual reasoning we must respect people's religious beliefs while trusting science to provide us with insights into our world and lives.

Unfortunately, the age of Earth cannot be computed from material that is solely from Earth. The oldest rocks that have been found on Earth thus far date to about 3.8 to 3.9 billion years ago. Some of these samples are, in fact, sedimentary rocks that are made of minerals that are 4 to 4.1 billion years old, providing and indicating that Earth's history began well before these sediments were deposited. Rock samples this old are extremely rare, but samples that are at least 3.5 billion years old have been found in North America, Greenland, Australia, Africa and Asia.[14] The oldest minerals analyzed to date, small crystals of zircon from Western Australia, date from at least 4.04 billion years ago. Rock samples from the primordial Earth's surface simply do not exist. The young molten Earth underwent a differentiation into the core, mantle and crust that subsequently has undergone a long history of mixing and remixing. Earth's crust has experienced endless change over billions of years caused by crustal recycling.[15] Old rock is constantly being metamorphosed and/or disassembled and reformed into new rocks—rocks that are aggregates of minerals of different ages.

The exact age of Earth is difficult to determine. Scientists work on the assumption that the entire solar system—all the planets, moons, asteroids and more—were made from the same mix of material at the same time, and thus Earth and the other planets are essentially the same age. Consequently, in calculating age-of-Earth estimates, meteorites and lunar rocks provided by both the six Apollo and three Luna missions were analyzed by radiometric dating techniques. An age of 4.54 billion years for the solar system and the 4.5 billion years for Earth is consistent with current calculations of 11 to 13 billion years for the age of the Milky Way Galaxy and 14 to 15 billion years for the age of the universe.[16]

PLATE TECTONICS:
THE RECYCLING OF EARTH'S CRUST

We live on a restless, always changing planet. The continents rest on slabs of rock, called tectonic plates, and these plates float on a sea of semi-molten

rock. These plates are constantly scraping, rubbing and pushing against one another, creating enormous pressures. Over time, this pressure builds and builds, and the plates slip and collide, over and under one another, releasing huge amounts of energy—creating undersea trenches, uplifting new mountain ranges and defining areas of volcanic activity.

Beginning around the end of the sixteenth century, naturalists noticed a comparative similarity of the coastlines of Europe, North America, Africa and South America. These early scientists deduced that these continents were co-joined at some point in time in the ancient past, followed later by a drifting apart, coming to rest at their current locations on the globe. Francis Bacon (1561–1626), the English philosopher, had access to the first accurate maps of Earth's continents and was the first to come to this conclusion. Abraham Ortelius (1527–1598), a Flemish cartographer, reasoned in 1596 that North America was ripped from Europe and Africa by earthquakes and floods, at that time a conclusion without any supporting evidence. Nevertheless, in 1756, German theologian Theodor Lilienthal found a biblical foundation for Ortelius's Theory: "…and unto Eber were born two sons: the name of one was Peleg; for in his days was the Earth divided" (First Book of Moses, 10:25).[17]

Alfred Luthar Wegener (1880–1930) was born in Berlin on November 1, studied the natural sciences and earned his doctorate from the University of Berlin in 1905 in the field of astronomy. Although he worked as a meteorologist, physicist and polar researcher, he is today best remembered for his theory of continental drift—the idea that Earth's continents relentlessly move over the planet's surface over hundreds of millions of years of geologic time. As early as 1910, Wegener had already pointed out that possibly the continents were once gathered together as a single landmass.

Even though Wegener maintained a deep interest in meteorology and polar research, working with his older brother, Kurt, he conducted groundbreaking research on Greenland, participating in four Arctic expeditions. His interests and insights in his theory of continental drift continued to evolve. He was the first researcher to overwinter on Greenland, conduct ice-core drilling on a moving Arctic glacier, establish a permanent meteorological station on Greenland and use kites and weather balloons to track arctic air masses. His lectures formed the basis for what would become the standard textbook in meteorology, *Thermodynamics of the Atmosphere*, first published in 1909–10. From 1919 to 1923, he conducted an innovative reconstruction of the climate of past eras while working in collaboration with Milutin Milankovic—a precursor to the field of

"paleoclimatology"—and published *The Climates of the Geological Past* while working together with his father-in-law, Vladimir Kōppen, in 1924. From 1910 until his unfortunate and tragic death while participating in a heroic effort to resupply stranded fellow meteorologists in November 1930 on the Greenland ice sheet, he made concerted efforts to establish the credibility of his continental drift theory, publishing major works on the subject in 1912, 1915 and 1929.

Wegener recognized the obvious congruence of the coastlines of North America, Europe, Africa and South America. He saw the 200m isobaths (lines of equal depth) as best indicators that these continents were once joined together and have over geologic time drifted apart to their present locations. The continents fit almost perfectly together at the 500m isobath.

World War I saw Wegener called up for service in 1914. He was wounded twice in fierce fighting. Declared unfit for active service, he was assigned to the army weather service and was still able to complete the first version of a major work on continental drift theory, publishing *The Origins of Continents and Oceans* in 1915. During November 1926, Wegener presented his continental drift theory to a symposium of the American Association of Petroleum Geologists in New York City. In 1929, he published the final edition of *The Origins of Continents and Oceans*.

In spite of supporting his lectures and writings with scientific observations showing a geographic fit for the continents, fossil evidence and similar geologic patterns on both sides of the Atlantic, his work was poorly received and he was never able to convince a skeptical audience that demanded more proof. Wagener simply did not have a strong argument for explaining the force that drove the continents to wander at a velocity of 250 centimeters per year. Wegener's driving force was the centrifugal force of Earth's rotation. The currently accepted rate for the separation of North America from Europe and Africa is about 2.5 centimeters per year. Also, unfortunately, Wegener was seen as an "outsider" by geologists, who were unsure and resistant to change and new ideas. Wegener was ahead of his time. It would take nearly thirty years for research to provide the data that would support his thesis.

Likewise, Wegener's hypothesis that there had once been a giant continent, consisting of all the existing continents (which he named Urkontinent, German for "primal continent" and analogous to the Greek Pangaea, referring to "all-lands" or "all-Earth"), found few adherents. Wegener would die tragically at age fifty on Greenland and not live to see the eventual acceptance of his ideas by the scientific community.

Through the 1930s and 1940s, continental drift theory faced strong opposition and consequently gained few followers, but in the 1950s, a new development, paleomagnetism, provided insight into the movement of continental land masses over geologic time. In the early 1950s, the new science of paleomagnetism was pioneered at the University of Cambridge by S.K. Runcorn and at Imperial College by P.M.S. Blackett, and it was soon producing evidence concerning the movement of continents that reinvigorated interest in Wegener's theory of continental drift. By early 1953, rock samples from India showed that the subcontinent had been in the Southern Hemisphere when the rock samples were magnetized in the past, as had been predicted by Wegener.

The science of paleomagnetism is based on the premise that when rock forms, from lava for example, cooling lavas become magnetized from Earth's magnetic field as the temperature drops low enough to solidify the rock, and iron oxides, abundant in lavas, crystalize and become magnetized parallel to Earth's magnetic field. Even sedimentary rock can become magnetized under certain conditions.

Magnetized rock crystals point up at the south magnetic pole, toward the north across the equator and then down at the north magnetic pole, allowing geologists to determine the precise location of land masses on the earth's surface in the geologic past.

By 1959, enough supporting data existed to support a renaissance in the idea of continental drift—minds were beginning to change.

Beginning with efforts during World War II to counter enemy submarine attacks on Allied shipping, attention was focused on mapping the sea floor utilizing sonar and the mapping of Earth's magnetic signature using towed magnetometers. Considerable resources were summoned in this effort to map both the depth and shape of the ocean floors.

This new age of exploration led to the discovery of both "mid-ocean ridges" and "fracture zones" by the mid-1950s; both geologic features would play major roles in the development of the theory of plate tectonics. Maps of the geomorphology of the ocean floors created by Marie Tharp in cooperation with Bruce Heezen were an important contribution to the paradigm shift that had begun. Wagener was then recognized as the founding father of one of the major scientific revolutions of the twentieth century. Later, with the advent of Global Positioning Systems (GPS), it became possible to accurately measure continental drift directly.

Additional discoveries were made regarding the structure of Earth itself, fostered by the rapid growth in seismology, the study of earthquakes. A shift

in perspective came about from the chemical stratification of Earth in terms of crust, mantle and core to another that emphasized strength—a strong lithosphere, from the Greek word *lithos*, meaning rock, overlaying a weaker asthenosphere, from the Greek *asthenos*, meaning weak.

The new paradigm views the surface of Earth as two distinct layers. The rigid lithosphere consists of the crust and the upper portion of the mantle, the outer 70–150km, to as much as 250km, thinner below the oceans, while asthemosphere consists of the lower mantle. Earth's crust is generally divided into two distinct types of rocks, continental and oceanic. Continental crust has an average thickness of 30–40km but could range up to 70km in thickness under mountain ranges and high plateaus. Oceanic crust is considerably thinner, ranging 5–8km in thickness, and forms the ocean floor. Most solids are strongest when cold and become weaker as temperature increases. Thus, the strongest rock is close to the surface, and rock weakens as depth and temperature increases. The lithospheric part of the mantle behaves in a brittle fashion and contrasts in this regard from the underlying "plastic-like" hotter asthenosphere.

German research vessels had discovered long submerged mountain ranges, known today as mid-oceanic ridges, near the end of Wegener's career. These ridges are a key to the concept of the modern plate tectonics theory, but skepticism of continental drift theory persisted into the 1950s, especially in the United States, even after the mid-ocean ridges had been rediscovered following World War II.

In 1960, American geologist Harry Hess proposed that as continents drift apart, new ocean floor forms between them by a process that Robert Dietz also had described and named sea-floor spreading. Mid-ocean ridges circle the globe in both the Atlantic and Pacific Oceans, and it is at these ridges that new oceanic crust is created. As new lithosphere crust is created, sea-floor spreading takes place in a process caused by injection and eruption of magma derived from the mantle, thus causing the oceanic lithosphere to spread laterally. Obviously, as new crust is created over millions of years, Earth does not become larger. There must be a process that compensates for this continued growth.

A breakthrough in understanding came in the early 1960s, when the sea-floor spreading theory gained support of the geological community. Sea-floor spreading offers a valid explanation for how the continents may drift across the globe and yet retain their deep roots by rifting at the base of the lithosphere and not at the Moho, the boundary between the crust and the mantle.

Hess, among others, suggested that as continents move toward one another caused by sea-floor spreading, old ocean floor between them sinks back down into Earth's interior in a process called "subduction." Subduction zones are continental boundaries where heavy old oceanic lithosphere dives under lighter continental lithosphere, creating areas marked by deep-sea trenches, earthquake activity and volcanoes and, many times, forming island arcs and thus compensating for the growth of new crust at the mid-ocean ridges.[18]

By 1968, geoscientists had developed a supportable model encompassing continental drift, sea-floor spreading and subduction zones, defining the plate tectonics theory as a grand unifying theory of geology. The fundamental substance of the basic idea of plate tectonics theory is simply a description of the relative movements of the several plates of the lithosphere as these plates move over the underlying weaker but hotter asthenosphere.

Earth's lithosphere, a relatively rigid shell, consists of about twenty distinct plates that slowly move relative to one another. Some plates consist entirely of continental lithosphere or entirely of oceanic lithosphere, and some plates consist of both. Most of the motion of the plates takes place by sliding along plate boundaries; the edges of the plates are not necessarily the edges of continental land masses. Plate interiors remain relatively unaffected by this motion. Four types of plate boundaries have been observed:

- DIVERGENT BOUNDARIES: Two plates move apart by the process of sea-floor spreading; a mid-ocean ridge is an example of a divergent boundary.
- CONVERGENT BOUNDARY: Two plates move toward each other and collide, and one plate subducts (sinks down to the mantle) beneath the other, creating a deep ocean trench, as well as earthquakes and volcanic activity on Earth's surface. Only heavy oceanic lithosphere can subduct.
- TRANSFORM BOUNDARIES: Two plates interact by sliding sideways past each other; the boundary between the two plates is marked by a large fault or fracture zone on which the sliding occurs.
- TRIPLE JUNCTION: Three plate boundaries meet; these junctions can occur where mid-ocean ridges meet and where two continents collide, forming mountains, because continental lithosphere is too light and buoyant to be subducted. Continental rifts (faults) may develop, and if a continent breaks apart, a new mid-ocean ridge develops.[19]

At first glance, geoscientists thought that the driving force for plate movement was convection cells in the asthenosphere, theorizing at first that heat rose at mid-ocean ridges and sank in subduction zones. However, plate motion is much too complex for this single explanation. While convection flow within the asthenosphere does occur and does influence plate motion, it does not directly drive motion.

Today, geoscientists favor the premise that two forces strongly influence the motion of individual plates:

- RIDGE-PUSH FORCE: Since the mid-ocean ridge is higher in elevation than the surrounding abyssal plain, gravity causes the elevated lithosphere at the ridge axis to push on the lithosphere that lies farther from the ridge axis and move it away, allowing new hot asthenosphere to rise and fill the gap created.
- SLAB-PULL FORCE: The force created by the subducting oceanic lithosphere pulls the plate toward the subduction zone.[20]

Tectonic plates do move, some great distances over geologic time scales. The Indian subcontinent was just a large island off the coast of Australia in the Southern Hemisphere 225 mya before it began its journey to the north. India moved north at a velocity approaching 9 meters per century and rammed into Asia 40–50 mya, forming the Himalayan Mountains. Recent media reports indicate that the continent of Australia has moved north 5 feet in the last 20 years. In addition, all oceanic crust older than 180 million years has been subducted.[21] Current estimates of the spreading rate for mid-ocean ridges (divergent plate boundaries) in the Atlantic Ocean is 2 to 5 meters per year—for example, the Atlantic Ocean has gotten about 6 feet wider in my lifetime, while the East Pacific Rise is moving along at a faster rate of 6 to 16 centimeters per year.

SUPERCONTINENTS: PANGAEA

Earth was formed from the debris, dust and rock fragments of exploding stars. The dust of the solar system gradually accumulated, assisted by gravitational forces, into planetismals and eventually into planets, like Earth, and began to cool. On Earth, the first rock formed 4.5 bya,[22] but the planet was under constant bombardment from asteroids and comets,

leaving the surface a molten volcanic (lava-like) environment. The molten earth eventually formed distinct layers—crust, mantle and iron core—as it cooled from the outside. The original rock was basalt, a heavy dark rock that eventually formed our ocean basins. Continents and oceans were developing by 4.28 bya. Continental rock was essentially granite, a lighter, more buoyant rock than the original rock basalt, so it "floated" on the heavier basalt.

Soon after the formation of defined continents, tectonic forces were at work, and land masses were constantly shifting and clashing, exhibiting a relentless and endless cycle of construction and destruction of landmasses—nature's process of death and rebirth.

From 1910 to 1915, Alfred Wegener publicly advocated the existence of "continental drift" and gathered data—geological, fossil, geographical and, to some extant, climatological—in support of his hypothesis that all the continents were once joined together in a single landmass, a supercontinent that had over millions of years drifted apart to form the continents as they exist today. Wegener's ideas were met with derision and doubt from the geological community for the reasons previously discussed. His work would eventually form the foundation for the theory of plate tectonics, which triggered a renaissance in modern earth science.

In 1915, Wegener published *The Origins of Continents and Oceans* to advance his theory that there had once been a single giant continental landmass, which he named Urkontinent. In the decades following Wegener's heroic death on Greenland, evidence would be forthcoming that would prove the existence of Pangaea and other supercontinents.

Nine supercontinents have gathered and then dispersed over the course of Earth's 4.5-billion-year existence:[23]

- Gondwana (510–180 mya)
- Laurasia (510–200 mya)
- Pangaea (300–210 mya)
- Pannotia, also called Vendian (600–545 mya)
- Rodinia (1.1 bya–750 mya)
- Columbia also called Nuna (1.8–1.5 bya)
- Kenorland (2.7 bya–2.1 bya)
- Ur, classified as the earliest known landmass, probably the largest and perhaps even the only continent 3 billion years ago (3 bya)
- Vaalbara; evidence of its existence was found in Western Australia and worldwide greenstone belts that were part of Gondwana and Laurasia (3.6 bya)

The Geologic History of the River

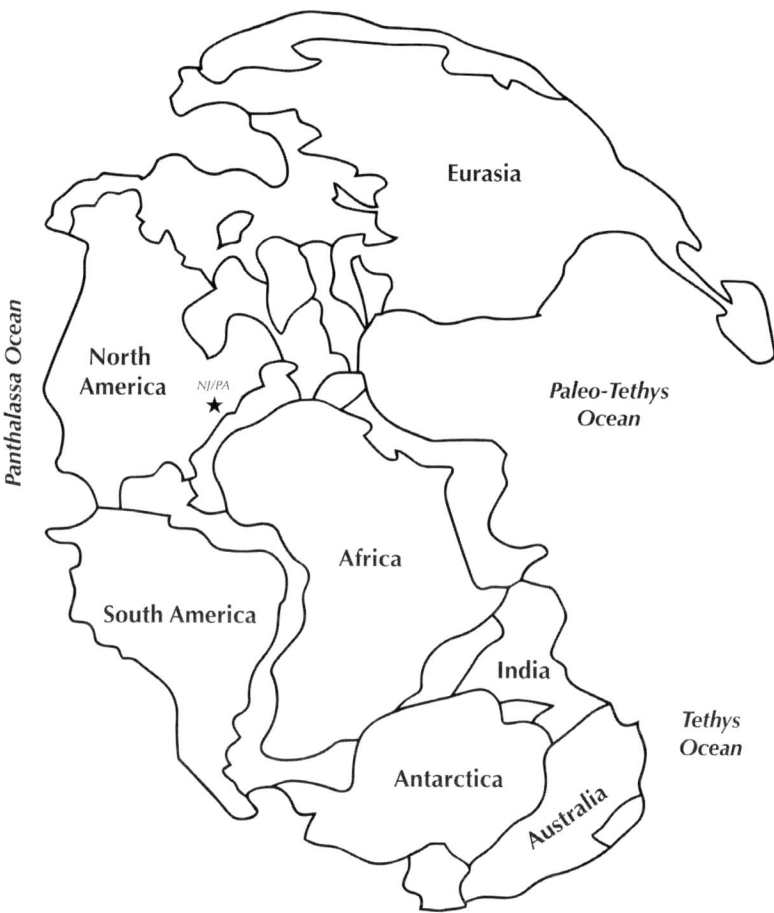

Pangaean Supercontinent
(360 to 200 mya, possibly 387 to 180 mya)

Wikipedia.

 The gathering of continents and microcontinents that would eventually become the Pangaea supercontinent began in the Paleozoic Era and continued through the Mesozoic Era until the Early Jurassic Period (300–175 mya). It assembled from earlier continental land masses approximately 300 mya and began to drift apart and separate in a cyclical process about 175 mya. In contrast to the present distribution of land masses on Earth today, much of Pangaea was located in the Southern Hemisphere and

was surrounded by a superocean, Panthalana. Pangaea was the last supercontinent to assemble and the first to be reconstructed by geologists, owing to the early work of Wegener and the efforts of modern-day paleontologists working with the distribution of similar plant and animal fossils found on the various continents that exist today.

Today, about one-third of Earth's surface is covered with continental land masses. Continental crust has not grown at a constant rate throughout the geological past, but crustal growth was particularly rapid during the late Archean Era, approximately 2.5–1.3 bya.[24]

The process of assembling Pangaea proceeded through a number of stages. Stage one involved the fledgling North American continent called Laurentia, which during the Cambrian Period (542–488 mya) sat astride the equator. In the early Ordovician, around 480 mya, the microcontinent Avalonia—a landmass incorporating fragments of what would become Newfoundland, the southern British Isles, Nova Scotia, parts of Belgium and France, New England, Spain and northwest Africa—broke free from Gondwana and began moving north toward Laurentia. Baltica, Laurentia and Avalonia all came together by the end of the Ordovician Period (444 mya) to form a minor supercontinent called Euroamerica or Laurussia. This collision also resulted in the formation of the northern Appalachian Mountains. Siberia sat near Euroamerica and Gondwana began to drift slowly toward the South Pole. This was the first step in the process of forming Pangaea.

The second stage of this process of assembling Pangaea involved the collision of Gondwana with Laurentia forming Euroamerica, while Avalonia inched its way toward Laurentia. Meanwhile, southern Europe broke free from Gondwana and began to move toward Euroamerica, colliding with southern Baltica in the Devonian Period (416–359 mya). Island arcs from Siberia collided with eastern Baltica, which was now part of Euroamerica. Behind these island arcs was the new Ural Ocean.

Stage three in the assembly of Pangaea began with North and South China splitting from Gondwana and heading northward. During the Devonia Period (416–359 mya), Gondwana itself headed northward toward Euroamerica. In the Early Carboniferous Period (359–299 mya), northwest Africa had touched the southeastern coast of Euroamerica, creating in part the southern portion of Appalachian Mountains. South America moved in a northerly direction to suture itself to southern Euroamerica, while the eastern portion of Gondwana (India, Antarctica and Australia) headed toward the South Pole from the equator; finally, the Kazakhstania microcontinent collided with Siberia.

The Geologic History of the River

The final stage in the formation of Pangaea occurred in the Late Carboniferous (318–299 mya), when Western Kazakhstania collided with Baltica, causing the formation of both the Ural Mountains and the supercontinent of Laurasia. At the same time, South America collided with southern Laurentia, forming both the southernmost portion of the Appalachian Mountains *and* the Ouchita Mountains. By this time, Gondwana had neared the South Pole, and glaciers were forming in Antarctica, India, Australia, parts of Africa and South America. Finally, North China collided with Siberia in the Late Carboniferous (318–299 mya). Finally, Pangaea rotated a bit, forming a "C" shape partially enclosing the Paleo-ethys Ocean.

Over the course of the 240 million years it took for Pangaea to assemble, beginning with the breakup of the supercontinent Pannotia 540 mya to its final completion in the Late Carboniferous, three orogenies (mountain-building events caused by the continental collisions) took place, which together resulted in the formation of the Appalachian Mountains on the eastern edge of what would become North America. (Just as an aside, *orogeny* is a fun word to pronounce, plus it sounds a little dirty!)

The three orogenies that resulted in the formation of the Appalachian Mountains occurred during the Paleozoic Era and include the Taconic Orogeny during the Ordovician Period (488–444 mya), characterized by extensive volcanism and the development of the Appalachian basin; the Acadian Orogeny during the Devonian Period (416–356 mya), caused by the collision of Avalonia, Europe and North America; and the Alleghanian Orogeny during the Permian Period (299–251 mya), characterized by mountain-building, faulting, folding and much erosion.[25]

Evidence to support the existence of Pangaea is both substantial and well founded in modern science and reinforces the data gathered by Wegener in the 1900s:

- Geological trends match between the eastern coast of South America and the western coast of Africa.
- There is continuity in mountain chains across continents now separated by oceans—for example, the Appalachian Mountain chain extends from the southeastern United States to the Caledonides of Ireland, Britain, Greenland and Scandinavia.
- Glacial deposits, specifically till, of the same age are found on separate continents that would have been contiguous on the continent of Pangaea.

- Paleomagnetic evidence allows geologists to reconstruct the movement and orientation of tectonic plates over geologic time.
- Plant and animal fossil evidence manifests the presence of similar and identical species on continents that are now great distances apart; for example, fossils of the freshwater reptile mesosaurus have been found only in localized areas of the coasts of Brazil and West Africa.

Pangaea was finally assembled by 300 mya during the Late Carboniferous, while the first indication of crustal fractures, the initial signs of continental breakup, began to appear perhaps as early as 200 mya during the early Triassic Period. Nevertheless, the breakup of Pangaea did not occur until the middle Jurassic at approximately 175 mya.

The breakup of Pangaea can be seen to proceed in four distinct phases:

- The first phase of the breakup process occurred with the separation of North America and northwestern Africa in the area of the present-day central Atlantic Ocean, while at the same time separating Europe and the Iberian Peninsula.
- During the second phase of the breakup, the South Atlantic Ocean between Africa and South America was formed; the rift moved northward, eventually opening into the central Atlantic Ocean.
- The third phase of the breakup saw the North Atlantic Ocean establish its final location. During the Early Cretaceous, the initial rift between Newfoundland and Iberia opened while the counterclockwise rotation of Iberia opened the Bay of Biscay. Rifting spread northward, creating the separation of Greenland from the British Isles, and westward, creating a failed opening between Greenland and Canada.[26]

The separation of Antarctica and Australia would lead to their migration to their current locations. India would begin its trek northward at unheard-of speed on its way to a relentless collision with Asia, in the process raising the Himalayan Mountains. This mountain-building event continues today. North Africa would also move northward, colliding with Southern Europe to form the Alps Mountains. Approximately 60 mya, hotspot volcanic activity would result in the birth of Iceland. The early Eocene (55 mya) would see the separation of Greenland from northern Europe, while continued

rifting would result in the spreading of the Laborador Sea and the final separation of Greenland and North America. Tectonic activity is ongoing and relentless. The East Africa Rift Valley is seen by some that the breakup of Pangaea is still progressing.

In the next 250 million years, Earth, based on past experience, may see the reassembly of a new supercontinent. The subduction of the Atlantic and Indian Ocean Basins would destroy the Atlantic Ocean and bring North America, Europe and Africa back together again. While on the basis of current tectonic technology the potential for a reconfiguration of our continents seems possible, our tools are too imprecise to project an accurate scenario that far into the future. Regardless, the quest to name the new supercontinent has begun. Suggested names include Anasia (the fusion of America and Asia), Pangaea Ultima, Pangaea II, Pangaea Proxima and, of course, Neopangaea.

THE APPALACHIAN MOUNTAINS

If we take a historical perspective of the tectonic history of the Appalachian Mountains, we discover that it reaches back nearly 2.5 billion years to the Archean Epoch with the creation of the first continental crust. During the Proterozoic Epoch, nearly 1 billion years later, the subcontinent of Laurentia, a landmass that one day would become North America, formed through the tectonic process of the accretion of microplates. Plate tectonics and the marvel of continental drift had begun nearly as soon as land masses appeared. Thus, the geologic history of the Appalachians represents nearly 1 billion years of tectonic events and processes.

The name "Appalachian" is the fourth-oldest surviving European place-name in the United States. The origin of the name dates to the Pánfilo de Narváez expedition, which explored along the northern coast of Florida in 1528. While exploring inland from the coast, members of the Narváez party, including Álvar Núñez Cabeza de Vaca, found a Native American village near present-day Tallahassee, Florida, whose name they translated as *Apalchen* or *Apalachen*. The name was soon altered by the Spanish to *Apalachee* and used as a name for both the local Indian tribe and the region, which spread far inland to the north. The Narváez expedition entered Apalachee territory on June 15, 1528.

Following the trek of explorer and conquistador Hernando de Soto deep into the territory of the modern United States and his discovery and crossing

of the Mississippi River in 1540, Spanish cartographers began applying the name of the tribe to the mountains themselves. The first cartographic use of the name Apalchen was on Diego Gutierrez's map of 1562. The first cartographer to apply the name to the entire mountain range was Jacques le Morne de Morguer in 1565.

Nevertheless, the name was not generally used for the whole mountain range until late in the nineteenth century. A more popular name was the "Allegheny Mountains" or just "Alleghenies." In the early 1800s, Washington Irving proposed renaming the United States either "Alleghenia" or "Appalachia."

The Appalachian landscape we see today is the result of millions of years of compressive mountain-building and folding, including faulting, deposition of sediment, uplifting, erosion and the scouring effects of continental glaciation. The land area encompassed by the Appalachian Mountains is referred to as the Ridge and Valley Providence and is bordered on the east by the Great Valley, a lowland area that extends the length of the eastern coast of the United States from St. Laurent, Canada, to Alabama and the Mississippi Valley to the west. The mountains of Pennsylvania and New Jersey represent only a small portion of a very large collision mountain belt zone.

This great linear mountain range extends continuously from Newfoundland nearly two thousand miles south to central Alabama and ranges from seventy to three hundred miles wide along its great length. The Appalachians were part of a much larger mountain system that split up and dispersed during the breakup of the Pangaean supercontinent. Eastern Greenland, the Caledonian Mountains of Great Britain and the mountains of northeastern Scandinavia were originally contiguous with the Appalachians. Other mountains of the same age in the Canadian Arctic, western Europe and North Africa may once have been part of this mountain system. Although the Adirondack Mountains of New York State have a different geological history from the rest of the Appalachians, the Ouachita Mountains of Arkansas and Oklahoma and the Marathon Mountains of Texas may also have once been part of the southern Appalachian Mountains but are seen now as separate mountain ranges disconnected through geological history.[27]

The Appalachian mountain system is divided into a series of ranges, with individual mountains averaging about 3,000 feet. The highest of the group is Mount Mitchell in North Carolina at 6,684 feet, which is also the highest point in the United States east of the Mississippi River. It is generally accepted that the Appalachians can be classified as Southern, Central and Northern regions, each with its own distinct characteristics.

The Geologic History of the River

It is believed that during the Devonian Period, some 400 mya, continued folding and uplifting raised the tops of the folds to an elevation of twenty-five to forty thousand feet above sea level, which made Pennsylvania a mountainous land as high or higher than the Alps or Himalayas today.

The existence of very old rocks, Precambrian Era (542–4,600 mya), in the New Jersey Highlands gives evidence that these mountains were formed by an early collision of continents that also affected large areas of eastern Canada. Rocks of Precambrian age are found in highly folded strata in both northwestern New Jersey and the Canadian Shield, which in addition to the existence of volcanic activity and granitic intrusions suggest an area where ancient crustal plates or continents have collided. This tectonic event is known as the Grenville collision and was one event in the assembling of the supercontinent Rodinia; it was named after a settlement near Montreal, Canada. The Grenville Orogeny generated a long mountain belt from southern Scandinavia to eastern Greenland, including large parts of eastern North America down to South America.

The next episode of the geologic history of the Appalachian Mountains is better documented and took place in the late Precambrian Era, about 600 mya. During this period, North America, Laurentia, was joined with both the African continent and a land mass that one day would become Europe. Rifts appeared, and these land masses began to move apart, opening the "Proto-Atlantic," forming the ancestral Atlantic Ocean. North America, with New Jersey and Pennsylvania attached to its eastern coast, began to drift away from Europe and Africa. The western edge of the Proto-Atlantic received enormous quantities of sediments from the older North American continent. A shallow-water trough (a eugeosyncline) developed on the continental slope. This trough filled with great quantities of sediments from the continental slope, creating a narrow belt of crustal deformation. Sedimentary deposits may have become two miles thick, creating a complex downward deformation and uplifting that separated a deepwater trough (a miogeosyncline) with the eugeosyncline to the west along the Atlantic margin. This complex formation would later become the Blue Ridge of the Appalachian Mountains.[28] Marine sediments were raised to great elevations during later mountain-building events.

Profound changes took place along the Atlantic margin by the late Ordovician some 440 mya. The Proto-Atlantic began to once again close, while the intrusions of igneous (granite) rocks caused extensive folding in the Precambrian rock layers and metamorphosed existing sedimentary strata.

Four distinct orogenies (on both coasts of North America, and we may never know how many orogenies occurred prior to the formation of Pangaea) would follow in the next 400 million years, each characterized by compressive mountain-building, folding, faulting, uplifting and extensive erosion and deposition.

Orogenies take place over millions of years, during which dispersed continental pieces are welded together into even larger land masses while creating complex networks of mountain ranges. The collisions that occur in orogenies involve the accretion of various terranes, which entails both narrow interior and exterior compressional processes. Large blocks of crustal rock are thrust upon each other, deformed by folding and faulting and metamorphosed at great depth, while the surface expression of these internal events, uplifting to form the mountain range, may take millions of additional years. Each orogeny may evolve in phases as one terrane after another is accreted to the growing landmass.[29]

During the Middle to Late Ordovician (458–444 mya), a group of microcontinents and island arc terranes accreted to the Laurentian continental margins prior to the Taconic Orogeny, beginning the formation of the north-central Appalachian Mountains. This early tectonic event is referred to as the Potomac Orogeny. It is associated with the formation of the Appalachian Basin, which persisted into the Middle and Late Paleozoic Era.[30]

The second orogeny, the Taconic, was a mountain-building series of tectonic events that ended 444 mya and affected most of modern day New England. As Africa and Europe began to move toward North America, the Proto-Atlantic began to close. A great mountain chain formed from eastern Canada south through Vermont and Massachusetts and into what is now the Piedmont off the East Coast of the United States.

Beginning in the Cambrian Period (490 mya), the weight of accumulating sediment and compressional forces forced the eastern edge of the North American continent to fold gradually downward. Shallow-water conditions that had existed gave way to a deepwater environment during the Middle Ordovician. During this process, a convergent plate boundary developed along the eastern edge of a small island chain, as did a subduction zone. Down-going crustal material overlaying the mantle melted and magma returned to the surface, forming the offshore Taconic Island arc.

By the Late Ordovician, this island arc had collided with the North American continent, causing great folding and faulting as well as intense metamorphism. This was the final episode of the Taconic Orogeny.

Basement rocks had been shoved tens or even hundreds of miles to the west. The subduction zone ceased to exist after the Taconic Islands were accreted to the eastern margin of North America. Inland seas that covered the mid-continent gradually expanded eastward. A westward drainage pattern was established for the young Appalachians at this time.

The Silurian Period (416–444 mya) was a tectonically quiet period of erosion and deposition. The Shawangunk conglomerate strata, which extends southward from the Hudson Valley along the eastern front of the Catskill Mountains and forms an impressive caprock ridge of the Shawangunk Mountains of New York extending eastward to the Kittatinny Mountains of New Jersey, dates from the Silurian Period. Aside from the episodic rise and fall of sea level, the tectonically quiet period extended into the Devonian Period (356–416 mya).

The third orogeny in the billion-year history of the formation of the Appalachian Mountains took place during the Devonian Period (356–416 mya). This was the Acadian Orogeny and involved the collision of Avalonia continental fragments, Europe and North America (Laurentia). The Acadian was a long-lasting mountain-building event that was active for nearly 50 million years and lasted until the early Mississippian Period (299–356 mya). Geographically, the effects of the Acadian Orogeny extended from the Canadian Maritime provinces southwestwardly toward Alabama. Nevertheless, the Northern Appalachian region, from New England northeastward into the Gaspe region of Canada, was the most greatly affected region of the event.

During the time of the Acadian Orogeny, Middle Devonian (385 mya), Laurentia was in the Southern Hemisphere near the equator. Gondwana was the supercontinent at this time, and it was located near the South Pole. The Acadian collision resulted in the closing of the southern Iapetus Ocean and the formation of a high mountain belt in the northeastern United States. After the Acadia collision took place, Gondwana began to move away from Laurentia, with the newly accreted Avalonian continental fragments left behind. As Gondwana continued to move away, a new ocean opened, the Rheic Ocean, during the late Devonian. Its subsequent closure would result in the fourth and final orogeny, the Allenghanian.

The Acadia Orogeny was a continent-continent collision along a subduction zone below eastern Laurentia, resulting in the uplift and formation of the high Northern Appalachians, as well as the closure of the southern Iapetus Ocean. Deformation, plutonic intrusion, over-thrusting and extensive metamorphism accompanied the uplifting. New faults formed

while older faults were reactivated. During the Middle Devonian, New England experienced volcanic activity while an inland seaway covered much of Southern and Central Appalachia. Drainage continued to the west and northwest into the vast mid-continent inland sea. The Acadian is noted for its formation of deltas and extensive erosion and deposition, especially throughout the Catskill region.

By the end of the Devonian (356 mya), the Proto-Atlantic had closed as North America collided with Europe, once again forming a single continuous continent landmass, Pangaea. A narrow belt of extensive crustal uplift separated and deformed the existing eugeosyncline from the miogeosyncline. These later became the Piedmont and Blue Ridge, respectively. The Western Appalachian region, however, remained a subsiding zone, and enormous quantities of sediment were shed into these lowlands from the highlands to the east during the Carboniferous Period (299–356 mya).[31]

The fourth and final orogeny was the Alleghanian, sometimes referred to as the Appalachian Orogeny, which resulted in the formation of the Southeastern Appalachian Mountains and the Allegheny Mountains and completed final assembly of Pangaea during the Permian Period (254–299 mya). The Alleghanian Orogeny was provoked by the collision of Northwest Africa with the then southeastern coast of Euroamerica. The orogeny compressed the already deformed rock strata of the Valley and Ridge Province, as well as folding and faulting the undeformed Pennsylvania and Permian strata of Pennsylvania into a series of plunging anticlines, synclines and monoclines.[32] The Appalachians were again raised to great heights by episodic folding, faulting and uplifting. Granite intrusions invaded the mountain range. The Appalachian basin was squeezed into great folds and thrust faults piled on top of one another, shortening the crust in North Carolina and Tennessee area by as much as two hundred miles. The greatest amount of deformation is associated with the Southern Appalachians. As one travels north, the amount of deformation lessens. The fold belt diminishes as you approach Pennsylvania in the Ridge and Valley Province and fades in the vicinity of the New York border. The Kittatinny Mountains in northwestern New Jersey mark the northeasternmost extension of the high ridges of the fold belt.[33]

The mountains formed by the Alleghania events were once high and rugged but have been eroded into only a small remnant of what once existed. During the Mesozoic Era (65–251 mya), the high mountains were eroded to a peneplane but little above sea level, the eastern rim of this plane being the Kittatinny mountain range through which the Delaware River now winds its way.

With the breakup of Pangaea during the Jurassic Period 175 mya, the drainage pattern changed to the east and southeast. Sediments continued to flow west into the Alleghany and Cumberland Plateaus but were also carried eastward by southeast-flowing rivers and streams to form the coastal plain and parts of the continental shelf as it exists today.

The Wisconsin period of continental glaciation, which began its retreat from the Northern Appalachians approximately eighteen thousand years ago, scoured the landscape into the gently rolling peaks we experience today. The ice sheet, reportedly one thousand feet thick over the Kittatinny Mountains, left only mountaintops free of ice and extended as far south as Belvidere, New Jersey.

THE DELAWARE RIVER: GEOLOGICAL HISTORY

The convoluted drainage pattern of the Delaware River system provides an uncommon example of a combination of drainage abnormalities that challenge various explanations as to just how this Appalachian river system evolved over time.

It is thought that the formation of the Delaware River Valley began approximately 30–50 mya during cycles of erosion and uplifting. The geological history of the Delaware actually began eons before that, beginning with the breakup of Pangaea between 220 and 200 mya, when numerous rift valleys formed from eastern Greenland to Guinea in West Africa. The "Newark Rift System" stretched from the Carolinas to Nova Scotia along what is now the east coast of North America.

When the Pangaean supercontinent finally rifted apart during the Triassic Period, the east coast of North America separated along the approximate line of a previous suture with Northwest Africa. Eurasia separated from the northeast coast of North America, Nova Scotia and Greenland. Water poured into the breach from the eastern equitorial Tethys Ocean to form the Proto-Atlantic Ocean. The Mediterranean Sea is all that remains of the Tethys today, and the Panthalassa Ocean eventually became the Pacific Ocean. Continued rifting and sea-floor spreading completed the breakup of Pangaea, creating the East Coast of the United States, the Atlantic Ocean and the continents as we see them today. During the active rifting and spreading, basalt flooded into parts of what are now the states of New Jersey and Connecticut. Magma that could not reach the surface intruded beneath

existing rocks to form volcanic "sills." One such sill has been uplifted and uncovered by erosion to form the Palisades Cliffs of the Hudson River, a high escarpment that owes its origins to the disintegration of Pangaea.

Cycles of mountain-building, uplifting and erosion over the previous 200 million years left the newly formed east coast of North America with a rugged mountain backbone, the Appalachian Mountains. Prior to the breakup of Pangaea, drainage was predominately to the west from the Appalachians into the great shallow inland sea that inundated the mid-continent region. With continued uplifting and tilting the drainage divide shifted, and drainage patterns changed dramatically to the east and southeast. Great rivers formed: the Connecticut, the Hudson, the ancestral Delaware, the Lehigh, the Schuylkill, the Susquehanna, the James and the Potomac—all flow east/southeast from the Appalachian eastern front.

The Delaware has its beginning in an obscure spring near Hobart, New York, on the western slopes of the Catskill Mountains.[34] This is the West Branch (also called the Mohawk Branch) of the Delaware. The East Branch, which also rises in the western Catskills, trickles from a small pond south of Grand Gorge in the town of Roxbury, New York, joining the West Branch at Hancock, New York, to form the main stem of the Delaware River. Drainage is south from the junction of these branches at Hancock on the Pennsylvania border. There is no question of the identity of the Delaware throughout its winding southward 320-mile course to the sea. Beginning a few miles above Hancock to Port Jervis, the Delaware forms the boundary between Pennsylvania and New York, while from Port Jervis southward, the river forms the boundary between Pennsylvania and New Jersey.

Beginning at Port Jervis and continuing south to the Delaware Water Gap, the ancestral Delaware follows a strike or subsequent valley thought to be eroded from the Schooley Peneplain that probably formed in pre-Cretaceous (150–140 mya) time.[35] Streams flowing into the Kittatinny Mountains excavated the intermountain troughs that define the New Jersey Highlands. The S-shaped bend of the present-day Delaware at Wallpack Bend is thought to be a floodplain meander developed by a tributary on the old Schooley Peneplain.

The Schooley Peneplain erosional surface corresponds to the mountaintop elevations of the present-day Kittatinny, Blue and Shawangunk Mountains; the Pocono Plateau; and Schooley's Mountain (1,200 feet high) in Morris County, New Jersey. The top of this long ridge of mountains maintains an elevation of between 1,200 and 1,600 feet; the existing mountaintops represent remnants of the ancient erosional surface that can be traced

throughout a wide region of the Appalachian Mountains. As the land has steadily risen through time, stream erosion has kept pace with the uplift, maintaining current surface levels. The nearly pure quartz content of the Shawangunk formation ensures that the rock is extremely resistant to both chemical and mechanical erosion, although existing mountaintops in the region show some irregularity since they have been eroded below former peneplain levels.

The Fall Zone Peneplain existed before the Schooley cycle. It laid high above the Schooley Peneplain. Its surface has now been completely erased by erosion:

> *There are some who believe that the Delaware was not always a river…*
> *For eons it was trapped as a huge lake north of the Blue Mountain barrier. Once this barrier was breached, during the retreat of the ice age, the river had a comparatively free course to the sea, leaving behind the famous Delaware Water Gap.*[36]

Also, some believed that the Delaware ends at the point the river becomes tidal at Trenton, New Jersey. Current theory supports an ancestral water course that was formed over millions of years of uplifting and erosion after the continents separated for the last time. "At first the Delaware was a sluggish river flowing across a relatively flat peneplain left after the erosion of the third generation Appalachian Mountains."[37] The river maintained its ancient course by cutting water gaps as new mountains rose, at first from the northwest from the Alleghany front and then turning south, draining the rugged western slopes of the Catskills. No one knows for sure, but the ancestral Delaware could have been a raging torrent, particularly during the spring thaw, in its race to the sea.

At Port Jervis in the Shawangunk Mountains, the river enters an intermontane trough. This is the Valley and Ridge Province of New Jersey, which borders the New Jersey Highlands Province. Rock strata in this region is of Devonian (359–416 mya) and Silurian (416–449 mya) origin and consists in part of the highly resistant Shawangunk conglomerate formation as well as resistant shales, sandstone and other quartzite rocks. The Blue Mountains and the Pocono Plateau are to the north on the Pennsylvanian side of the river, while to the east, the Kittatinny Mountains skirt the Delaware River on the New Jersey side.

At this point in our journey down the ancestral course of the Delaware River, the trend is in a southwesterly direction. The river flows through the

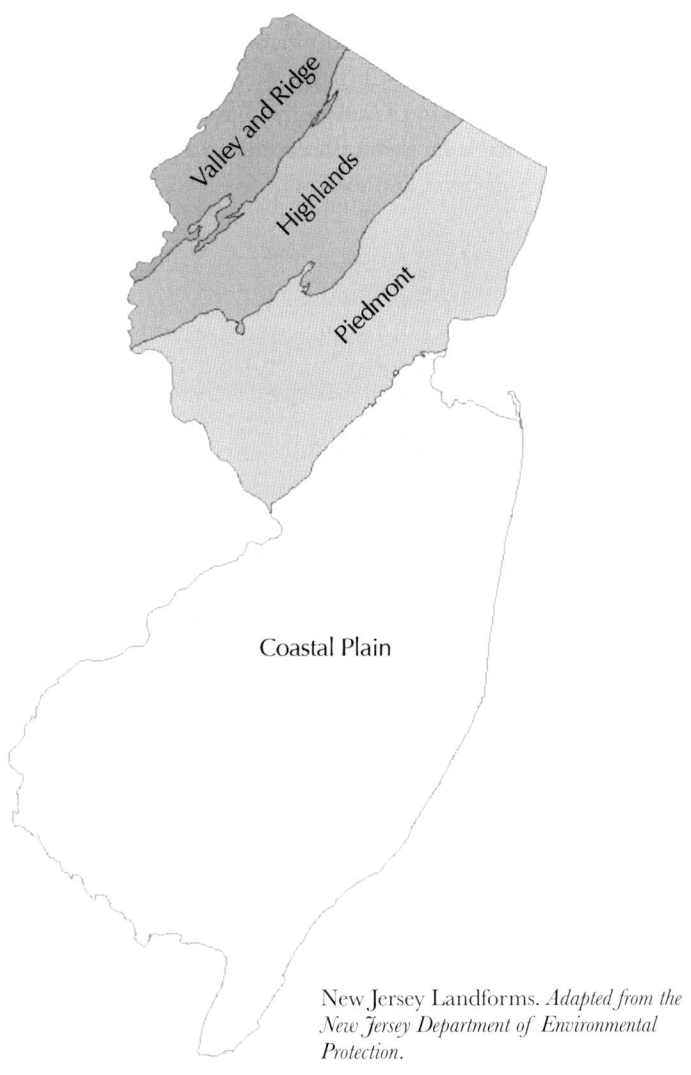

New Jersey Landforms. *Adapted from the New Jersey Department of Environmental Protection.*

Minisink Valley and the S-bend at the Wallpack before gliding past Tocks Island and through the breach in the Kitattinny Mountains at the Delaware Water Gap.

From the Water Gap to Trenton, the Delaware flows in a southeast course, which is thought to be the ancestral direction of flow. Below Trenton, New Jersey, the river is tidal and closely follows its contact with the bedrock formation of the Piedmont Province. It remains a mystery why at Trenton

the river is diverted at a right angle toward the estuary by softer sediments when it had eroded more resistant rock, including diabase, shale and sandstone farther upstream. It may be possible that the ancestral Delaware flowed southeastward across the entire width of the coastal plain of New Jersey to the sea, as did the Schuylkill River. Both the Delaware and the Schuylkill might have become victims of stream capture by smaller streams flowing southwest, creating the existing environment of the Delaware River and Bay we see today.

Beyond the Water Gap, the Delaware transverses a narrow valley diversified with cliffs, escarpments and plateaus. The Nockamixon Rocks, three miles long and nearly two hundred feet high, are a dramatic example of the finest cliffs that constrict the Delaware on both sides of the river, nearly the entire distance south to Easton, Pennsylvania. On the New Jersey side, the river travels south beyond the Valley and Ridge into the Piedmont Province.

After transversing the Delaware Water Gap, the river, through cycles of uplifting and erosion, has excavated a course through very old rock strata. On the New Jersey side, the rocks are primarily of Ordovician (444–488 mya) shale and limestone, while on the Pennsylvania side of the river, the strata consists of Devonian (359–416 mya) red sandstone, gray and black shale and limestone, as well as, farther south, Ordovician shale, limestone and sandstone rock. As the river continues to flow south, it passes Belvidere, New Jersey, over the rapids at Foul Rift—which challenge kayakers and canoeists today as they once did the log rafters and Durham boats of the 1800s—and continues a few miles beyond through the terminal moraine of the last Wisconsin continental glacier. The confluence of the Delaware and the Lehigh Rivers occurs at Easton, Pennsylvania. The river is thought to have followed its present course since the Schooley Peneplain cycle.

Just south of Easton, the river course changes to a southeasterly direction on its way to the falls at Trenton. Once again, the inner valley is very narrow, being constricted by shoreline cliffs on both sides of the river. South of Easton on the Pennsylvania side of the river, cliffs dominate the landscape. Red shale cliffs, the Bloomsburg formation, are particularly prevalent on the New Jersey side between Frenchtown, Stockton and south beyond Lambertville. Route 611 in Pennsylvania and Routes 80, 46 and 29 in New Jersey are truly scenic.

Rock strata on the Pennsylvania side of the river is of Jurassic (146–200 mya) and Triassic (200–251 mya) origins. On the New Jersey side of the river, the Piedmont Province continues to be evident and consists

primarily of Mesozoic Era (65–251 mya) rock formations, including shales, conglomerates, sandstone, limestone, siltstones and volcanic basalts. The falls at Trenton include an abrupt eight-foot drop in elevation and have been traditionally seen as a barrier to navigation north of the city since the 1600s.

Within the Piedmont Province near Trenton, the river encounters both bedrock and softer sediments and makes an abrupt right-angle turn to the southwest into the Delaware Bay before turning southeast once again, into the estuary past Philadelphia and Camden. The river becomes shallow, broad and sluggish beyond Philadelphia, surrounded by extensive salt marshes.

The ancestral Delaware may have continued to flow southeastward across the breadth of New Jersey to the sea from Trenton, but as a result of stream capture, it changed course to the southwest.[38] After the Delaware makes its turn to the southwest, it enters New Jersey's coastal Plain Province, consisting primarily of Cretaceous Period (65–146 mya) formations made up primarily of sand, salt and clay. South of Philadelphia, Quarternary Period (0.01–1.8 mya) deposits are evident, consisting of relatively young sand, gravel and silt deposits.

The Wisconsin continental glacial event began its retreat approximately eighteen thousand years ago. At its height, it is thought that the continental ice sheet was one thousand feet thick in the Kittatinny Mountains, leaving only the mountaintops visible like islands in a sea of white moving ice. The ice scoured the land to a point a few miles south of Belvidere, New Jersey, where a terminal moraine marks its limit. Glacial erosion in the upper Delaware left dramatic changes in the landscape, while glacial deposition built high and low terraces along the riverbanks south of the moraine. Tremendous amounts of gravel, sand, clay and silt were deposited south of Trenton and into the estuary. Gravel deposits farther north, closer to the terminal moraine, tend to be coarser materials than those deposited farther south. High terraces along the river tend to be constructed of coarse gravels and sand, while low terraces are mostly sand deposits. Gravel deposits become thinner as one travels south along the course of the river. In general, the material of the glacial terraces is heterogeneous, both physically and lithologically. The ice that carried the erosional material had come great distances over a variety of rock formations and therefore carried various types of rock and debris in different conditions.[39]

Some remnants of high terraces exist along the upper reaches of the Delaware. However, most terraces are low, thirty feet high or less, especially

where the river valley is wide. The low terraces tend to be constructed in short, narrow bands on the concave sides of bends of the river and in sheltered places along the river, while they are absent from the convex sides of the bends and the narrower gorge-like portions of the river valley.

When the ice was in its most advanced position, which it maintained for some considerable amount of time, huge quantities of silt, sand and gravel were transported south of the moraine, building benches and terraces, and while the ice was retreating, stratified till was deposited north of the terminal moraine to great depths. The ice carried a heavy load of debris while advancing as well as during the retreat.

Terrace development was once continuous from Belvidere to Trenton, filling the Delaware Valley to a depth of forty to eighty feet with silt, sand, gravel, cobbles and boulders supplied by the ice. The deposition was widespread where the pre-glacial valley was wide, up to four miles at some points, and narrow where the pre-glacial valley was constricted by cliffs. The old valley plain is no longer intact.

The velocity of the river was perhaps enhanced by the gradual uplift of the upper drainage basin eroding the Kittatinny breach at the Delaware Water Gap. This acceleration of the river flow increased its erosion power. It has been estimated that between two-thirds and three-fourths of the till deposited by the glaciers below the terminal moraine has been removed by the erosive action of the river flow.[40]

Between Holland, New Jersey, and Rieglesville, Pennsylvania, only remnants of terraces remain on the New Jersey side of the river. A bit north, between Phillipsburg, New Jersey, and Carpentersville, New Jersey, where the river channel narrows, much of the gravel till has been removed, but terracing is still evident. At Trenton, any terracing that once existed has all been removed; however, the city of Trenton is built on a till bench. Deposition and characteristics vary greatly along the river. Small as the terraces are in comparison with their surrounding hills and cliffs, they are the most conspicuous topographical features in the river valley, often constituting broad flat benches on which most of the towns between the moraine and Trenton have been built.[41]

The islands of the Delaware seem to be made up of mostly gravel deposits. Burlington Island has more gravel than the others.

The Delaware River

The River Today[42]

The River Between	Description of Terrain
A. Port Jervis, NY, to Delaware Water Gap	1. River valley, a "trough."
	2. Minisink Valley is a drowned valley with glacial till to depths of 140 feet.
	3. Terraces evident particularly on New Jersey's Kittatinny Shore.
	4. Alluvial deposits at tributary mouths.
B. Delaware Water Gap/Columbia, NJ, to Belvidere, NJ	1. Narrow river valley.
	2. Cliffs on both sides of river.
	3. Terminal moraine with stratified drifts south of Belvidere.
	4. Outwash plain consisting of stratified sand and gravel.
	5. Low terraces extend south.
C. Belvidere, NJ, to Easton, PA/Phillipsburg, NJ	1. River flow through a gorge.
	2. Well defined low terraces seventy to eighty feet above the river; secondary terraces exist.
	3. Sand, gravel (limestone) and cobbles.
	4. The original valley nearly five hundred feet deep and four miles wide now filled with glacial till.
	5. Low terraces at Harmony of secondary origin.
	6. At Martin Creek river flows north of west but turns south; terracing on concave bend (New Jersey side).
	7. Rapids exist at Foul Rift.
D. Phillipsburg, NJ, to Carpenterville, NJ	1. Width of river is constructed by narrow gorge.
	2. Remnants of old valley appear both above and below Phillipsburg, NJ.
	3. Confluence with Lehigh River.
	4. High and low terraces are evident at Phillipsburg.
	5. High terrace appears at mouth of Musconetcong River.
	6. Terrace at concave curve of river above Carpenterville.

The Geologic History of the River

E. Carpentersville, NJ Riegelsville, PA Milford, NJ Frenchtown, NJ	1. River constricted by cliffs on both sides (Pohatcong Mountain, NJ side).
	2. Terracing at Riegelsville, PA.
	3. Holland, NJ, a narrow terrace exists forty to fifty feet above the river.
	4. River valley becomes wider and course becomes southeastward as it exits the Triassic rock belt.
	5. At Milford post-glacial erosion evident; terrace remnants remain; also remnants of ancient river plain exists.
	6. At Frenchtown, NJ, a flat topped terrace exists; however, the river is once again constricted by high shale wall cliffs.
	7. Terraces have more extensive development on the Pennsylvania side.
F. Frenchtown, NJ Raven Rock, NJ Stockton, NJ Raven Rock, NJ Lambertville, NJ	1. Two miles below Frenchtown, NJ, river is again constricted by red and, farther south, black shale cliffs.
	2. Little terracing exists in the narrowed river and remnants of the original plain found only in protected areas.
	3. North of Lambertville the river turns eastward and the valley widens notably.
	4. Terracing is evident at the concave bend in the river; secondary terracing has developed.
	5. At Raven Rock, NJ, glacial gravel is present at one hundred feet elevation, but this does not constitute a terrace.
	6. There is some evidence of pre-Wisconsinian glacial deposits at Raven Rock, NJ.
	7. At Lambertville, gravel is present at the one-hundred-foot elevation level and terracing is present.
	8. Fine molding sand is present.
	9. Farther south, the river widens and terraces representing the original level of the valley are evident.
G. Lambertville, NJ, to Washington's Crossing, NJ	1. The river crosses a trap rock belt, and occasional benches of gravel are seen.
	2. A small terrace is present that is fifty to fifty-five feet above the river representing the original level of the river.

H. Washington's Crossing, NJ, to Trenton, NJ	1. At Trenton, NJ, the river shifts course nearly ninety feet from the southeast to the southwest
	2. The city of Trenton is built on a broad gravel bench about sixty feet above sea level that is at some places forty feet thick.
	3. The falls at Trenton represent the boundary between the tidal and non-tidal rivers.
	4. Gravel deposition is thinner and gravel is less coarse.
I. Trenton, NJ, to Delaware Bay	1. River flow is southwest but turns southeast once again before entering the Atlantic Ocean
	2. The river is wide and sluggish.
	3. Salt marshes are present on both sides of the river but are more prevalent on the New Jersey side.
	4. Sand, clay and silt deposits predominate.

The Delaware River today is not the raging torrent it once must have been. Over the eons, the river has been able to cut a deep channel in some rather resistant rock, and much of the evidence of glacial deposition from fifteen thousand years ago has been washed into the sea. Terraces have been eroded away, and secondary terraces have been constructed by the river in their place.

Post-glacial erosion in the Delaware Valley has been more considerable than in any other valley in this region of the Appalachians. The river has cut its channel from the level of the highest gravel terraces to its present level. In the narrow parts of the valley, such as at the Water Gap, post-glacial erosion has been sufficient to remove all the gravel originally deposited there. Locally, the river has lowered its channel as much as 100 to 120 feet, and floodplains of some width, frequently a half mile or more, have developed at the new river levels. Conditions along the river vary greatly, and water withdrawals have decreased the flow of the river. The Pequest has cut a gorge 40 to 45 feet deep across the moraine near Belvidere, while the Flatbrook has deepened its valley 60 feet in some places and none at all at others.

Today's river levels are much lower than they were in antiquity. Climate has changed, and the river flow is closely regulated and maintained by timely releases of water from reservoirs in both New Jersey and New York to create a critical buffer against the intrusion of salt water downstream from the confluence of the Schuylkill and Delaware Rivers at Philadelphia in efforts to protect the public water supply. Nevertheless, the Delaware remains free-flowing and undammed!

The Geologic History of the River

THE DELAWARE WATER GAP

The Delaware Water Gap is a geological wonder that has left explorers, travelers, sportsmen and tourists in awe since the early 1800s. The Water Gap was once the focus of a tourist industry that rivaled Atlantic City and Newport, Rhode Island. The cool summer forests and the excitement provided by water sports and camping drew people from New York City and Philadelphia. Some stayed for the entire summer season in luxurious hotels that had been constructed in the region. The Water Gap remains a prime tourist destination, even though the hotels have long disappeared, since it is the focal point of the Delaware Water Gap National Recreation Area.

The formation of the Delaware Gap has been the subject of myth, legend, much speculation and considerable scientific research since the 1840s.

Kittatinny Mountain was uplifted 450 mya when a chain of volcanic islands collided with proto–North America while Pangaea formed as these islands slid up and over the North America tectonic plate, forming the Kittatinny Mountains and valley.

Delaware Water Gap viewed from the north. New Jersey's Mount Tammany (*left*) and Pennsylvania's Mount Minsi (*right*). Scenic PA Route 611 and Interstate 80 (NJ) are visible. *Grant Heilman Photography, reproduced under license from Grant Heilman Photography Inc., Lititz, Pennsylvania.*

THE DELAWARE RIVER

Delaware Water Gap viewed from the south; the Shawangunk formation is prominent on both sides. I-80 crosses into Pennsylvania here. *Grant Heilman Photography, reproduced under license from Grant Heilman Photography Inc., Lititz, Pennsylvania.*

About 400 mya, a small, narrow micro-continent collided with proto–North America. The heat from this collision melted the quartzite, which allowed it to bend the quartz. This layer was then uplifted and cracked over thousands of years. During this period, an ancient river that would become the Delaware slowly cut its path down through the shattered and cracked quartzite. If the quartzite had not been bent and then shattered, the river would not have been able to cut its path through the hard and resistant rock to form the gap.

The ridges that border the gap consist of the Silurian Shawangunk conglomerate, which is a gray quartzite and highly resistant to weathering. The ridge on the eastern side of the gap, in New Jersey, is called the Kittatinny Ridge; on the western side of the gap, in Pennsylvania, that ridge of the Appalachians is called Blue Mountain. To the north in New York State, the ridge is called the Shawangunk Mountains.[43]

The Delaware Water Gap is approximately 980 feet wide at river level, 283 feet above sea level and 1,500 yards wide at the top. In New Jersey,

The Geologic History of the River

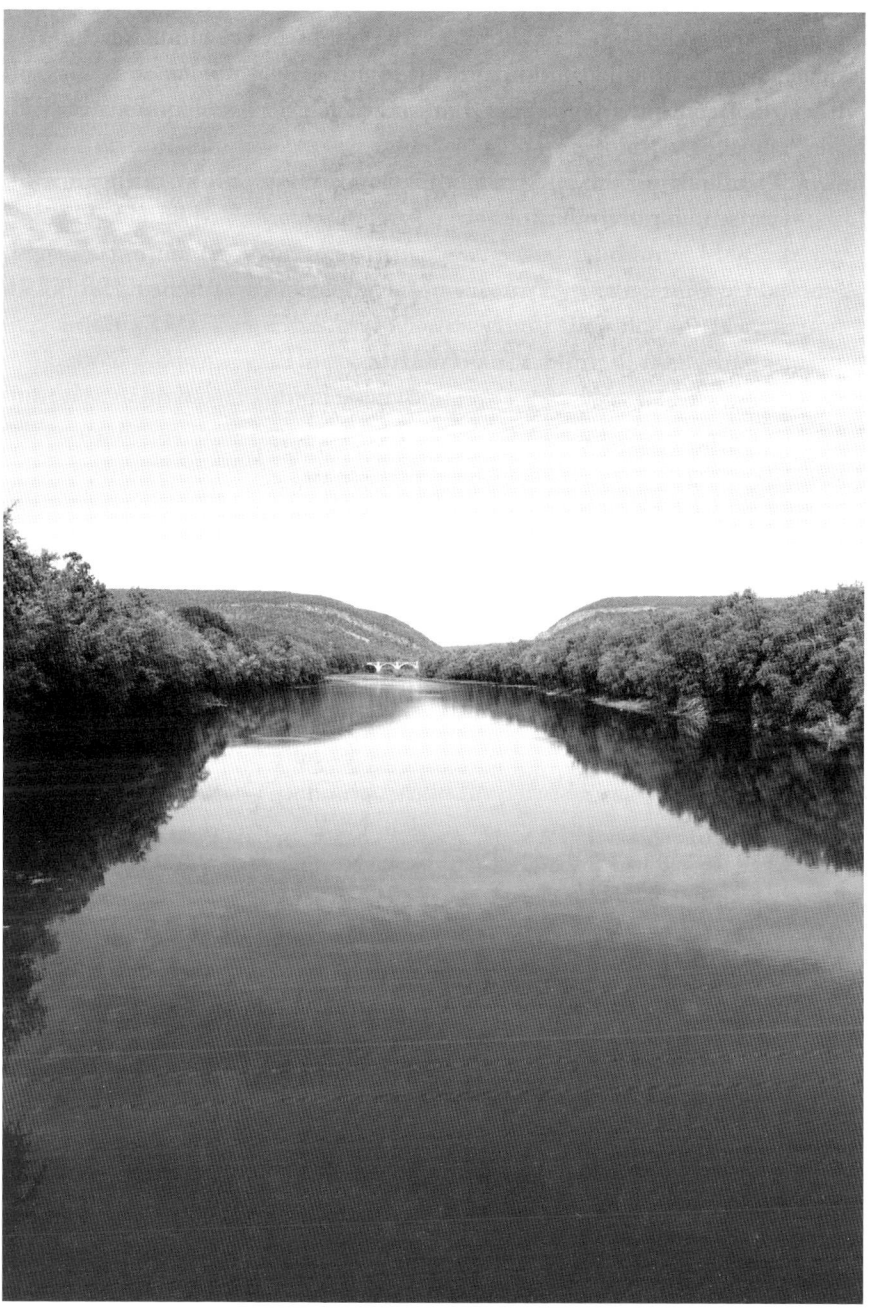

The Delaware Water Gap from the south. *Thinkstock*.

the dominant mountain is Mount Tammany, named after the Leni-Lenape chief Tamanend. The summit is 1,526 feet above sea level, while on the Pennsylvania side of the Water Gap, Mount Minsi, named after the local tribal natives, rises to a height of 1,460 feet above sea level.

The Silurian Period (444–416 mya) Shawangunk formation is a bedrock formation that underlies eastern Pennsylvania, northwestern New Jersey and southern New York. The Shawangunk sequence is approximately 1,400 feet thick and is defined as a light- to dark-gray fine to very coarse grained stone and conglomerate containing a few slate beds, quartzite, calcareous sandstone, siltstone and shale. It is a very hard weather-resistant rock stratum and was named by W.W. Mather in 1840. The Shawangunk formation is visible on both sides of the Delaware Water Gap but is most prominent on the Western Pennsylvania side. The Shawangunk formation is predominately siliceous sandstone and conglomerate at the Water Gap site.

The Blue and Kittatinny Mountains are part of a single ridge supported by the Shawangunk bedrock formation and are cut by numerous gaps, including the Delaware Water Gap, Totts Gap, Fox Gap and Wind Gap.

A number of geologists have studied the structure of the Delaware Water Gap. An analysis of mapping of the Blue and Kitattinny Mountains, and of ridges to the north, has shown that there exists a specific set of conditions that correlate positively with the formation of gaps, both water and wind. These predetermining conditions include:

- steep dips[44] of beds and narrow outcrop widths of resistant units (rocks)
- dying out of folds within short distances
- more intense folding locally than nearby[45]

The structural realities of Delaware Water Gap conform to these preconditions in a number of ways. The general trend of the Kittatinny/Blue Mountain ridge is northeast–southwest. Where the Kittatinny crosses the Delaware River to the Pennsylvania side, the ridge crest is offset seven hundred feet at the gap. The ridge crest in New Jersey lies about seven hundred feet northwest of the arc of the crest on the Pennsylvania side. Numerous observers beginning in 1858 and continuing until 1949 attributed this displacement to the existence of a transverse fault at the gap, although recent observations did not confirm the existence of a cross fault.[46]

The Shawangunk formation is prominent on both sides of the gap. This rock sequence dips thirty-five to forty-five degrees to the northwest on both

sides of the river, although at Mount Tammary on the crest of the New Jersey side the dip is about fifty degrees. At Mount Minsi on the Pennsylvania side, the dip decreases to less than twenty-five degrees as one approaches the crest, according to Jack B. Epstein.

Geologists have observed an abrupt change in strike[47] of the rock beds that formerly occupied the site of the Water Gap. The resistant but brittle Shawangunk must have been severely fractured in the flexure zone. The existence of this zone of severely fractured stone was of primary concern in the determination of the locations of the gap. There is a number of early observations indicating a belief that the Water Gap was formed by a violent cataclysm.[48] Nevertheless, modern theory regarding the formation of Delaware Water Gap supports the dual ideas of a turbulent eroding away of this zone of shattered quartzite rock as the land itself slowly rose, a result of the orogenies that took place during the construction of Pangaea.

Finally, and equally important in controlling the location of the Water Gap, is the fact that the outcrop width of the Shanangunk Conglomerate is narrower at the site of the gap than to the northeast, where the formation is repeated in the southwest plunging Cherry Valley anticline. According to Epstein,[49] the river now flows on the hard resistant Shawangunk where it crosses the anticline but once flowed over weaker stone beds earlier in history before cutting down into the Shawangunk.

On a clear day, there is a good view across Kittatinny Valley toward Kittatinny Mountain and the Delaware Water Gap from an overlook on the eastbound side of I-80, and at the rest stop on the westbound lanes, you can see that the Kittatinny Mountain in Pennsylvania south of the gap is at the same elevation as the mountain north of it. They are part of the Schooley Peneplane,[50] a flat erosional surface that developed in the early Tertiary (65 mya):

> *From a distance of five or ten miles to the southeast one is impressed by a cliff-like front bordered below by heavy talus, and an even crest rising to about 1,500 feet above sea level. Actually the crest is not as uniform as it appears at a distance, the elevation ranging from 1,380 feet at Fox and Top Gaps to 1,526 feet on Tammary Mountain, just east of the water gap. However, this narrow crest is not at all ragged, for the slopes rise and fall very gradually. Delaware Water Gap is an exception to this. It is a sharp notch bordered by cliffs that drop down to the river just under 300 feet above sea level at this point. The northwest side of the mountain is a rugged slope rather than a cliff.*

This mountain owes its prominence and continuity to the fact that it is composed of hard Silurian (Shanagunk) quartzite and sandstone dipping steeply to the northwest.[51]

The Delaware Water Gap cuts through a zone where the rock has weakened and shattered by a sharp fold. The flexed rock is largely eroded away, but there is evidence of its former existence. The Shawangunk beds match perfectly at river level. They are exposed directly across from each other and dip at an angle of approximately forty degrees to the northwest on both sides of the gap without any offset that might suggest the existence of an ancient fault. The Shanangunk beds at the top of Mount Tammary, on the New Jersey side, dip fifty degrees to the northwest, while those of Mount Minsi, on the Pennsylvania side, dip only about twenty-five degrees to the northwest. Further, Mount Tammary is offset seven hundred feet northwest to the trend of Mount Minsi. Clearly the rock strata there have been shoved farther northwest and tilted up more steeply than those on Mount Minsi. The intervening slant fold or fault weakened the brittle quartzite rocks, making them easily vulnerable to river erosion.[52]

A second theory on the formation of the Delaware Water Gap is provided by the National Park Service in the form of an information sheet titled "Delaware Water Gap: How the Gap Was Formed," which is available to visitors to the Delaware Water Gap National Recreation Area.

THE FORMATION OF THE DELAWARE WATER GAP
The Delaware Water Gap is the best known feature of the park, a distinct notch cut into the Kittatinny Ridge by the Delaware River. Once touted as a scenic Wonder of the World, it is about a quarter mile wide at river level and nearly a mile wide from the top of one mountain to the top of the other.

WHAT IS A WATER GAP?
Several words in the English language denote a break *or* cleft *in the mountains. Chasm and notch are popular in New England; pass and gorge in the South and West of the United States. Gap is especially common in this part of the country. A* gap *or* wind gap *is a break or pass through the mountains, in this case the Appalachian Mountains. A water gap is a pass that a river runs through the mountains.*

The Geologic History of the River

How Does a Gap Form?

Though the geologic time frame may seem vast and remote, the results of geological processes are the mountains we hike on, the river we swim in, and the scenery we admire. There have been many ideas about how the Delaware Water Gap formed. One current theory explains the Gap through a series of processes: continental shift (involving plate tectonics), mountain-building (orogeny), erosion, and the capturing of rivers and streams.

Stage 1: Collision

The story begins 420 million years ago when the ancestral continents of North America and Africa collided. The impact caused Earth's crust to rise and mountains to form, including the Appalachian range.

Streams flowing westward off these mountains eroded their slopes, carrying sand and pebbles west and depositing them in layers. These layers later compacted into erosion resistant gray sandstone and conglomerate rock called the Shawangunk Formation. This rock is the dominant feature of the ridges on either side of the Delaware River today.

About 290 million years ago, in a second era of mountain-building, further pressures crumpled and folded the layers of rock.

These layers eroded at different rates: softer limestone and shales eroded more quickly into valleys, while harder sandstone and conglomerate rock remained as mountains like Kittatinny Ridge. After this, the mountain part of today's Gap was essentially in place.

Stage 2: Erosion

Millions of years ago, streams flowed into a river on the north side of the ridge, which flowed southwest. Meanwhile, a second river whose headwaters were around present-day Trenton, New Jersey, flowed south to the sea.

The headwaters of this river eroded their way north toward the Kittatinny Ridge.

Stage 3: Capture

When the headwaters of the second river eroded their way through the Kittatinny Ridge, they captured the river on the north side, forcing the water to flow through the gap.

Over time, this south flowing river has further eroded the soil and rock of the gap area and the river valley is continuing to deepen and widen the size of the gap to this day.

ARE THERE OTHER GAPS?
Near the recreation area are several other gaps whose formation is related to that of Delaware Water Gap.

At one time, rivers may have run through these gaps also, and it is possible that the Delaware River had captured the rivers in these other gaps as well.

When these gaps dried up, the erosive action of the river stopped, and most of these gaps are much higher (less eroded) than the Water Gap.

While in the area, look on maps and signs for other gaps. There is Culvers Gap near Newton, NJ. On the Pennsylvania side Totts Gap, Foxtown Gap, and Wind Gap are examples of three gaps west of the southern end of the recreation area.

West of Philadelphia, near Rt. 30, is a town simply named Gap.

By what mechanism did the Delaware River cut through steeply dipping, erosion-resistant rock strata to form a deep, V-shaped notch in a narrow, linear mountain? Water gaps appear as breaks or interruptions in the otherwise continuous, linear pattern of a folded Appalachian Mountain ridge. Although water gaps are not completely understood, generally:

> "Precipitation runoff down mountain slopes starts to cut ravines on both slopes of a linear ridge, opposite one another. As headwater erosion progresses, a notch forms at the ridge crest. As this process continues, the notch becomes deeper until the gap is almost complete. At this point, the dominant stream captures the other, and a through-flowing water gap is formed. If the part of the stream system that is captured is in the process of developing the beginning of another water gap farther along the ridge, that gap will be abandoned and left as a wind gap."[53]

In summary, two great forces were at work: (1) uplifting to the land caused by the orogenies associated with the formation of Pangaea and (2) downcutting into the rock beds by the turbulent precursor to the Delaware River. Today the Delaware River has cut through Kittatinny Mountain to an elevation now only 283 feet above sea level. On either side the ridge has an elevation in excess of 1,400 feet. The Gap is nearly a quarter-mile wide at river level and 1,500 yards wide at the crest. The base of the mountain through which the Delaware cut its gorge is a bit over two miles through.[54]

The Geologic History of the River

The Wisconsin glaciation which began approximately 150,000 years ago brought continental ice as far south as Belvidere, which may have been 1,000 feet thick in the Kittatinny and Blue Mountain region. During the period of melting and retreating ice, about 15,000 years ago, an ice and debris dam formed at the Water Gap. This moraine dam supported a large glacial lake, Lake Sciota, which gradually drained as the ice and debris at the Water Gap was removed. "Later, after the ice retreated up the Delaware Valley, a new outlet was formed as Delaware Water Gap was uncovered and the drift dam or stagnant ice plug in the gap was slowly removed." The lake lowered to an altitude of about 350 feet, after which the gap was cleared and the lake drained.[55] There does not seem to have been a cataclysmic bursting of the debris dam. Today, Delaware Water Gap, Wallpack Bend, north of the gap, the meandering course of the Delaware from Easton, Pennsylvania to Milford, New Jersey across hard and soft rock, and the meandering of the Pequannock across the Highlands from Stockholm to Pompton, New Jersey, all mark present-day sections of modern rivers which still follow the ancient courses established by ancestral streams on the ancient Schooley Peneplain.

The Delaware River actually has another albeit less spectacular water gap along its main stem. This second water gap, Weygadt Gap, may have preceded the existence of Delaware Water Gap and is located about three miles upstream from the Easton, Pennsylvania/Phillipsburg, New Jersey area. Marble Mountain (708 feet) is located on the New Jersey side of the river while Chestnut Hill (700 feet) is situated on the Pennsylvania side.[56] The geologic history of the Weygadt Gap remains to be studied.

Chapter 2
Legends and Myths

The Delaware Water Gap in the Kittatinny Mountain range provides a channel through the mountains for the Delaware River as it streams to the expansive estuary of Delaware Bay and then to the Atlantic Ocean. Mount Minsi on the Pennsylvania side of the gap rises to an elevation of 1,450 feet, while Mount Tammary on the New Jersey side of the gap ascends steeply to a height of 1,600 feet above the river level. The Delaware Water Gap, displaying the grandeur of the breach in the mountains, is thought of as the gateway to the Pocono Plateau in Northeastern Pennsylvania and the Catskill Mountains in southern New York State.

Paleo-Indians entered the Kittatinny Mountains between ten thousand and twelve thousand years ago. The occupation of the area north of the Delaware Water Gap, which would become known as the Minisink Valley during the period around 8640 BC, is substantiated by archaeological evidence, according to Bertland, Valence and Wooding. During the Late Woodlands Period, AD 1000–1350, several different cultures can be differentiated in this area, including the Iroquois of Upper New York State and the Algonquin people of the Upper Delaware Valley. Between AD 1350 and 1650, a definitive "minisink" culture of great antiquity was evident. The culture that evolved was that of the northern branch, Wolfe clan, of the Leni-Lenape tribe that spoke (and still speaks) the Munsee dialect of the Lenape languages.

Munsees (Minsis, Munsies) refers to the "people of the minisink," which in turn means "people of the stony country." The Munsee word *minisink*

refers to "where there is an island," as *minnis* means "island" in the Munsee dialect. In another source, the word *minsi* refers to "where the stones are gathered together," and *minsi* (*minsiu, minassiniu*) could also refer to the people as "mountaineers." Kitochtanemin refers to Kittatinny, or "endless mountains."

Other meanings of the word *minisink* (i.e., the Minisink Valley) survived the centuries with full knowledge that much of what the early chroniclers heard was misinterpreted and/or misunderstood. "Much of what they heard was in the form of oral tradition, and part of it was possibly colored or slanted."[57] Yet another interpretation persists in the form of legend!

In essence, a Lenape tradition or legend refers to the Minisink as a land that was covered by water, forming a great lake, before the waters of the Delaware broke through the mountains and formed the Delaware Water Gap. Minisink thus refers to "the land from which the water is gone." This version of this legend appears in its first publication in 1828 and may have its beginnings as early as 1730.[58]

In a comparable version of this mythic tradition, from Brodhead's *Delaware Water Gap*, the legendary Indian princess Winona remarked:

> *She spoke of the old tradition*
> *Of this beautiful valley*
> *Having once been a deep*
> *Sea of water, and the*
> *Bursting asunder of the*
> *Mountains at the will of*
> *The Great Spirit, to*
> *Uncover for the home of her*
> *People the vale of the*
> *Minisink; the mighty*
> *Chasm in the mountain, and*
> *The twin giants overlooking*
> *The vast extent of country to the*
> *Rising sun, as far as the*
> *Eye can reach.*

This version of the Minisink legend expands the idea of a land of "receding waters" to one in which there was a cataclysmic breaching of the Kittatinny Mountain by the Great Spirit to form the Delaware Water Gap (again from Brodhead's *Delaware Water Gap*):

Whether this immense
Chasm has been caused
By one mighty eruption, or
By a gradual yielding of
Stratum after stratum,
By the immense pressure
Of the waters of a lake
Thousands of acres in area,
Down to the present bed of
The river; or by the active
Dissolution of the material
Upon which the foundation of the
Mountain resided, burying the
Whole mass deep in the gulf
Thus created, is of course a
Subject of mere conjecture, and
Can never be satisfactorily
Determined. The depth and
Solidity of the
Stratification on either side of
The chasm would seem, however,
To favor the first hypothesis.

It is interesting to note that modern-day geologists tend to discount the possibility of an expansive glacial lake north of the present-day Water Gap even though the geography of the Minisink Valley forms a basin that was the proposed Tocks Island dam site. Absolutely no credence is given to the hypothesis of a cataclysmic breach of the Kittatinny Mountains. The dam, originally proposed in the 1950s, would have created a lake thirty-seven miles long between New Jersey and Pennsylvania with a depth of nearly 140 feet. Other evidence exists. Reporting in the *32nd Field Conference of Pennsylvania Geologists*[59] in 1967, Jack and Anita Epstein of the U.S. Geological Survey indicated that the ice sheet covering the Kittatinny Mountains during the last Wisconsin ice advance approximately fifteen thousand years ago was more than 1,300 feet thick; a large glacial lake existed, Lake Sciota; and as the ice retreated up the Delaware Valley, a new outlet was formed "as the Delaware Water Gap has uncovered and the debris drift dam or stagnant ice plug in the gap was slowly removed.… The lake lowered to an altitude of about 350 feet, after which the gap was

cleared and the lake drained."⁶⁰ This scenario could certainly have played out during the period of time that Paleo-Indians were inhabiting the Upper Delaware Valley and may have become part of their oral tradition that was passed on to the Munsee Lenape tribe.

A second legend involves intrigue and an obsessive quest for the wealth of the Orient. There was a great secret between England's King Charles I and explorer-adventurer Thomas Yong. Yong thought that he was in possession of the secret to the long-sought water passage to the Orient. Yong speculated that the route to the Northwest and ultimately to the Pacific Ocean and the markets of the Orient was via the Delaware Bay, "discovered" and named by Samuel Argall in 1610. Yong believed that a river erupted into the bay and the river, in turn, had at its source a great lake, Lake Laconia, far to the north from which another (nameless) river would take him to the Pacific Ocean.

Yong understood that other possible water routes to the mythical lake had been explored; the Jamestown colonists had ventured up both the James and Potomac Rivers. In 1608, Captain John Smith explored the Susquehanna River, which has its source in Otsego Lake in what is now New York State, and the North River (now the Hudson River) was under the control of the Dutch. The only other water route north was by passage through Delaware Bay and up the South River (Delaware River), located in the "buffer zone created by James I"—an area for which the English had few maps and little knowledge.

In May 1634, Yong sailed from England with two vessels. Considerable secrecy surrounded the entire undertaking. He reached Virginia on July 3 and dropped anchor in the James River. The governor of the Jamestown Colony, John Harvey, showed great interest in the venture and provided much-needed support. Governor Harvey provided Yong with intelligence gained from the Dutch concerning the South River and assisted him in constructing a shallop to be used in exploration of the bay and river. On July 20, Yong set sail for Lord De La Warre's Bay, now assured that he would find the route to the Orient.⁶¹

Yong might have been less confident in his success if he had had access to the maps and journals of previous explorers who had ventured into the "Great Bay," including the Englishman Thomas Dermer as well as Cornelius Hendricksen, Hendrick Christiaenser, Adviaen Block, David de Vries, Cornelius May and Peter Heyes, among other Dutch captains.⁶²

In his exploration of the bay, Yong took possession of the land for his king, set his majesty's coat of arms on a tree, renamed the Delaware River that

Legends and Myths

he thought was the Charles River and was surprised by the appearance of a Dutch trading vessel. While the English took "possession" of land settled by the Dutch, they made no effort to remove the Dutch from the land. Yong's progress was halted by the "falls" of the Delaware at present-day Trenton. News from an Indian chief who had traveled the river renewed his belief that Lake Laconia did exist at the headwaters of the Delaware, but the "falls" at Trenton proved to be an insurmountable barrier and with the fear of attack by the Indians, Yong's efforts were thwarted. Yong concluded that the mysterious lake would have to be reached via one of the rivers of New England.[63] It is not known for certain how long Yong remained on the Delaware, but the Dutch remained in control of both sides of the river and enjoyed a brisk trade with the natives until 1664.

The myth of Lake Laconia persisted in England for many years, based on the belief that the great rivers of northeastern North America sprang from a common source: a great lake located somewhere in the interior of the continent. This belief became associated with the pursuit of the Northwest Passage and access to the wealth of the Orient. "In addition to the Laconia Company, there was even formed in England in 1612 a Northwest Passage Company, supported by men of wealth and rank."[64]

In the 1640s, interest in the mysterious lake was renewed among Boston businessmen. Interest in finding the lake had obsessed Yong, Sir Fernando Gorges, Thomas Dormer, Captain John Mason and other English explorers, and when one Darby Field, an Irishman, claimed to have seen the lake from a cloudy peak in the White Mountains during an exploration, interest swelled once again. Two Indians had accompanied Field, and they stated that three great rivers issued from the lake. One was the river of Canada (the St. Lawrence River), the second purportedly the Potomac and its third a nameless river that flowed westward toward the South Sea (i.e., the Pacific). The territory surrounding the lake was eventually named Laconia.[65] As explorers and settlers filled in the gaps in the maps, interest in the mythical lake ebbed. What lake Field claimed to have seen was never revealed.

Following is a legend of the Delaware Water Gap: "Winona; or, The Story of Lover's Leap," the story of Winona, an Indian princess and the beloved and only daughter of Chief Wissinoming, and her love for a young Dutch adventurer, Hendrick Van Allen. It is presented here just as it appeared, including punctuation, in the 1870 edition of *Delaware Water Gap: Its Scenery, Its Legends and Early History* by L.W. Brodhead and published by Sherman & Company, Printers of Philadelphia.[66]

The Delaware River

Winona; or, The Story of Lover's Leap: An Historical Legend

She loves, but knows not whom she loves,
Nor what his race, nor whence he came;
Like one who meets, in Indian groves,
Some beauteous bird without a name,
Brought by the last ambrosial breeze,
From isles in th' undiscover'd seas,
To show his plumage for a day
To wondering eyes, and wings away.

—Moore.

Two centuries ago there reigned, in the valley of the Minisink, a noble chieftain named *Wissinoming*. He was the head of that once most powerful and ancient people, known as the "Lenni Lenape." Their possessions extended from the highest sources of the rivers Delaware and Susquehanna to the ocean, and every valley and hilltop drained by their tributaries echoed the praises of Lenape's chieftain.[67]

 The Lower Minisink was the headquarters of this nation. Here Wissinoming resided, and here emanated the decrees dispatched by fleet-footed couriers, in case of war or apprehended danger, or signaled by "firelights" kindled on a hundred hill-tops,[68] which reassured and thus preserved the unity of the confederate tribes. For how many centuries Wissinoming's ancestors reigned in this beautiful valley, and plied their boats on these quiet waters, and chased the deer in these forests, and defied their enemies in these rocky fastnesses, and worshiped on these mountain-heights, time will never reveal to us. And when the red man first visited the shores of our continent, whether before or after the departure of the Israelites from Egypt, is not material to our present story.

 Winona was the beloved and only daughter of Wissinoming. She and her brother Manatamany were the pride of this noble chieftain, and were the objects of his greatest care and solicitude; all the instruction that a wise but uncultivated parent could impart were bestowed on these children. They, consequently, grew up at least free from the ruder habits of their people, and Winona manifested a character of great strength and beauty. Her father had impressed her with the fact that she was of the descent of a noble race of chieftains, and that her people could claim great antiquity, and she readily saw that they were greatly superior to all the other tribes whose representatives at times visited her father's home.

Legends and Myths

The Lenape were bold and fearless, but considerate and just; and having enjoyed years of peace, paid some attention to the cultivation of the soil, and were acquiring habits bordering on civilization; and when the whites first appeared among them, that civilization was ready to dawn. The first settlers were, therefore, received with open arms. They continued their friendly intercourse, and were not averse to their permanent residence amongst them. The improved methods to promote comfortable existence by the new-comers, their ready discernment led them to at least appreciate, if not adopt, and all that was now needed was fair and honorable dealing; and had the policy of the elder Penn been continued, it is fair to presume that the Lenape would have at this day existed in this valley, a comparatively enlightened and cultivated people.

The first appearance of the whites was only to explore the country. They were from the Holland settlement on the Hudson. They found a considerable extent of land under cultivation, and were delighted with its appearance, and with the friendship manifested by the natives, and soon thereafter arrangements were made for the introduction of a colony. A number of families at length arrived, and formed the first settlement in the Minisink country, and perhaps in the State.

Winona seemed to be drawn instinctively to the society of the cultivated ladies forming the settlement. On account of her position as the daughter of an illustrious chief, she was well received. Her beauty of person, her dignified but gentle manners, her desire to learn of the white ladies and adopt their customs, soon made her a great favorite, and she came to be styled by them Princess Winona. *She continued to be ever after the firm friend of the whites, and proved herself, on more than one occasion, a very Pocahontas, indeed.*

The exploring party, just named, with the prevailing thirst for gold, had discovered in the mountain at Pahaqualong, a few miles above, evidences of what they supposed to be a rich mine of copper, and the information having been forwarded to their mother country, a company was speedily formed under the auspices of the Holland Government, and an expedition fitted out and placed in charge of a young man of rank named Hendrick Van Allen.[69] *He was a gentleman of fine accomplishments, pleasing address, and fair exterior, full of adventure, and the kind of wild frontier life he was for a time obliged to lead seemed well suited to his inclinations. He soon became accustomed to the hardships incident to a life where few evidences of civilization were to be witnessed, much less enjoyed.*

He visited the settlement a few miles below, soon after his arrival, and there heard, at the house of one of the colonists, the fame of the "Indian

Princess." The thought of Prince or Princess had not entered Hendrick's mind since he left the land of civilization, and he supposed himself now far beyond the influences of nobility; hence to hear of an embryo "Queen" in this remote wilderness struck him as rather ludicrous. He, however, promised his friend to see her again when he visited the settlement again.

The young adventurer having satisfied his own mind that about one-half of the Kittatinny Mountain was composed of copper ore, he commenced the construction of the Great Wagon Road from Pahaqualong to the Hudson River, a distance of one hundred miles. Whilst this work was in progress, he employed himself in the sports of the chase. He fancied himself an expert in the use of the rifle, and found the wild game as abundant as he could wish.

At Hendrick's next visit to the settlement, he met the young "Princess" at the house of his friend, where, ever since their arrival, she had been a frequent and welcome visitor. Hendrick expected to see in the daughter of the famous chief less rudeness of manner, perhaps, than in the other daughters of the forest; but he was unprepared for what he now witnessed.

Winona's modesty, refinement, and dignified deportment were unaccountable to him; and though he had heard her beauty highly praised, she far excelled in his mind the most favorable descriptions given of her. Not having measured the character of her mind, he introduced such conversation as he thought adapted to her understanding and suited to her inclinations. He spoke of the enjoyment he had experienced in imitating the free and unrestrained life of her people; the excitement of the chase; the unbounded park filled with game that had not yet learned to flee at the report of his gun, and was not too modest to mention the skill he had acquired in its use by frequent practice. Winona, though accustomed to the wild sports of her people, and confident of her skill in the use of the bow and arrow, having often employed them as an exercise and an amusement, was more modest in the estimate of her prowess; and Hendrick learned, too, from the tenor of her conversation, that there were other themes better suited to the character of Winona's mind, and more pleasing for her contemplation. A friendship, very natural under the circumstances, was at once formed, and Hendrick henceforward fancied that the better hunting-grounds were in the direction of the new settlement and Winona's home.

Not long after this event the old chief Wissinoming died. It was the saddest period of Winona's life. She grieved, not only on account of her own loss, but she mourned also the loss her nation had sustained. The affairs of her people were in a critical condition. The Lenape had been invaded by

some tribes from the North, and though the latter had been severely chastised during her father's reign, Winona and her brother, Manatamany, feared a renewal of hostilities.

The following incidents, though having no direct connection in this narrative, are still important, as relating to the Lenape nation, and on the account their recital will, perhaps, be justified.

The power of the Lenape was undisputed, and they had enjoyed untold years of undisturbed quiet; but before the reign of *Wissinoming*, a cloud had gathered in the North. Some ambitious tribes had commenced invading their territory, and though they had always been repulsed with severe losses, the Lenape were at length confronted by that powerful union of hostile tribes, composed of the Mohawks, Onondagas, Senecas, Oneidas, Cayugas, and Tuscaroras, and known as the "Six Nations." The clouds that had been gathering culminated, and a terrific storm burst upon the devoted heads of the Lenape. The war raged for many years, with varying success; the people of the Minisink maintained their ancient prestige, though other portions of the Lenape nation were forced to succumb, or accept annihilation. It was not until near the middle of the eighteenth century, when the Six Nations received the countenance and encouragement of the whites, that the *Minsi*—the elder sons and occupants of the ancient heritage of the Lenape—yielded to power and intrigue. The conduct of certain of the whites at the memorable conventions held at Philadelphia and Easton—where the Delawares (as they were now called) were browbeaten and disgraced, and their chief, on one occasion, led out of the convention by the hair of his head by an upstart of the Six Nations—is unaccountable upon any other hypothesis, than that by the dispersion of the Delawares, and by the encouragement extended to the Six Nations, they could more readily gain possession of territory to which neither themselves nor the Six Nations had a shadow of claim.

It has been alleged that the Delaware chief behaved cowardly on this occasion. The assertion is unwarranted by the facts. Surrounded by enemies greatly superior in numbers to his own people, and who were supported by the wealth and influence of the English, he well knew that resistance would end in the destruction of his remaining followers. Hence, the course he pursued is such as a wise man would have adopted.

At a subsequent council, held at Easton, it is said, "the English had made so many presents to the Six Nations that they would hear no explanations from the Delawares." Well might Tedyuskung have said, with reference to the whites, "And you, too, my brothers!"

To the credit of *William Penn* and his true *followers, be it ever remembered, that they did not desert the Delawares in their extremity, but stood up for them on all occasions, and condemned the unjust treatment they received.*

The subjugation of this people, and their exile from the Valley of the Delaware, form one of the saddest episodes in the history of nations. Is it to be wondered that they lingered long upon the waters of their favorite river? That they viewed with terror, from the heights of the Kittatinny, the approach of the white man to take possession of the homes they were compelled by their enemies to abandon? To be despoiled of all they held dear, even the places made sacred by the dead of centuries? I fancy I can see them as they meet in the last hurried council: no fire is kindled; no glad voices are heard; no songs of mirth and rejoicing, naught but a saddening wail, the requiem of departing glory. The corn and dried venison are collected together. The aged chief, who has cheered his followers in the thick strife of contending hosts, now trembles with emotion at his exile from the land he loves. Hear him, for his utterance is choked: "Let us take a last lingering look as the departing rays of light are shed upon the Blue Hills, and then go hence to that strange land, whilst the sun sleeps behind the mountain, that the white robber may not laugh at our tears."

This digression has led to a view of the condition of the Lenapes, nearly a century subsequent to the main incidents of our story. At the death of Wissinoming, Manatamany was looked upon as the natural and legitimate successor to his father, whom he much resembled in strength of mind and heroic deportment. Being younger, however, than his sister Winona, she was looked up to as the "guardian angel" of her people, and as much consulted in matters of state as her brother. To add to their other troubles, a serious outbreak now occurred between a portion of their people and the colonists, in which a young man, a favorite of the colonists, was killed. Much excitement was manifested by both parties. The cause of the quarrel was the attempted occupancy and cultivation, on the part of the settlers, of the Great Shawano Island *opposite the Indian town of Wyomissing. This island was a favorite resort of the Indians, and was a cherished part of their possessions. Its great productiveness*[70] *excited the cupidity of the colonists, and frequent attempts had been made for its purchase; but no offer, however liberal, would be entertained for a moment. In the quarrel Manatamany took no part, though his heart was with his people. Winona, the friend of the colonists, as well as the beloved oracle of her own nation, was looked to by the friends of peace in both parties as the only hope of an*

amicable settlement of the difficulty. Winona felt the responsibility of her position, but did not shrink from the performance of her duty.

The town of Wyomissing was the ancient home of the Lenape chieftains. In front of the lodge of Winona and her brother were assembled the excited multitude. On the rocky parapet, bordering her little flower-garden, stood the Queen of the Forest, the heroine and orator of the occasion; to her, all eyes were directed; to her, all were ready to listen with reverence, and now waited in breathless silence the Sibylline utterances:

"Winona is the daughter of Wissinoming, who lies sleeping on yonder hill-top, overlooking the waters of Lenape's river. The island, the cause of this quarrel, also lies before him. For how many centuries Wissinoming's fathers reigned in the Minisink, Winona knoweth not; but the moons will count in number as the hairs of Winona's head. Winona's father sometimes speaks from the spirit-land, and Winona hears his words of love and wisdom in the whispering winds. She listens to catch the music of his voice to-day; but the winds do not speak, and Winona's heart is heavy with grief. Winona loves the people of her fathers, and desires to do them good. She rejoices in their successes, and mourns over their misfortunes. Their song of joy, or wail of grief, is echoed in Winona's heart. Winona's heart is sad now! Winona loves her white neighbors also, and hoped to live with them in peace and friendship forever. Their ladies are kind and gentle to Winona, and have taught her many ways that Winona loves, and filled her mind with many wonderful thoughts that are beautiful, and that Winona dreamed not of. Winona's heart is very sad! The weight of grief would melt in tears, but Winona cannot weep now. Winona loves not strife nor bloodshed; but Winona is not herself afraid to die.

"A young man has been slain by our people. He was much beloved by our neighbors. Who committed the fatal deed we know not. It is but justice, and according to the custom of our own nation, that his death should be avenged, and one of our number be offered to appease the just wrath of our neighbors. Winona is not afraid to die! Hear, then, what Winona saith: On the morrow, on the first wake of the morning, before the sun shows his face from behind the hills of the Kittatinny, let Winona be slain by the hands of her own people, and let her be buried beside her noble father, Wissinoming. Let Hendrick be called from the mountain; let him raise Winona's head, as in the custom of the burial of my people,[71] that the earth may rest lightly upon it, and let him pray to his God for the spirit of Winona. The Shawano Island is loved by our people. It is fair to look upon, and the corn has ripened upon it for my people for more summers than the numbers of

our nation. Winona's canoe has passed many times around it, and touched at every shore.

"The white man must not take it from my people; but let my good brother give to them the Island Manwallamink, and may the dove of peace descend, and hover over the people of my fathers and our white neighbors forever!"

A saddening wail, mingled with murmurs of discontent, rose upon the still air, and Manatamany essayed to give utterance to these incoherent mutterings; but the shouts of the colonists drowned his voice: "Winona must not, shall not die! She shall live to bless us and you! We ask no sacrifice; we only ask, that if it please Manatamany, Winona may be adopted as our sister, and be to us, as to you, a princess and 'guardian angel.'"

This interesting event proved most auspicious; years of uninterrupted friendship followed, and, indeed, its influence was never entirely lost upon either the natives or the colonists. The settlement increased in numbers, and amity reigned, and an apparent desire to benefit the condition of each by the other manifested itself upon all occasions. How easily this policy might have been continued, and how glorious would have been its results! All that was now needed was honesty of purpose, and a little forbearance. How readily on all occasions might the truths of the Christian religion be introduced among a people who are strangers to its teaching, if its beautiful precepts were practised by those desiring its promulgation! Winona had become to the colony an object of love and veneration, and continued to be the idol of her people; and when Hendrick visited the settlement again, he found the praises of Winona on every tongue. His visits now became more frequent, and he found himself fascinated by Winona; and yet it does not appear that he took much thought beyond the present pleasure of her society; into the future he did not stop to gaze. He had now become more occupied in his duties at the mines; the hours of relaxation, however, afforded him, were entirely devoted to her, not dreaming that he was awakening a passion of dangerous intensity in the susceptible heart of Winona. She at first seemed to look upon Hendrick in the character of a brother and instructor in things that delighted her and filled her mind with wonder; and such he had been to her. He had taught her many customs and things that were entirely new, and she was a most apt pupil.

Riding on horseback, though practised by the male members of her people, could not be indulged in to any extent by Winona, as the condition of the roads (being mere trails or footpaths) forbade it. But Hendrick now used his new road, originally constructed for the transportation of ores from the mines, to a more satisfactory purpose, and much to the delight of

this flower of the forest. In the absence of Hendrick, it was the custom of Winona to spend much of her time alone, and with her little red canoe, and bow and arrow, she passed many hours in that portion of the river which flows between the islands and the mainland of which Wyomissing was situated. The borders of this stream were skirted on both sides, then as now, by a growth of large and beautiful trees, some of which are still standing, no doubt, upon which Winona once gazed with delighted admiration, and from whose uppermost branches the wild-fowl and other game, then so abundant, were brought down with absolute certainty, when she was inclined to exercise her skill with the bow and arrow. On one of these occasions, when Winona's canoe was gliding leisurely over these quiet waters, she heard on the island, and quite near her, the report of a rifle. At first, the report of a gun was a terror to Winona; but Hendrick's visits to the settlement being now always announced in that way, it had become, instead, a feeling of delight, and her first thoughts now were of the near presence of Hendrick. She moored her boat to the shore, and quietly waited and watched. Hendrick continued to fire, and she soon discovered a black squirrel upon one of the loftiest branches of a large tree near her. Taking up her bow, and selecting from her quiver a choice arrow, with deliberate, well-directed aim, she brought down the animal bleeding at Hendrick's feet. He picked up the squirrel, thinking it had fallen from the effect of the discharge of his own gun a moment before, but was greatly astonished to find it pierced with an arrow still sticking in its body. Recollecting to have seen Winona's skill with the bow and arrow before, he at once divined her near presence, and soon sought out his fair rival, with her little bark moored under the edge of the beach, near where he stood. This unexpected meeting gave mutual delight. Hendrick complimented Winona on her prowess, and though she could not indulge him with equal compliment, she gave expression only to the pleasure the circumstance of their meeting afforded her; and before parting, on this occasion, Hendrick should have discovered the spark he was kindling, and the danger of fanning to a flame that which, in a breast like Winona's would continue to burn forever.

It would be most interesting to know the manner and character of thought indulged in by a child of nature with the active powers of mind possessed by Winona before coming in contact with any other light than that furnished by the vague traditions of her people. Winona spent many hours with no other companion than her little boat; these were her hours of solitude.

That great mind could not be idle. Of what did she muse? She could not wander in thought far back into the past, and if so, the traditions of her people were not sufficient to supply much food for thought, and the successive days of the passing present were a uniform round of uninteresting sameness. She could, perhaps, run over in her mind the uncertain stories of a long line of noble chieftains, and could recite deeds of daring heroism performed; but Winona needed something more than all this. Her mind yearned for more refined food for thought. Yearned for the light, that light her penetrating vision had caught in faint glimmerings through the misty clouds that had inveiled her people for centuries. Could she behold the sun as it rose from behind the great mountain, and picture to herself that it had for some hours before it appeared to her, lighted up cities filled with gay and lively people—such as she since came in contact with, and which had given her so much pleasure—without any other light than that furnished by her own unassisted imagination? She may have heard her noble father speak of the "great flood of waters," lying toward both the rising and setting sun, and may have accompanied him on one of his visits of state to where the blue waters of the great ocean were revealed to her astonished vision. If so, could it have been to her mind only an unending flood, extending beyond the utmost stretch of her imagination into vast illimitable infinity? Or could she, by the powers of her mind, give to its bounds comprehension, and to its measure limits?

Might she not in these hours of solitude have been led to inquire into the first great cause, and by communion in spirit with her Heavenly Father have had revealed to her by impressions we, who have clearer light, do not conceive of, the blessed story of Redemption? It would be terrible to think that that communion could not be enjoyed by the multitudes who, like Winona, must have felt an "aching void" without it, and who may have lived lives of comparative freedom from actual transgression.

It is natural to suppose that after Winona's introduction into the society of the colonists her mind took a different turn, and that she now had new elements of thought furnished her; and during her interviews with Hendrick at this period, which had become quite frequent, the whole effort of her mind was employed in making him the active medium of intelligent thought. She labored for new ideas, new facts, and new emotions. She was inquisitive without the power of asking directly for that which gave her so much delight to hear; and her efforts, therefore, were incessant to make Hendrick talk, and he could converse on no subject without affording her both instruction and pleasure. To Hendrick this was the most agreeable and interesting

of employments, and such promptings as he received were calculated to bring into active employment the full measure of his capacity. Winona was a charming listener, and he an equally good talker—the former quality almost as rare in the general world as the latter. Hendrick was intelligent and observing, and had seen much of that world he was revealing to her, which Winona termed "the world of light," and all his recitals were to her astonishing.

After the conclusion of one of his lively descriptions, Winona appeared sad, and he was at no loss to divine the cause. She grieved that she could give but such poor return for the great boon to her of Hendrick's conversation; and felt so much her inferiority in this respect as to cause her on this, and other occasions, to shrink away in sadness and dejection. But Hendrick saw in her a precious bud awaiting the light and heat of the sun of intelligence to develop the beautiful, fragrant, full-blown rose of lovely womanhood. She would try, however, to interest him in subjects relating to her own people. She spoke of the wealth of her nation in unbounded forests, plains, and rivers; the numerous tribes whose chiefs looked up to her people and called them "Fathers;" the heroism and endurance of the warriors of her nation; scenes of the chase in which she was permitted to participate; some remarkable skill displayed in the use of the bow and arrow. But she felt, at the same time, the meagerness of the intellectual repast she was furnishing to him whom it would be her highest ambition and enjoyment to please. On one subject, however, she did not hesitate to speak with some degree of confidence, and with the assurance that its contemplation would be a source of delight to Hendrick, as it always was to herself: the great natural beauty of the country she inhabited.

She spoke in raptures of the grand old river that lay before them; of the lovely Valley of the Minisink, of many days' travel in extent, which the waters of this river adorned. She described the numerous water-falls on its tributaries, and gave the euphonious and expressive titles by which they were known. And, above all, the majesty of the surrounding hills, and that grand stretch of mountain bordering the river that shut out the light of early day, and which had no ending.[72]

She spoke of the old tradition of this beautiful valley having once been a deep sea of water, and the bursting asunder of the mountains at the will of the Great Spirit to uncover for the home of her people the vale of the Minisink; the mighty chasm in the mountain, and the twin giants overlooking the vast extent of country to the rising sun, as far as the eye can reach. Hendrick had only seen the Delaware Water Gap[73] *from the town*

where Winona resided. She now proposed to him a visit from Wyomissing in her canoe to the foot of the cliff, and to ascend by the Indian trail to the summit, and Hendrick's next visit was agreed upon for this excursion.

In the meantime, the English government had obtained possession of New York, and after the surrender of Stuyvesant, the Dutch Governor, orders were sent out to Van Allen to abandon the mining operations in the Minisink, and to report to his government without delay.[74] The news fell like a leaden weight upon Hendrick's heart; all his fair prospects were blasted in a moment, and his first thoughts were how to break the sad intelligence to Winona.

He met her at the appointed time. She appeared lovelier than ever before, and manifested more than her accustomed vivacity. She was dressed mostly after the custom of her white lady friends, through whom she had ordered from abroad a habit of rich crimson cloth, trimmed with gold lace, made somewhat after the style, which in modern days has vainly struggled for supremacy, known as the "Bloomer." She wore her long hair in plaits reaching near her feet. Her head was usually adorned with a wreath made from the gay plumage of birds; but was now crowned with wild flowers. Her jewels were the finer quality of the minerals common to the country. She wore a necklace of beads composed of crystallized quartz, party-colored jasper, and some of the varieties of agate.[75] And estimating their value by the amount of labor bestowed upon their finish, they would rival the more costly of those worn by modern belles.

Winona made the best use of her knowledge of the locality, and conducting the canoe herself, she let it glide to quietly over the waters as to afford the best opportunity for witnessing the different objects of interest, none of which escaped Winona's observation. And she gave such vivid descriptions of the lovely scenes before them as to startle Hendrick from the sad reverie in which he was indulging. At the junction of the Analoming with the Delaware, which she termed "the marriage of the waters," she rested her boat to point out one of the favorite haunts of her youth, in the grove bordering these two streams, and where her father first permitted her to prove her skill with the bow and arrow, on as large and highly prized game as the forest elk; and though he stood with his own bow ready drawn, he did not have occasion to speed the arrow, as hers proved quite effectual.

The contrast between this and former meetings of Winona and Hendrick was marked. Winona now afforded the intellectual entertainment. They each had acquired a good knowledge of the other's language; but, at the request of Hendrick, on this occasion Winona spoke in her native tongue,

and he thought her truly eloquent. In their ascent up the mountain, Winona proved herself familiar with every crag and cliff; every murmuring rill or gurgling brook, to most of which she had herself been the intelligent nomenclatress; and she discovered and pointed out beauty everywhere, from the mossy carpet under their feet to the extended panorama from the towering summit; and but for the sorrowful revelation Hendrick was soon to make, this would have been the charmed day of their lives. They had now descended from Mount Minsi, and were seated on a mossy bed overlooking the river as it slowly wound its way through the narrowing gorge. Hendrick had tried to conceal the burden that was pressing so heavily upon him; but Winona had discovered his unwonted quiet, and after having several times rallied him from his abstracted moods, she now, in sympathy with him, was silent and contemplative.

This silence reigned for several minutes; the fated moment had now arrived. Hendrick could not endure the thought of leaving without communicating the cause of his separation; and though he loved Winona sufficiently well to make her his bride, his relation to his government was such as to forbid the possibility of his taking her with him as his wife, even if she should consent to such an arrangement (her relation to, and fondness for her own people rendering in quite improbably), and Hendrick did not dare to hold out the promise of ever being able to return to claim her in her own country, though he entertained a secret hope that such happiness might be in store. It does not appear, however, that Hendrick dreamed of the extent of Winona's passion for him, and how it had deepened since their last meeting.

At length, he drew forth the fatal letter containing the peremptory orders from his government, and made known to Winona its startling contents.

She gave vent to no unusual emotions; did not shriek; did not shed a tear; did not even murmur at the terrible blow that fell upon her with a force sufficient to crush a weaker mind to earth. She paused but for a moment, then standing firm and erect as the forest oak, displaying the heroism of her noble ancestry, but, alas, resolved upon a purpose so common with her people, and which Hendrick did not in time discover.

With unfaltering voice she addressed him in the following words:

Winona's sun has set forever!
She awakes from a beautiful dream;
But such a dream,
The gladdening beams of morning light

The Delaware River

Do not dispel.
O thou loveliest of Winona's images!
Thou fairest of her creations,
And thou skilfullest of limners!
Canst thou behold the picture
Thy noble self hath painted,
On the virgin heart of Winona?
It shall not be blotted out;
Winona will wear it
In the spirit land,
And cherish it there.
Winona doubteth not
The love that Hendrick bears her;
But the fashion of his love
Is not like Winona's.
Hendrick's love may melt away
Like the snows of winter
In a new sunlight.
The current of the deep river
Flows on forever;
So does the love of Lenape's daughter.
But Winona will not stay
To stem the current alone.
The Great Spirit who rules the heavens
Is the father of Winona's people:
He calls Winona home.
Hendrick's duty bids him away
Beyond the great waters.
Let him go hence,
Beloved of Winona!
Winona would not chide
The dear author of these fleeting joys;
The unwilling cause
Of this deadliest sorrow.
Winona would die,
And live to die again,
Once more to feel the gentle current,
The rising, swelling, joyous torrent,
Flowing from this fount of love.

Farewell, brother!
Tutor, lover!
Winona's sun has set forever.

In a moment she disappeared from view. Hendrick ran to the cliff, caught her in his arms; they reeled on the precipice, and—

Chapter 3

THE EVOLUTION OF DUCKS, GEESE AND SWANS

Classifications

Anseriformes is a medium-size order of water birds consisting of 48 genera and 180 living species that are divided among four families: ducks, geese, swans and screamers. The family *Anatidae*—ducks, geese and swans—makes up 40 genera and 146 living species worldwide.[76]

The systematics of the *Anatidae* are also in a state of uncertainty. Previously divided into six subfamilies, a study of anatomical characteristics by Livezey[77] suggested that the family is better understood in nine subfamilies. This classification was popular into the 1990s; however, mtDNA sequence analysis indicates, for example, that the dabbling and diving ducks do not belong in the same subfamily.[78] Nevertheless, mtDNA may be an unreliable source of phylogenetic information in many waterfowl, especially dabbling ducks, due to their ability to produce fertile hybrids.[79] Also, since the sample size of many mtDNA molecular studies available to date are small, the results of these studies must be considered with caution.

Alternatively, the *Anatidae* could be considered to consist of three subfamilies: ducks, geese and swans. The goose subfamily, *Anserinae*, also contains whistling ducks; the *Cygninae* subfamily contains the swans; and the *Anatinae* contains all other ducks.

For the purposes of this writing, we will consider the genera of the family *Anatidae* to be subdivided into ten subfamilies as follows:

- *Dendrocygninae* (whistling ducks)
- *Thalassorninae* (African white-backed duck)
- *Anserinae* (geese and swans)
- *Stictoneltinae* (Australian freckled duck)
- *Plectropterinae* (African spur-winged goose)
- *Tadorninae* (shelducks and sheldgeese)
- *Anatinae* (dabbling ducks and the flightless Hawaiian moa-nalo, which is extinct)
- *Aythyinae* (diving ducks)
- *Merginae* (eiders, scoters, sawbills and other sea-ducks)
- *Oxyurinae* (stiff-tail ducks)

Characteristics and Ecology

The family *Anatidae* is a diverse group of small- to large-sized water birds having a broad and elongated general body design and that possess many common descriptors. Nearly all the species of *Anatidae* are strong swimmers (the *Aythyinae* having excellent diving abilities, some able to dive to a depth of fifty feet or more) and equally strong flyers. The ducks, and especially the geese and swans, tend to be migratory. Some fly great distances to breeding and/or wintering grounds. The *Anatidae* are unusual among birds in that they moult all their flight feathers at one time, usually following the period of time after breeding pairs have established nesting sites and after eggs have hatched. The birds are essentially flightless for a period of one to three months during this time of eclipse (meaning female-like) plumage. Then ducks either retain a cryptic plumage until the next spring, when they undergo a second moult to return to their breeding plumage, or grow directly into their breeding plumage following the eclipse stage. Nesting usually takes place on the ground, near water, even though a few species, notably the wood duck and the goldeneye, nest in holes in trees, and one species, the torrent duck from the Andes, nests in holes in the riverbanks. The female chooses the nesting site, builds the nest and incubates eight to fourteen eggs, which take twenty-four to twenty-eight days to hatch. The young, being precocial, are led to water upon hatching by the female and can feed themselves.

With the exception of geese, swans and black ducks, there is normally considerable sexual dimorphism among the *Anatidae*, with the male being more brightly colored in the breeding season and the females being duller and

more cryptically colored. Most ducks and geese display a highly ritualized courtship, even though the duration of the pair bond varies greatly. Bonding generally lasts through one breeding season. Some geese bond for multiple breeding seasons, while bonds established by swans are lifelong.

The *Anatidae*—ducks, geese and swans—have a broad and elongated general body design. Diving species vary from this in that their body design is rounded and the legs are placed closer to the rear, making them somewhat awkward walkers. Most have long necks and flattened spatulate bills made of soft keratin. The mergansers have pointed serrated bills designed to catch fish. The birds' wings are short and pointed and are supported by strong wing muscles across the breast that generate rapid beats in flight. All *Anatidae* have webbed feet, which have a leathery feel, and their legs have a scaly texture. Their feathers are excellent at shedding water due to special oils, produced in the uropygial gland above the tail, which provide buoyancy.

Anatids are generally herbivorous as adults, feeding on various water plants and wild grains, although some species also eat mollusks and aquatic arthropods. Mergansers are primarily piscivorous and have serrated bills to assist in catching fish. Canada geese eat primarily grasses.

Dabbling ducks (puddle or river ducks of the subfamily *Anatinae*) include the mallard, gadwall, American wigeon, black duck, blue-winged teal, green-winged teal, cinnamon teal, Northern pintail, Northern shoveler, mottled duck and wood duck. They are predominantly herbivores, although they will take advantage of available insects and aquatic life. Dabbling ducks are so called because they feed in shallow water and flooded meadows, putting only their heads and shoulders under water. They do not dive. Dabbling ducks are migratory to some degree. Pintail, teal and wigeon are migratory, mallards and black ducks less so, even though some populations fly great distances. Dabblers have worldwide distribution, especially in the Northern Hemisphere.

Diving ducks, pochards, are members of the subfamily *Aythyinae* and include canvasback, lesser scaup, greater scaup, goldeneyes, ring-necked duck, long-tailed duck, bufflehead, common goldeneye, Barrow's goldeneye, redhead, ruddy duck[80] and the three mergansers—American, common and hooded. They have worldwide distribution, primarily in the Northern Hemisphere. *Aythyinae* are good flyers and poor walkers but excellent divers, with the long-tailed duck being an exceptional diver. Many feed on underwater plants, especially wild celery, as well as shellfish, crustaceans and aquatic insect larvae. Most nest in waterside vegetation, although the goldeneye, a notable exception, nests in hollow trees up to two meters above ground.

The subfamily *Anserinae* is populated by geese and swans. There are fourteen species of true geese, which are for the most part confined to the Northern Hemisphere. Geese are medium to large birds that fly and swim well. These birds have long necks and strong legs. Geese are gregarious, often found in large flocks during winter, but they split into breeding pairs with strong, long-lasting bonds during the spring breeding season.

Geese can be subdivided into two groups corresponding to the two genera *Anser* (gray geese) and *Branta* (black geese). The ubiquitous Canada goose exists in twelve different races distinguished mainly by size, ranging from that of a large duck to that of a smallish swan. The Canada geese and the snow geese are the most prized by North American hunters.

Swans are among the largest birds, and seven species are noted. Several of the large Northern Hemisphere species are capable of making extremely loud calls, thus their common names: "trumpeter swan," "whooper swan" and "whistling swan." The nearly silent "mute swan" is the exception. Swan pairs bond for life and show real attachment to their mates. Female swans are called *pens* and males *cobs*. They build large nests of aquatic and semi-aquatic vegetation; the nest of the trumpeter swan may be a floating structure. Some species will carry their young, cygnets, on their backs. When they are young, whooper and trumpeter swans are migratory and fly in a V-formation like geese.

Human Interaction

Humans and *Anseriformes* have had a long and mutually beneficial relationship, even though five species of ducks have become extinct due to the activities of humans since 1600. Members of this order can be kept in captivity with ease, and some members have been long domesticated. The Eastern graylag goose was first domesticated in Egypt four thousand years ago and has given rise to eight varieties of farmyard geese. Likewise, the mallard was first domesticated in China two thousand years ago, and currently more than ten varieties are now regularly farmed for meat and eggs. The Muscovy duck was domesticated by the peoples of South America long before the Spaniards arrived in the 1500s.

Today, some species are in decline, threatened by hybridization, loss of habitat and hunting, even though hunting activities are highly regulated and the excesses of the past have been curtailed.

The Appearance of Birds

The scientific-paleontological community, supported wholeheartedly by the popular press, has developed a consensual agreement that birds have evolved from a group of theropod dinosaurs during the Mesozoic Era (251–265 mya). Nearly all paleontologists view birds as coelurosaurian (maniraptoran) theropod dinosaurs, generally small meat-eating dinosaurs. Maniraptorans include several dinosaur lineages: *Alvarezsaurids*, *Therizonosaurs*, *Oviraptorosaurids*, avians (birds), *Dromaeosaurids* and *Troodontids*. If they do not have a direct evolutionary lineage with theropod dinosaurs, birds certainly have a direct link with an archaic common ancestor.

A significant amount of controversy exists as to when "modern" bird lineages first appeared. According to some recent research, modern birds originated 100 mya, long before the demise of the dinosaurs. The current fossil record suggests that modern bird lineages began approximately 60–65 mya, when other lineages of dinosaurs, along with at least half of all terrestrial animals (including birds), were extinguished by an asteroid impact at the end of the Cretaceous Period (65 mya):

> *Sixty-five million years ago, a twelve-kilometer-wide asteroid, traveling at 20 kilometers a second, slammed into the present-day Chicxulub coast of Yucatán. It blew out a crater 10 kilometers deep and 180 kilometers wide and rang the planet like a bell. There followed volcanic eruptions, earthquakes, acid rains (including global fires), and a mountainous ocean wave that traveled around the world. Soot shaded the skies, blocking sunlight and photosynthesis. The darkness held on long enough to finish off most of the surviving vegetation. In the killing twilight the temperature plummeted and a volcanic winter, i.e., impact winter, gripped the planet. Seventy percent of all species disappeared, including the last of the dinosaurs.... Earth required roughly 10 million years to recover.*[81]

This cataclysmic event is delineated today by a worldwide deposit of ash, red clay and iridium and is known as the Cretaceous-Tertiary (K-T) boundary.

About the same time in our ancient past, 66.25–65 mya, the volcanoes of the Deccan Traps were erupting on the Indian subcontinent. According to some sources, this series of eruptions may have lasted nearly 30,000 years and, in the process, deposited multiple layers of solidified flood basalt that were more than 2,000 meters (6,562 feet) thick, covering an area which may have included 1.5 million kilometers. Due to 65 million years of erosion and

plate tectonics, the present area of observable lava flows encompasses an area of 512,000 square kilometers (197,684 square miles).

The Deccan Traps eruptions have been associated with a deep mantle plume (i.e., a hotspot driven by plume dynamics); also, the motion of the Indian tectonic plate has shown a strong correlation with and the eruptive history of the Traps. However, there are some among the scientific community who feel the event at Chicxulub triggered the eruptive episode. Whatever the immediate trigger, the eruptions released incalculable amounts of sulfur dioxide into the atmosphere during the duration of the event, contributing to lower worldwide temperatures, dramatic worldwide climate change and what must have been an extremely toxic atmosphere when one considers the immediate and long-term global effects of both the asteroid strike in the Yucatán and the long duration of volcanic eruptions in India.

It is difficult to imagine that any life could survive these extreme climate-changing events, let alone birds, fragile creatures that they are. Nevertheless, it seems that at least one lineage of ancient birds survived past the Cretaceous Period to populate the Tertiary Period (65–1.64 mya) with modern bird lineages.

Scientific interest into the origins of birds began within a year of the publication of Charles Darwin's *On the Origin of Species* (1859). A single fossilized feather was uncovered in Germany's Late Jurassic (157–146 mya) Solnhofen limestone in 1860. The first skeleton of *Archaeopteryx*, known as the London Specimen, was unearthed near Langenaltheim, Germany, in 1861; it was sold to the Natural History Museum in London, where it remains today and was described by Richard Owen in 1863. The skeleton is missing most of its head and neck and is referred to as an *Urvogel*, German for "first bird" or "original bird."

Since the London Specimen was found in 1861, twelve other specimens have been uncovered, possibly representing a number of different species. Most specimens that have been found are fragmentary skeletons. The Berlin Specimen—discovered in 1874 or 1875 near Eichstätt, Germany—is considered to be the most complete specimen found to date and includes a complete head. The Haarlem Specimen—found in 1855 near Riedenburg, Germany—was originally described as a *Pterodactylus*, a small Jurassic Period (208–146 mya) flying reptile related to but not a dinosaur (*Pterodactyl* means "winged finger"). They became extinct at the end of the Jurassic Period. This specimen was reclassified as an *Archaeopteryx* in 1970. The single feather impression found in 1860 is generally attributed to *Archaeopteryx*, but it could

also represent a yet-unknown proto-bird. The most recent specimen, found in 2010, remains, as of 2014, to be scientifically described.

Archaeopteryx, "original bird," is classified as a genus of bird-like dinosaurs that is transitional between non-avian feathered dinosaurs and modern birds, and it is generally accepted by paleontologists and the popular press as the oldest known bird—a member of the group *Avialae*. *Archaeopteryx* lived around 150 mya in the late Jurassic Period in what is now southern Germany during a time when this land mass was closer to the equator and Europe consisted of an archipelago of islands surrounded by a warm, shallow tropical sea. Similar in size to a blue jay, though possibly ranging in size to that of a raven, it had broad rounded wings and was probably a more competent glider than a flyer. *Archaeopteryx* had more in common with small Mesozoic Era (245–65 mya) dinosaurs than with modern birds, having jaws with sharp teeth, a long bony tail, feathers (which also suggest warm-bloodedness), a second toe similar to the "killing claw" of a dinosaur and various dinosaur-like skeletal features. Since it displays features common to both birds and non-avian dinosaurs, *Archaeopteryx* has often been considered a link between the two, important to the study of both the origins of birds and theropod dinosaurs.

The specimens of *Archaeopteryx* that have been discovered are most notable for their well-developed asymmetrical flight feathers, showing a structure similar to modern birds. This indicates that the evolution of advanced forms of feathers (flight feathers) began before the Late Jurassic Period. Tail feathers were less asymmetrical yet somewhat similar to modern birds.

Even though *Archaeopteryx* had well-developed flight feathers, possibly some back feathers, it remains unclear whether it was capable of flapping flight or simply a glider. Since the flight feathers were asymmetrical, this has been interpreted as evidence that it was a flyer, since flightless birds tend to have symmetrical feathers. Controversy exists, and the generally accepted theory is that the animal was a more competent glider than a flyer.

The study and analysis of the existing *Archaeopteryx* specimens are important to the scientific debates about the origin and evolution of birds, as well as to the debates swirling about the origin of flight. Some scientists see it as a semi-arboreal tree-climbing animal, supporting the idea that birds evolved from tree dwelling gliders—the "trees down" hypothesis. Other scientists see *Archaeopteryx* as running quickly along the ground and flapping his wings to gain flight—the "ground up" hypothesis. Still others suggest that, like modern birds, *Archaeopteryx* may have been at home both on the ground and in the trees, although some evidence exists that it was not particularly adept at either running or perching.

Modern paleontology has classified *Archaeopteryx* as the most primitive bird, although it is not thought to be a true ancestor of modern birds but rather a close relative of their ancestor. In addition, the evolution of feathers has stirred the imagination of scientists as to their primary evolutionary purpose(s)—flight, sexual display, brooding, species recognition and/or insulation for a "warm-blooded" animal.

The Evolution of Feathers

Through the revelations brought about by the recent discoveries in China, we are now discovering that dinosaurs like the *Velociraptor* and its kin, portrayed in the widely popular *Jurassic Park* films, are now thought to have been wearing feathers. The discovery of feathered dinosaurs has inspired, once again, considerable scientific discussion and research into both the evolutionary transition of dinosaurs, or their archaic ancestors, into modern birds and the evolutionary purpose of their feathers—insulation, sex and display, camouflage, species recognition, brood-rearing and/or powered flight.

The evolutionary process that produced feathers is just one of a long list of adaptations and mutations—including in part light hollow bones, larger brains, reduction of the reptile tail, fucula (wish bones), loss of teeth, pygostyle (parson's nose on your roast chicken) and avian beaks—that cumulatively led to birds. "Indeed, the recent findings…in the now-famous Liaoning Lake deposits of northeastern China since the mid-1990s of feathered dinosaurs and early birds shows just how rapidly our perspectives on evolution can change."[82]

The fossil of a late Jurassic (160 mya) small dinosaur, unearthed in Inner Mongolia in 2007 and named *Epidexipteryx* (display feather), preserved the delicate impressions of four twenty-centimeter-long ribbon-like tail feathers. This fossil provided the first clue that feathers had found a use in display, possibly complex seduction-courtship displays, long before they ever assisted animals to become airborne.[83]

Li Yumin, a Chinese farmer and part-time fossil hunter, was prospecting near the Liaoning Province during August 1996 for fossils to sell to collectors and museums when he made the dramatic discovery of the first feathered dinosaur. Ultimately named *Sinosauropteryx*, the creature was a 125-million-year-old theropod dinosaur, not a bird. Its protofeathers, a thin layer of

hollow filaments covering its back and tail, were obviously not meant for flight. Since this 1996 discovery, nearly forty species of dinosaur fossils, and hundreds of specimens, have been uncovered with direct feather impressions and/or circumstantial evidence of the existence of feathers. The vast majority of these new discoveries are of carnivorous theropods. Most were uncovered in northeastern China, but others were found in Europe, North America, Madagascar and Mongolia, pointing to the widespread existence of feathered dinosaurs beginning during the mid-Jurassic Period. Having feathers may have been a common trait among theropod dinosaurs.

Nevertheless, modern asymmetrical flight feathers required millions of years of evolution to develop. The protofeathers of these Jurassic theropods were simple in structure—more "dinofuzz"[84] than feathers in the modern sense. The question as to how feathers evolved remains one of evolution's long-standing mysteries. A number of theories are extant, and related research efforts are ongoing. Remember, the crow-sized creature *Archaeopteryx* was capable of flight, at least to some extent, 150 mya, while the recently discovered chicken-sized dinosaur *Anchiornis* was covered with extravagant plumage similar to flight feathers but had feathers that were symmetrical (i.e., similar to feathers of modern flightless birds, which were probably too weak for flight).[85]

In another recent discovery, an animal only slightly smaller than *T. rex* (ten meters from snout to tail), dubbed *Yulyrannus*, included a patch of preserved fossilized skin having shaggy kiwi-like feathers. Do you visualize *T. rex* as a bird with feathers?[86] A road runner from hell!

It is evident that different lineages of theropods evolved different types of feathers, ranging from the fluffy down of modern birds to symmetrically arranged barbs, while others developed long stiff ribbon-like feathers unlike anything modern birds sport.

One theory of feather evolution supported by some members of the paleontological community proposes that feathers evolved from the reptilian scales of theropod skin, even though the exact mechanism of this evolutionary leap from the simple to the amazingly complex remains unknown. In the 1990s, Richard Prum, a researcher from Yale University, and Alan Brush, of the University of Connecticut, conducted a research project investigating the development of feathers in bird embryos. The researchers found that all feathers on a developing chick begin as bristles that only later split open into more complex shapes. These bristles grow from tiny patches of skin called placodes. Interestingly, reptiles also have placodes. The giant leap from reptilian scales to bird feathers might have depended on a simple switch in

the wiring of the genetic commands inside the placode, causing cells to grow vertically into feathers rather than horizontally into scales.[87]

Prum based his theory on the evolution of feathers on his research with chick embryos. He postulated that feather development took place over millions of years in five stages: Stage I feathers may have evolved at the dawn of dinosaur evolution and are consequently not well represented in the fossil record in the early Triassic Period (250–200 mya) and probably consisted of down-like filaments. Stage II feathers are represented by the formation of a single long quill with a soft tuft of filaments, much like modern down feathers, rather than a vane. Stage III feathers may have seen the development of the first microscopic branching structures on their barbs (barbules) with some development toward the formation of a type of advanced down known as a semiplume; however, the fossil record of these developments is not informative. Stage IV feathers took advanced levels of development of primary barbs and secondary barbules of the semiplume to another level of branching in the form of hooklets, allowing barbules to hook together to form vanes. And Stage V feathers are feathers with asymmetrical vanes that are capable of supporting powered flight, such as those of *Archaeopteryx* 150 mya.[88]

We may never know if *T. rex* sported feathers. Oftentimes the fossil evidence is remarkably fragmentary, even though equally remarkable fossilized soft tissue and feathers have been unearthed:

> *A few of the new Chinese fossils hint that feathers have their origins much deeper in the dinosaur family tree, not close to the species that evolved into birds. There's even the tantalizing possibility that feathers originated in the ancestors of animals that gave rise to dinosaurs and their sister groups of flying reptiles.*[89]

Mesozoic Birds

The Mesozoic Era—consisting of the Triassic Period (251–200 mya), the Jurassic Period (200–146 mya) and the Cretaceous Period (146–65 mya)—was the apex of major events in the development and evolution of life on Earth. Evolutionary processes, including natural selection, gave rise to a diversification of life, as well as a diversification of species, while enduring great extinction events during the Triassic (200 mya) and Cretaceous Periods

(65 mya). The Mesozoic is known as the Age of Reptiles, lasting for 185 million years. Then again, possibly it should be known as the "Age of Big Weird Feathered Things."[90]

Prior to the Mesozoic Era, evolutionary processes were at work as well. The first multi-cellular organism may have arisen 800 mya; the first primitive plants, lichens and mosses appeared 434 mya; and amphibians, all the way back to the first vertebrates to climb out of the water, appeared 370 mya—nearly 140 million years before the dinosaurs evolved. Insects roamed the land 364 mya and would soon rule the skies until the birds developed, and they may have arisen as early as 400 mya, indicating an early evolution of wings.

During the Mesozoic Era, the earliest dinosaurs rose 225 mya, and the first shrew-like mammals appeared within the next 10 million years. Birds appeared and diversified 160 mya, and significantly, the first flowering plants, angiosperms, were diversifying and invading every landmass beginning about 130 mya. Some of these flowering plants have structures that attracted insects and other small animals to spread pollen. Other angiosperms were pollinated by the wind and water. This innovation caused a major burst of animal evolution by providing animals and birds with new ecological niches and sources of food. The earliest bees appeared 100 mya, the first snake 90 mya and the ancestors of ants evolved 80 mya. Grasses show up in the fossil record in fossilized dinosaur dung about 67 mya.

Paleontologist Richard Owen coined the term *dinosaur*, derived from the Greek, meaning "terrible" or "fearfully great" "lizard" in 1842. Darwin published his seminal work *On the Origin of Species* in 1859, establishing "natural selection and gradualism" as the primary mechanisms of evolutionary change. In 1860, *Archaeopteryx lithorgaphica* was discovered in a Germany limestone quarry. By 1862, Owen had examined the *Archaeopteryx* fossil and unequivocally declared it a bird, disregarding its reptilian features such as tail and teeth.

It is interesting to note that a Mesozoic, Late Cretaceous (66 mya) small gull-like bird, *Coniornis*, was found in the American West in 1845 and collected by Yale's Peabody Museum of Natural History. It was not named or scientifically described until 1893, by Othniel Charles Marsh. The bird has subsequently been found in Saskatchewan, Wyoming, Colorado and Montana.

Thomas Henry Huxley, an English biologist (comparative anatomist), known as "Darwin's Bulldog" for his advocacy of Darwin's theory, published his own paper on *Archaeopteryx* in 1868, detailing the remarkable similarities between it and the small dinosaur *Compsognathus* and concluding not only that

the species was the "first" bird but also that it was the missing link between dinosaurs and birds. Huxley saw many similarities between the skeletons of birds like pigeons and small meat-eating dinosaurs.[91]

Huxley's study of fossil reptiles led to his demonstrating the fundamental affinity of birds and reptiles, which he published under the title of *Saurosida*, while his papers on *Archaeopteryx* are still of great interest today. *Archaeopteryx*, the "first" Mesozoic Era bird, has been previously described. During the 1870 "Bone Wars"[92] in the American West, the second and third Mesozoic Era birds were uncovered in Kansas. *Hesperornis*, a huge Late Cretaceous Period (83.5 mya) flightless bird, was unearthed by O.C. Marsh from Yale's Peabody Museum in Kansas. It sported both teeth and beak. Benjamin Medgea, Marsh's student, unearthed *Ichthyornis* in the Greenhorn formation of Kansas. This bird, also dating to the Late Cretaceous Period, was pigeon-sized, had prominent teeth and is characterized as the Mesozoic equivalent of a modern seabird. These discoveries clearly indicate that birds had a reptilian origin.

Marsh would endorse Huxley's theory of bird origins after he described the fossils of both *Hesperornis* and *Ichthyoenis* in 1880. Huxley's theory of bird origins in reptilian ancestors held sway until 1926.[93]

Danish amateur zoologist and natural history artist Gerhard Heilmann published an influential book, *The Origin of Birds*, in 1926. In his book, Heilmann argued that birds could not be descended from dinosaurs because dinosaurs didn't have collarbones. This was the cordonts hypothesis. At that time, it was not known that some dinosaurs did have collarbones and that, in fact, they had evolved into wishbones. Heilmann continued by suggesting that birds had descended from arboreal reptiles. This new theory held sway for the next fifty years and had a chilling effect on Huxley's conclusions. Many of the theropods unearthed since the 1920s have, in fact, shown evidence of collarbones that have fused into complete wishbones exactly like modern birds.[94] Heilmann's theory that birds descended from an earlier lineage than dinosaurs went unchallenged until the discoveries made by Yale's John Ostrom.

Few fossils had emerged hinting at the transition between dinosaurs and birds since the discovery of *Archaeopteryx* in the 1860s. By the 1960s, new evidence was unearthed that caused renewed interest in Huxley's theory that birds descended from dinosaurs.

A Polish expedition to Mongolia in the 1970s found that dinosaurs had not only wishbones but also breastbones as modern birds do. Shortly afterward, a Russian effort led by Sergei Kurzamov to Mongolia's Gobi

Desert found a dinosaur fossil with so many attributes of birds he named it *Auimimus portentosus* (the "amazing bird mimic"). Kurzamov argued that his dinosaur had quill-knobs (small pits in the bone where feathers were attached)—evidence of feathers.[95] Kurzamov would be vindicated in 2007, when a team of paleontologists found quill-knobs on the bones of a fossil *Velociraptor* excavated in 1998 in Mongolia. In this instance, the presence of quill-knobs pointed directly to the existence of feathers.

John Ostrun (1928–2005) was a young paleontologist with Yale's Peabody Museum in the 1960s when he discovered a new theropod dinosaur while prospecting for fossils in Montana. In 1963, Ostrum described and named his new find: *Deinonychus* ("terrible claw").

In 1972, British paleontologist Alick Walher proposed that birds arose not from the cordonts but rather from crocodile ancestors. Crocodiles are today believed to be the oldest living ancestor of modern birds. Ostrum published a succession of reports in the mid-1970s, based on his work with both theropods and birds, in which he laid out the numerous similarities between birds and theropod dinosaurs while at the same time resurrecting the theories first put forth by Huxley more than a century before.

Ostrum's research with *Deinonychus* and other theropods, his findings and insights into dinosaur biology and behavior led to the demise of the cordont hypothesis and a reinaissance in the way people think of dinosaurs. Ostrum changed the way people perceive dinosaurs. Almost single-handedly he convinced the scientific community that birds descended from dinosaurs. Before Ostrum's work, dinosaur biology was stuck in the backwater of the 1920s and 1930s—dinosaurs were widely considered to be slow-footed, indolent, cold-blooded and dim-witted reptiles. Ostrum painted a picture of *Deinonychus* as an aggressive, warm-blooded carnivore with a high metabolic rate that may have hunted in packs to bring down larger prey. Additionally, he catalogued more than two dozen similarities between *Deinonychus* and birds. *Deinonychus* was the prototype for the vicious velociraptors in the popular *Jurassic Park* books and movies, and the behavior of the raptors in the movies was based on dinosaurs' behavioral models developed by Ostrum. Ostrum's research findings were the spark that ignited Michael Crichton's wondering about what it would be like to bring back to life an intelligent, fast-moving, kick-boxing dinosaur.

In 1978, Jack Horner, a paleontologist and curator of the Museum of the Rockies, was the first fossil prospector to find fossilized dinosaur eggs. The discovery took place at Egg Mountain, Montana, in deposits from the Late Cretaceous (75 mya), and additionally, he provided evidence of

dinosaur brooding behavior. Since then, fossil eggs have been found in Early Jurassic (197–190 mya) deposits in Lufeng, China. Dinosaur embryos have also been discovered.

The scientific consensus is that birds are a group of theropod dinosaurs that evolved during the Mesozoic Era. The close relationship between birds and dinosaurs was first proposed in the nineteenth century after the discovery of the primitive bird *Archaeopteryx* in Germany. Huxley's original work in the 1860s provided the underpinnings for the theory that birds were descended from dinosaurs, and Marsh endorsed Huxley's theory in 1868. Ostrum's research in the 1970s established that birds were descended from theropod dinosaurs while reviving Huxley's fundamental premise, which had gone out of favor over the years. This current theory, supported by most of the paleontological community, is that birds did descend from theropod dinosaurs during the Mesozoic Era; however, there are dissenters—critics who support different theories of the origins of birds, including the proposition that dinosaurs and birds had a common ancestor in the time of the *Archosaur* during the Early Mesozoic Era.

Dinosaurs are classified into two major subgroups: the saurischian, or "lizard-hipped" dinosaurs, which include all the bipedal carnivorous theropods; and the ornithischian, or "bird-hipped" dinosaurs, which include, in part, the herd-living herbivores. Confusing as it seems, birds did not descend from the "bird-hipped" dinosaurs but rather the "lizard-hipped" dinosaurs, more specifically from the maniraptoran theropods.[96] As previously noted, crocodiles are modern birds' closest living ancestor.

John Alan Feduccia is a noted paleornithologist, specializing in the prehistoric origins of birds, who is currently Professor Emeritus at the University of North Carolina. Feduccia has written two books, *The Age of Birds* and *The Origin and Evolution of Birds*. The latter was first published in 1996 after years of research and then updated in 1999. Feduccia is probably best known for his sometimes severe criticism of the widely held view that birds originated from the maniraptoran theropods. In spite of near universal acceptance of the theropod-bird linkage, Feduccia is a noted doubter. He argues for an alternative theory in which birds share a common "stem"—an ancestor among the more basal archosaurian dinosaur lineages, with birds originating from small "arboreal" archosaurs in the Triassic Period (251–200 mya). Feduccia's skepticism about the origin of birds from theropods and a "ground-up" origin of avian flight stems from the absence of any evidence of the existence of arboreal theropods. He also argues that at least one, possibly two evolutionary radiations of birds had happened long before

Archaeopteryx evolved, pushing back the evolution of the "first" bird by many millions of years.[97]

In 1996, Feduccia researched an intriguing bird, *Llaoningornis*, which had a breastbone like modern birds and was probably capable of long flights and lived just after *Archaeopteryx*. Feduccia believes that birds were widespread during the Mesozoic Era, occupying a variety of niches, but contrary to some contemporary thinking, he believes that most of them—but not all—died out 65 mya during the catastrophic K-T event extinction. According to Feduccia's hypothesis, there was an explosive Cenozoic Era adaptive radiation of modern birds following the extinction event at the end of the Cretaceous Era. This adaptive radiation of modern birds took place 65–53 mya, independently of dinosaurs, and is termed the "Big Bang theory of birds." Feduccia hypothesizes that a lineage of "transitional shorebirds" managed to survive the K-T boundary event and that this lineage of *Graculavidae* provided the ancestral stock for modern orders of birds.[98]

Protoavis ("first bird") is a primitive bird known from fragmentary remains from Late Triassic (210 mya) deposits from Texas, although there is some controversy as to exactly what this animal is. If the identification is valid, its discovery would push avian origins back some 60–75 million years, existing far earlier than *Archaeopteryx*, its skeleton being more bird-like. *Protavis* is reconstructed as a toothed carnivorous bird with feathers because of the possible, but inconclusive, evidence of "quill-knobs" on the skeleton. There is considerable doubt among the paleontological community that *Protoavis* is actually a bird, and its fragmentary remains may not be the remains of a single species.

The reader must realize that a certain amount of speculation and even imagination, along with the best fossil evidence available, plus inspiration from living animals, are necessary components in the reconstruction of long-dead creatures. Mesozoic plumage is inferred. The book illustrations and descriptions provide us with plausible outward appearances, keeping in mind that "fragmentary" evidence sometimes means the discovery of a single bone!

The K-T boundary event was a bottleneck that few birds, other than the transitional shorebirds or *Graculavids*, survived. No modern birds are known from before this event 65 mya, with the exception of possibly *Neogaeornis*, a Late Cretaceous loon, discovered in Chile and based on fragmentary evidence (and therefore suspect). Mesozoic birds met an evolutionary dead end. "Neither are any modern water birds known for certain from before the Cretaceous Tertiary boundary, although some may have existed."[99] The distinction between bird and dinosaur is sometimes blurred because of condition of and the paucity of physical evidence.

Mesozoic Birds of North America

Species	Description
Alexornis	Late Cretaceous (73 mya), known only from a single fragmentary skeleton
Apatornis	Late Cretaceous (83.5 mya), known from a single fragmentary skeleton
Avisaurus	Late Cretaceous, two species both known from only single fossilized foot bones
Baptornis	Late Cretaceous (87–80 mya), flightless aquatic discovered in Kansas in 1870
Brodavis	Late Cretaceous (66.8–66 mya), four species of freshwater bird, known from fragmentary skeletons
Canadaga	Late Cretaceous (67 mya), flightless toothed seabird
Ceramornis	Late Cretaceous (66 mya), sometimes considered a waterfowl
Cimolopteryx	Late Cretaceous (66 mya), small gull-sized bird found in Saskatchewan, Wyoming and Montana
Graculavus	Late Cretaceous (68–62 mya), two species of shorebird known
Halimornis	Late Cretaceous (80 mya), seabird known only from a fragmentary fossil
Hesperornis	Late Cretaceous (83.5–78 mya), flightless aquatic toothed bird discovered by O.C. Marsh in the 1870s in Kansas
Iaceornis	Late Cretaceous (83.5 mya), marine bird known from a single partial skeleton found in Kansas
Ichthyornis	Late Cretaceous (95–83.5 mya), toothed seabird found in Alberta, Kansas and Texas, equivalent to modern gulls
Laornis	Late Cretaceous (66–63 mya), semi-aquatic bird found in New Jersey and known from a single leg bone

The Evolution of Ducks, Geese and Swans

Lonchodytes	Late Cretaceous (70 mya), aquatic bird that appears to be closely related to modern birds
Martinavis	Late Cretaceous, known only from a partial skeleton
Palintropus	Late Cretaceous (76.5–75 mya), known from two species found in Wyoming and Alberta
Parahesperornis	Late Cretaceous (85–82 mya), flightless bird found in Kansas
Pasquiaornis	Late Cretaceous (95–93 mya), flightless toothed seabird
Potamornis	Late Cretaceous, a hefty flightless diving seabird
Telmatornis	Late Cretaceous (76–68 mya), aquatic bird found in New Jersey known from a single species
Torotix	Late Cretaceous (66 mya), unclear whether a seabird or freshwater bird
Tytthostonyx	Late Cretaceous (66 mya), seabird known from a single species, may be related to ancestors of modern birds

Mesozoic Birds of Asia

Species	*Description*
Abavornis	Late Cretaceous, single species known from only a fragmentary skeleton
Apsaravis	Late Cretaceous (78 mya), found in the Gobi Desert in 1998
Asiahesperornis	Late Cretaceous, a flightless toothed diving seabird
Brodavis	Late Cretaceous, freshwater bird also found in North America, possibly fast flight ability
Catenoleimus	Late Cretaceous (90 mya), single species known from only a fragmentary skeleton
Cretaaviculus	Upper Cretaceous, known only from an isolated asymmetrical contour feather
Elsornis	Late Cretaceous, known only from a fragmentary skeleton found in the Gobi Desert

Enantiopheonix	Fossil remains recovered from Lebanon
Explorornis	Smallish Mesozoic (90 mya) bird, questions somewhat unresolved
Gobipteryx	Late Cretaceous, found in Gobi Desert in 1971, not known to have any direct descendants, capable of flight
Gurilynia	Late Cretaceous (70–66 mya), known only from fragmentary skeleton
Hollanda luceria	Late Cretaceous (75 mya), fast-running ground bird
Hulsanpes	Late Cretaceous (73 mya), found in Mongolia in 1970, consists of a partial right foot skeleton
Incolornis	Late Cretaceous (89–86 mya), found in Uzbekistan, genus unclear, fragmentary remains
Judinornis	Late Cretaceous (probably 70 mya), flightless bird found in southern Mongolia
Kizylkumavis	Late Cretaceous, found in Kyzl Kum, Uzbekistan
Kuszholia	Late Cretaceous, primitive bird or bird-like dinosaur found in Uzbekistan
Laevisoolithus	Fossil egg probably laid by a bird or small theropod dinosaur
Lenesornis	Late Cretaceous (75 mya), found in Kyzl Kum, Uzbekistan
Sazavis	Late Cretaceous, found in Kyzl Kum, Uzbekistan, known only from a single bone
Styloolithus	Upper Cretaceous, fossil egg found in Mongolia
Teviornis	Late Cretaceous (70 mya), found in Gobi Desert, known only from fragmentary skeleton
Yandangornis	Late Cretaceous (85 mya), discovered in 1986 in Zhejiang Province, China, primitive bird or possibly a non-avian theropod
Zhylgaia	Late Cretaceous, found in central Asia, possibly a shorebird

Source for charts: Wikipedia

The post K-T boundary event fossil evidence points to an explosive radiation and diversification of modern birds that occurred over a period of 5 to 10 million years, beginning in the early Tertiary (65–1.8 mya). Both land and water birds appeared nearly simultaneously from a common lineage. A second scenario envisions a more diverse group of survivors of the K-T boundary event. Based on cautious interpretations of the fossil evidence, which at times is fragmentary, this theory proposes that members of certain modern bird groups lived during the Cretaceous Period before the K-T boundary event: *Charadriiformes* (wading birds), *Anseriformes* (ducks and geese), *Gulliformes, Palaeognathae* (large flightless birds including ostrich, rehea, moa and cassowaries) and *Palecaniforms* (some cormorant-like birds). Grebes and rail-like birds have also been reported from the Late Cretaceous.[100]

It is believed by some paleontologists that at least one lineage or species, examples of each of the previous groups, survived the K-T extinction event and diversified into modern birds during the Cenozoic Era; furthermore, evidence of a diverse bird fauna uncovered in the Honertown formation of New Jersey includes an abundance of water birds and waders, including representatives of most of the groups just mentioned. These findings support the premise that most of the birds that survived the K-T extinction event were primarily "waterbirds," which later evolved into modern land birds.[101]

Jacques Gauthier of the University of California–Berkeley was working in the mid-1980s to identify features unique to birds and certain groups of predatory dinosaurs. Gauthier's work began the process of solidifying the bird-dinosaur hypothesis into one of today's most accepted and unchallenged theories of vertebrate evolution.[102]

In spite of Feduccia's exhaustive research and astute discussion, the commonly held hypothesis seems to be that birds descended from maniraptoran theropod dinosaurs.

In the 1960s, only a few fossil birds were known; however, with the most recent discoveries unearthed in China, Mongolia and North America, nearly seventy species have been collected and described today.[103]

The resurgence in interest and research in dinosaurs hit the ground running with the phenomenal discoveries made in the Liaoning Lake deposits in northeastern China beginning in the mid-1990s. Renewed interest in dinosaurs spread worldwide. Paleontologists and fossil prospectors unearthed an amazing and incredibly diverse avian and non-avian dinosaur menagerie of Mesozoic life in North America, Europe, Madagascar, Mongolia and South America. These new discoveries filled the "fossil gap" that had separated the origins of modern birds from their dinosaurian

predecessors. Complete articulated fossil remains unearthed since the 1990s established beyond a reasonable doubt that birds evolved from carnivorous dinosaurs, some of which sported flamboyant plumages.

In 2004, a remarkable fossil was unveiled named Mei Long (meaning "sleeping dragon"), which provided both anatomical and behavioral evidence of the link between birds and dinosaurs. Mei Long is a *troondontil* dinosaur, a group that some paleontologists claim are closer to birds than any other theropod dinosaurs. Mei Long was uncovered in a sleeping position similar to that of a modern bird, although on the ground, not in a nest in a tree.[104]

The astounding discoveries in the now famous Liaoning Lake deposits of China first became known to the scientific community through the appearance of specimens illegally smuggled into the United States and Europe that had been purchased at auction by private collectors. Eventually, the significance of these discoveries was recognized, and a cooperative sharing relationship was established with the Chinese scientific community.

One of the first and best-known Cretaceous birds to emerge from within this new relationship with the Chinese was *Confuciusornis*, which is known from at least one thousand good specimens today. The most extraordinary things about these fossils are their detailed preservation of complete articulated skeletons and the presence of feathers, according to Long and Schouten's *Feathered Dinosaurs*.

We know today that Mesozoic birds were an incredibly diverse collection of life, and the discoveries unearthed since the 1990s have shown that some of the most well-known dinosaurs, including the raptors, can be included among them. "Today, a vast majority of scientists hold the opinion that birds are the dinosaurs' direct descendants, and therefore are considered to be a sub-group within *Dinosauria*."[105]

Today, birds represent the most diverse vertebrate genus on the planet in the animal kingdom, with nearly ten thousand species; mammals are represented by five thousand species and most probably billions of individuals. For those readers who have a deeper interest in Mesozoic birds and/or the origins and evolution of modern birds, the following three publications may be of interest:

- *Feathered Dinosaurs: The Origin of Birds* by John Long and Peter Schouten contains more than seventy-five illustrations of dinosaurs, feathered dinosaurs and Mesozoic birds.
- *Flying Dinosaurs: How Fearsome Reptiles Became Birds* by John Pickrell contains descriptions of forty feathered dinosaurs for which we

have direct evidence of feathers from fossil impressions or other skeletal evidence.
- *A Field Guide to Mesozoic Birds and Other Winged Dinosaurs* by Matthew P. Martyniuk contains color reconstructions of 149 Mesozoic birds.

THE ORIGIN OF *ANSERIFORMES (ANATIDAE)*

Numerous species of birds have been identified from the Mesozoic Era, mainly from the Late Cretaceous Period (146–65 mya), but many are known from remains that are much too fragmentary to reconstruct their life appearance with any degree of confidence.[106] Due to this poor fossil record, there has been considerable debate regarding not only the origins of birds but also the timing of the adaptive radiation and diversification of modern birds. The great Mesozoic radiation and diversification of birds ended with the worldwide environmental calamity of the K-T boundary extinction event—an evolutionary dead-end for most Mesozoic birds.

There are those who disbelieve in the K-T boundary extinction event, including Luis Chappe of the American Museum of Natural History and his colleague Kevin Padian of Berkeley. These men state that there is no positive evidence for these extinctions and "there is no evidence that they perished suddenly."[107] However, Chappe cites fossil evidence of modern birds from the Cretaceous, but these formations are now known to be of the Paleocene Epoch.

Feduccia (1999) proposes the hypothesis that only the transitional shorebirds—water birds—were able to survive this event and that no modern bird lineages are known from before the K-T boundary, with the possible exception of *Neogaeornis*, a loon from Cretaceous Chile, whose remains are so fragmentary that its identification is suspect. The transitional shorebirds, *Graculavids*, included the *Presbyornithids*, which were a prehistoric lineage of a family of advanced waterfowl (i.e., wading ducks). These birds lived until the Oligocene Epoch (32–24 mya) but are now extinct and are characterized as a flamingo-like wader with duck-like features. The discovery of a complete articulated skull of *Presbyornis* in 1977 made the relationship with ducks even more clear.[108]

Presbyornis, a shorebird duck, was a goose-size Mesozoic bird with long legs and a duck-like body. *Presbyornis* was one of the first *Anseriformes* and

something of a cross between a goose, a duck and a flamingo. Two species are known from fragmentary skeletons, although complete skeletons from the Paleocene Epoch (65–56 mya) and Early Eocene Epoch (56–34 mya) formations have been uncovered. It has been suggested that the birds nested in colonies. There is some evidence that *Presbyornis* represents a lineage of the "transitional shorebirds" that survived the K-T boundary event into the Cenozoic Era (65–1.8 mya).

In 1997, two other researchers, Alan Cooper and David Penny, conducted a series of molecular (DNA) studies in an effort to determine the age of the lineages of modern birds—essentially an attempt to read their molecular clock. They concluded that at least twenty-one orders of modern birds passed through the K-T boundary extinction unharmed, pointing to an Early Cretaceous origin of modern birds. Thus the debate continues.

Matthew P. Martynuik in 2012 took a third position based on "tentative" interpretations of the fossil evidence. He supports the theory that it is likely that members of some modern bird (avian) groups existed before the K-T boundary and somehow survived that event:

- *Charadriiforms*: wading shorebirds
- *Anseriformes*: including *Vegavis*, a primitive duck
- *Galliformes*: ratites (flightless birds)
- *Petecaniforms*: cormorant-like birds

According to Martynuik, it may even have been possible for certain members of the (non-avian) toothed shorebirds to have survived the K-T boundary event and lived for a few million years into the Cenozoic Era (65 mya to modern times).

Vegavis iaai was a goose-like relative of the modern duck, an *Anseriforme*, that was unearthed in 1992 on Vega Island in West Antarctica. It was found in Late Cretaceous (98–66 mya) deposits. Its discovery lends considerable weight to the idea that modern birds lived in the Late Cretaceous Period.

There exists some evidence that mallards and Muscovy ducks shared a common ancestor 50 mya. The mallard and the Muscovy have been genetically isolated essentially since the beginning of the Eocene Epoch (56–34 mya). When did ducks, geese and swans share a common ancestor? The answer seems to be that their common ancestor was the *Presbyornithids* and that this lineage successfully crossed the K-T boundary.

Eonessa, supposedly the first duck, was described in 1938 by Alexander Wetmore as a bird resembling the modern ruddy duck. The remains,

The Evolution of Ducks, Geese and Swans

A long-legged shorebird/duck wader, which, like flamingos, often formed large nesting and feeding flocks. *Image created from Alan Feduccia's* The Origin and Evolution of Birds.

originally described as a Middle Eocene (56–34 mya) *Anseriforme* from North America, are fragmentary, and the bones were crushed during fossilization. This fossil has been since reclassified as a *Gruiforme*, a wading bird, rather than a duck.

The first recognized duck fossils were unearthed in Oligocene Epoch (34–21 mya) deposits in France and Belgium. In addition, three species of whistling ducks, *Dendrochen* and a fossil closely related to swans, *Cygnopterus*, were also found in France.[109]

The North American fossil *Anseriformes* include a duck, *Paranyroca magna*, from the early Miocene of South Dakota. Ducks are noticeably rare in deposits of the Paleogene Age (65–23 mya), however, though they become extremely common in the Neogene (23–1.8 mya). In fact, in the relatively recent North American freshwater deposits of the Pliocene and Pliestocene (1.8 mya), ducks are often the dominant group of birds.[110]

Evolutionary cousins of ducks and chickens roamed the earth with non-avian dinosaurs more than 65 mya. The dinosaurs, and much of life, were wiped out during the K-T event, leaving a few mammals and very few lineages of birds such as the transitional shorebirds to evolve, in parallel, into the tribes and genera of modern mammals and birds. Shorebirds developed into *Anseriformes*, and by the Miocene Epoch, the *Anatidae* had become dominant among birds.

The post-Cretaceous world witnessed the "Big Bang," the explosive adaptive radiation of birds. Some still dispute this "Big Bang" theory. Nevertheless, there is little or no fossil evidence of modern birds from the Cretaceous Period. There are at least twenty-eight types of ducks living in North America; not included in those water birds are the eiders, loons, mergansers, snews, scoters or teal. With regard to the *Anatidae* alone, there are approximately 54 million individuals making their annual migratory flights to their selected breeding grounds in just North America. On their return flight to wintering grounds, a significant proportion of these ducks are guided to the eastern flyway and, from there, into the Delaware River migratory corridor.

Chapter 4

A LIVING TRADITION

Delaware River Decoys

Paleo-Indians migrated into the area of the Delaware River Basin sometime between 6000 and 8000 BC. These were hunter-gatherers with a limited tool and food kit. They were followed during the Archaic Period, approximately 1000 BC, by other migratory hunter-gatherer groups organized around families and clans and possessing a more diverse "kit" of hunting weapons and tools. Little archaeological evidence of these early migrations has been found. These early peoples undoubtedly developed strategies and hunting techniques—possibly including traps, snares and primitive decoys—to harvest the abundant wildfowl available along the Delaware River.

During what the paleontologists call the Woodland Period, beginning approximately AD 1300–1400, organized tribes of peoples began moving from west to east in successive migratory waves. These tribes were characterized by their hierarchal tribal leadership based on sophisticated familial and/or clan structures, knowledge of horticulture, pottery making and use of the bow and arrow. They settled in more or less permanent villages, and there exists some archaeological evidence that they engaged in long-distance trade.

The group that would become the eastern woodland tribes spoke either an Iroquoian or Algonquian language and established tribal lands extending from the Appalachian Mountains in the west to the Atlantic coast. The

Susquehannocks (Minquas) settled the Susquehanna Valley, the Iroquois and Mohawks were in upper New York, the Pohatan Confederacy settled the Virginia area and the Leni-Lenapes (Delawares) established communities in the Delaware River Basin to the Atlantic coast.

The Leni-Lenapes were the first of the indigenous people to have contact with Europeans when they encountered the explorer Giovanni da Verrazzano in lower New York Bay in 1524. The Leni-Lenapes, the "people of the sunrise country," were organized into matrilineal communities and were divided into three clans based on dialect: the Munsees (Munsey, Minsi) lived in the Kittatinny Valley in the upper reaches of the Delaware, the Unannis established their communities in more or less the area of the forks of the Delaware and the Unalichtigos settled the estuary of the Delaware Bay north to the falls at Trenton. These people built their villages along tributary streams and undoubtedly took advantage of the seasonal wildfowl and fish migrations.

In the early 1600s, the universal obsession with accumulating wealth, the driving force of the quest for the Northwest Passage to the riches of the Orient, the wonders of exploring and conquering new lands and peoples and the felt need to spread Christianity led first the English then the Dutch, Swedes and Finns into the Delaware Basin. The English came again, the Dutch came again and they were finally followed by the English once more to explore and settle the Delaware Bay and River. Initially, whaling was the driving force, but later furs, lumber and tobacco provided the economic incentive to endure the extreme danger and hardship of establishing new colonies. The abundant waterfowl of the Delaware Bay and Upper River provided the European settlers with a seasonal but reliable source of protein and variety to a diet that must have been somewhat monotonous—primarily fish and venison, with the few vegetables and grains, primarily wheat, they were able to grow themselves, although the settlers did acquire corn (maize), beans, squash and tobacco from the indigenous people. Later, as the new settlements developed the "kitchen gardens," the Dutch trading stations provided a greater variety of fruits and vegetables that the Europeans introduced into the New World. Domesticated animals including cattle, sheep, pigs, chickens, ducks, geese, horses and the honeybee were introduced. Nevertheless, considering the primitive food preservation technology that existed in the early 1600s, late winters ("starving time" for the Lenapes) proved to be difficult times also for the colonists.[111] They also learned the value of decoys in hunting waterfowl from the natives.

A Living Tradition

Throughout the eighteenth century, wildfowl were hunted whenever the birds were present, utilizing both firearms and strategies and techniques learned from the Leni-Lenapes. Very little has been documented about hunting activities engaged in along the Delaware during the 1700s, but by the early 1800s, the use of decoys to attract ducks and geese was in evidence.

There exists some evidence of very early use of decoys by indigenous peoples. The earliest known were those found in 1924 at Lovelock Cave, Nevada. Thule reed decoys designed to mimic the canvasback duck were carbon-14 dated to be two thousand years old.[112] Decoys made with waterfowl skins stuffed with grass were used on Lake Champlain in 1687.

The earliest record of wooden decoys being utilized in North America was on Delaware Bay as recorded by the Scottish-American poet, naturalist, ornithologist and the father of American ornithology, Alexander Wilson (1766–1813). Wilson wrote in about 1800:

> *In some ponds frequented by these birds, five or six wooden figures, cut and painted so as to represent ducks, and sunk by pieces of lead nailed to their bottoms, so as to float at the usual depth on the surface, are anchored in the favorable position for being raked from a concealment of brush…on shore. The appearance of these usually attracts passing flocks, which alight, and are shot down.*[113]

Arthur Bartholomew Vance (1818–1889) was carving decoys well before the Civil War. He was born thirty-four years before John Blair and may have provided inspiration for that great artist. Also, early Delaware River carvers may have influenced the carving traditions developed in the Chesapeake Bay region to the south.[114]

John Blair, born in 1842, carved his first rig of seventeen mallards around 1866. His lifetime's work would become legion. Innovations in both carving and painting would follow. John English was born in 1852 in Florence, New Jersey, and would carve until he retired in 1900. The abstract painting of John Dawson (1889–1959) and his profound work would throw new light on what a decoy could become. Three schools of carving, each with its own unique traditions, would evolve along the Delaware from Philadelphia north to Trenton. Blair's work would foster the development of the "Philadelphia School" in the Philadelphia area, and English's innovations in carving based on the requirements of a unique hunting tradition and the conditions on the river would inspire other carvers and lead to the "Florence School." The "Bordentown School" would evolve as an offshoot of the "Florence School."[115]

The Delaware River

Dick Swiveller described hunting in the late 1800s on Delaware Bay out of a blind: "[T]wenty-five yards from shore, in front of the blind, we had strung out over two hundred wood decoys. In the coops were thirty-odd live duck decoys and eleven domesticated wild geese."[116] Hunting conditions and strategies on the upper Delaware were much different.

To the sorrow of the duck hunting community everywhere, the market gunners were plying their deadly trade on the Delaware early in the 1800s.[117] Although they helped meet the increasing demand for protein required by the growing populations of Philadelphians and the numerous river communities, the devastation they wrought on the migrating flocks is still evident today. The 1913 Migratory Bird Act slowed the slaughter, but it would not truly end until the use of live decoys was outlawed in the 1930s.

There were wildfowl present on the entire length of the Delaware River. However, it was the unique tidal ecosystem present in the stretch of the river from Trenton south to Philadelphia that provides a flight path, a corridor, through which migratory wildfowl concentrate during the fall migration. The short twenty-five-mile segment of the river is tidal and contained in 1898 less than 4,500 acres of prime wetlands and marshes that attracted the birds as a resting and feeding ground.[118] The towns located on both sides of the Delaware along this part of the river are legendary in the hunting and decoy community. In New Jersey, beginning with Trenton and moving south, they include Bordentown, Florence, Roebling, Burlington, Beverly, Delanco and Riverton. On the west bank of the Delaware, noted towns include Yardley, Tullytown, Edgeley, Bristol, Craydon and Ardalusia.

Delaware River decoys were generally more lifelike, necessitated by hunting techniques, than those used in the coastal areas of Barnegat Bay. Early decoys were carved with rounded bottoms until the 1930s, when dredging changed river conditions and carvers modified their designs to flatten bottoms, some with keels, for reasons of stability. Decoys were linear-shaped for increased visibility in rough water. Blair's decoys were sleek and realistically painted, with full breasts and carefully detailed carving and feather painting. With few exceptions, decoys were of hollow two-piece construction; a few are found with bottom boards. Both cedar and pine were preferred. Heads were typically mounted directly to the body in the low head, resting, contented position. Some early decoys had tack eyes, but usually glass eyes are evident.

Upriver, English and his imitators were creating dabbler decoys with extremely well-carved raised primaries and incised tails and with extraordinarily realistic and often intricate feather painting. Diving ducks

were carved with incised tails but not raised primaries, as were the dabblers. Many decoys were carved by the hunters themselves—a matter of pride.

The typical hunter in the area used a sculling boat or a "double-ender" to essentially bushwack the ducks, sometimes carrying up to forty decoys. This strategy required the decoys be realistic enough to both attract the ducks and hold them during the sculling drift. Sculling boats evolved from the double-ended to the dedicated sculling boat, which had a design much influenced by the Barnegat Bay sneakbox. Generally, upriver decoys were known for their exquisite feather carving, while those of the Philadelphia area were desired for their superb feather painting.

Dredging the Delaware

Navigation on the Delaware River has been a major concern, beginning with the earliest explorers in the 1600s. In fact, the English explorer Yong, in his quest to locate the Northwest Passage in 1634, believed that the Delaware led to the legendary Lake Laconia, which in turn supposedly led to the way across the continent to Asia. Yong was not able to progress north beyond the falls at Trenton. In 1607, an earlier party of adventurers sent from the Virginia Colony was unable to proceed upstream beyond these falls.[119] The Dutch, Swedes and Finns did not colonize north of present-day Trenton simply because the falls of the Delaware at Trenton were the head of navigations. From Cape May north to Philadelphia, submerged rocks, mud shoals and small islands were also hazards to navigation.

The area had both a psychological and a physical barrier to the exploration and settlement of the lands north of Trenton. The exploration and colonization of the upper reaches of the Delaware, Minisink and Kittatinny Valleys by the Dutch in the early 1600s proceeded from the north and east—New Amsterdam and Albany—rather than from the south.

The Delaware is tidal north to the falls at Trenton and at that point is only about fifty feet above sea level. The river was shallow and the current slow. Early dredging efforts were concentrated on the non-tidal areas. Around 1770, private interests raised funds to improve the passage of log rafts, coal arks and Durham boats through the rapids at Trenton. A channel through the rocks was cleared and marked. In 1771, Pennsylvania authorized a private group to improve navigation north from Trenton to the Neversink River. Their efforts were concentrated on blasting a channel through the obstructions at Foul Rift. Officially, both New Jersey and Pennsylvania

recognized their common economic interests in the importance of free and unimpeded navigation on the Delaware. Both states appointed commissioners who negotiated the Treaty of 1783, which stated in part that "[the] whole length and breadth [of the Delaware River] thereof, is and shall continue to be and remain a common highway equally free and open for use, benefit and advantage of each state."[120] The Treaty of 1783 would become known as the "anti-dam" treaty and would have a significant impact well into the twenty-first century.

As Philadelphia grew into the economic and commercial center of the country, its harbor became the epicenter of economic activity. By the mid-1800s, it had become of paramount importance to opening and maintaining a deep-water channel through the estuary north from Cape May into Philadelphia Harbor and beyond. The economic health of the nation rested on the shoulders of the continued growth of Philadelphia.

The Philadelphia Maritime Exchange (1875–1950) encouraged dredging efforts. Privately funded projects made some progress but were uncoordinated, not part of a much-needed comprehensive plan for the waterway.

The U.S. Army Corps of Engineers, with Congressional approval, eventually became a driving force in the development of a comprehensive long-range plan for navigation on the Delaware. As early as 1836, the Corps was involved in active dredging, but its efforts were of limited scope—channel deepening and widening, as well as frequent removal of rock obstructions. Nevertheless, the Corps was actively involved in study and planning and put forward a number of proposals.[121]

Up to 1885, the controlled depth of the river at Philadelphia was seventeen feet. The first comprehensive dredging program was adopted that year, which proposed an increase in channel depth to twenty-six feet by 1899. A subsequent planning cycle covering the period from 1899 to 1910 projected a channel depth of thirty feet. "The Philadelphia to the Sea Project," adopted in 1910, authorized the widening of the ship channel to four hundred feet in Philadelphia Harbor and one thousand feet through the estuary (Delaware Bay). The next planning/dredging cycle, covering the years from 1910 to 1938, authorized a thirty-five-foot channel depth. In 1938, the authorized depth was increased to forty feet, and this continues to be the authorized depth from Philadelphia south to Cape May today. A 1976 modification of the authorized comprehensive plan provided for a widening of the existing channel in Philadelphia to one thousand feet.[122]

The Corps had its eyes pointed upstream from Philadelphia as well. The "Philadelphia to Trenton Project" was adopted in 1930 and then modified

in 1935, 1937, 1946, 1954 and finally in 1976. The 1930 authorization provided for a channel forty feet deep and four hundred feet wide from Alleghany Avenue (Philadelphia) twenty-four miles north to Newbold Island, a thirty-five-foot channel from the upper end of Newbold Island to the Trenton Marine Terminal and, finally, a twelve-foot channel from there to the Penn Central Railroad Bridge in Trenton—a total of 30.5 miles. This project, modified in 1954, was completed by 1964.[123]

In total, over the years there have been five deep-draft projects and seventeen shallow-draft projects proposed and completed by the U.S. Army Corps of Engineers. All are currently federally maintained. Nearly 8 million cubic yards of material is dredged annually from the Federal Deep Draft Projects in the estuary, and 6 million cubic yards will be dredged annually from the Philadelphia to the Sea Project. Both federally and privately owned pump-out/dump sites are used to hold the dredged spoil from the bottom of the river. The unavailability of sufficient disposal capacity will jeopardize the Corps' ability to maintain a safe channel in future years.[124]

The deepening and widening of the Delaware River was accomplished—and is ongoing—for legitimate economic reasons: the continued economic growth and health of the Greater Philadelphia region, the continued viability of the Philadelphia Naval Yard (closed in 1995), the accommodation of increasingly larger ships, increasing maritime traffic and the overall health and economic well-being of the lower Delaware River Basin, where there were environmental consequences to the dredging.

The Delaware River Basin, as a whole, represented one of the most diverse ecosystems in the United States. The spoil from the river bottom dredged up from the Philadelphia to Trenton Project was dumped/pumped into the surrounding marshes and wetlands, creating prime real estate, but at the same time devastating an entire tidal wetlands ecosystem. The Delaware River along the stretch from Trenton to Philadelphia was a prime waterfowl migration corridor, an integrated component of the eastern flyway, for numerous species of ducks and geese. The marshes and wetlands had provided much-needed resting and feeding grounds for migratory birds on their trip to their wintering areas farther south. Gone were thousands of acres of wetlands important for flood control; spawning grounds for fish, reptiles, amphibians and other aquatic wildlife; and breeding grounds for countless species of birds and other wildlife. As the river has been deepened, the river's current has become faster.

The scene is best expressed in the words of a riverman who experienced the destruction of the wetlands firsthand:

The Delaware River

At first, the engineers only dredged the river as far as the city itself. They cut a deep, unseen scar into the river floor, creating a channel the deeper ships could navigate. This new channel didn't completely reshape the river. The river rats on Halfway House Point never saw or felt its impact; it all occurred downriver. However, unbeknownst to Vince, while he had been away at Peekskill, the river had been dredged again, all the way north, past the point. The river could have survived the deep channel carved into its back, but it couldn't survive the massive amounts of black river mud the engineers drew up from its depths. As they moved north, they used this mud to fill in marshes and coves, low-lying areas prone to flooding. They connected small islands that once stood offshore to the mainland to create parklike riverfronts where new river walls turned the land into prime real estate. Expensive mansions commanding majestic views of the river were constructed, their foundations resting in the mud, the lifeblood of the river itself. In succession, each cove and inlet was lost, and with it went the ability of the river to clean itself.

The crisis had been coming for years, but the dredging had pushed it over the edge. Massive fish kills resulted. Moreover, without the coves, there was

Pintail Drake by: John Blair

simply nowhere for the next generation of fish to grow. With the fish gone, and the vegetation that puddle ducks ate no longer available, the birds and the waterfowl disappeared, seeking food elsewhere. The increased pollution in the water eventually killed the shellfish, and the heavier diving ducks had to move farther south, to the Delaware Bay itself, before they could feed. The water became toxic, unable to support even the tiniest organisms that could restart the circle of life within the river. A million gallons of dead water moved down the Delaware each day, and not a single life form stirred its waters.

The Delaware River had become the blueprint for how modern man—an industrialized nation—could rapidly and completely destroy a river.[125]

The Philadelphia School

Carvers and Decoys

John Blair Sr. (1842–1928) is considered to be the inspiration and founding father of the school of decoy carving that developed in the mid- to late 1800s in the Philadelphia area and became the Blair School. Some details of his life, the number of decoys he carved (if any) and his possible innovations in design are in question. Some decoys are believed with great confidence to be his work, while others with a similar "look and paint," but of an uncertain origin, are referred to as Blair School decoys. There is a general consensus that the Philadelphia School involved more than one carver and certainly more than one painter dating back at least to the Civil War years.

Blair lived on the Pennsylvania side of the Delaware River near Philadelphia, possibly Frankford, Pennsylvania, and conflicting accounts indicate that he was either a wheelwright or a carriage maker. One controversial story portrays him, incorrectly, as an influential Philadelphia banker.[126]

Blair decoys are known for their skill in carving and painting, even though he did not paint the decoys himself. Blair carved decoys in three distinct styles: hollow with round bottoms, hollow with flat bottoms and solid with flat bottoms. The hollow decoys with round bottoms are considered the "classics."[127] Key traits of Blair decoys include round-headed upholstery tacks for eyes, the head being mounted on a raised platform, flat bottoms and rectangular beveled weights that are mounted more forward than the typical

Delaware River decoy because they were used in more placid waters.[128] Other characteristics of Blair decoys are hollow, two-slab construction keyed by dowels fore and aft with nailed edges; a smooth oval body in cross-section; a body that is also simple in outline and gracefully worked with a full and swelling breast; a painting style that includes a solid-colored dark oval on the bottom; and stylized painting that includes crescent-shaped feathering detail on the breast, shoulders and back.[129]

There exist too many decoys with simply too much variation in carving and painting to be the work of a single individual.

Blair had two sons, John Jr. (1881–1953) and Walter (1889–1966). Both sons were decoy carvers. John Jr. is suspected to have carved fewer than thirty decoys, but he did have a work-related acquaintance with Joel Barber when Barber was actively collecting decoys and researching his book *Wildfowl Decoys* (1934). Here lies a possible source of misinformation about John Sr.'s decoys. Barber accepted an invitation to examine the family's collection of John Sr.'s decoys. Later, Barber would quote the younger Blair in stating "the painting was done by a Philadelphia portrait painter, left unnamed, of considerable note."[130]

The general consensus exists today, which follows Bob White's interpretation, that the elder Blair was the owner of a luxury carriage manufacturing firm and that one of his employees who did finish work was the actual decoy painter in question.[131]

Little is known of Walter Blair other than that he moved to Elkton, Maryland, and is thought to have carved more than one thousand decoys; his birds have the definitive influence of Havre de Grace decoys.[132]

John Sr. made his first rig, seventeen mallards, around 1866.[133] He carved actively for thirty-four years and retired to the life of a gentleman farmer around 1900 to the south bank of the Elk River. John Blair III, his grandson, indicated that his grandfather's lifetime output was somewhere around thirty to forty decoys of each hunted species, primarily for his own use and for friends. Evidently, John Sr. did not sell his decoys commercially.[134]

He also did not sign his decoys, and the classic Blairs carry a variety of brands, all of them presumably designating previous owners. This, of course, has led to identification problems, complicated by the work of John Jr., whose work is very similar to his father's.[135] When one is considering the source of the ideas underlying the designs of the Blair classics, outside influence as well as inspiration and investigation must be considered. It would be misleading to only consider regional sources. A myopic view would be extremely limiting. In the mid-1800s, Barnegat Bay carving was

A Living Tradition

Pintail Drake by John Blair, Jr.

in its infancy, and carving traditions had not yet developed in the upper Delaware region. Nevertheless, the proximity of Chesapeake Bay and, more specifically, Havre de Grace meant that the unique designs developing in that region were certainly available in the Philadelphia area.[136]

Influences from afar are always a possibility, even in the age of railroads. Joy Cooke was a wealthy, influential Philadelphia banker. He was extremely well connected and handled the majority of Union war bonds during the Civil War. He had both private and business connections in Sandusky, Ohio. Ned John Hauser (1826–1900), also of Sandusky, was employed as a master painter and decorator by the Mansfield and Newark Railroad, which would later become the important Baltimore & Ohio Railroad. Hauser also carved hollow decoys. Cooke was an avid waterfowl hunter in the marshes near Sandusky, as well as the marshes south of Philadelphia (he had joined the Warriors Shooting Club in 1856). Cooke and Hauser could have been acquaintances, or Blair was at least aware of his work, and Cooke could have carried examples of Hauser's hollow decoys back to Philadelphia, where they could have influenced the work of a young John Blair Sr.[137]

The Delaware River

Upper Delaware River Flyway Corridor

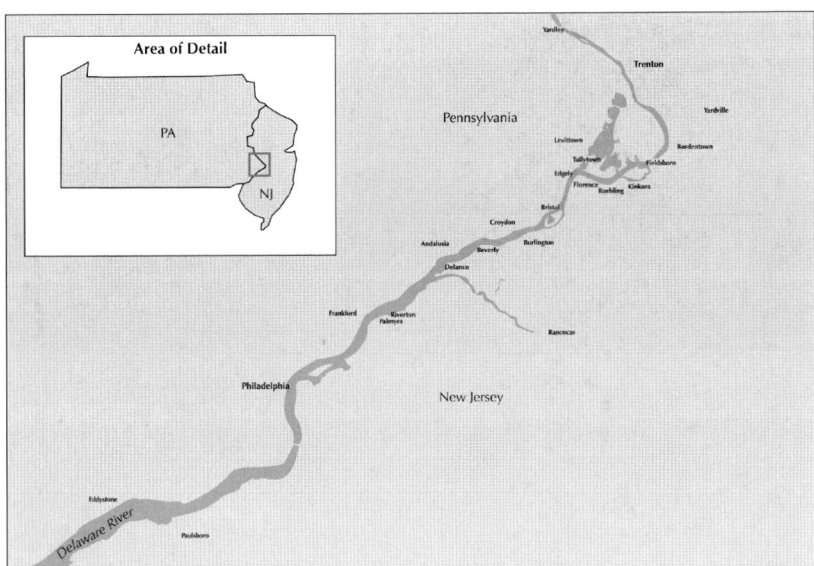

Google Maps.

Two theories exist regarding the role John Sr. played in the founding of the Philadelphia School of decoy carving. The first is an elegant story of a successful businessman and skilled decoy carver—an inspiration. The second is an emerging and evolving tale of Blair as an immigrant duck hunter who simply hunted with decoys that were produced in carving shops and painted by highly skilled artists—machine-made decoys produced by a cottage industry that developed in the late 1800s.[138]

The Delaware River was home to a number of talented and prolific decoy makers, including men such as Arthur Bartholomew Vance, according to Chad Tragakis,[139] the real founder of the Philadelphia School of carvers that he inspired. He subsequently may have influenced the later work of the Blair, English and Black clans. Vance was thirty-four years old when Blair was born, and his influence on the work of later carvers could have been profound.

By the late 1800s, the Susquehanna flats in the northern reaches of the Chesapeake Bay had established itself as a premier duck hunting and decoy carving region. The proximity of the flats to the Delaware River, even though hunting methodologies differed, ensured that decoys and influence traveled

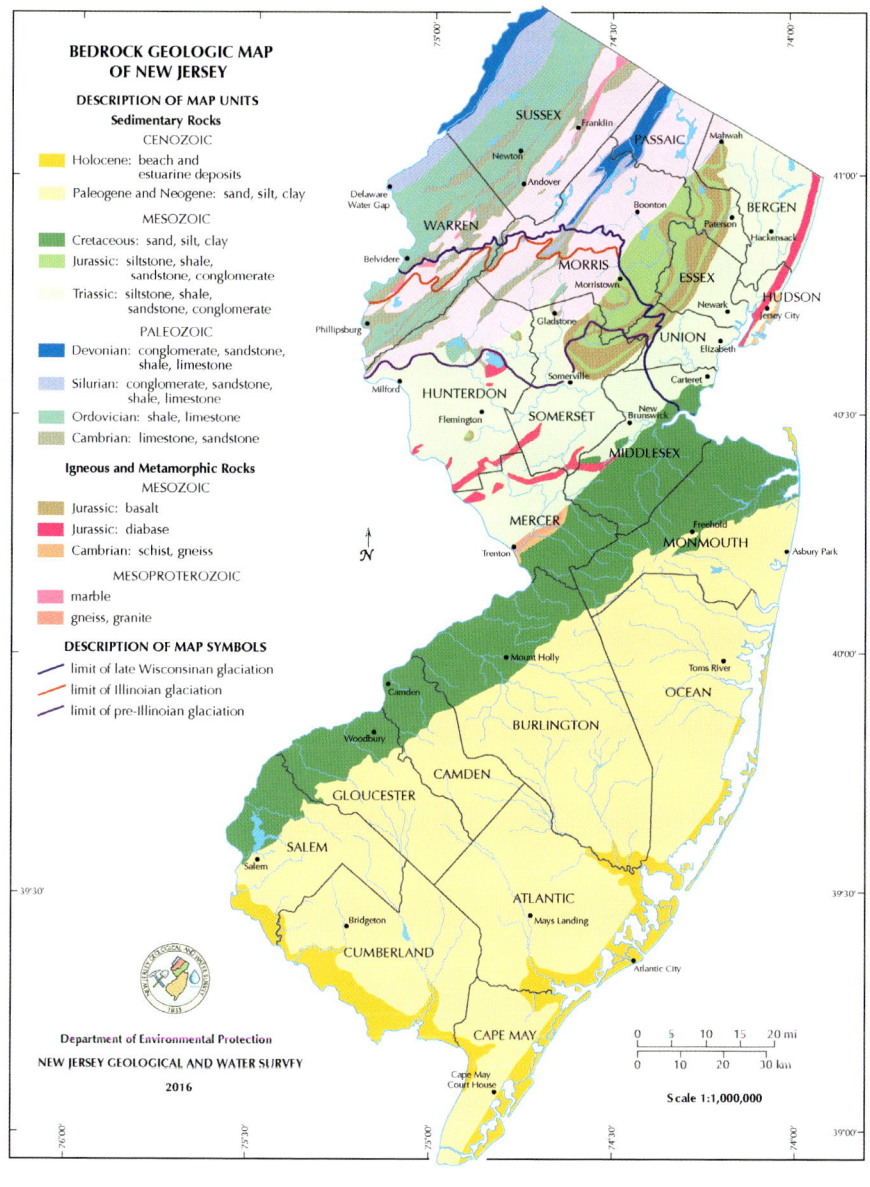

Geologic Map of Eastern Pennsylvania

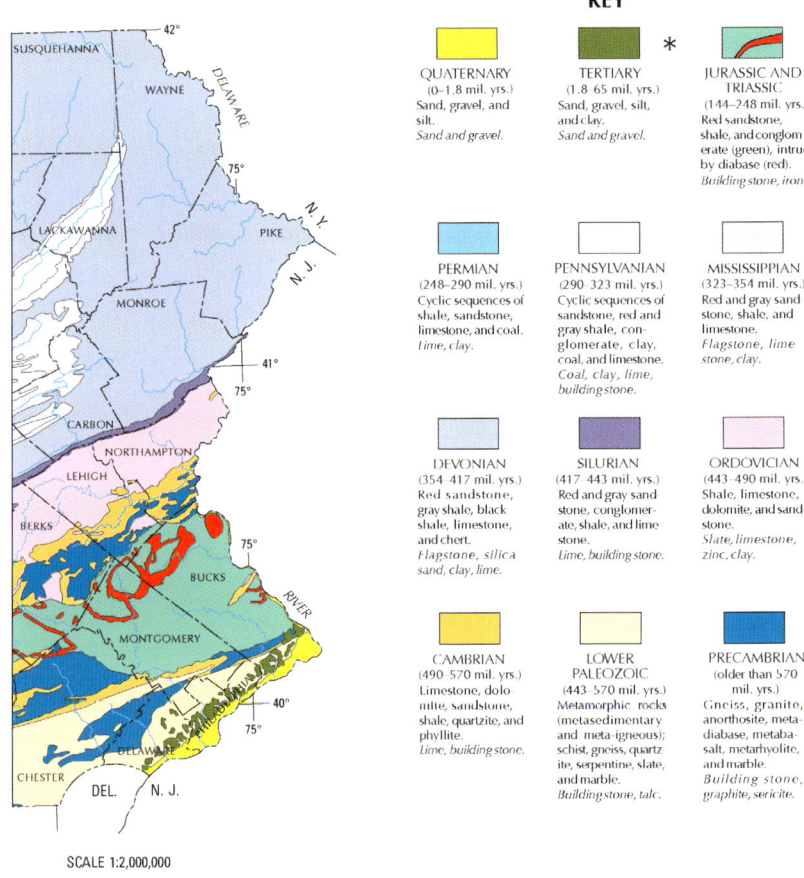

Pennsylvania Geological Survey, 2002.

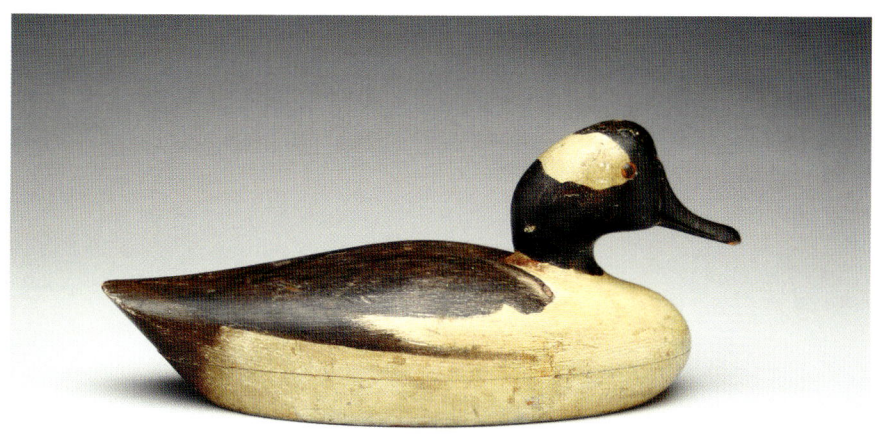

Bufflehead decoy by Arthur B. Vance, Philadelphia School. *Guyette & Deeter, St. Michael, Maryland.*

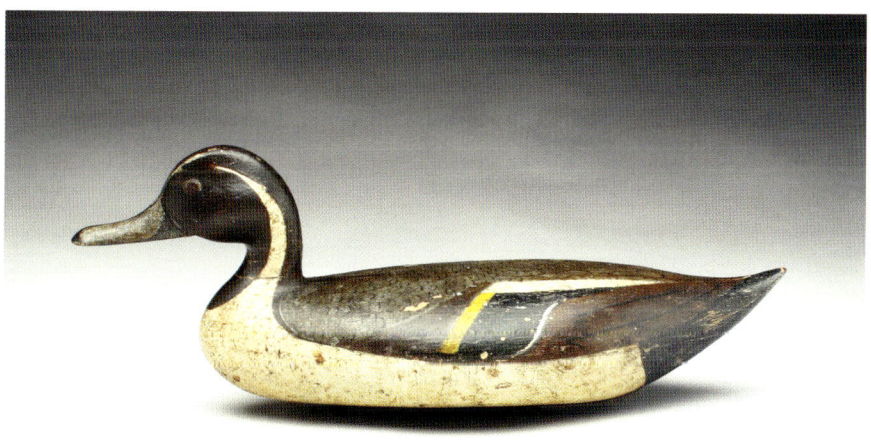

Pintail drake decoy by John Blair Jr., Philadelphia School. *Guyette & Deeter, St. Michael, Maryland.*

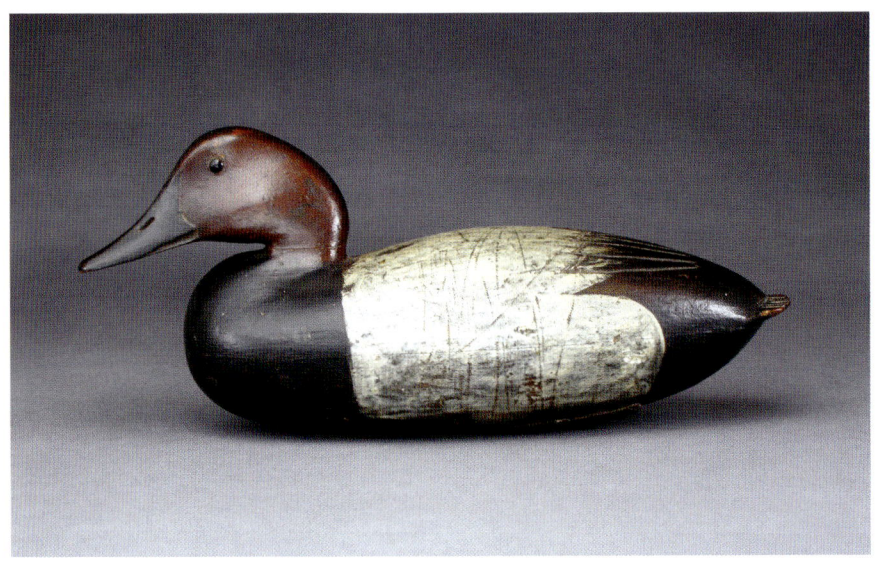

Canvasback drake decoy by John English, Florence School. *Guyette & Deeter, St. Michael, Maryland.*

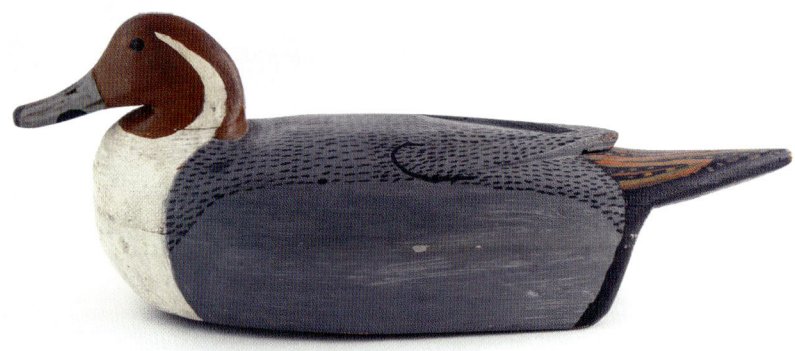

Pintail drake decoy by Tom Fitzpatrick, Florence School. Frank Moyer personal collection. *Rick Knecht, Proof Positive.*

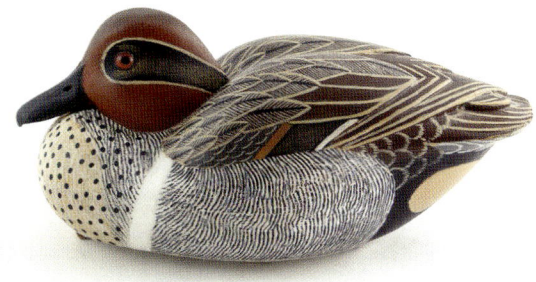

Greenwing teal drake decoy by John McLoughlin, Bordentown School. Frank Moyer personal collection. *Rick Knecht, Proof Positive*.

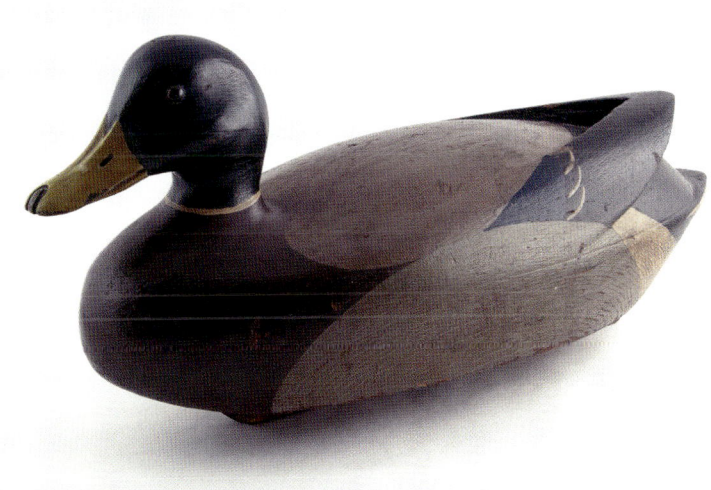

Mallard drake decoy by Tony Bianco, Bordentown School. This decoy appeared in *Floating Sculpture* by Huster H. Harrison and Doug Knight, 1982. Frank Moyer personal collection. *Rick Knecht, Proof Positive*.

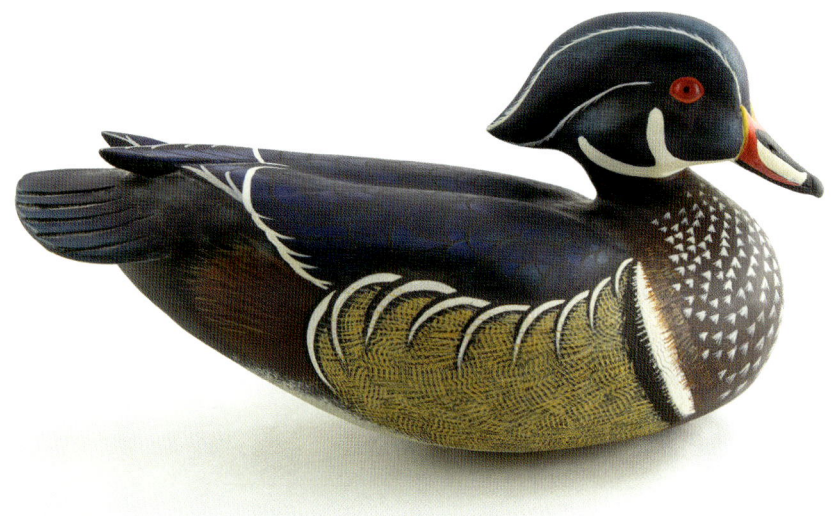

Wood duck drake by John Wood, a contemporary carver. Frank Moyer personal collection. *Rick Knecht, Proof Positive.*

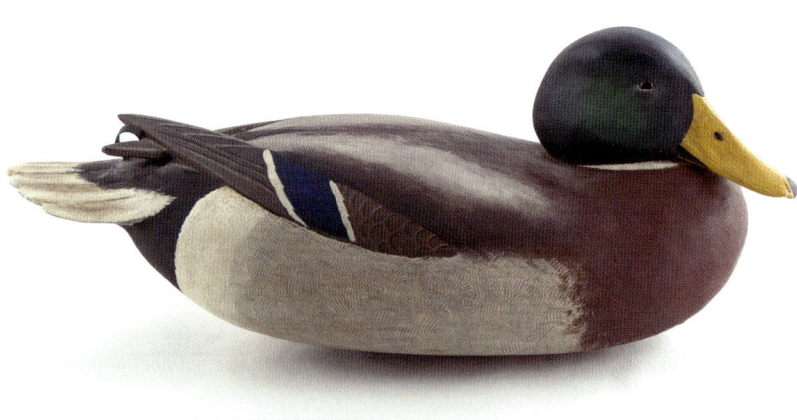

Mallard drake decoy by Bob White, a contemporary carver. Frank Moyer personal collection. *Rick Knecht, Proof Positive.*

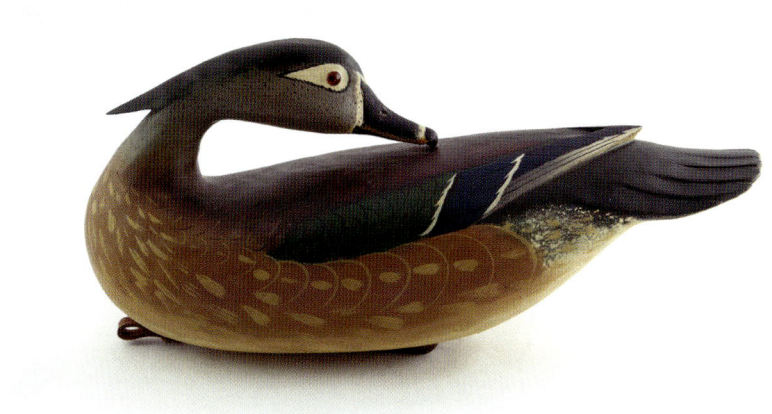

Wood duck hen decoy by Bob White, a contemporary carver. Frank Moyer personal collection. *Rick Knecht, Proof Positive.*

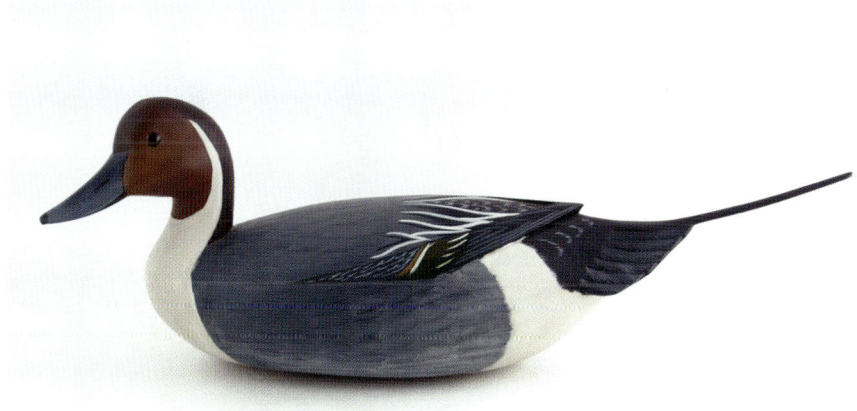

Pintail drake decoy by Kevin Wharton, a contemporary carver. Frank Moyer personal collection. *Rick Knecht, Proof Positive.*

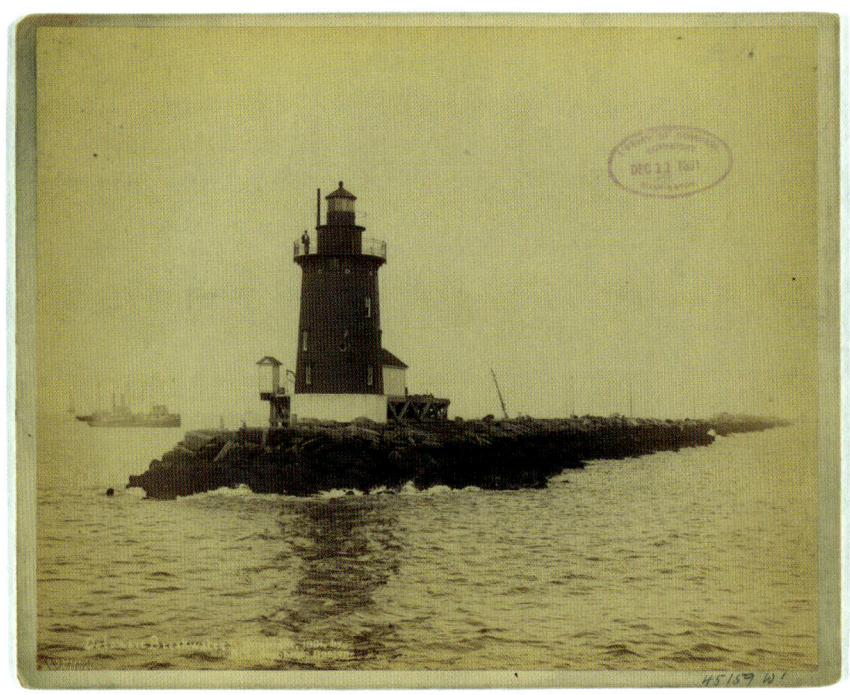

Delaware Breakwater, Delaware, circa 1891. The breakwater was completed in 1921. *Library of Congress*.

A summer rainbow over the Delaware. *Thinkstock*.

Canoeing along the Delaware River. *Thinkstock*.

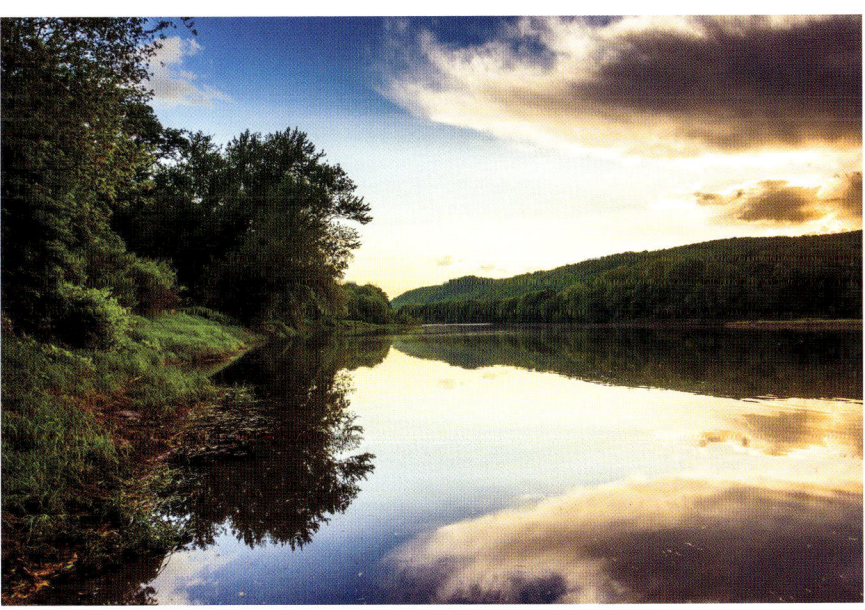

Evening reflections on the Delaware River at the Delaware Water Gap. *Thinkstock*.

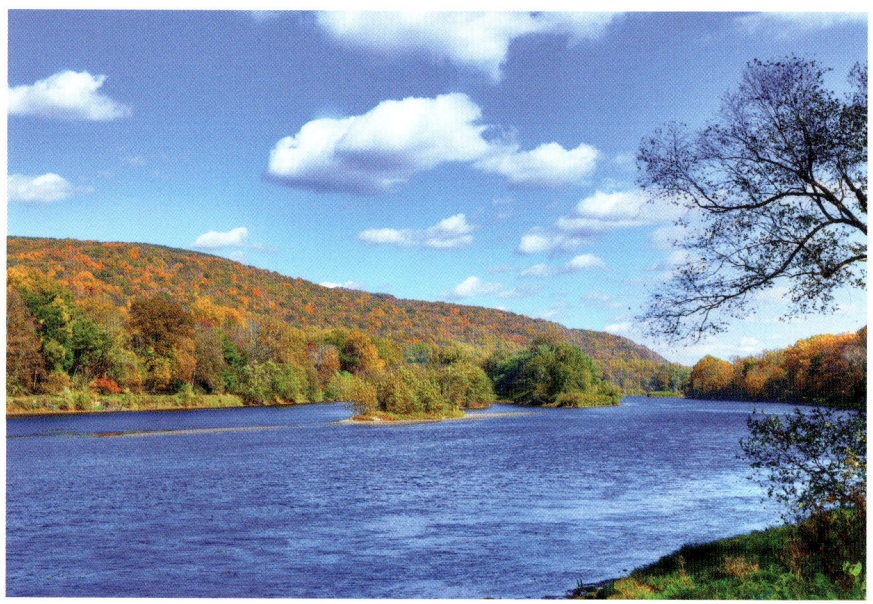

Scenic fall view of the Delaware River north of the Delaware Water Gap. *Thinkstock*.

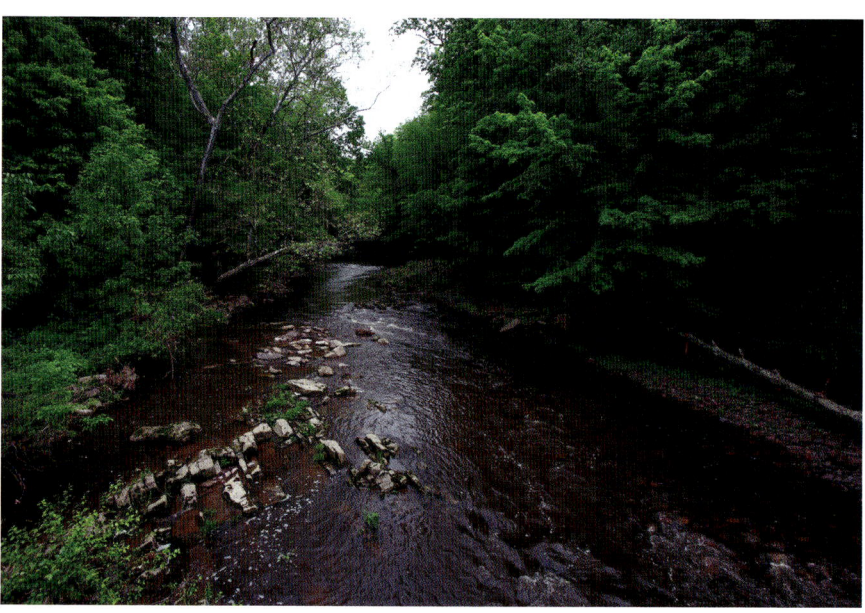

One of the many tributary streams feeding the Delaware River. *Thinkstock*.

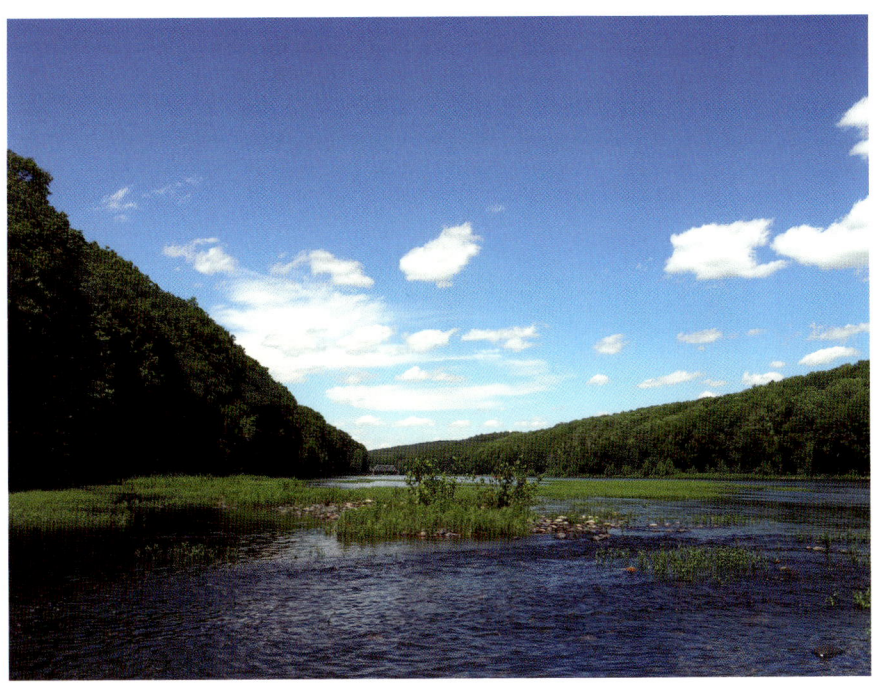

Marshland along the Delaware River. *Adobe Stock.*

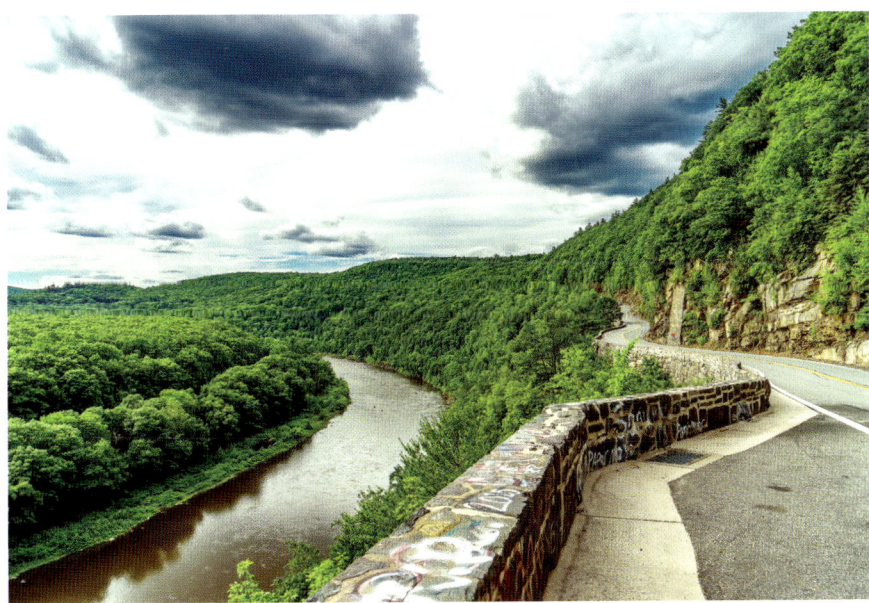

The upper Delaware River bends through a forest in New York State. *Adobe Stock.*

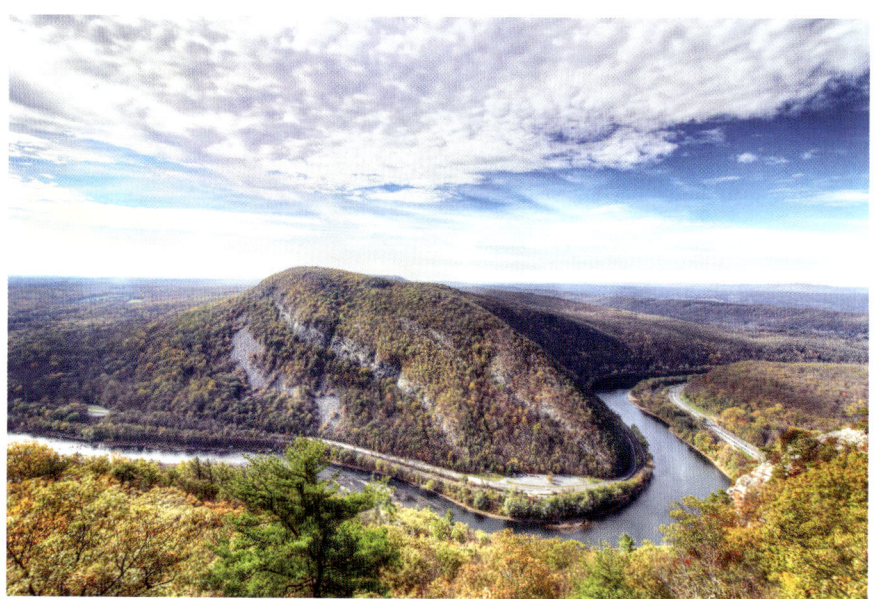

Mount Minsi Delaware Water Gap viewed from the summit of Mount Tammany, New Jersey. *Adobe Stock*.

Higher water quality has improved the fishing along the Delaware north of Trenton, New Jersey. *Thinkstock*.

Fall kayaking on the Delaware River. *Thinkstock*.

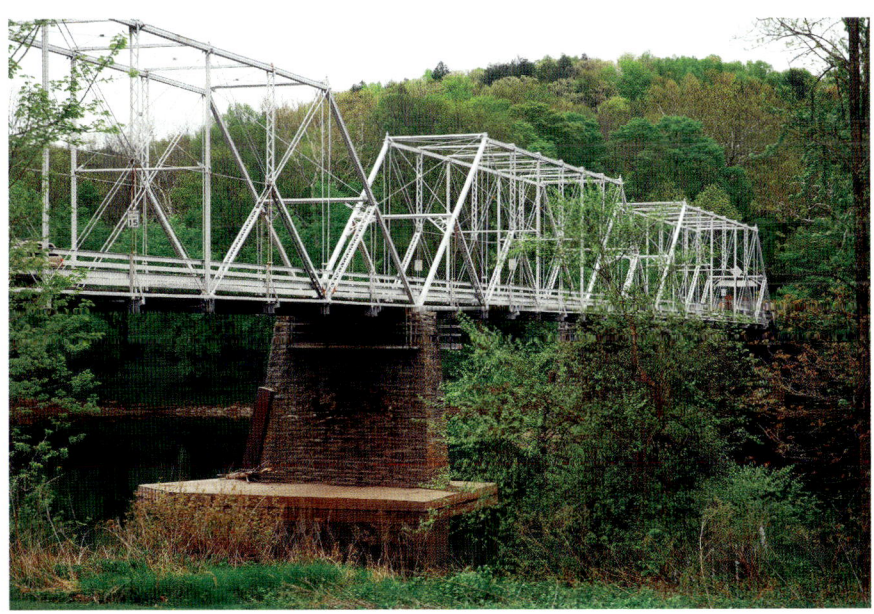

Dingman's Ferry Bridge north of the Delaware River Water Gap. *Thinkstock*.

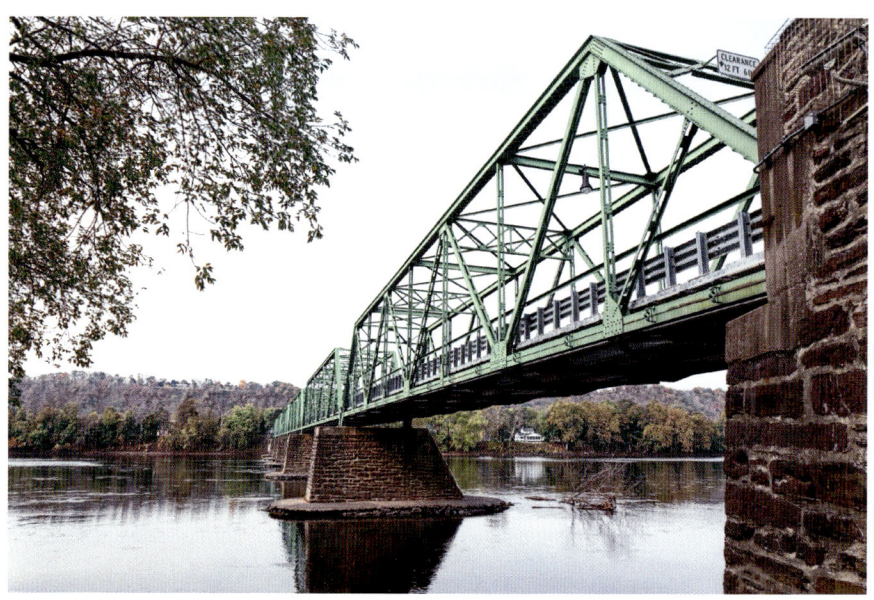

Uhlerstown-Frenchtown Bridge over the Delaware River. *Thinkstock*.

The swimming hole. *Thinkstock*.

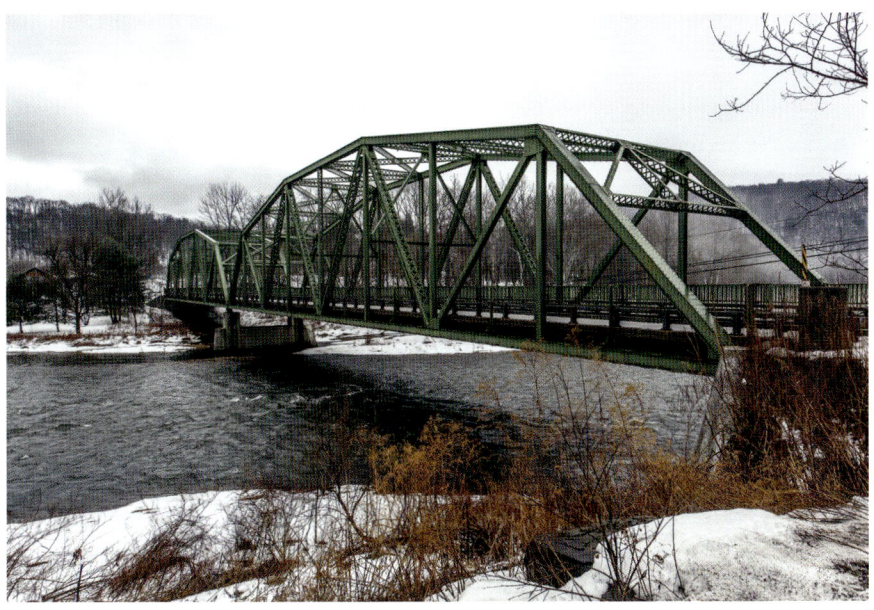

The Delaware River was at the heart of the Industrial Revolution. Historical bridges provided crossings at key points. *Adobe Stock*.

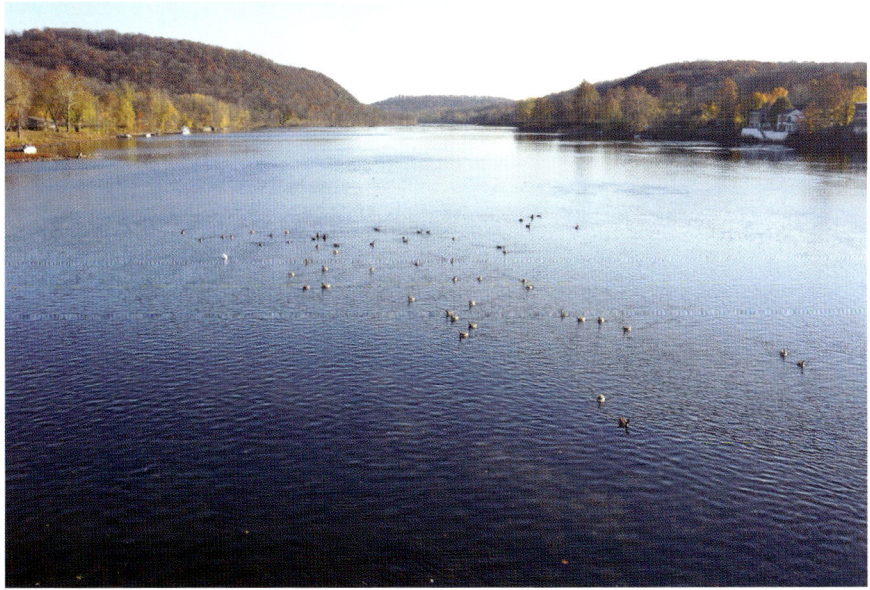

The Delaware River is a natural corridor for wildfowl during their biannual migrations. *Adobe Stock*.

Spectacular nighttime view of the Delaware Memorial Bridge. *Adobe Stock*.

The confluence of the Delaware and Lehigh Rivers at Easton, Pennsylvania. *Adobe Stock*.

in both directions. Decoys from Havre de Grace, Maryland, particularly those of carver Jim Holly, are highly prized among collectors simply because they were hunted over on the Delaware River.[140]

I leave it to future writers and Delaware River "bird" men to solve the dilemma of just who were the most influential early carvers on the Delaware River.

THE FLORENCE SCHOOL

Florence, New Jersey

The towns of Florence and Roebling are unincorporated communities in the township of Florence, New Jersey, with a total area of 10.177 square miles. The population of the township in 1890 was 1,922, 7,824 in 1930 and 12,109 in 2010. The population of the town of Florence was 4,426 in 2010. Florence, the town, is located on the shores of the Delaware River, across the river from Tullytown, Pennsylvania, and its sandy beaches have attracted summer visitors since the mid-1800s.

In 1849, an association of New York businessmen organized and founded the Florence City Company and called for the issuance of five thousand shares of stock. Four thousand shares were used to pay for six hundred acres of land in Mansfield Township along the Delaware River. The company also oversaw the construction of the town wharf and the Florence Hotel. In addition, one thousand shares of stock were sold to finance the construction of waterworks, additional wharves and a city hall. Despite the promise of the area, the Florence City Company eventually succumbed to poor management and fell into bankruptcy. Nevertheless, the town and its inhabitants remained.

As early as 1850, Florence was billed as an ideal vacation destination or place to invest in real estate to profit from vacationers. Boats such as the *Pekenoket*, *Columbia*, *Springfield*, *Burlington*, *John A. Warner* and the steamer *Florence* served summer visitors.

The Florence Iron Works was built along the Delaware River in 1857 near present-day Foundry Street. In 1867, Richard D. Wood purchased the foundry and ushered in an era of community development. Stores, homes, recreation facilities and a library were erected for the company's workers. The R.D. Wood Company built most of the present-day water and sewage

The Delaware River

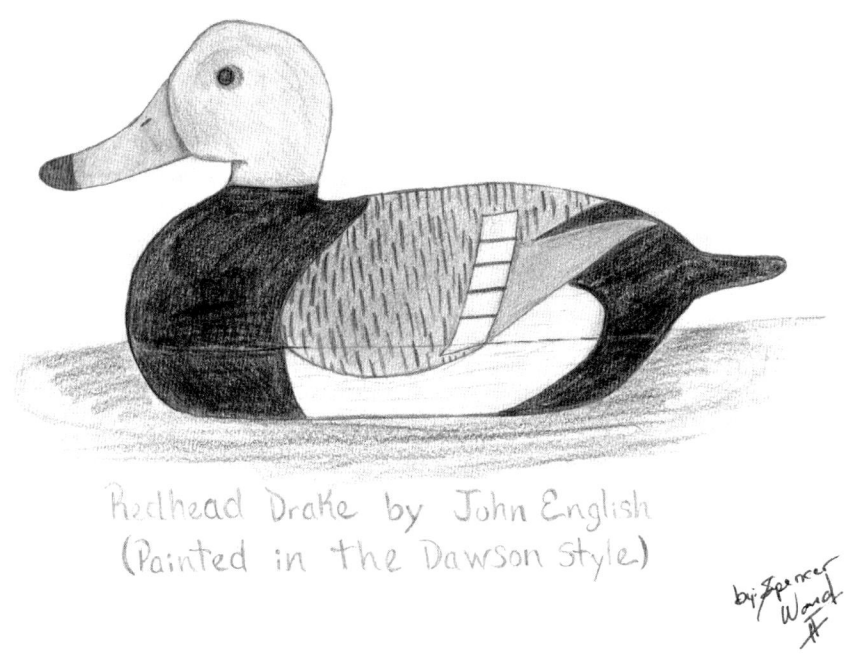

Redhead Drake by John English (Painted in the Dawson Style) by Spencer Ward

systems for the community. The company had an international reputation for exporting pipe, valves and fire hydrants to Paris, France, as well as fabricating components for nuclear submarines for the U.S. Navy.

The New Jersey Transit River Line light-rail system offers service south to Camden and north to Trenton; connections to the New Jersey Transit system provide service to New York City. Connection to SEPTA trains allows service to the Philadelphia area. Amtrak trains provide service to the wider Northeast Corridor, and bus service is available to both Trenton and Philadelphia.

Carvers and Decoys

The innovative carving initiative by John English (1848–1915) provided the foundation for the Florence School of carving. Clearly his insights were not influenced by any existing New Jersey decoys, which generally were plainly carved and smooth-backed. Those insights and inspirations led to the creation of a unique and extremely lifelike decoy that is highly desired among collectors. English was the most influential of the New Jersey carvers—the

father of the Florence (New Jersey) carving tradition. English is credited with developing the classic upper Delaware River carving style, with the raised V-shaped wings, superbly carved incised feather detail and the often low "snuggled" contented heads. But was his carving style influenced by his father or his grandfather?

John English had two sons: Jack (1878–1944) and Daniel (1883–1962). Dan was a prolific carver and followed the legacy of his father, while there exists some disagreement as to the extent of Jack's carving career.[141] Both sons used their father's carving techniques. While Dan's decoys were understandably very similar to his father's, he did eventually develop his own style. His decoys became bigger and "stockier" than his father's.

English was a masterful painter as well as carver. His plumage patterns were applied in greater detail than that achieved by his contemporaries. The output of English and his sons were mostly black ducks, canvasbacks, pintails and bluebills; however, only puddle ducks were carved with the raised primaries. English decoys were hollow, two-piece and lightweight, facing forward with narrow heads and carved nostrils. Tack eyes were predominant. Most often decoys were carved with full extended breasts and the low tucked heads of a contented duck. Carved wing tips (primaries) are slightly raised, while tail and back feathers are precisely incised. Ballast weights were placed to the rear. In sum, John English's decoys were carefully sculptured following the natural silhouette of the birds, with finely detailed and delicately raised wing carvings and incised tails. Painting was lifelike and painstakingly done with a limited paint palette.[142] His is the work of a true innovator.

John Dawson (1889–1959), of Trenton, New Jersey, was a kiln operator, a carpenter, an accomplished painter of landscape "oils," a masterful decoy carver in his own right and a superb painter of decoys, even though his decoy painting was a bit abstract in style. Dawson sold his decoys commercially through a Trenton sporting goods store. English hunted on Duck Island south of Trenton.

English had retired before Dawson got into decoy making, but Dawson managed to acquire nearly 150 John English decoys from an uncle.[143] Dawson proceeded to give the English decoys a new life by repainting them with his bold, impeccable geometric patterns, often painting a triangle on the underside of the bill as a signature, and in doing so he created the so-called English/Dawson decoys, much sought after by collectors. Decoys that Dawson personally carved and painted are referred to as "Dawson/Dawson" decoys.

Other notable carvers who followed the initiative of John English and became known collectively as the Florence School include David Foulks (1875–1954), August Glass (1905–1973), Claude Trader (1902–1972), Thomas Fitzpatrick (1887–1958), Jess Heisler (1891–1943), William Quinn (1915–1969), Caleb Ridgeway Marter (1893–1977), Al Reitz (1907–), Lawrence McLaughlin (1911–), Joseph Bauer (1933–) and Joe King (1909–).[144] Fitzpatrick lived in a houseboat in Delanco, New Jersey, as a true "River Rat"—one of those who made their living hunting, fishing, carving decoys and possibly boat-building along the Delaware River. Quinn created the "English-Quinn" decoys when he utilized heads carved by Dan English on bodies he had carved. McLaughlin's decoys are strikingly similar to those of Dan English. The men were hunting partners and spent time together. Even though McLaughlin didn't use Dan's patterns, Dan's influence on McLaughlin's carving and painting was profound. Individual differences in carving technique were evident: Jack English tails were squared with deep feather carving and August Glass tails were rounded and fluted, while Joseph West carved simple rounded tails without feather carving.[145]

The Bordentown School

Bordentown, New Jersey

Bordentown is a river town located at the confluence of the Delaware River, Crosswicks Creek and Black's Creek. Located in Burlington County, it has an area of 0.968 miles and is 5.8 miles southeast from Trenton and 25.3 miles across the river northeast of Philadelphia. The population in 1890 was 4,232, 4,405 in 1930 and 3,924 in the 2010 census.

Thomas Farnsworth, an English Quaker, was credited with being the first European settler (in 1682) in the area that would one day become Bordentown. He made his home on a windswept bluff above a bend in the river. "Farnsworth Landing" soon became the center for the fur trade in the region.

Joseph Borden, for whom the town is named, arrived in 1717. By 1740, he had established a line of stagecoaches and boats traveling between Philadelphia and New York City. The village was originally incorporated as a borough by an act of the New Jersey legislature on December 9, 1825, from a portion of Chesterfield Township. It was reincorporated as a city on April 3, 1867, and separated from Chesterfield Township in 1877.

A Living Tradition

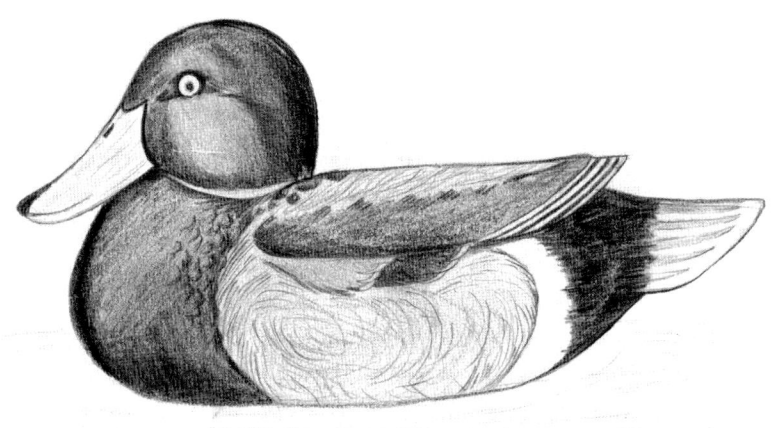

Mallard Drake by: John Wood

by Spencer Ward

During the American Revolution, Bordentown became a hotbed of rebel activity. Thomas Paine, the renowned Revolutionary War propagandist, was a resident. The Hessians occupied the town in 1776, and during May and June 1778, the British ravaged and ransacked the village. As part of Washington's December 25, 1776 surprise attack on Trenton, his right wing had to cross the river south of Trenton and both block the escape of the Hessians south out of Trenton and prevent Hessian reinforcements from marching north from Bordentown. Unfortunately, severe river ice prevented this southern thrust from fulfilling its mission.

Clara Barton established the first free public school in Bordentown in 1852 and later founded the American Red Cross. Another notable resident of the village was Joseph Bonaparte, after he was banished from France. He had been king of Naples and Spain and was brother to Napoleon I of France. He resided in Bordentown for seventeen years in exile, built an estate named Point Breeze and also built a private lake near Crosswicks Creek that was two hundred yards wide and one half mile long. The famous steam engine "John Bull" was assembled in Bordentown in August 1831 by mechanic Issac Dripps for the Camden & Amboy Railroad.

Carvers and Decoys

The Bordentown School of decoy carving styles was an offshoot of the Florence School. These decoys reflect differing water and hunting conditions as well as regional tastes. In the Bordentown region, four carvers are prominent. The most noted was Charles Black (1882–1956), whose decoy innovations have probably influenced more young carvers than any other Delaware River master other than John English. Black was also a trapper and commercial net fisherman. "Mr. Black enjoyed the reputation of being the best 'gun' on the middle stretches of the river and has often been given credit for being the builder of the first 'true' double-ender duck boat."[146] The remaining three carvers, all younger but highly skilled, were Joseph West (1907–1986), Antonio Bianco (worked 1951–68) and John McLoughlin (1911–1985).

Other carvers in the Bordentown School who were important but less influential included Charles Allen (1893–1984), Joseph Morgan (1924–

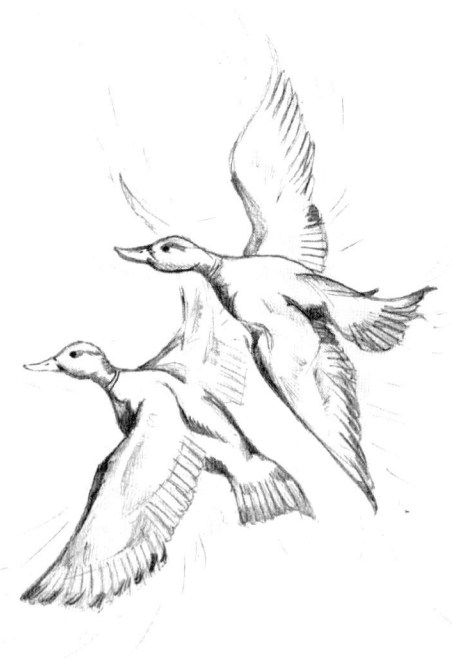

2001), Harry Fennimore (1886–1970), Charles Burkley (1910–1983), George Burkley (1917–1979) and Captain James West (1937–2000).[147] George C. Runyan, West and Black were market hunters.

Bordentown School decoys were carved with the typical incised tail, carved from the bottom slab; raised and carved primary wing feathers; and generally with the tucked head of a contented duck. Bordentown carvers generally followed the tradition of the flat-bottomed decoys and had a tendency for a down-curving profile of the back, often placing the weight to the extreme rear of the decoy.

Evolutionary changes in style developed as refinements rather than needed changes, while individual variation in technique occurred frequently. Allen's brilliant paint finishes were obtained by applying multiple layers of paint, and many of his decoys carry a code mark "X" for each decade, indicating the period when the decoy was carved. Fennimore's tails were arrow-shaped, while Bianco carved the letter *T* under the bill. Black carved raised primaries of almost extreme elevation, and some examples have carved "weep" holes following the curve of the back. McLoughlin changed direction and began carving decoratives rather than working decoys and then moved to Arizona, to the dismay of collectors.[148]

The "Delaware Ducker" and a True Sculling Boat

Although sculling was practiced in Connecticut (Camp 1952) and along the Mississippi River, it is primarily associated with a twenty-mile stretch of the Delaware River extending from Trenton, New Jersey, south to the towns of Delanco, New Jersey, and Anadalusia, Pennsylvania. This area included the New Jersey towns of Yardville, Bordentown, Roebling, Florence, Burlington, Beverly, Delanco and Riverton, while in Pennsylvania, Tullytown, Edgely, Bristol, Croydon and Anadalusia were river towns. The various hunting grounds along this river corridor were hallowed territory. Bordentown (and Trenton) hunters favored Mikes Creek, Hennessey Cove, Crosswicks Creek and the Brickyards, while Florence hunters preferred Newbold Island, Back Channel and Scotts Creek. Other productive hunting grounds included Biles Creek, Middle of the Woods, Burlington Island, Shedaker Flats, Biddles Island, Rancoeas Creek and Frankfort Creek.[149]

The Delaware River

The Delaware River is tidal north to Trenton, New Jersey. The estuary of Delaware Bay, from Philadelphia south to Cape May, New Jersey, contains extensive areas of salt marsh, but it was the unique conditions of the river from Trenton south to Delanco and Anadalusia, a mere twenty-five miles, that made it ideal for migrating ducks to rest and feed on their long and arduous journey south to their wintering grounds. These ideal conditions persisted until 1930.

Conditions along the Delaware River north of Trenton did not favor the migrating waterfowl; consequently, a duck hunting tradition never developed there, while duck hunting was practiced in the Delaware Bay south of Philadelphia. Little has been recorded of its traditions, so one is left to assume that hunting was essentially done from blinds along the edge of the salt marshes and, quite possibly, the occasional Barnegat Bay sneak box.[150]

The river habitat from Trenton south for about twenty miles provided the migrating ducks with approximately 4,500 acres of tidal marsh, with extensive areas where wild rice and wild celery grew profusely in the late 1800s.[151] On both sides of the river, numerous bays, small islands and tributary stream outlets provided ideal conditions for both ducks and hunters.

The habitat and unique conditions in the narrow migratory corridor encouraged (and required) the development of hunting techniques that took advantage of the habitat and rafting ducks. The combination of inspiration, creative genius, woodworking skills and need led inevitably to the evolution of the Delaware River sculling boat.

Two distinct types of ducking boats were utilized to great effect on the Delaware. The Bordentown design, referred to as the "banana boat" by Pennsylvania hunters, was a "twelve-foot to fourteen-foot sharply double-ended, half-decked, lap strake type with a skep astern."[152] This model may have been derived from a nineteenth-century gunning boat utilized in the area south of Philadelphia and was referred to as the "Delaware Ducker." It was constructed with multiple strakes with curved sides.[153]

Double-ended boats often served multiple purposes. During "railbird" season, these boats were ideal for poling into the marsh grass and reeds, while during duck season they were easily converted to sculling duckers.[154]

The design of the dedicated Delaware River sculling boat had its origins in the Barnegat Bay sneak box, which originated about 1836 in West Creek, Ocean County, New Jersey. These early designs influenced Jess Heisler (1891–1943), a decoy carver and boat builder of Burlington, New Jersey, whose creations have persisted into contemporary times even though his last boats were built in the late 1930s. Since Heisler's boats were custom-made,

A Living Tradition

Delaware River Sculling Boat by Jess Heisler (1891–1943) circa 1939

Rick Knecht, Proof Positive.

there are variations, although the basic design remained intact. His total output with regard to sculling boats remains unknown.

The author recently acquired a Heisler sculling boat built in 1939 from Clarence Fennimore of Wrightstown, New Jersey. Previous owners include Mort Haines and Bob White, so the boat has a respectable history. The boat is painted a marsh-grass brown and is thirteen feet, eleven inches from bow to stern, with cockpit dimensions of twenty-six inches by eighty-five inches. The coaming surrounding the cockpit is approximately three and a half inches in height. In general, the freeboard seems to be less than six inches. The beam is fifty-four inches. The boat is fully decked and is designed to shed water. The hull is of semi-V construction at the bow, and this construction is carried through to the stern, although there is a definite flattening, with a keel, in the last four or five feet. The stern is thirty inches wide, again with about a ten-inch freeboard, and is provided with a substantial motor mount more than sufficient for an electric motor.

The boat seems to be built for two-person use, but with guns, decoys and other gear, this may be somewhat problematic. Dual oar locks twenty-six inches apart are provided in order that the boat can be rowed both forward and backward, and an oar lock for the sculling oar is mounted on the port side near the stern. The oar locks are cast bronze. Removable rails are provided to facilitate camouflage material, either reeds, marsh grass, sedge or modern camouflage material.

Sadly, Heisler's creation is not destined for work on the Delaware River again but rather will explore the bays and inlets of Merrill Creek Reservoir.

The Delaware River

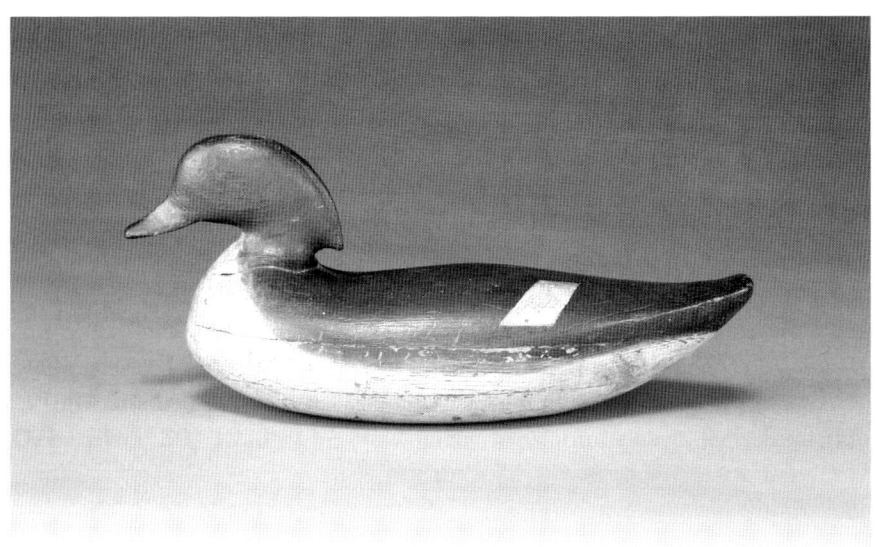

Wood duck decoy by unknown carver, Philadelphia School. *Guyette & Deeter, St. Michael, Maryland*.

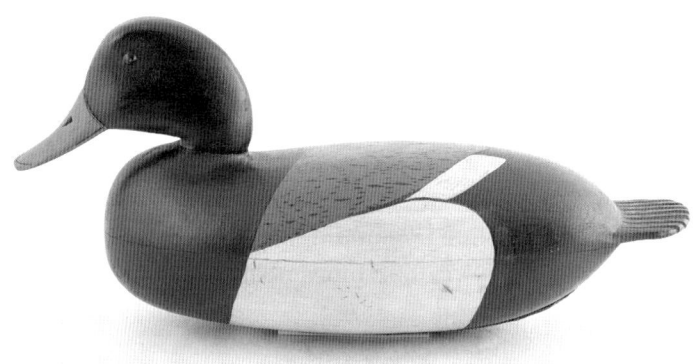

Blue-bill drake decoy by Dan English, Florence School. Frank Moyer personal collection. *Rick Knecht, Proof Positive*.

A Living Tradition

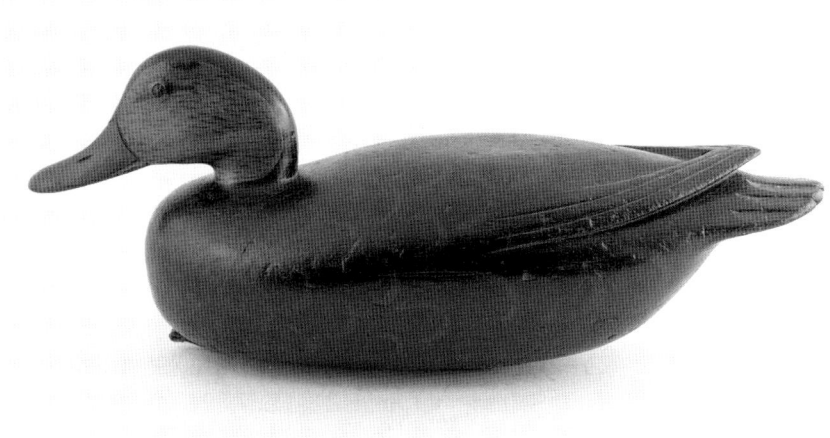

Black duck decoy by Jess Heisler, Florence School. Frank Moyer personal collection. *Rick Knecht, Proof Positive.*

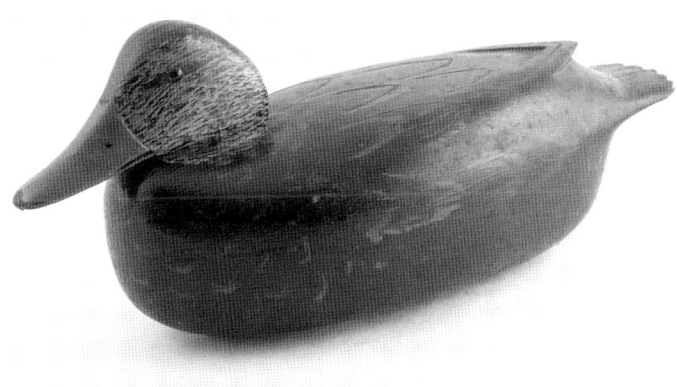

Black duck decoy by Larry McLaughlin, Florence School. Frank Moyer personal collection. *Rick Knecht, Proof Positive.*

The Delaware River

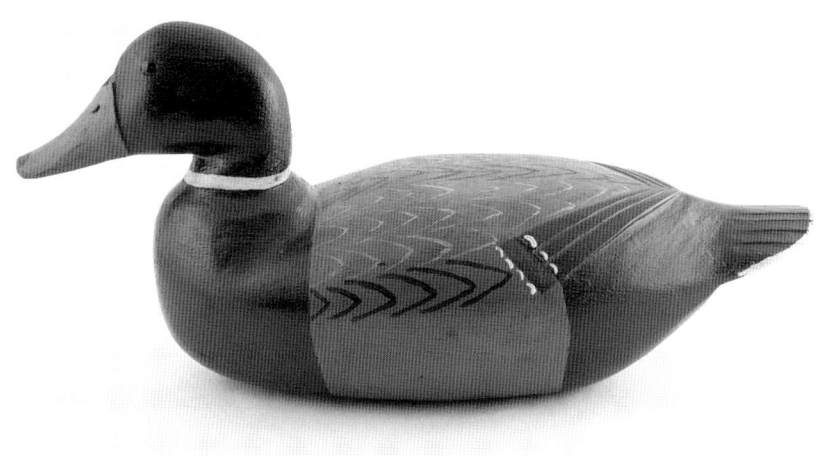

Mallard drake decoy by Harry Fennimore, Bordentown School. Frank Moyer personal collection. *Rick Knecht, Proof Positive.*

The main purpose of the sculling boat was to put the hunter very close to the decoys and rafting waterfowl, if not directly into them, for closer shooting. This made for very dramatic hunting scenarios where the hunter came very close to the rafting ducks. The essence of the sculling technique provides for the hunter placing his decoys, up to forty, in a location where the water depth is twelve to fifteen feet, and then rowing upstream for a distance of up to one hundred yards and anchoring. The hunter installs his sculling oar and the hunt becomes a waiting game—waiting for the migrating ducks to land among the hunter's decoys. Binoculars may have been necessary.

After detecting the arrival of his quarry, the hunter ships his anchor, securing the location of his anchor rope with a float, possibly a spare decoy. He lies on his back and uses his sculling oar over the stern as the only means of propulsion. Steering slowly, he drifts toward his decoys and the feeding ducks. The use of the sculling oar required a practiced technique:

> *If he was good, the man in the…boat would lie on his back, grasp the handle and wave it back and forth over his chest. By adding a twist on the backhand stroke, the blade would slide easily through the water and reduce the waves it produced, helping to camouflage the drifting boat….Regardless*

of the technique used, it was critical the motion was done without producing any waves that would alert the ducks.[155]

The success of the hunt depended on the stealth of the drift. After the hunter collected his downed ducks, he rowed back upstream to his anchoring point and repeated the sculling drift process as long as the ducks were working.

A CHRONOLOGICAL HUMAN AND ENVIRONMENTAL HISTORY OF THE DELAWARE RIVER AND ESTUARY[156]

18,000 BC: Melting glaciers causes sea level to rise and the formation of Delaware Bay.[157]

circa 11,000 BC: Paleo-Indians begin inhabiting the Delaware Estuary region in small groups.

circa AD 600: Lenape Indians migrate from the west and settle in the Delaware Estuary area, clearing land along streams for extensive maize farming.

Summer 1497: John Cabot discovers the east coast of North America, probably Labrador, establishing King Henry VII's claim of ownership of the land from Virginia to Canada by right of discovery.[158]

1524: First contact with Europeans—the Leni-Lenapes first encounter with Europeans in lower New York Bay. Italian navigator Giovanni da Verrazzano explores New Jersey's coastline but somehow does not find the entrance to Delaware Bay.[159]

April 10, 1606: King James I grants a charter for the Virginia Colony that includes the entire Delaware drainage systems and, in 1620, allows the Puritans to colonize Plymouth (without a charter), creating a "buffer zone" between the two English colonies (Virginia and Plymouth) between the 38th and 41st parallels.[160]

pre-1609: Lenape Indians call the Delaware River *Lanapenlhittic*, or "river of the Lenape."[161]

August 28, 1609: Henry Hudson, an English explorer and adventurer sailing for the Dutch, discovers the entrance to the Delaware Bay in search of the Northwest Passage, giving the Dutch first claim on the estuary for fur trading.

A Chronological History of the Delaware River and Estuary

1609: The Dutch designate the Delaware River as the South River, the North River being the Hudson.

1609–16: The Dutch become interested in the commercial possibilities of Hudson's discoveries.

August 27, 1610: Captain Samuel Argall enters a bay located in the "buffer zone" that he names the "De la Warre Bay" in honor of Sir Thomas West, the 3rd Lord De La Warre. The English make no further attempt to explore the bay until after the Dutch are firmly established.[162]

1614–67: New Netherland is colonized by the Dutch West India Company; the Delaware is referred to as "South River."

1614: The first white men explore the Minisink Valley from the north.[163]

1616: Cornelius Jacobsen May (Mey), a Dutch navigator and fur trader, is in American waters, and in 1620, he visits the Delaware River. His visit is noteworthy since May's name is remembered in Cape May.[164]

August 19, 1616: Dutch captain Cornelius Hendrickson reports the "discovery" of a bay and three rivers located between 38 and 40 degrees longitude. These three rivers are the Delaware, the Schuylkill and possibly the Christina.[165]

1620: Thomas Dermer explores the Delaware Bay, seeking the Northwest Passage unsuccessfully.[166] English colonists begin arriving to hunt whales following Dermer's "discovery" of the Delaware but are unsuccessful.

1623: Captain Cornelius May establishes the first-known permanent European settlement on the banks of the Delaware—the Dutch trading post at Fort Nassau, near present-day Gloucester, New Jersey—in an effort to legitimize Dutch claims to the Delaware Bay and River.[167]

1624: The Dutch see economic opportunity in the British lack of interest in the "buffer zone" territory, which includes both the Hudson River and the Delaware River, and establish a trading post, Fort Wilhelmus, on an island about twelve miles north of the future site of Philadelphia.[168] The Dutch have designs on Burlington Island as the capital of New Amsterdam, but on second thought, after experiencing summer mosquitos and winter ice, they choose Manhattan Island in the Hudson River instead.[169]

1626: Dutch settlers withdraw from the Delaware to Manhattan Island, which becomes the capital of New Netherland.[170]

1630–1767: The English expect the Lenapes to sell their land peacefully. The Lenapes put their marks on nearly eight hundred deeds conveying nearly all their remaining ancestral total territory; the English are simply too determined and too powerful to resist.[171]

1630–50: Clearing of land by settlers for expanding agriculture needs, especially for growing maize, beans and squash.

1631: The Dutch establish a whaling station, Swanendael, which is destroyed by the natives one year later; in 1658, the Dutch reestablish the colony as a fort, and in 1663, it is named Hoornkill (Hoerekill). In 1664, the English call it Whorekill. It is the present site of Lewes, Delaware.[172]

1631: Drawn by whale hunting, Dutch settlers establish first permanent settlement in Delaware, on Cape Henlopen (destroyed in the winter of 1631–32 by natives).

June 20, 1632: King Charles I awards a royal grant and charter for the new colony of Maryland to George Calvert, 1st Lord Baltimore. When he dies, the grant and charter are awarded to his son Cecilius Calvert. The charter includes the provision of *hactenus inculta*—excluding previously settled land—but this provision does not apply to previous settlement by indigenous peoples.

1632: Sir John Harvey, the royal governor of Virginia, dispatches a small sloop with seven or eight men to explore and determine if a river did, in fact, empty into Delaware Bay.[173]

1632: Dutch explorer David Pietersz de Vries meets with the Delaware Indians (Leni-Lenapes); his purpose is to reinforce the colony of Swanendael and conduct whale fishing.[174]

1633–1702: The Lenapes may have suffered fourteen epidemics (measles, smallpox, and/or malaria); only one-tenth of their 1609 population is alive in 1679.[175]

June 2, 1634: Sir Edmund Plowden receives a charter for lands on the east bank of the Delaware River from Charles II, essentially all of modern-day New Jersey. His ill-fated attempt at colonization fails in the 1640s because of mismanagement of money, payments to his ex-wife and attempts to provide for his eighteen children. His claim to the land is ignored by Charles II, and his great-great-grandson prolongs the claim by attempting to collect rents from property owners in New Jersey after the Revolutionary War. His claims are ultimately denied by none other than President George Washington.[176]

1634–35: Englishman Thomas Yong explores the Delaware River seeking the mythical Lake Laconia and the Northwest Passage; his expedition is blocked by the falls at Trenton. An attempt to found a settlement on the Delaware is unsuccessful.[177]

1638–41: The Swedes purchase land on both sides of the Delaware as far north as present-day Trenton and the Schuylkill River.[178]

1638–55: New Sweden exists for only seventeen years as a political entity under the control of the Swedish royal family and the New Sweden Company.[179]

1638–55: With Scandanavian influence, the log cabin makes its debut in the Delaware Valley.[180]

1638–56: Johann Printz builds his capital of New Sweden, Printzdorf, on Tinicum Island in the Delaware.[181]

1638: New Sweden is founded on the Delaware with the building of Fort Christina on the West Bank of Delaware by Peter Minuit, who is no longer working for the Dutch.[182]

March 1638: Miniut, now working for the Swedes, brings the Swedish colonists into Delaware Bay at Minquaskill surreptitiously so as not to alarm the Dutch at Fort Nassau and builds Fort Christine, the colony called New Sweden, near present-day Wilmington.[183]

1640: The beaver, never particularly plentiful in Lenape territory, perishes from the area entirely, forcing the tribe to travel west into hated and feared Susquehannocha land to obtain the pelts necessary for trade with the Dutch and Swedish.[184]

1641–42: English colonists from New Haven, Connecticut, with the support of New Haven's governor, sail to the Delaware Bay, purchase land from the Lenapes at a site on the Varkens Kill (Salem River) for their colony and establish a trading post on the Schuylkill River, which the Dutch soon eliminate.[185]

1642–43: Dutch stockholders in the West India Company are also stockholders in the New Sweden Company, which creates an "uncomfortable" situation, since Swedish rivalry in the fur and tobacco trade is causing Dutch trading to suffer.[186]

February 1642: Johan Printz replaces Peter Hollander Ridder as governor of New Sweden and announces his intention to establish permanent settlements and expand the territory of New Sweden.[187]

1642: Fort Elfsborg, built on Salem Creek on the East Bank of the Delaware, and New Sweden, with Swedish and Finnish settlers, "flourish" from 1643 to 1653 under Governor Johan Printz; actually, very few settlers arrive.[188]

1642: Swedish and Finnish colonists settle Raccoon Creek area, present-day Bridgeport.

Spring 1643: Sir Edmund Plowder is unsuccessful in his attempt to establish a settlement in New Albion.[189]

1646: Reverend Johan Campanius completes the task of translating Martin Luther's *Little Catechism* into the Lenape dialect.[190]

circa 1650: Dutch adventurers find copper in Kittatinny Mountains.[191]

1650: Old Mine Road is built by Dutch to carry copper from Pahaquarry mine on Kittatinny Mountain to Esopus (Kingston), New York.[192]

Fall 1651: Governor Stuyvesant prevents a vessel from New Haven bound for the Delaware from landing fifty settlers.[193]

1651: Dutch headquarters move from Fort Nassau to Fort Casimir at present-day New Castle.

1654: Fort Casimir is conquered by Swedes.

September 15, 1655: New Sweden as a political entity ends with the signing of a peace treaty between Johan Rising and Peter Stuyvesant.[194]

1655–64: The Dutch-ruled territory previously known as New Sweden first becomes a possession of the West India Company under the command of Peter Stuyvesant and is later a colony governed by the City of Amsterdam. Holland, the town, and the former Fort Casimir are renamed New Amstel.[195] After the bloodless capitulation of New Sweden, the West India Company changes its policy toward colonization when it realizes the potential profits of increased numbers of people utilizing the natural resources available in the Delaware Bay area. African slaves are introduced to increase the workforce.[196]

1656: Dutch re-conquer Fort Casimir and take Fort Christina.

1659: Lord Calvert's interpretation of Lord Baltimore Charles's inquiry was that land below the 40th parallel was part of the Maryland charter; even though maps at the time were highly inaccurate, the charter continued the provision of *hactenus inculta*, meaning that previously settled land was excluded from the charter. Since the Dutch were already settled on the disputed land, it could not be considered part of the Maryland Colony.[197]

September 6, 1659: Colonel Nathaniel Utie, an emissary from Maryland, notifies the Dutch that they are trespassing on Lord Baltimore's land. He assumes his patent includes the western shore of Delaware Bay, land that lies below the 40th parallel (one must realize that accurate maps simply did not exist in 1658), and the English have little knowledge of Delaware Bay.[198]

1659: The Dutch return to the site of the Swanendael massacre and build a fort called Hoerenkil.[199] The first reliable chart of Delaware Estuary region is published by Augustine Herman.

1660: The Scandanavian population in the Delaware Valley does not exceed four to six hundred.[200]

1661: A canal connecting the Chesapeake and Delaware bays is first suggested by Augustine Herman.

1664: King Charles II gives area between Hudson and Delaware Rivers to James, Duke of York (later James II). The duke grants all of present-day New Jersey and more to his friends, John, Lord Berkeley, and Sir George Carteret, thus making an indefinite division between East and West New Jersey. "Nova Caesarea" (New Jersey, named after the Isle of Jersey) is used for the first time in the deed.[201]

1664: The non-indigenous population of New Jersey is approximately 2,000; by 1700, population has leaped to about 20,000 and is about 30,000 by 1726. By 1790, the population has surged more than 500 percent in sixty-seven years to 184,000 people.[202]

1664: King Charles II, his brother James the Duke of York and Parliament are in agreement that the land occupied by the Dutch in New Amsterdam and New Amstel is British territory by right of prior discovery.[203]

Fall 1664: James, Duke of York, attacks New Amsterdam with a naval force, and by September 8, it has been given a new name: New York. Sir Robert Carr, with four ships, is ordered to capture the Dutch forts on Delaware Bay and the Delaware River on October 1.[204]

October 1664: New Amstel surrenders to Sir Robert Carr's forces and becomes New Castle. Carr destroys the Dutch Mennonite colony of Whorekill, and all Dutch territory falls under control of the Duke of York.[205]

1665: "Concessions and Agreements" are issued by Berkeley and Carteret to potential settlers, giving freedom of conscience, trial by jury and representative assembly.[206]

1670: The Dutch had purchased treaty of land from the natives for their settlements, but the English claim all land by right of conquest.

1670: Upstream landing on the Appoquinimink River is abandoned as unusable due to heavy siltation from agricultural runoff.

Christmas Eve 1673: Lord Baltimore's troops burn Whorekill to prevent it from falling back into Dutch hands.[207]

August 8, 1673: New Netherland and the Delaware territory, including New Castle, which were captured by the British in 1664, are again seized by the Dutch.[208]

1673: England gains control of all Dutch holdings in North America by the end of the Anglo-Dutch War.

February 19, 1674: All former Dutch territory in the "buffer zone" on the Delaware is given to the English under the Treaty of Westminster.[209]

1675: John Fennwick settles Salem.[210] Greenwich is established along the Cohansey River.

1679: Stacy's Mills, located near the mouth of the Assumpink, anchors the village of Trenton; William Trent rebuilds the mill in 1714 and erects a mansion, which is now the William Trent House on land on the main streets of "Trenton town."[211]

1679: The first settlers in Trenton are Quakers who refer to their settlement as "Ye Falles of ye DelaWarr." The "Falls" is the name commonly given to Trenton, and in 1716, it is referred to as the head of sloop navigator.[212]

1681: Burlington is named the West New Jersey capital.[213]

August 24, 1682: The Duke of York conveys lands on the west bank of the Delaware to William Penn. This land eventually becomes the states of Delaware and Pennsylvania.[214]

1682: William Penn arrives aboard the *Welcome*. He stays only until 1684 but returns to Pennsylvania in 1699, again for only two years.[215]

October 27, 1682: The city of Philadelphia is founded by William Penn. The population exceeds ten thousand by 1717 as immigration increases.[216]

1688–89: East and West New Jersey, with New York, are annexed to New England and governed from Boston.[217]

1690: The first paper mill in North America is built along the Wissahickon Creek near Germantown in Philadelphia.

1700s: Forests are cleared and plowed by European settlers for wheat farming.

1700s–1800s: The Delaware Estuary region is ruled by wheat farming; streams are dammed, sometimes several times, for wheat mills. There is a mill-building boom in response to increase in wheat farming and increase in population. International trade begins.

1702: East and West New Jersey are united into a single province by Queen Anne.[218]

1727: Nicholas Depui purchases land from the natives and moves his family from the Hudson Valley to present-day Shawnee on the west shore of the Delaware.[219]

1730: Thomas Penn, son of William, discovers Depui living on land that he claims is his and forces Depui to repurchase the land from him.[220]

1732: Lambertville, New Jersey, begins as Corpell's Ferry and supports both a gristmill and a sawmill. Future crossing point for the Patriot army in 1776.[221]

1736: Along the upper reaches of the Delaware on the Pennsylvania side of the Minisink Valley, the land along the River Road from Bushkill, Pennsylvania, to Milford, Pennsylvania, a distance of about twenty-five miles, is the site of four forts and twenty-seven houses and small farms. Full-scale tribal raids continue until the end of the Revolutionary War.[222]

A Chronological History of the Delaware River and Estuary

August 25, 1737: Two sons of William Penn, Thomas and John, along with land speculators William and James Allen, produce a questionable copy of a deed dated 1686 that conveys to William Penn "lands as far as a man could walk in a day and a half." Lenape chiefs had no memory of this deed, and since the signers have died, this document becomes the basis of the "Walking Purchase" Treaty.[223]

September 19, 1737: Edwin Marshall, Solomon Jennings and Edmund Yeates set out on the "walk" beginning in Easton, Pennsylvania, after ten Iroquois chiefs put pressure on the Lenapes to assent to the questionable treaty. Marshall is the only one to complete the walk; he covers sixty-five miles in eighteen hours. This fraudulent land grab scheme deprives the Lenapes of their treasured Minisink hunting grounds.[224]

1738: There is no specific verifiable date for when the Durham boat was first built. It is thought that Robert Durham, working at Durham Furnace in Durham, Pennsylvania, constructed the first Durham boat. The boats vary in size, up to sixty-six feet long, six feet wide, three feet deep, flat-bottomed and double-ended. They were propelled by both oars and poles using a long steering oar by a crew of three to six men and could carry cargo approaching seventeen tons. It has been estimated that at one time there were one thousand Durham boats working the Delaware River. George Washington "confiscated" Durham boats to make his crossing of the Delaware on December 25, 1776; eventually, the railroads put both the Durham boats and the canals out of business.[225]

1739: New Jersey's first successful glassworks in America is established in Salem County, according to John T. Cunningham's *Colonial New Jersey*. Benjamin Franklin petitions the Pennsylvania Assembly to stop waste dumping and to remove tanneries due to foul smells, lowering property values and disease.

1740: The Lenapes leave homelands for resettlement in its Ohio and Susquehanna Valleys.

1742: At a Philadelphia treaty council, the Iroquois diplomat Canasatego treats the Lenapes rudely and disrespectfully by referring to them as "women" in ordering them off land claimed by the Pennsylvanians as a result of the Walking Purchase of 1737.[226]

1750–1800: The Industrial Revolution in the United States begins with the first shipments of anthracite coal along the Lehigh Canal and the Delaware River to Philadelphia.[227]

1754–63: During the French and Indian War, Delawares from the Susquehanna and the Ohio Valleys ally with the French and raid into northern New Jersey.[228]

1755: The Delawares and Shawnees of Ohio proclaim war against the English, and before the end of November, the Pennsylvania frontier from the Delaware Water Gap to Maryland is aflame.[229]

November 24, 1755: The Moravian Indian Missionary settlement at Gnadenhutten, Pennsylvania, is burned, and eleven Moravian brothers are murdered and scalped by Susquehanna Delawares.[230]

1756: The first stagecoach line from Philadelphia to New York is initiated.

April 14, 1756: New Jersey declares war on the Delaware Nation and offers a bounty for native scalps.[231]

1756–58: The Lenapes (now called the Delawares), after becoming allies with the French during the French and Indian War and conducting raids into New Jersey, realize the weakness of the French and meet with the English in peace treaty negotiations in the frontier town of Easton, Pennsylvania.[232]

1756–58: An armistice of peace talks is concluded in Easton between the English and the Delawares from the Susquehanna and the Ohio Valley.[233]

1756–1836: Tom Quick Jr. loses his father to an attack in 1756 along the Delaware near Milford, Pennsylvania; the French and Indian War is raging throughout the Delaware Valley, and the Leni-Lenapes are used as pawns by both the French and the British. Quick seeks retribution for his father's death and claims to have killed nearly one hundred natives—men, women and children. His infamous exploits, possibly exaggerated hearsay, are legendary, and he becomes known as the "avenger of the Delaware and Indian slayer."

Late 1700s: Large mills are established on the Brandywine Creek at Wilmington. Development of anthracite coal industry begins at headwaters of the Schuylkill and Lehigh Rivers. Marsh is reclaimed near settlement on Burlington Island.

August 29, 1758: With the decline of the Lenape population and the settlement of all old tribal land claims, New Jersey purchases 309 acres in Indian Mills in Shanong Township for the state's first (and only) Indian reservation, called Edgepillock (Brotherton). The reservation attracts indigenous people who had converted to Christianity, but by 1800, the reservation has ceased to exist. The remnants of the tribe are removed to western reservations.[234]

1762: St. George's Marsh Company is formed to manage the impoundment meadows of St. Georges, Marsh and Cripple Creeks in northern Delaware.

1764: Daniel Skinner from Callicoon, New York, is the first to try timber rafting on the Delaware. By 1861, huge rafts, some 60 feet wide and 190

feet long, are common; by 1875, nearly three thousand rafts have traveled the river.[235]

1769: Pollution first noted in the estuary.

1771: The first water concern for the non-tidal Delaware River is navigation. Private interests raise funds to improve the channel through the rapids at Trenton for the passage of lumber rafts, Durham boats and coal arks.[236]

1774–1800: Philadelphia becomes the de facto capital of the nascent country, beginning with the First Continental Congress on September 5, 1774, and continuing until 1800 with Congress's move to Washington, D.C. Noted exceptions: when Congress moves to Lancaster, Pennsylvania, and then to York, Pennsylvania, during the British occupation during the winter of 1777–78.[237]

1774: One year after the Boston Tea Party, the patriotic citizens of the town of Greenwich, New Jersey, on the Cohansey River dress as "Indians" and burn the cargo (tea) of the brig *Greyhound*.[238]

1775–83: The American Revolution is fought.

1776: The Provincial Congress adopts a constitution. William Livingston is the first governor of New Jersey. The British capture New York; Washington retreats across New Jersey.[239]

1776: Colonists of the three lower counties of Pennsylvania adopt a constitution for the state of Delaware; on December 7, 1787, it becomes the first state to ratify the new Constitution of the United States.[240]

December 25–26, 1776: Washington recrosses the Delaware and surprises the Hessian forces in Trenton, New Jersey.[241]

1776–1830: Durham boats, in addition to convoying Washington's troops across the Delaware in 1776, could carry twenty tons of iron or 150 barrels of flour per trip. They also carry livestock, grain and whiskey.[242]

January 2–3, 1777: The Second Battle of Trenton (January 2) and Battle of Princeton (January 3) are victories for Washington's army; this is their first winter at Morristown.[243]

1777: American rebels hold two forts on the Delaware: Fort Mercer in New Jersey and Fort Mufflin on Mud Island on the Pennsylvania side. In addition, underwater obstacles have been placed in the river to prevent the British from supplying troops occupying Philadelphia. On November 15, Fort Mufflin falls to the British, and on November 20, after a courageous fight, Fort Mercer is abandoned. Howe captures Philadelphia by sea.[244]

1778: Washington winters at Valley Forge, Pennsylvania. The British abandon Philadelphia.[245] The Delawares (Leni-Lenape) are the first tribe to sign a peace treaty with the United States.

June 1778: After Valley Forge, Washington crosses the Delaware once again in pursuit of the British as they abandon Philadelphia and attempt to conduct a strategic retreat to New York City.

1779: The U.S. Army Corps of Engineers is formed.

April 1780: North of the Delaware Water Gap in the Minisink Valley, the Battle of Raymonskill (Coneshaugh) is the result of a tribal ambush led by Joseph Brant, a British-educated Mohawk, and his band of irregular Tories and their Iroquois allies, of a force of assorted local militia under the command of Lieutenant Ennis and Captain Etter. Most of the militia runs away; of those who stand and fight, Lieutenant Ennis, Captain Westbrook and twelve others are killed. The wounded survivors escape across the Delaware River, saving both their lives and their scalps. The area is known today as Death Eddy.[246]

1780–1800: Fifth-generation Anglos of Philadelphia coexist comfortably with Palantine Germans, Swedes, Welsh, Scotch-Irish, Irish, French royalists, free blacks, Native Americans and frontiersmen.[247]

June 28–November 4, 1783: New Jersey is the "capital" of the United States when the Continental Congress meets in Nassau Hall, Princeton.[248]

1783: A treaty (the anti-dam treaty) is signed between Pennsylvania and New Jersey declaring that the "whole length and breadth [of the Delaware]… is and shall continue to be and remain a common highway." During the early 1800s, wing dams constructed to divert water for canals create ongoing controversy.[249] The existence of this treaty helps to keep the main stream of the river free of dams into the twenty-first century.[250]

July 1786: John Fitch launches his prototype steamboat on the Delaware at Philadelphia. It fails. Humiliated, Fitch redesigns the propulsion system and successfully launches his second steamboat on August 27, 1787, years ahead of Robert Fulton's *Clermont* in 1807.[251]

1788: New Jersey passes a law to promote marsh reclamation through formation of meadow management companies.

1790: Ben Franklin makes a provision in his will for funds for a public water supply system in Philadelphia; annual epidemics of waterborne diseases (typhoid and cholera) kill thousands, and fire is a constant threat to the city.[252]

1791: Private commercial interests make efforts to create a channel, using explosives, through the falls at Trenton to make river commercial traffic safer; a similar early effort was made to clear a channel, on the Pennsylvania side, through the rapids at Foul Rift.[253]

1791: The first public canal company in the country is chartered in Philadelphia: the Schuylkill and Susquehanna Canal Company.

A Chronological History of the Delaware River and Estuary

1792: The Philadelphia and Lancaster Turnpike Company is chartered, building and operating the first turnpike road in Pennsylvania, which stretches from Lancaster to Philadelphia by 1818.

1792: The first coal company in the region is formed.

1793: Antoine Dutot, a French plantation owner fleeing a slave uprising, travels north to the Water Gap, purchases a large tract of land and lays out an inland city that he calls Dutotsburg. It does not flourish and eventually becomes the borough of Delaware Water Gap.[254]

1793: The borough of (Delaware) Water Gap, Pennsylvania, is founded. The residents work the river and the forests, harvesting hemlock bark for the tanneries and providing rooms and board for the log rafters.[255]

1793: A yellow fever epidemic rages in Philadelphia.

1793–94: Philadelphia is the nation's political, economic and cultural capital, with a population approaching fifty thousand, and it is by far the largest city in North America. It is also by far the largest seaport in North America, with more than a quarter of the nation's total exports passing through its docks.[256]

1794: Congress authorizes the building of six frigates in response to the commerce raiding of the Barbary pirates in the Mediterranean Sea, the first for the fledgling navy, one of which, the *United States*, would be built in the South Work shipbuilding district of Philadelphia. Philadelphia is a multicultural, multi-religious, polyglot society and very much tolerant of its own diversity.[257]

1794–95: The construction of the *United States* is one of Philadelphia's most popular sightseeing destinations.[258]

1796: The town of Milford, Pennsylvania, is laid out by John Biddis, who names some streets after his children.

1796–1802: The Oneida tribe of New Stockbridge, New York, invite the Delawares from Brotherton to come live with them.[259]

1797: The Philadelphia Watering Commission is established to provide safe drinking water.

May 10, 1797: The frigate *United States* is launched and becomes the first vessel of the U.S. Navy. It is commissioned on July 11, 1797.

1798–1800: Abram B. Gile constructs a wagon road through the Water Gap, and Dutot opens a toll road with connections north to Shawnee. This road is superseded by a road built by the State of Pennsylvania in 1823.[260]

1799: Congress moves to Trenton to escape Philadelphia's annual yellow fever epidemic.[261]

A Chronological History of the Delaware River and Estuary

1799: Work starts on the Schuylkill Water Works in Philadelphia, the first water plant of its kind in the United States. The first pollution study is conducted in the estuary.

early 1800s: Sturgeon are reported as abundant throughout the estuary.

early 1800s: The population of Philadelphia increases enormously during the Industrial Revolution.

1850–1900: Atlantic sturgeon population is decimated due to high demand for their meat and roe; in 2012, they are placed on endangered species list.[262]

1800–1930: Extensive clearing of forested lands for agriculture takes place. Intensive turbidity develops in estuary.

1802: Summer yellow fever epidemics in Philadelphia become annual events.

1804: Work on canal connecting the Chesapeake and Delaware Bays begins.

1804: The first American bird-banding experiments, perhaps the first of importance anywhere in the world, are conducted on the Atlantic flyway near Philadelphia by John James Audubon.[263]

1805: The original bridge at the Bull's Island Recreation Area is of wooden construction with masonary piers. That bridge is lost in the 1903 flood and rebuilt by Roebling. In 1944, that structure is closed and rebuilt in 1947 as a pedestrian bridge.[264]

1806: Work on canal connecting the Chesapeake and Delaware Bays comes to a standstill.

1806: First recorded bridge built across the Delaware is at Trenton: the Lower Trenton Bridge.

1806: The first bridge between Easton, Pennsylvania, and Phillipsburg, New Jersey, opens to traffic. This is the Northampton Street Bridge, the second covered bridge built in the United States. A unique cantilever suspension bridge design replaced it in 1896, and it still exists in 2019.[265]

1809: The first experimental railroad track is built in Philadelphia.

1810: A stagecoach route opens between Easton and Marshalls Creek, Pennsylvania.[266]

November 1812: The British Royal Navy establishes a military and commercial blockade of Delaware Bay to suppress privateers and damage America's maritime economy.[267]

1812: Traditional rowing boats, hired with or without a rower, are common on the Delaware River until the 1950s; this is a river tradition that remains to be explored.[268]

1812–13: The Delaware Bay is closed to trade by British ships during the War of 1812.

1819: Construction begins on Fairmont Waterworks in Philadelphia to bring fresh water into the city.

1820–1940: Coal silt pollution problems exist in the estuary due to coal mining operations in Northeastern Pennsylvania.

1820: The first summer visitors to the Delaware Water Gap, attracted by the scenic beauty, arrive from Philadelphia and stay in private homes.[269]

1820: The Industrial Revolution begins in the United States.[270]

1820: Asian yellow fever strikes in Philadelphia.

1820: A dam constructed on the Schuylkill River blocks shad runs.

1822–35: Canal construction reaches its height.

1824: Work on the canal connecting the Chesapeake and Delaware Bays resumes.

1825–28: The sixteen-foot-high dam constructed at Lackawaxen, Pennsylvania, raises the river level for canalboats from the Delaware and Hudson Canal; it is the only true dam to be constructed across the river. It blocks shad runs.[271]

1825: Shad decline starts.

1828: Construction begins on the East End Lighthouse. It will commence operation in 1885.

1829: The Delaware and Hudson Canal is opened, built to carry clean-burning anthracite coal from Pennsylvania to New York City.[272]

1829. Slavery is abolished in New Jersey.[273]

1829: Dutot begins construction of the Kittatinny Hotel at Delaware Water Gap, which can accommodate 25 guests; by 1851, William A. Brodhead has purchased the hotel and expanded its capacity to accommodate 60 guests. By 1860, under new management, the capacity of the Kitattinny has been expanded to serve 250 guests.[274]

1829: Work begins on the Delaware Division of the Pennsylvania Canal (Delaware Canal), running sixty miles from Bristol to Easton.[275]

1829: The Chesapeake and Delaware Canal opens, providing a sorely needed alternative to the long journey around the tip of the DelMarVa Peninsula connecting the Chesapeake and Delaware Bays, especially for commodities moving between the ports of Philadelphia and Baltimore.

1830: Construction begins on the Delaware and Raritan Canal, running from Bordentown to New Brunswick, New Jersey, at tide water on the Raritan River, covering a distance of forty-three miles. A feeder canal runs twenty-two miles north along the river to Lambertville, where a controversial wing dam is constructed. Navigation on the canal is established in May 1834; the canal operates for another hundred years.[276]

1830−60: On the eve of the Civil War, the Pocono Mountains experience the appeal of summer visitors and sportsmen that will allow it to grow into a summer vacation mecca rivaling that of Atlantic City well into the next century. The Kittatinny Hotel serves guests until 1931, and the Henryville House begins its 150-year history in the 1830s.[277]

1831: The Morris Canal from Port Delaware in Phillipsburg to Newark is completed. Its final segment, terminating on the Hudson River at Jersey City, is completed in 1836. The canal provides a connection between the Pennsylvania anthracite coal fields and growing iron industry of the Lehigh Valley and New York City, covering a distance of 107 miles. In 1871, the canal is leased to the Lehigh Valley Railroad, and it is taken over by the state in 1921, when it is abandoned.

1832: Cholera epidemic rages in Philadelphia.

1832: Philadelphia law prohibits discharge of any "putrid or noxious matter" into the river.

1833: Carl Getter is hanged twice for murdering his pregnant wife (the first time the rope broke!) on Abel Island near Easton. The island is thereafter known as Getter Island.[278]

1837: The Conashaugh Spring House is opened as a rafter's hotel; it is converted to summer tourist trade in the 1870s, and in 1890, the owners run a telephone line to the train station at Port Jervis, New York, creating one of the first telephone companies in Pennsylvania. The hotel burns down in 1915.[279]

1840–1900: The forks of the Delaware have developed into a major transportation depot and manufacturing center, especially the manufacturing of iron goods. In addition to the Andover Furnace, the J.R. Templin & Company iron and brass foundry opens in 1848. Between 1849 and 1876, A.R. Reese & Company does an extensive business in the manufacture of agricultural implements. Warren Foundry and Machine Company is chartered on March 6, 1856. The Phillipsburg Rolling Mill is established along the river in 1860, and Tippett & Woods begins operations in 1886.

1840: New Jersey is just at the beginning of its era of greatest industrial growth. New transportation technology—canals and railroads—has the greatest impact on growth. Much diversified industrial growth takes place in the Delaware River Valley, especially the iron industry.[280] Manufacturing in Wilmington includes railroad cars, heavy machinery, gunpowder, textiles, flour and iron ships.

1841: The Bridges Freshet of January 1841 sweeps away nine bridges on the Delaware River. Other major flooding occurs in 1786, 1869,

October 1903, August 1955, January 1996, September 2004 and April 2005.

October 1846: Poet William Cullen Bryant is inspired by the beauty of the Delaware Water Gap while staying at the Kittatinny to take advantage of the emerging vacation business.[281]

1848: Architect John A. Roebling is engaged to build a viaduct across the Delaware River above Columbia, New Jersey, to convey canalboats across the river. The viaduct removes the conflict between log rafters and canalboats on the river at the Lackawaxen Dam.[282]

1848: The Delaware and Hudson Canals' Roebling Aqueduct is completed, reflecting the need to expand the canal due to increasing business. In the same year, the Erie Railroad expands into the Delaware Valley, eventually dooming the canal.[283]

1849: Cooper Furnace is erected in Phillipsburg by Peter Cooper and Abraham Hewitt; it becomes the Andover Furnace in 1867, receiving iron ore from boats on the Morris Canal and coal shipments from the Bel-Del Railroad and supplying the Trenton Iron Works with iron ingots. Rising production costs force it out of business on August 9, 1912.[284]

1850: The first Philadelphia water intake on the Delaware is operational.[285]

1850: The Bel-Del Railroad is built to service the transportation of passenger needs from Trenton to points north along the eastern shore of the Delaware River.[286] Philadelphia leads the nation in production of cloth, iron, leather and wood.

1850–1920: Between 1 and 5 million horseshoe crabs are harvested each year, primarily for bait and fertilizer, prompting population declines in horseshoe crabs and shorebirds.[287]

1850–1930: America's vacation habits, the limitations of transportation and the entrepreneurial spirit of a few local residents, coupled with spectacular scenic beauty, lift the little borough of Delaware Water Gap to the heights of Atlantic City; Coney Island; Bar Harbor, Maine; and Newport, Rhode Island.[288]

1852: Delaware passes a law making it unlawful to harvest oysters in any pond or creek from May through August.

July 11, 1855: The telegraph, the "lightning line," reaches the Kittatinny House at the Delaware Water Gap from Easton.[289]

May 27, 1859: A train leaving New York at 7:30 a.m. would arrive at the Delaware Water Gap station by 1:15 p.m.—a trip of nearly six hours on the Delaware, Lackawanna & Western Line.[290]

1859: Fort Delaware is completed, built on Pea Patch Island in the Delaware. It is utilized as a prisoner of war camp during the Civil War, especially after the Battle of Gettysburg. Overcrowding causes deplorable conditions and many deaths.[291]

March 6, 1860: The Kittatinny Improvement Company's steamboat *Alfred Thomas*, meant for the Belvidere, New Jersey–Port Jervis, New York run, explodes and sinks at Easton near Getter Island, killing thirteen crew and passengers.[292] The boat is subsequently raised and rebuilt and sees service on the Schuylkill River.[293]

March 1860: The final trip using a Durham boat on the Delaware is captained by Issaac Van Norman.[294]

1860: Pennsylvania produces 50 percent of iron in the United States and has more than 2,598 miles of railroad.

1870–1930: Delaware River–style decoy carving develops and peaks.

1861: The town of Phillipsburg, New Jersey, is incorporated in spite of efforts of private interests from Easton, Pennsylvania, to limit the town's development. Phillipsburg first appears on maps in 1749 and is organized in 1861 at the site of the native village of Chintewink; by the 1890s, it is a major gateway to the west and transportation hub of five railroads: Bel-Del, Lehigh Valley, Delaware & Lackawanna, Central New Jersey and Pennsylvania. All have track and service into the town depot and utilize the roundhouse that has been erected in the town's railyard.

1861: A whale is caught in the Delaware River at Philadelphia.

1861–65: The American Civil War causes increases in manufacturing and the expansion of railroads.

1862: John Reigel converts an old gristmill at Finesville, New Jersey, to manufacture paper products. He eventually operates four paper mills that become the Reigel Product Division of the James River Corporation in October 1977; by 1982, all paper production has ceased.[295]

1863: Confederate prisoners of war who are captured at Gettysburg are held at Fort Delaware on Pea Patch Island.

1865: The Riverton Yacht Club is founded in Riverton, New Jersey; this is the oldest yacht club on the Delaware.[296]

1866: The Pennsylvania Fish and Boat Commission is formed, with the primary focus of shad restoration.

1867–72: Six new hotels are constructed in the Delaware Water Gap: the Brainerd, the Lenape, the Riverfarm, the Glenwood, the Arlington and, on June 20, 1872, the Water Gap House, which rivals the Kittatinny in size and splendor. The Glenwood is the only hotel operating today.[297]

A Chronological History of the Delaware River and Estuary

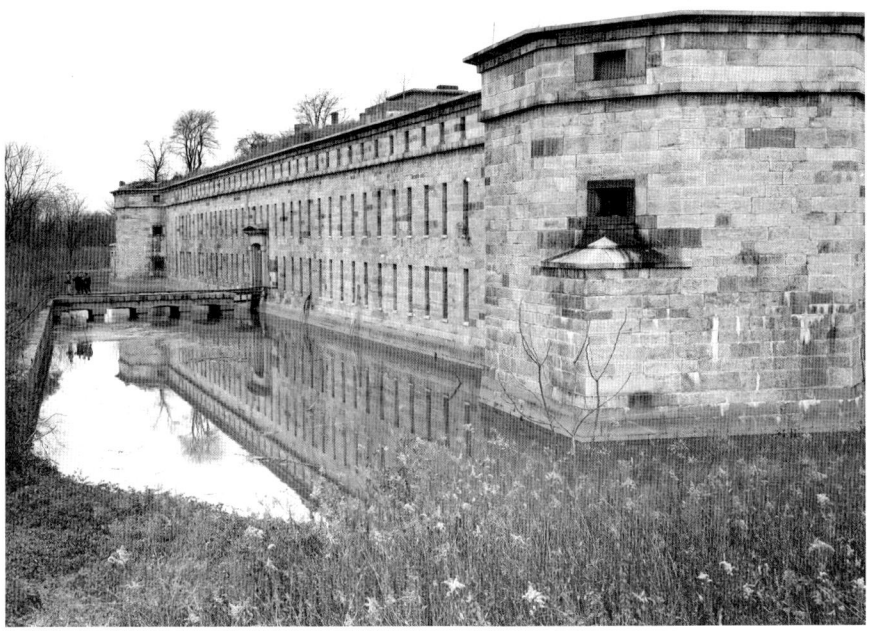

Fort Delaware on Pea Patch Island. The fort dates back to 1859. *Delaware Historical Society*.

1870–1930: Unlike today's vacationer, Victorian Americans would often spend the entire season at their favorite Delaware Water Gap resort, escaping from both the insufferable heat of the cities and the frequent summer cholera outbreaks.[298]

1870: The first bridge between Port Jervis, New York, and Matamoras, Pennsylvania, built in 1854, is blown down in 1870 by a violent windstorm; the replacement bridge, the Barrett Bridge, is built in 1872 and destroyed in 1875 by an ice jam. The second Barrett Bridge is built in 1876 but is lost in the 1903 flood. A third Barrett Bridge is built but is replaced in 1939 by a structure that still is in use.[299]

1873: Many tanneries in the Poconos close due to the financial panic of 1873, damaging the local economy severely. Local farmers have been supplementing their meager income by harvesting hemlock bark used in the tanning process.[300]

1875: The log and timber rafting era reaches its greatest height.[301] More than 3,100 rafts pass through the Lackawaxen Dam and under Roebling's viaduct with minimal damage.[302]

1876: Between Easton and the Delaware Water Gap, the Slate Belt, there are seventeen manufacturers producing sixty thousand cases of school slate per year.[303]

1876: Manunka Chunk, New Jersey, becomes a major rail center after two major railroads—the Delaware, Lackawanna & Western and the Pennsylvania Railroad—establish a junction. Both build new freight and passenger stations, and thus transfers to each other's lines are possible.[304]

1877–82: Early dredging of the Delaware: rock excavations take place at Schooner Ledge, and the fill is placed behind Chester Islan; the dredging of shoals takes place at Petty Island and Fort Mifflin, and the fill is placed at Fort Mifflin and League Island.

May 1879: The *Kittatinny*, a steamboat operated by the Kittatinny Hotel, arrives from Bristol, Rhode Island, to provide tourists with a scenic view of the Delaware Water Gap. In 1899, it is replaced by the *Kittatinny II*.[305]

1880: 2.9 million bushels of oysters are harvested from the Delaware Bay.[306]

1880: Many of Philadelphia's streams are converted into sewers as part of the city's sanitation plan.

1880s: Railroads outcompete canals.

1885: Debates begin regarding a clean water supply, including the possibility of an upland water supply within the Delaware Water Gap region.[307]

1885: The federal government enacts legislation authorizing permanent improvement of the Delaware River and Bay through construction of anchorages, dikes, revetments and harbors.

1886: The Pennsylvania State Board of Health is established to improve sanitary conditions, especially in providing clean water.

1888: Serious decline in sturgeon catches is reported.

1890s: Millworkers at the Roebling wire rope plant in Trenton could expect to earn nine to fifteen dollars per week for a sixty-hour week; child workers at the Ingersoll-Trenton watch factory earn about three dollars per week for a week of six and a half workdays.[308]

1890: The western terminus of the Morris Canal is at Port Delaware in Phillipsburg. Here boats are lifted out of the Delaware for their journey along the Morris Canal; it is at Port Delaware that five railroads and the Morris Canal come together to form a transportation hub.[309]

1890: The New Jersey Rubber Company operates in Lambertville, New Jersey, for forty-five years, closing in 1935, producing 7 million pounds of India rubber products per year. There were six rubber plants along the Delaware River between Trenton and Stockton.[310]

A Chronological History of the Delaware River and Estuary

1890: Trenton hosts thirty-seven establishments producing pottery and ceramics and as such is considered the pottery-making capital of the United States.[311]

1890: Estimates of 19 million pounds of American shad are harvested each year; declines are caused by pollution, overfishing, dams and the invasion of striped bass.[312]

1891: Shad increase due to construction of a fishway on the Lackawaxen Dam and artificial propagation.

1891: The Delaware Breakwater is built to protect shipping from Atlantic storms. It is completed in 1921.

1894–98: Dredging of Smiths and Windmill Island near Philadelphia; fill is placed on League Island to improve new Navy Yard.

1895: The cost of a train trip from New York to the Gap is $2.55; by 1933, the price has gone up to $2.82. Passenger service on the Delaware, Lackawanna & Western ends on January 5, 1970, due to America's changing vacation habits and the automobile.[313]

1895–1929: The American Horse Shoe Works operates on the Pennsylvania shore of the Delaware at Easton.[314]

1896: Dredging a thirty-foot channel authorized from Bombay Hook to Philadelphia.

1898: The Delaware and Hudson Canal is abandoned as a result of the growth of railroads into the area.[315]

1898: The Rosen Kranz Cable Ferry begins operating at Bushkill, Pennsylvania; the ferry operates until 1945 and is the last of its kind along the Delaware.[316]

1899–1911: Philadelphia builds "slow-sand" filtration plants to treat water from the highly polluted Delaware.[317]

1900: The New York Shipbuilding Plant opens in Camden; originally slated for Staten Island, Camden was seen as a more profitable site. It operates until 1967.[318]

1900: Seven major railroads and five canals intersect the Delaware River, signifying it as a major transportation corridor during the American Industrial Revolution. The Delaware River becomes known as the "American Clyde" after the Scottish shipbuilding industry on the Clyde River. The unique combination of a heavy-metal industrial base and a skilled workforce makes Philadelphia and Camden leaders in iron and steel shipbuilding well into the twentieth century.[319]

1900: The Delaware Estuary is the site of one of the world's largest concentrations of heavy industry, including steel-making, oil refining,

paper-making, shipbuilding and general manufacturing. The estuary becomes grossly polluted to the point that the smell sickens people.[320]

1900–1950: Pollution in the Delaware and Schuylkill Rivers is so severe that the Philadelphia Water Department continues to build a system of water treatment plants.[321]

1900–1980: Spring shad fishing north of Trenton is unpredictable because the shad have difficulty passing through the pollution created in the river in the Philadelphia and Camden areas.[322]

early 1900s: Menhaden fishery thrives for use in lamp fuel, paint and fertilizer; shad fishing reaches its peak.

early 1900s: Height of steamboat industry.

1901: Thomas Edison builds a cement plant in New Village, New Jersey; by the 1930s, the plant is shipping one hundred railroad cars of cement per day. Two other cement companies become major producers: the Alpha Portland Cement Company and the Lehigh Portland Cement Company. Lehigh closes in 1960, followed by Alpha in 1964.[323]

1902: The single-lane Milanville Bridge is completed. Initially, all bridges that cross the Delaware are privately owned toll bridges; in the 1920s, state agencies begin purchasing these bridges and eliminating their tolls.[324]

1902: Tocks Island is first surveyed as a possible dam site for a proposed hydroelectric project.[325]

October 1903: The Pumpkin Flood, the worst flood to date, washes away nine wooden bridges along the Delaware after nine inches of rainfall.[326]

1904: The Ingersoll-Rail company moves from West Easton, Pennsylvania, to a new facility in Phillipsburg, New Jersey, because of flooding concerns.

1904: The J.T. Baker Chemical Corporation is founded by John Townsend Baker along the Delaware River in Phillipsburg's north end. It acquires the Taylor Chemical Corporation in 1928 and the Dessoway Company in 1929; Baker itself is acquired by the Vick Chemical Company in 1960 to become Mallinckrodt Baker Inc. Since March 7, 2011, the company operates as Avantor Performance Materials.[327]

1905: The Pennsylvania legislature authorizes the Commonwealth Department of Health to control sewage discharges by permit.

1906: Mosquito control measures start in Delaware and New Jersey with parallel-grid ditching of marshes.

1907: The New York State Water Supply Commission studies a potential water supply and power project consisting of a large reservoir at Cannonsville, New York, on the West Branch of the Delaware. Included in the proposal are three other low dams designed for power production.[328]

1908: Standart Silk Mill, the Continental Silk Mill and Ryans Silk Mill are established in Phillipsburg.

1909–23: Trenton's Mercer Automobile Company manufactures a very popular high-class race-about type automobile that sells for $4,000. About five hundred are produced, and two Mercer race-abouts are lost when the *Titanic* sinks on April 15, 1912.[329]

1910–13: A New Jersey company promotes a hydropower dam at Belvidere, but the project is blocked by the 1783 anti-dam treaty. Other grand schemes include proposals for up to forty hydropower dams above Port Jervis, New York.[330]

August 2, 1910: Theodore Roosevelt visits the Water Gap House at Delaware Water Gap.[331]

1910: Weakfish fishery reaches its peak.

1910: The project "Philadelphia to the Sea," dredging the main shipping channel, is adopted.

February 21, 1911: Portions of the mountain at the narrowest point of the Water Gap are dynamited to permit space for the construction of trolley tracks. Within a few years, trolley service into the Water Gap is established both from Stroudsburg, Pennsylvania, and, with train connections, from the Philadelphia area.[332]

1911: Charles C. Worthington, a New York millionaire pump manufacturer, likes to vacation in the Poconos, so he builds his own resort with a private golf course: the Buckwood Inn at Shawnee-on-Delaware. Worthington's private 1,600-acre deer park in New Jersey has since become part of the Worthington State Forest.[333]

1912: Worthington invites a group of professional golfers to compete on his course at Shawnee-on-Delaware. This group becomes the forerunner of the Professional Golfers' Association of America, which is formed in 1916.[334]

1912–13: Through legislation passed in both New Jersey and Pennsylvania, the Joint Commission for the Elimination of the Toll Bridges on the Delaware River is formed.

1913: Pennsylvania passes Act 375, prohibiting discharge of anthracite coal, culm or refuse into streams.

1915: The Water Gap house burns to the ground and is never rebuilt.[335]

November 25, 1915: The Liberty Bell stops in Union Square in Phillipsburg on its way back to Philadelphia from the San Francisco Pan America Exposition. The bell is met by a throng of ten thousand spectators.[336]

A Chronological History of the Delaware River and Estuary

1915: The world's largest shipyard, built on a Hog Island mudflat, builds 122 ships, both cargo and troop ships used during World War II. It is closed in 1921. The land is filled with spoil dredged from the river channel. Today, it is the Philadelphia International Airport.

1917–18: U.S. involvement in World War I begins; ship traffic on the Philadelphia-to-the-sea channel increases.

1918: The height of Philadelphia's shipbuilding industry.

1919: The federal government takes over the Chesapeake and Delaware Canal, widens and deepens the canal and removes locks.

1920s: The Boy Scouts of America have been allowed to camp at the Water Gap Reservation since the early 1920s at the foot of Mount Tammany in the Gap. The Boy Scouts acquire the land in 1928 and operate two campgrounds, Camp Minsi and Camp Weygadt. The Easton Area Council of the BSA operates the combined camps as Camp Weygadt from 1931 until its closing in 1968. A smaller Boy Scout camp is sponsored at the site of the Pahaquarry Copper Mine for a short time. (The author was at Camp Weygadt the last week of July 1956; does anyone remember the copperhead snake pit, the rifle range, evening campfires and, of course, the snipe hunts followed by the trek to the summit of Mount Tammany?)

1920–50: Philadelphia-Camden shipbuilding dies out.

1920: The 1783 anti-dam treaty is starting to be seen as an impediment to the future development of hydropower projects on the Delaware River. It becomes clear that New Jersey, New York and Pennsylvania need to discuss mutual water supply needs regarding the Delaware River Basin.[337]

1920: Shad fishery is almost eliminated due to pollution, habitat loss and overfishing. Oyster harvest rates begin to decline.

1921: Hugh Eugrett Moore builds his paper products factory in Easton, and the hazards of sharing the "tin dipper" lead to the invention and success of the Dixie Cup. Dixie merges with the American Can Company in 1957, which is in turn acquired by the James River Corporation in 1982.[338]

January 6, 1922: Construction begins on the Benjamin Franklin Bridge, originally named the Delaware River Bridge, connecting Center City Philadelphia with Camden, New Jersey.

1923: The era of lumber rafts ends.[339] The Chesapeake and Delaware Canal reopens. Philadelphia's first major modern water treatment plant begins operating.

1924: First study to propose a water supply dam at Wallpack Bend above the Delaware Water Gap.[340]

A Chronological History of the Delaware River and Estuary

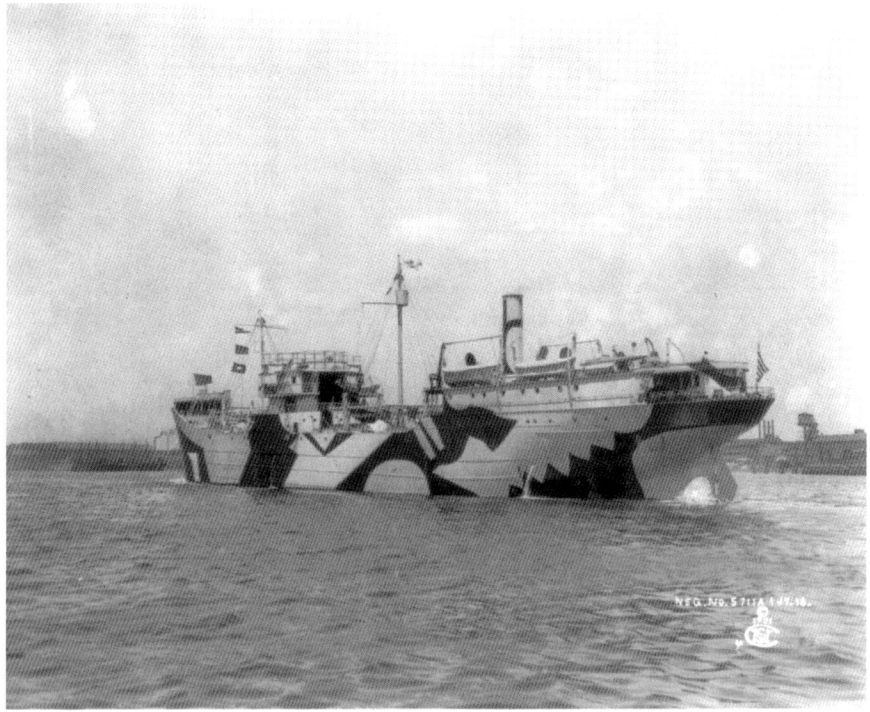

Camouflage freighter *Absecon* on trial trip in Delaware Bay, circa 1921. *Library of Congress.*

1928: Companies offering trolley service in the Delaware Water Gap try, unsuccessfully, to compete with the growing bus lines.[341]

1929: Robert E. Horton's report prepared for the Trenton Public Works Department is the first to propose the multipurpose development of the Delaware River Basin.[342]

1929: The Gilbert Electricity Generating Station in Holland Township, New Jersey, requires six hundred tons of coal per day to operate. In 1971, to comply with New Jersey Air Quality Standards, it is converted to oil firing, requiring 225 railroad tank cars of oil per month. In 1974, it is converted to natural gas.[343]

1930–34: First comprehensive Water Resources Plan for the Delaware, including a proposal for Tocks Island Dam. Aerial spraying of salt marshes with persistent pesticides (e.g., DDT) begins. Salt marshes are drained or diked, destroying important ecological breeding grounds.

1930–58: The Philadelphia main ship channel is dredged to thirty-five feet and then to forty feet.

A Chronological History of the Delaware River and Estuary

1930s: The Consolidated Fisheries Company has the largest menhaden processing plant in the country. The inedible fish is used for lamp oil, fertilizer, paint production and animal feed.[344]

1930: White perch fishery reaches its peak. The oyster crop of New Jersey is valued at $5 million annually.[345]

1930: 90 percent of salt marshes from Maine to Virginia are parallel-grid ditched for mosquito control by this time.

1930: Citizens petition Roosevelt about the effects of the estuary's pollution on health of women and children.

May 4, 1931: Justice Oliver Wendell Holmes of the Supreme Court affirms New York's right to a fair share of water from the Delaware River. The U.S. Supreme Court decree, amended in 1954, allows New York City to withdraw water from the Delaware as long as mandated flows are maintained by releases from water supply reservoirs built on the West Branch, East Branch and Neversing Rivers in New York State. The Delaware may be undammed but is far from free-flowing.[346]

October 1931: The bankrupt Delaware Canal sees its last traffic.[347]

1931: The Delaware River Joint Toll Bridge Commission (DRJTBC) is established by state and federal legislation and has jurisdiction over 146 miles of the river.

1934: The Delaware and Raritan Canal is returned to state control and ceases operations.[348]

1934: The Delaware River 308 Report is the first comprehensive water resource management plan for the Delaware River Basin, including navigation, electric power, flood control, irrigation, water supply and water quality. Dam sites examined include Chestnut Hill at Easton, Belvidere, Wallpack Bend and Tocks Island.[349]

1936: The Flood Control Act of 1936 expands the federal role in flood control and assigns specific responsibilities to the U.S. Army Corps of Engineers, eventually becoming the nation's largest dam-building agency.[350]

1936: New York, New Jersey and Pennsylvania create the Interstate Commission on the Delaware River Basin (INCODEL) to establish water quality standards and take measures to meet them.

1937: Bombay Hook National Wildlife Refuge established in Delaware. Pennsylvania first exerts controls on industrial water pollution. Anti-stream pollution law authorizes $5 million to remove coal silt from the Schuylkill River.

January 14, 1938: The Easton-Phillipsburg toll bridge is opened to east-west traffic.

A Chronological History of the Delaware River and Estuary

1938: State of Delaware joins INCODEL.

1940s: As the result of three hundred years of expanding human habitation in the Delaware River Basin, the tidal Delaware River is largely considered an open sewer for both public and industrial waste. Pollution is rampant—people are sickened by the mere smell of the river, and large portions of the estuary are considered "dead zones," areas almost or completely devoid of oxygen needed for the survival of fish and other aquatic life.[351]

1940–42: First major deepening project removes 42 million cubic yards of dredge material from the Philadelphia ship channel, deepening it by forty feet.

1940–50: Dissolved oxygen levels reach catastrophic lows, with anoxic conditions stretching for twenty miles around Philadelphia. Widespread use of DDT kills mosquitoes but also has detrimental effects on non-target species.

1940–60: Widespread creation of impoundments for control of salt marsh mosquitoes.

1941–45: World War II increases ship traffic and industry in the estuary.

1941: President Roosevelt orders investigation to determine if pollution is hampering war buildup efforts on the Delaware. Only 8 percent of industrial waste is treated before discharge.

1942–43: Channel maintenance dredging removes 29 million cubic yards of dredge material annually.

1942: Test borings taken to a depth of 140 feet at Tocks Island lead to the rejection of the site as a proposed water supply dam; Wallpack Bend becomes the preferred dam site.[352]

1943: Fred Waring acquires the Buckwood Inn at Shawnee-on-Delaware and becomes famous for his 1945–54 CBS TV program *The Fred Waring Show*, featuring the choral group The Pennsylvanians.

1945: After World War II, the Philadelphia Board of Consulting Engineers is appointed to conduct a study of the potential upland water sources. The board promises a main-stem dam project in the upper Delaware region but rejects the Tocks Island site because of the results of the 1942 test boring done by the Corps of Engineers. A main-stem dam at the "S" curve at Wallpack Bend would create a reservoir thirty miles long and half a mile wide; potential recreational use becomes an asset of the project.[353]

1946: Philadelphia launches an $80 million sewer improvement and treatment program.

October 4, 1947: Passenger service between Philadelphia and the Delaware Water Gap ends, according to Martin Wilson's *History of Delaware Water Gap*.

A Chronological History of the Delaware River and Estuary

1949: The Delaware River Development Corporation is formed and, in 1951, receives federal approval to study three possible Delaware River power dams. The largest proposed is at Tocks Island, creating a twenty-two-mile-long lake and generating capacity of 150,000 horsepower.[354]

February 1, 1949: Construction begins on the initial span of the Delaware Memorial suspension bridge, which opens on August 16, 1951. The second span, a twin, opens on September 12, 1968. The height of the bridge is 441 feet, and the overall length approaches 11,000 feet.

1949: New law allows oyster dredging under power, which damages beds and spreads silt over seed oysters, which then fail to reproduce.

Mid-1900s: Estuary suffers from gross pollution. Wastewater treatment facilities are built.

1950: The urban reach of the Delaware River is one of the most polluted rivers in the world.[355]

1950–80: A disease originating in Asia (MSX) causes drastic declines in oyster populations.

1951: Philadelphia Northeast sewage treatment plant is rebuilt to upgrade level of treatment.

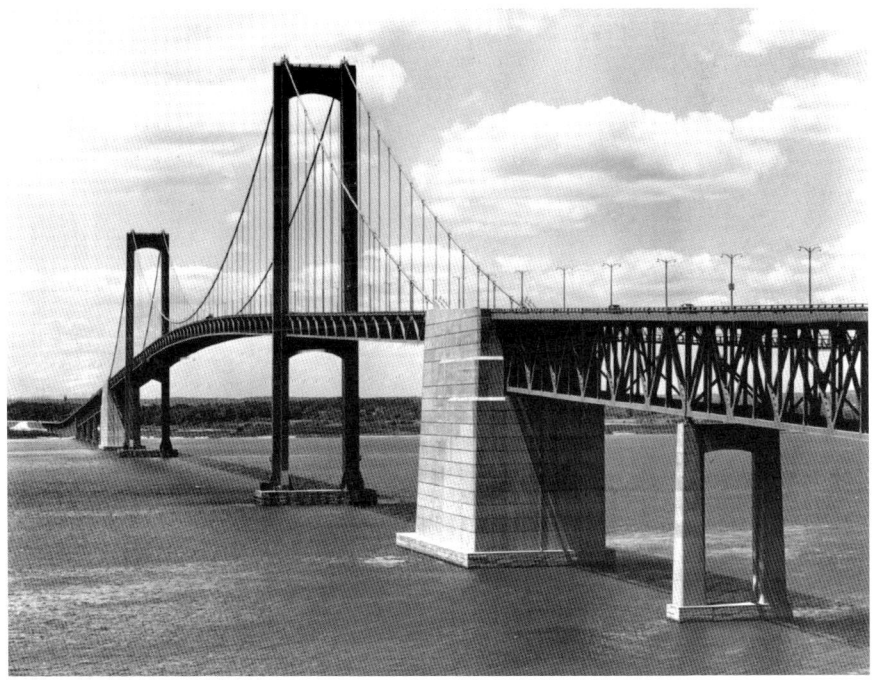

Delaware Memorial Bridge, circa 1951. *Delaware Historical Society.*

1952: New York City petitions the Supreme Court to reopen the Delaware River Case, seeking to increase its water allotment; under the Montague Formula agreed to, water allotments are increased, and it is also agreed that a minimum flow is to be maintained at Port Jervis, New York.[356]

1952: New York State plans to build a reservoir at Cannonsville with or without the assent of New Jersey, Pennsylvania or Delaware.[357]

1953: Morrisville, Pennsylvania Waste Water Treatment Plant opens; the plant is expanded over the years based on urban population growth.

August 1, 1953: Construction begins on the Walt Whitman Bridge connecting Gloucester City, New Jersey, with Philadelphia. The span opens on May 16, 1957, at a length of 11,982 feet and a height of 378 feet.

December 30, 1953: The New Jersey legislature enacts legislation that allows Pennsylvania the authority to build a dam at Wallpack Bend and revokes the anti-dam provision of the New Jersey and Pennsylvania Treaty of 1783.[358]

1954: Philadelphia Southeast sewage treatment plant opens, with only primary treatment.

1954: Amended Supreme Court decree permits New York City to increase its withdrawal from 400 mgd to 800 mgd and permits another diversion to central and northeastern New Jersey through the Delaware and Raritan Canal.

1955: The Pepacton Reservoir is completed; releases from the reservoir change the East Branch from a warm-water fishery to a cold-water one.[359]

August 1955: Two hurricanes in succession, first Connie and then Diane, devastate the Delaware Valley with torrential rains exceeding twenty inches over four days. In Phillipsburg, the river rises to a level of forty-three feet, ten feet above the record set in the 1903 flood. The death toll for the two storms climbs to four hundred, the most shocking of which are the thirty-seven young children and campers who drowned while camping on Broadhead Creek.[360]

August 19, 1955: The 761-foot covered bridge between Columbia, New Jersey, and Portland, Pennsylvania, built in 1839 and rebuilt in 1867, is washed away. It is replaced with a 770-foot pedestrian bridge.[361]

August 1955: Planning focuses on the possibility of New Jersey and Pennsylvania building a dam at Wallpack Bend, creating a lake twenty-five miles long containing 121 billion gallons of water. After Hurricanes Connie and Diane descend on the Delaware Valley with massive flooding and loss of life, the possibility of significant federal involvement is raised, since flood control is clearly the responsibility of the federal government.[362]

A Chronological History of the Delaware River and Estuary

September 1955: The U.S. Army constructs Bailey Bridge between Easton, Pennsylvania, and Phillipsburg, New Jersey, as a temporary fix for the damage caused by the floodwaters that make the Free Bridge impassable.

1955: Gulf Oil donates 145-acre non-tidal wetland to City of Philadelphia for the Tinicum Wildlife Refuge (now John Heinz National Wildlife Refuge).

1956–60: Corps of Engineers Comprehensive Study of the Delaware River Basin takes four years to complete.

1956: The Delaware River Basin Survey Commission changes its name to the Delaware River Basin Advisory Committee (DRBAC) and sets its goal to make sure any dam project recommended by the Corps is actually built.[363]

February 20, 1956: The Senate Committee on Public Works adopts a resolution directing the Corps of Engineers to study the feasibility of constructing and operating a reservoir on the Main Stem of the Delaware River near Wallpack Bend or Tocks Island, with the cooperation of New Jersey and Pennsylvania.[364]

February 1957: The results of the Corps study indicate that an earth-filled dam could be built at its Tocks Island site.[365]

1957: Oyster production collapses as a result of an outbreak of the MXS microscopic parasite, followed in 1990 by an outbreak of the DERMO or perkisosis parasite; 90 percent of New Jersey oysters die by 1959.[366]

January 1959: The Corps announces its preliminary reservoir plan for the Delaware River Basin: five dams are to be constructed before 1980, and an additional sixteen dams are deemed to be necessary beyond 1980. The keystone to the whole project is to be a dam at Tocks Island.[367]

May 22, 1959: The second major objective of the DRBAC is achieved with formation of a basin-wide citizens' advisory organization.[368]

1959: Menhaden fishery starts to decline. Bluefish fishery reaches its low.

1960–70: Weakfish fishery reaches its low.

1960s–1970s: Wetland filling for highway projects in Camden, Philadelphia and Wilmington, Delaware, destroys important tidal ecological areas.

1960–83: Motorized trawling outlawed in the bay. Large-scale cooling-water entrainment and impingement of organisms begins. Many cities above Philadelphia have secondary water treatment plants; only primary water treatment is required below Philadelphia.

1960: The Corps of Engineers begins acquiring land for the Tocks Island Dam; ultimately, fifteen thousand people are evicted and three to five thousand homes and other buildings are acquired and demolished in preparation for the dam and the subsequent flooding of the Minisink Valley.[369]

1960: Corps reservoir plan is finalized; Tocks Island is the largest dam in the plan. Power companies announce plans for the Kittatinny Mountain Pump-Storage Project, expecting to use water from the Tocks Island Dam for generating power.[370]

March 1960: The Corps announces its finalized plans for a fifty-year comprehensive water resource plan for the Delaware River and its tributaries. From a potential 193 dam sites, 19 are selected for construction; of the 19 selected, 8 are chosen for immediate authorization by Congress. Tocks Island is seen as essential to the entire program.[371]

1960: Corps report calls for fifty-eight water control projects to be built over a fifty-year period, including the Tocks Island Dam.[372]

1960: Horseshoe crabs are discovered to have a substance in their blood capable of detecting harmful toxins in biological testing.

early 1960s: Construction of Interstate 95 through Churchmans Marsh and Christina River Corridor, affecting more than one thousand acres of tidal marsh and non-tidal wetlands.

1961: Power companies purchase land from the State of New Jersey, including Sunfish Pond, for their Pump-Storage Project; public outcry would follow.[373]

1961: Peregrine falcons no longer found in Pennsylvania.

1961–67: Record drought in basin.

1961: Value of oyster resource is decreased from $27 million in 1954 to only $18,000. U.S. Public Health Service initiates its Delaware Estuary Comprehensive Study (DECS).

1961: The Delaware River Basin Commission (DRBC) is created under federal law signed by John F. Kennedy as an interstate compact, an agency of the United States government. Membership includes the governors of Delaware, New Jersey, Pennsylvania and New York and a representative of the U.S. Corps of Army Engineers, a ranking officer, who holds the chair.[374] On December 13, the DRBC gathers at the Nassau Inn in Princeton for its first meeting.[375]

October 23, 1962: Congress passes the Flood Control Act of 1962 and authorizes the comprehensive development of the Delaware River Basin.[376]

May 23, 1962: The DRBAC is officially dissolved.[377]

1962: As a result of the severe flooding, property damage and deaths caused by the 1955 flood, Congress passes the Flood Control Act, providing for a huge main-stem dam at Tocks Island, six miles north of the Delaware Water Gap. The Army Corps of Engineers becomes Public Enemy No. 1.

Public and local political reaction are swift and negative. The dam is never built and is finally de-authorized.[378]

1962: The Delaware River and Bay Authority (DRBA) is formed in a bi-state agreement between Delaware and New Jersey.

1962: A dredged forty-foot channel is completed between the Navy Base and Alleghany Avenue in Philadelphia.

February 27, 1964: Adoption of the first Water Resource Program based on the long-range comprehensive plan.

July 1, 1964: The Cape May–Lewes ferry begins operations.

1965: The Water Quality Act of 1965 (Public Law 89-234) and the Water Quality Improvement Act of 1970 (Public Law 91-224) both provide for substantial fines and extensive liability for the discharge of oil into navigable waterways.

September 1, 1965: President Johnson signs Public Law 89-158, making the Delaware Water Gap National Recreation Area a reality. This provides for the acquisition of 47,675 acres of land at a cost of $37.4 million, in addition to the 24,000 acres previously authorized for the

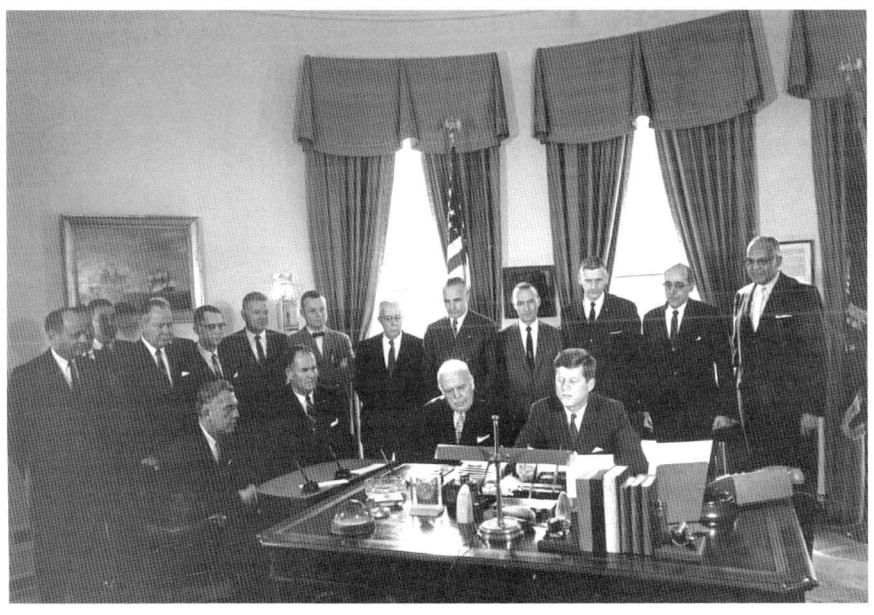

President John F. Kennedy prepares to sign the Interstate Federal Compact for the Delaware River Basin. *Delaware River Basin Commission.*

From left to right: Governors Nelson Rockefeller (New York), Richard Hughes (New Jersey) and Elbert Carvel (Delaware). *Delaware River Basin Commission*.

Tocks Island Dam Project. The DWGNRA will eventually encompass an area of 72,000 acres (104.3 square miles) along a 40-mile stretch of the Delaware River, to be administered by the National Park Service of Pristine Forest.[379]

1965: The Delaware Valley Conservation Association is formed to fight both the dam and the recreation area.[380]

1965: Pennsylvania passes the Anthracite Coal Mine Act, establishing a program to prevent pollution from anthracite mining operations.

1965: The DRBC declares a state of water supply emergency in the Delaware River Basin.

1966: The Lenni Lenape League forms to fight the Pump-Storage Project to be built on Kittatinny Mountain.[381]

1966: Menhaden fishery stops due to lack of fish.

1967: The Clean Water Council of New Jersey is established to serve as an advisory body to the NJDEP and to improve the Water Pollution Control Program in New Jersey.

1967: The DRBC adapts the most comprehensive water quality standards of any interstate river basin in the nation, which include bacterial standards for water recreation activities.[382]

1968: The DRBC adapts regulations for the implementation and enforcing of its comprehensive water quality standards.[383]

1968: Construction of Salem nuclear power station begins.

1969–70: Three fish ladders are installed on the Brandywine.

1969: The Corps of Engineers has accumulated an inventory of empty houses and other buildings in the Tocks Island area. It attempts to rent these buildings to offset the loss of local tax revenue. Squatters began moving in on both sides of the river and create a great deal of unrest among the residents. Court battles ensue, and on November 12, 1973, it is ruled that squatters are illegally occupying federal property. When people refuse to vacate, on February 4, 1974, the squatters are removed by the Justice Department using a paramilitary force of marshals and state police.[384]

July 1, 1969: The public had generally been ignorant of the earlier sale of Sunfish Pond to the power companies in 1961. Amid political controversy and environmentalist outrage, the pond is sold back to the State of New Jersey and once again becomes part of the Worthington State Forest.[385]

1969: The National Environmental Policy Act (NEPA) is enacted.

1970s: Tenneco proposes an 1,100-acre Liquid National Gas (LNG) facility in West Deptford Township, Shell Oil proposes to build an oil refinery on 1,600 acres in Logan Township and Tranco proposes another LNG plant on 2,300 acres in Logan Township—all in Gloucester County, New Jersey, along the shores of Delaware Bay.

1970: New Jersey legislature passes the Wetlands Act, protecting many of the state's environmentally sensitive areas.[386]

December 2, 1970: The establishment of the Environmental Protection Agency (EPA) results in federal water programs for expanded water quality protection, state departments of environmental protection and conservation and legislation requiring environmental impact statements.

June 28, 1971: The Delaware legislature passes House Bill 300, which includes a ban on the construction of deep-water port facilities and certain heavy industrial and oil tank farms in the coastal zone. As a sequel to Bill 300, a joint House resolution appoints a Delaware Bay Transportation Committee to study future port facility needs.

1971: About 70 percent of all the oil that is delivered to the East Coast of the United States moves by water up the Delaware Bay and River.

A Chronological History of the Delaware River and Estuary

August 1972: There are seven oil refineries located on the Delaware Bay and River.

1972: A study of the Tocks Island Project by the Environmental Defense Fund concludes that costs were underestimated and that benefits were overstated.[387]

1972: Congress delays dam construction until environmental issues are resolved. New Jersey governor William T. Cahill outlines conditions for his state's continued support for the dam—they are never met.[388]

December 1972: Governor Shapp of Pennsylvania signs into law the Pennsylvania Scenic Rivers Act, which provides for stream management and special protections. The National Wild and Scenic River Act comes with a prohibition against dams, a restriction that would require further consideration in the future, according to Tim Palmer's *Rivers of Pennsylvania*.

1972: Use of DDT is outlawed in the U.S. Osprey populations rebound.[389] The Coastal Zone Management Act (CZMA) is passed. Federal Water Pollution Control Act is amended (Clean Water Act).

June 1972: Schuylkill oil spill, Schuylkill River, Pennsylvania: 8 million gallons of waste crankcase oil and sludge are released into the river following flooding caused by Hurricane Agnes.

1973: Congress enacts the Endangered Species Act (ESA).

1974: Congress authorizes $65 million for a Tocks Island review study; for the first time, no money is appropriated for the dam.

1974: First bill to de-authorize the Tocks Island Dam.

1974: Governor Branden T. Byrne of New Jersey reveals other economic options exist to reduce flooding and improve water supply than the dam.

1974: Congress enacts the Safe Drinking Water Act (SDWA).

1975: The Delaware River Basin Commission—made up of the governors of New Jersey, Pennsylvania, New York and Delaware—votes three to one to disapprove the construction of Tocks Island Dam.[390]

1975: Shad populations increase.

1975: *Corinthos* oil spill, Marcus Hook, Pennsylvania: 11 million gallons of Algerian crude oil are spilled after an American tanker, *Edgara M. Queeny*, rams the Greek tanker *Corinthos*.

1975–77: Further attempts to de-authorize the dam.

1976: The DRBC begins Level B Study to identify and resolve water resources issues.

1976: The DRBC receives a $1.1 million grant from the U.S. Water Reservoir Council to reevaluate its comprehensive plan (the Level B study). State

water supply studies are conducted by Pennsylvania and New Jersey, and the Corps has flood-control and salinity studies underway—each seeking alternatives to the Tocks Island Dam.[391]

1976: Congress enacts the Resource Conservation and Recovery Act (RCRA) and the Toxic Substances Control Act.

1977: Two nuclear generating stations are constructed on an artificial island in Delaware Bay. Salem Unit No. 1 begins producing electricity in 1977 and Salem Unit No. 2 becomes operational in 1981. Two additional nuclear generating stations are proposed at Hope Creek, New Jersey, with ten reactors. When operational, New Jersey would have the greatest nuclear dependency of any other state in the nation.

1978: "Good Faith Negotiations" are to provide the basis for the new formula for the equitable apportionment of the basin water by the partners of the 1954 Supreme Court decision.[392]

1978: Corps of Engineers transfers the land that was acquired by purchase and eminent domain to the Delaware Water Gap National Recreation Area.

November 10, 1978: President Jimmy Carter signs legislation, the National Parks and Recreation Act, which designates both the upper Delaware and the middle Delaware as components of the National Wild and Scenic River System. The provisions of the act make construction of the Tocks Island Dam virtually impossible.[393]

March 1979: Good Faith Negotiations begin.

July 1979: Congress appropriates $1.5 million to fund a study to seek alternatives to the Tocks Island Dam.

1980s: By this date, more than $1 billion has been spent on improving wastewater treatment facilities in the Delaware River Basin, to the benefit of both people and aquatic life in the river.[394]

1980 85. Years of drought always lead to concern about maintaining minimum river flow to prevent salt water from the estuary approaching water intakes in Philadelphia; again discussions involve Tocks Island Dam.[395]

1980: Southeastern Pennsylvania Ground Water Protected Area is established.

1981–86: Philadelphia Northeast, Southeast and Southwest sewage treatment plants are upgraded to secondary treatment with disinfection.

February 12–14, 1981: One of the worst ice jams in the river's history. On February 12, the river reaches flood stage of 26.6 feet at Port Jervis, New York, 1 foot higher than the previous record set in the ice flood of 1904.[396]

1981: Salem nuclear power station Unit II becomes operational.

1981: Congress enacts the Comprehensive Environmental Response, Compensation and Liability Act (CERCLA), commonly known as Superfund. DRBC releases Level B Study; identifies a preferred plan of action for water resources management through 2000.

1981: Highest record shad catch above Trenton since 1896.

1983: Good Faith Agreement signed by parties to the U.S. Supreme Court Case. The DRBC adopts the Good Faith recommendations, and construction of the dam is deferred until sometime after 2000.[397]

1983: There is a 60 percent reduction in BOD waste discharge loading compared to 1958. Large-scale chlorination of municipal and industrial waste begins. Widespread use of organotin antifouling paints begins.

1984: Significant upgrades to Philadelphia's sewage treatment plants reduce pollution in the waterway by 95 percent.[398]

1985: Drought declared. Ground is broken for the Merrill Creek Reservoir, the first project agreed to under the Good Faith Negotiations.[399]

1985: White perch fishery lowest since 1940.

1985: Creation of the Western Hemisphere Shorebird Reserve Network, linking the Delaware Estuary to a hemisphere-wide chain of shorebird protection sites.

1985: *Grand Eagle* oil spill, Marcus Hook, Pennsylvania: the Panamanian tanker *Grand Eagle* runs aground and spills 435,000 gallons of crude oil into the estuary.

1986–92: Water conservation program established by the DRBC for Pennsylvania's portion of the basin.

1986: The *DeBraak*, a British sloop of war, is raised from Delaware Bay. It had sunk during a storm in 1798, taking forty-seven souls to the bottom.[400]

1986: Hope Creek nuclear power station becomes operational. The DRBC, with state and federal agencies, begins the Delaware Estuary Use Attainability Project.

1988: The Delaware Riverkeeper Network (DRN) is established, a nonprofit membership organization consisting of a professional staff and volunteers. It is the only watershed-wide advocacy group with the goal of the protection and restoration of the Delaware River, taking a strong stance on local and regional issues that threaten water quality and the ecosystems of the Delaware River.

1988: Delaware Estuary is awarded status in USEPA's National Estuary Program.

1989: The DRBC initiates its Delaware Estuary Toxics Management Program, designed to develop methods to control the discharge of toxic

pollutants from wastewater treatment plants; in 1999, changes in the regulations add many toxic substances to those controlled, and in 2010, DRBC's toxics criteria are updated once again.[401]

1989: *Presidente Rivera* oil spill, Marcus Hook, Pennsylvania: the Uruguyan tanker *Presidente Rivera* runs aground, ripping open four of seventeen tanks and spilling 306,000 gallons of no. 6 oil (heavy industrial grade).

1989: Merrill Creek reservoir is dedicated to replace consumptive water losses from power generation.

1990: Peregrine falcons return to Pennsylvania.

1992: The Delaware River Basin Commission launches the Special Protection Waters (SPW) program, which establishes regulations to "keep clear water clean" in the upper and middle sections of the non-tidal river.[402]

1993: Nutrient Management Act passed by Pennsylvania, requiring farms to develop a nutrient management program.

1993: *M/V Ellen Knutsen* oil spill, Philadelphia, Pennsylvania: a crack between a cargo tank and a ballast tank allows a mixture of oil and ballast to leak out, totalling about sixteen thousand gallons.

1993: *T/B New Jersey* oil spill, C&D Canal: 4,915 gallons of no. 6 fuel oil leak from the starboard tank.

1994–2006: PSEG Estuary Enhancement Program restores more than twenty thousand acres of salt marsh and adjacent uplands.

1994: *T/V Kentucky* oil spill, Paulsboro, New Jersey: the *T/V Kentucky* hits something in the water, damaging the bottom and spilling thirteen thousand gallons of Arabian light crude oil.

1996: The Comprehensive Conservation and Management Plan for the Delaware Estuary is created to coordinate the efforts of many organizations. The Partnership for the Delaware Estuary, a nonprofit organization, is also established.[403]

1996: *T/V Anitra* oil spill, Big Stone Anchorage, Delaware Bay: the *T/V Anitra* develops a leak in the cargo hold, causing forty-two thousand gallons of Angolan crude oil to leak out.

1996: Comprehensive Conservation Management Plan (CCMP) is adopted for the Delaware Estuary. The DRBC adopts regulations governing discharge of toxic pollutants from wastewater treatment plants to the estuary.

1996–2006: 6,500 acres of both coastal and inland wetlands are lost to human development, sea level rise and erosion.

1997: *T/V Mystra* oil spill, Delaware Bay: a faulty valve causes a spill of ten thousand gallons of crude oil.

1998: Fish populations show sharp increases due to water quality improvements. Withdrawal limits are set for Southeastern Pennsylvania Ground Water Protected Area.

1999: Governors of the four basin states sign the "Resolution on the Protection of the Delaware River Basin" and call for development of a new comprehensive water resources plan for the basin.

2000: As the result of the improvement in water quality, the federal government designates an additional 38.9 miles of the Delaware as part of the Delaware National Wild and Scenic River System.[404]

2000: Pipeline oil spill, Tributary, near Tinicum, Pennsylvania: seventy-five thousand gallons of oil leak from a pipeline.

2001: DRBC declares a state of water supply emergency in the Delaware River Basin.

2002: The Tocks Island Dam is officially de-authorized as a separate entity from the Delaware Water Gap National Recreation Area. The dam would have created a reservoir thirty-seven miles long with a depth of 140 feet in places. More than seventy-two thousand acres of land were acquired, purchased, condemned and/or seized by eminent domain for the dam; this land is given to the DWGNRA.

2003: TMDLs established for PCBs in tidal portions of the River.

2004: Partnership for the Delaware Estuary merges with the Delaware Estuary Program (DELEP) and becomes the administrator for the EPA's Delaware Estuary Program.

2004: *Athos I* oil spill, Delaware River near Philadelphia: a Cypriot tanker strikes several pipes and other underwater objects, breaching a cargo tank and releasing 265,000 gallons of Venezuelan heavy crude oil.

2005: The DRBC adopts a rule establishing pollutant minimization plan requirements for point and non-point source discharges of PCBs to the estuary.

2005–12: Harvests of blue crabs have increased, averaging 8.3 million pounds per year, due to a fishery management plan implemented after sharp harvest declines.[405]

Summer 2009: The Army Corps of Engineers, encouraged by the governor of Pennsylvania and Senator Arlen Specter, takes steps to deepen the Delaware River from the currently authorized forty feet to forty-five feet for a distance of 102 miles despite the fact that it does not have the necessary permits and approval from the states of Delaware and New Jersey and the Government Accountability Office (GAO) has twice challenged the purported economic benefits of the project (DRN).

Spring 2010: Governor Rendell of Pennsylvania and the Army Corps of Engineers propose a project called the Southport Marine Terminal, a new container facility, which would require the filling of seven acres of wetlands and thirty-three acres of open water, as well as the destruction of the few remaining sections of natural riverbank. It is presented as a method of disposing of spoils from the Army Corps Delaware deepening proposal (DRN).

2010: The population of the Delaware River Basin grows to 8,255,013.

June 28, 2011: Salem Unit No. 2 has a "hot shutdown" after a cooling pump failure.

2012: Of the six biggest floods in the last one hundred years, three of them occurred in the last fifteen years.[406]

2013: The Calhoun Street Bridge in Trenton is 130 years old and the longest and only wrought-iron bridge on the Delaware River system.[407]

2014: The Delaware River Scenic Byway is both a scenic and historical tour of the Delaware River corridor, defined by the parallel historical transportation arteries, including the canals, the river, the railroads and the roads.[408]

March 2015: Since the DRBC and its member states' environmental agencies often share similar mission objectives and regulatory programs, as part of its "One Project/One Permit" initiative, the DRBC and the New Jersey Department of Environmental Protection have concluded an administrative agreement focusing on cooperation and shared responsibility in processing wastewater project applications.[409]

2015: The NJDEP Storm Watch Initiative's Storm Water Pollution Prevention Plan (SPPP) establishes standards and regulations for the cleaning and maintenance of municipally owned and operated storm water facilities.

Spring 2016: Since the DRBC was created by legislature action in 1961, it has processed a docket of applications for permits for both municipal wastewater projects (forty) and industrial wastewater projects (sixty-four); applications processed included initial permits as well as approvals for modifications to existing permits.[410]

2016: The work of the DRBC is far from complete, although great strides have been made in cleaning up the river; parts of the river are still not "fishable nor swimmable," which is the stated goal of the Federal Clean Water Act.[411]

2017: Farmers employ Best Management Practices (BMPs) to protect the surface and underground water of the Delaware River Basin/watershed.

BMPs are sustainable conservation practices that are both practical and cost-effective actions for handling agricultural waste, manure, compost, chemical fertilizers and other agricultural-use chemicals, focused on minimizing the possible adverse impacts on human, animal and plant life within the basin.

APPENDIX I

WATERSHED/STAKEHOLDER GROUPS AND PARTNERS

Source: www.nj.gov/drbc

Name of Organization	City	State	Telephone
1. Aquashicola/Pohopoco Watershed Conservancy	Kresgeville	PA	570-992-5125
2. Aquetong Watershed Association	New Hope	PA	267-714-8170
3. Berks Nature	Reading	PA	610-372-4992
4. Bertsch-Hokendauqua-Catasaqua Watershed Association		PA	610-746-1971
5. Brandywine Valley Association	West Chester	PA	610-793-1090
6. Brodhead Watershed Association	Henryville	PA	570-839-1120
7. Bushkill Stream Conservancy	Tatamy	PA	
8. Cape May County Watershed Management Area 16	Cape May Court House	NJ	609-465-1085

APPENDIX I

Name of Organization	City	State	Telephone
9. Chester-Ridley-Crum Watersheds Association	Media	PA	610-892-8731
10. Christina Conservancy Inc.	Wilmington	DE	
11. Citizens United to Protect the Maurice River	Millville	NJ	609-774-5853
12. Coalition for the Delaware River Watershed	Trenton	NJ	609-392-1182
13. Cooks Creek Watershed Association	Springtown	PA	
14. Cooper River Watershed Association	Haddonfield	NJ	856-428-8672
15. Cooper's Ferry Partnership	Camden	NJ	856-757-9154
16. Crafts Creek Spring Hill Brook Watershed Association Inc.	Bordentown	NJ	609-298-4262
17. Crosswicks-Doctors Creeks Watershed Association Inc.	New Egypt	NJ	609-752-1832
18. D&R Greenway Land Trust	Princeton	NJ	609-924-4646
19. Darby Cobbs Watershed Partnership	Philadelphia	PA	215-563-0250
20. Darby Creek Valley Association	Drexel Hill	PA	610-789-1814
21. Delaware & Raritan Canal Watch	Rocky Hill	NJ	609-924-2683
22. Delaware Audubon Society	Christiana	DE	302-292-3970
23. Delaware Direct Watershed Partnership			

Appendix I

Name of Organization	City	State	Telephone
24. Delaware Highlands Conservancy/Eagle Institute	Hawley	PA	570-226-3164
25. Delaware Nature Society's Stream Watch	Hockessin	DE	302-239-2334
26. Delaware River Greenway Partnership	Erwinna	PA	609-239-0444
27. Delaware Riverkeeper Network	Bristol	PA	215-369-1188
28. Delaware River Shad Fishermen's Association	Bethlehem	PA	
29. French and Pickering Creeks Conservation Trust	Phoenixville	PA	610-933-7577
30. Friends of Abbott Marshlands	Princeton	NJ	609-259-3734
31. Friends of Bombay Hook National Wildlife Refuge	Smyrna	DE	302-653-9872
32. Friends of Cherry Valley	Stroudsburg	PA	570-460-0463
33. Friends of Cobbs Creek	Philadelphia	PA	
34. Friends of Lake Afton	Yardley	PA	
35. Friends of Poquessing Watershed Inc.	Philadelphia	PA	215-862-2021
36. Friends of the Delaware Canal	New Hope	PA	215-862-2021
37. Friends of the Delaware Water Gap National Recreation Area	Bushkill	PA	570-426-2435 ext. 2150
38. Friends of the Manayunk Canal	Philadelphia	PA	
39. Friends of the Pennypack Park	Philadelphia	PA	215-934-PARK

APPENDIX I

Name of Organization	City	State	Telephone
40. Friends of the Upper Delaware River	East Branch	NY	607-363-7848
41. Friends of the Wissahickon	Philadelphia	PA	215-247-0417
42. Friends of White Clay Creek State Park	Newark	NJ	
43. Fry's Run Watershed Association	Easton	PA	484-373-0987
44. Gallows Run Watershed Association	Kintersville	PA	610-346-8997
45. Green Valleys Association	Pottstown	PA	610-469-4900
46. Hay Creek Watershed Association	Geigertown	PA	
47. Hunterdon Land Trust	Flemington	NJ	908-237-4582
48. Lacawac Sanctuary	Lake Ariel	PA	570-689-9494
49. The Lackawaxen River Conservancy	Rowland	PA	
50. Lake Wallenpaupack Watershed Management District	Hawley	PA	570-226-3865
51. Little Lehigh Creek Watershed Association			610-746-1971
52. Lower Merion Conservancy	Gladwyne	PA	610-645-9030
53. Maiden Creek Watershed Association	Kutztown	PA	
54. Mantua/Woodbury Creeks Watershed Association	Glassboro	NJ	856-881-9540
55. Martins-Jacoby Watershed Association	Martins Creek	PA	

APPENDIX I

Name of Organization	City	State	Telephone
56. Monocacy Creek Watershed Association Inc.	Bethlehem	PA	610-861-5151
57. Musconetcong Watershed Association	Asbury	NJ	908-537-7060
58. Natural Lands Trust	Media	PA	610-353-5587
59. Nature Conservancy of Delaware	Wilmington	DE	302-654-4707
60. Neversink River Program/The Nature Conservancy	Cuddebackville	NY	845-858-2883
61. New Jersey Audubon Society	Bernardsville	NJ	908-204-8998
62. New Jersey Coalition of Lake Associations		NJ	
63. New Jersey Highlands Coalition	Boonton	NJ	973-588-7190
64. New Jersey Water Watch	New Brunswick	NJ	732-247-8177
65. Newton Creek Watershed Association	Collingswood	NJ	
66. North Branch Watershed Association	Doylestown	PA	215-345-7577
67. North Pocono CARE Association	Thornhurst	PA	570-472-3274
68. Oldmans Creek Watershed Association	Mullica Hill	NJ	856-478-6527
69. Partnership for the Delaware Estuary Inc.	Wilmington	DE	800-445-4935 302-655-4990
70. Paulinskill-Pequest Watershed Association	Blairstown	NJ	908-362-9125
71. Pennsylvania Organization forWatersheds & Rivers	Harrisburg	PA	717-234-7910

Appendix I

Name of Organization	City	State	Telephone
72. Pennypack Ecological Restoration Trust	Huntington Valley	PA	215-657-0830
73. Pennypack Watershed Partnership	Philadelphia	PA	215-685-6300
74. Perkiomen Watershed Conservancy	Schwenksville	PA	610-287-9383
75. Phillipsburg Riverview Organization	Phillipsburg	NJ	908-454-4141
76. Pine Creek Valley Watershed Association Inc.	Oley	PA	610-987-6582
77. Pinelands Preservation Alliance	Southampton	NJ	609-859-8860
78. Pompeston Creek Watershed Association	Cinnaminson	NJ	856-235-9204
79. Poquessing Watershed Partnership	Philadelphia	PA	215-685-6300
80. Pretreatment Information Exchange Inc.	Glen Rock	PA	717-227-9180
81. Raccoon Creek Watershed Association Inc.	Mullica Hill	NJ	856-478-4800 856-881-0845
82. Rancocas Conservancy	Vincentown	NJ	609-859-8860 ext. 17
83. Red Clay Valley Association	West Chester	PA	610-793-1090
84. Salem County Watershed Task Force	Woodstown	NJ	859-769-1524
85. Saucon Creek Watershed Association	Hellertown	PA	
86. Schuylkill Action Network			
87. Schuylkill Canal Association	Oaks	PA	610-917-0021

APPENDIX I

Name of Organization	City	State	Telephone
88. Schuylkill Headwaters Association	Pottsville	PA	570-622-3742
89. Schuylkill River Greenway Association	Pottstown	PA	484-945-0200
90. Southampton Watershed Association	Southampton	PA	215-355-3430
91. South Jersey Land and Water Trust	Glassboro	NJ	856-881-2269
92. Stony Brook-Millstone Watershed Association	Pennington	NJ	609-737-3735
93. Stony Creek Watershed Committee (also the Stony Creek Anglers)	Norristown	PA	610-584-9437
94. Tinicum Conservancy	Erwinna	PA	610-294-1077
95. Tobyhanny/Tunkhannock Creek Watershed Association	Pocono Lake	PA	570-643-2001
96. Tookany/Tacony-Frankford Watershed Partnership	Philadelphia	PA	215-744-1853
97. Twin and Walker Creeks Watershed Conservancy	Shohola	PA	570-296-2244
98. Upper Delaware Council	Narrowsburg	NY	845-252-3022
99. Upper Maurice River Watershed Association	Franklinville	NJ	856-694-3681
100. Upper Perkiomen Watershed Coalition	Palm	PA	215-679-3404
101. Water Resources Association of the Delaware River Basin	Wilmington	DE	610-850-9106
102. Watershed Alliance of Southeastern Pennsylvania			215-545-4570

Appendix I

Name of Organization	City	State	Telephone
103. Watershed Coalition of the Lehigh Valley	Nazareth	PA	610-746-1971
104. The Watershed Institute	Pennington	NJ	609-737-3735
105. White Clay Creek Watershed Management Committee	Newark	DE	302-731-1756
106. White Clay Watershed Association	Landenberg	PA	610-274-8499
107. Wildlands Conservancy	Emmaus	PA	610-965-4397
108. Wissahickon Restoration Volunteers	Philadelphia	PA	215-951-0330 ext. 101
109. Wissahickon Valley Watershed Association	Ambler	PA	215-646-8866
110. Wissahickon Watershed Partnership	Philadelphia	PA	215-685-6300

Appendix II
ISLANDS OF THE DELAWARE RIVER

Source: www.nj.gov/drbc

Name	State	River Mile	Tidal/Non-Tidal
1. Stony Point (Artificial Island)	NJ	49.55	Tidal
2. Reedy Island Dike	DE	52.00	Tidal
3. Artificial Island		54.44	Tidal
4. Reedy Island	DE	55.31	Tidal
5. Pea Patch Island	DE	60.00	Tidal
6. Chester Island	NJ	82.98	Tidal
7. Monds Island	NJ	84.07	Tidal
8. Little Tinicum Island	PA	85.55	Tidal
9. Petty Island	NJ	101.50	Tidal
10. Mud Island	PA	111.90	Tidal
11. Burlington Island	NJ	118.45	Tidal
12. Money Island	PA	122.95	Tidal
13. Newbold Island	NJ	124.93	Tidal
14. Blanguard Island	NJ	135.80	Non-Tidal

Appendix II

Name	State	River Mile	Tidal/Non-Tidal
15. Rotary Island	NJ	136.40	Non-Tidal
16. Unnamed Island	PA	139.70	Non-Tidal
17. Hendrick Island	PA	152.10	Non-Tidal
18. Eagle Island	NJ	153.10	Non-Tidal
19. Prahls Island	PA	158.37	Non-Tidal
20. Walls Island	PA	158.95	Non-Tidal
21. Resolution Island	PA	160.00	Non-Tidal
22. Rush Island	NJ	160.00	Non-Tidal
23. Treasure Island	NJ	160.20	Non-Tidal
24. Marshall Island	PA	160.80	Non-Tidal
25. Shyhawks Island	NJ	161.00	Non-Tidal
26. Pinkertons Island	PA	161.20	Non-Tidal
27. Fishing Island	PA	162.40	Non-Tidal
28. Pennington Island	PA	163.00	Non-Tidal
29. Lynn Island	PA	171.50	Non-Tidal
30. Raubs Island	PA	177.10	Non-Tidal
31. Old Sow Island	PA	178.50	Non-Tidal
32. Whippoorwill Island	PA	179.30	Non-Tidal
33. Getters Island	PA	184.11	Non-Tidal
34. Keifer Island	PA	191.80	Non-Tidal
35. Masons Island	PA	194.50	Non-Tidal
36. Capush Island	NJ	194.65	Non-Tidal
37. Foul Rift Island		196.40	Non-Tidal
38. McElhaneys Island	PA	197.84	Non-Tidal
39. Macks Island	NJ	200.30	Non-Tidal
40. Dildine Island	NJ	201.50	Non-Tidal
41. Thomas Island	PA	202.60	Non-Tidal
42. Attins Island	PA	202.90	Non-Tidal

Appendix II

Name	State	River Mile	Tidal/Non-Tidal
43. Arrow Island	PA	210.30	Non-Tidal
44. Unnamed Island	PA	212.11	Non-Tidal
45. Schellenbergers Island	PA	212.30	Non-Tidal
46. Shawnee Island	PA	213.20	Non-Tidal
47. Depue Island	PA	214.90	Non-Tidal
48. Labar Island	PA	216.30	Non-Tidal
49. Tocks Island	NJ	217.20	Non-Tidal
50. Poxono Island	NJ	219.90	Non-Tidal
51. Depew Island	NJ	221.50	Non-Tidal
52. Sambo Island	PA	224.60	Non-Tidal
53. Buck Bow Island		230.90	Non-Tidal
54. Shapnack Island	PA	234.90	Non-Tidal
55. Namanock Island	NJ	241.90	Non-Tidal
56. Minisink Island	NJ	243.50	Non-Tidal
57. Quicks Island		248.70	Non-Tidal
58. Mashipacong Island	NJ	249.30	Non-Tidal
59. Cherry Island	NY	258.65	Non-Tidal
60. Big Island	NY	301.10	Non-Tidal
61. Frisbie Island	NY	322.70	Non-Tidal

Appendix III
THE BRIDGES OF THE DELAWARE RIVER

Source: www.nj.gov/drbc

Name	River Mile
1. Delaware Memorial Bridge (First Span)	68.70
2. Delaware Memorial Bridge (Second Span)	68.75
3. Commodore Barry Bridge	81.90
4. Walt Whitman Bridge	96.83
5. Benjamin Franklin Bridge	100.16
6. Delan Pennsylvania Railroad Bridge	104.50
7. Betsy Ross Bridge	104.75
8. Tacony-Palmyra Bridge	107.09
9. Burlington-Bristol Bridge	117.48
10. Pennsylvania–New Jersey Turnpike Bridge	121.23
11. Morrisville-Trenton Pennsylvania Bridge Railroad	133.31
12. Morrisville-Trenton Highway Toll Bridge (U.S. Route 1)	133.37
13. Morrisville-Trenton Bridge Street Bridge	133.80
14. Morrisville-Trenton Calhoun Street Bridge	134.34

Appendix III

Name	River Mile
15. Reading Railroad Bridge (Yardley, PA)	137.30
16. Interstate 95 Bridge Scudders Falls	139.00
17. Washington Crossing Highway Bridge	141.80
18. New Hope–Lambertville Highway Bridge	148.70
19. New Hope–Lambertville Route 202 Toll Bridge	149.70
20. Stockton–Center Bridge Highway Bridge	151.90
21. Lumberville–Raven Rock Bridge (footbridge)	155.40
22. Point Pleasant–Byram Highway Bridge	157.20
23. Uhlerstown-Frenchtown Highway Bridge	164.30
24. Upper Black Eddy–Milford Highway Bridge	167.70
25. Reigelsville Highway Bridge	174.80
26. Easton Lehigh Valley Railroad Bridge	183.50
27. Easton DLW Railroad Bridge	183.50
28. Easton L&H Railroad Bridge	183.63
29. Easton, Northampton Street Bridge	183.82
30. Easton, Bushkill Street Toll Bridge	184.03
31. Pennsylvania Railroad Bridge, Martins Creek	190.70
32. Riverton-Belvidere Highway Bridge	197.84
33. DL&W Railroad Bridge	205.40
34. Portland–Columbia Highway Toll Bridge	207.20
35. Portland, LNE Railroad Bridge	207.60
36. Slateford, DL&W Railroad Bridge	208.60
37. Delaware Water Gap Highway Toll Bridge	212.10
38. Dingmans Ferry Highway Bridge	238.70
39. Milford–Montague Highway Toll Bridge	246.00
40. Port Jervis–Matamoras Highway Bridge, Interstate 84	253.65
41. Matamoras–Port Jervis Highway Bridge, U.S. Routes 6 and 209	254.75
42. Mill Rift, Erie Railroad Bridge	258.40

Appendix III

Name	River Mile
43. Pond Eddy Highway Bridge	265.50
44. Shohola-Barryville Highway Bridge	273.50
45. Minisink Ford–Lackawaxen Highway Bridge	277.46
46. Tusten Station, Erie Railroad Bridge	285.20
47. Narrowsburg Bridge, U.S. Route 106	289.90
48. Milanville–Skinners Falls Bridge (closed December 15, 2015)	295.40
49. Damascus Bridge	298.40
50. Callicoon Bridge	303.70
51. Lordville Bridge	321.60

Appendix IV
TRADITIONAL DECOY CARVERS

The carvers listed here were identified as having carved decoys in the Delaware River tradition in the past (or are currently producing decoys in the Delaware River style) through a search of the literature and a review of decoy auction catalogues from Guyette & Schmidt (Deeter), Frank & Frank Sporting Collectibles and Decoys Unlimited Inc. for the past twelve years.

The references cited here include *New Jersey Decoys* by Henry A. Fleckenstein Jr.; *Decoys: Sixty Living and Outstanding North American Carvers* by Loy S. Harrell Jr. (this publication is not paginated; please refer to the alphabetical listing of carvers at the front of the book); *Decoys: North America's One Hundred Greatest* by Loy S. Harrell Jr.; *Floating Sculpture: The Decoys of the Delware River* by Harrison Huster and Doug Knight; *Working Decoys of the Jersey Coast and Delaware Valley* by Kenneth L. Gosner; *Flights of Fancy: New Jersey Waterfowl Decoys* by Deborah F. Starker and Peter Rothenberg; *The Decoy Artist: America's Last Hunter-Carver* by David F. Giannetto; "Delaware River" by Bruce Williams in *The Great Book of Wildfowl Decoys*, edited by Joe Engers; and *Decoys: A North American Survey* by Gene and Linda Kangas.

Appendix IV

Carver	Reference(s)	Lifespan	Hometown
Charles L. Allen	*New Jersey Decoys*, 185, 223, 250–21 *Floating Sculpture*, 12–13, 19 *Working Decoys…*, 88, 99–100, 105 *Flights of Fancy*, 8 "Delaware River," 126, 134 *Decoys: A North American…*, 60	1893–1984	Bordentown, NJ
Don Allen			
W.K. Allen	*New Jersey Decoys*, 185		Bordentown, NJ
Richard Anderson		1924–2012	Tullytown, PA
William Appleton			Bristol, PA
Samuel T. Archer	*New Jersey Decoys*, 185 *Floating Sculpture*, 14–15 "Delaware River," 126, 132, 135 *Decoys: A North American…*, 60	1894–1986	Bordentown, NJ
Howard Bacon Sr.	*Floating Sculpture*, 16–17 "Delaware River," 126	1882–1956	Delanco, NJ
Howard Bacon Jr.	*Floating Sculpture*, 16–17, 21	1917–	Delanco, NJ
Herbert O. Baines		1882–1954	Edgely, PA
John H. Baker	*New Jersey Decoys*, 185 *Floating Sculpture*, 18 *Decoys: A North American…*, 59 *Decoy Magazine*, November–December 1989, 26–29	1916–2004	Bristol, PA Edgely, PA
Louis Barkalow	*Working Decoys…*, 109		
Joseph W. Bauer	*Floating Sculpture*, 23	1933–	Roebling, NJ

APPENDIX IV

Carver	Reference(s)	Lifespan	Hometown
Antonio "Tony" Bianco	*New Jersey Decoys*, 185, 192, 208, 258 *Floating Sculpture*, 22, 24–25, 132 *Working Decoys...*, 100, 103, 106 *Flights of Fancy*, 8 "Delaware River," 126 *Decoy Magazine*, September–October 1997, 32–34	1915–1968	Bordentown, NJ
Jim Birch			Trenton, NJ
Charles W. Black	*New Jersey Decoys*, 185, 207, 238, 249 *Floating Sculpture*, 26–27 *Working Decoys...*, 88, 97–100, 105 *Flights of Fancy*, 9 "Delaware River," 126, 134	1882–1956	Bordentown, NJ
Chester Black	*Floating Sculpture*, 28, 144 "Delaware River" p. 134	1903–1976	Bordentown, NJ
Dave Black			
Reese Black		1946–2001	Bordentown, NJ
John Blair Sr.	*New Jersey Decoys*, 185, 231, 232 *Decoys: North America's...*, 28, 124, 178 *Floating Sculpture*, 29–39 *Working Decoys...*, 74, 76–78, 80–81, 85 *Flights of Fancy*, 5 "Delaware River," 124–26, 130–31, 134 *Decoys: A North American...*, 53–54 *Decoy Collector's Guide*, 1977 Annual, 70–77	1842–1928	Frankford, PA Philadelphia, PA

Appendix IV

Carver	Reference(s)	Lifespan	Hometown
John Blair Jr.	*Floating Sculpture*, 34, 40–41 *Working Decoys…*, 77, 80–82 "Delaware River," 126, 131	1881–1953	Philadelphia, PA
Walter Blair	*Floating Sculpture*, 42	1889–1966	Philadelphia, PA
Louis Boldizar	*New Jersey Decoys*, 185, 193, 208 *Flights of Fancy*, 10 *Decoy Magazine*, May–June 1995, 16–17	1917–	Roebling, NJ
Leon "Buck" Borkowski	*New Jersey Decoys*, 190 *Floating Sculpture*, 134	1953–	Burlington, NJ
Charles "Cooper" Burkley	*New Jersey Decoys*, 185 *Floating Sculpture*, 20, 42–43 *Working Decoys…*, 88, 100, 105 "Delaware River," 126	1910–1983	Bordentown, NJ Fieldsboro, NJ
George Burkley	*Floating Sculpture*, 43	1917–1979	Fieldsboro, NJ
Walter Bush	*New Jersey Decoys*, 185, 200		Newark, NJ
Pete Butler	*Decoy Magazine*, May–June 2016, 17		
Thomas Church			
Glenn Cooke		1932–	Manasquan, NJ
Edward "Mims" Corradetti			Bristol, PA
Emanuel Corradetti	*Flights of Fancy*, 10	1927–	Bristol, PA
Ralph E. Dalsh			
R.W. Davids			Philadelphia, PA

APPENDIX IV

Carver	Reference(s)	Lifespan	Hometown
John Dawson	*New Jersey Decoys*, 185, 218 *Decoys: North America's…*, 130, 206 *Floating Sculpture*, 20, 44–46, 118–21 *Working Decoys…*, 85, 88–91, 93–94, 104, 107 "Delaware River," 126, 132, 135 *Decoys: A North American…*, 54–55, 57 *Decoy Magazine*, January–February 2003, 8–13	1889–1959	Duck Island, NJ Trenton, NJ
David Downey	*Floating Sculpture*, 47 "Delaware River," 126	1893–1953	Florence, NJ
John Egeli		1954–1993	Roebling, NJ
Daniel Gleason English	*New Jersey Decoys*, 185–86, 189, 194–95, 203, 242 *Floating Sculpture*, 48–51, 57–58, 124–26 *Working Decoys…*, 85, 89–91, 94–95, 103 "Delaware River," 126, 133, 135 *Decoys: A North American…*, 54, 62 *Decoy Magazine*, September–October 1992, 8–10 *Decoy World*, September 1974, 14	1884–1962	Florence, NJ

Appendix IV

Carver	Reference(s)	Lifespan	Hometown
John "Old Jack" English Sr.	*New Jersey Decoys*, 186, 189, 191, 194–95, 197, 209 *Decoys: North America's...*, 138, 206 *Floating Sculpture*, 53–56, 59–63, 118–21, 148–49 *Working Decoys...*, 85, 88–91, 94, 97, 103–4, 107 *Flights of Fancy*, 6 "Delaware River," 124–28, 130, 132 *Decoy Magazine*, March–April 2000, 8–12	1852–1915 1848–1915	Florence, NJ Bordentown, NJ
John "Jack" English Jr.	*New Jersey Decoys*, 186, 226, 233 *Floating Sculpture*, 52, 127, 130 "Delaware River," 126, 132	1878–1944	Florence, NJ
William M. Ethington II	*Decoy Magazine*, July–August 2001, 40–42	1954–	Bordentown, NJ
David Faulks	*Floating Sculpture*, 69 *Flights of Fancy*, 6 "Delaware River," 126	1875–1954	Florence, NJ
Clarence Fennimore	*Decoys: Sixty Living and Outstanding...* *Decoy Magazine*, July–August 2005, 28–30 *Hunting & Fishing Collectibles Magazine*, May–June 2007, 45–48 *Hunting & Fishing Collectibles Magazine*, November–December 2006, 24–26	1935–	Bordentown, NJ Columbus, NJ

Appendix IV

Carver	Reference(s)	Lifespan	Hometown
Harry Fennimore	*New Jersey Decoys*, 186, 192, 225, 254 *Floating Sculpture*, 64–65, 131 *Working Decoys…*, 88, 101, 107 "Delaware River," 126, 134 *Decoys: A North American…*, 61	1886–1970	Bordentown, NJ
Thomas Fitzpatrick	*New Jersey Decoys*, 186, 189, 193, 196–97, 204–5 *Floating Sculpture*, 66–68, 79, 131 *Working Decoys…*, 88–91, 96–97, 105 *Flights of Fancy*, 7 *The Decoy Artist*, 30, 61–63, 89, 109, 138 "Delaware River," 126, 133 *Decoys: A North American…*, 63 *Decoy Magazine*, July–August 1996, 36–38	1887–1958	Delanco, NJ
Robert Freirich	*Floating Sculpture*, 135, 152 *Decoys: A North American…*, 59 *Decoy Magazine*, January–February 1999, 8–11	1912–1971	Tullytown, PA
William "Bid" Furness	*Decoy Magazine*, January–February 1991, 24–27	1909–1965	
Matt Geis	Decoys: Sixty Living and Outstanding…		Cherry Hill, NJ

Appendix IV

Carver	Reference(s)	Lifespan	Hometown
Vincent Giannetto III	*Decoys: Sixty Living and Outstanding…* *Floating Sculpture*, 138, 145 *The Decoy Artist* (Biography) *Hunting & Fishing Collectibles Magazine*, September–October 2004, 18–22		Beverly, NJ
Gumpy Gilbert	*New Jersey Decoys*, 186, 210		Trenton, NJ
August Glass	*Floating Sculpture*, 70–71, 130 *Flights of Fancy*, 6 "Delaware River," 126	1905–1973	Florence, NJ
Vince Goddard	*Floating Sculpture*, 71	1921–	Bordentown, NJ Kinkora, NJ
Paul Green	*New Jersey Decoys*, 186, 190, 246 *Floating Sculpture*, 72 *Working Decoys…*, 88, 100, 105 *Flights of Fancy*, 7	1904–1973	Florence, NJ Yardville, NJ
Jess Heisler	*New Jersey Decoys*, 186, 188, 191, 193, 206–7 *Floating Sculpture*, 73–75, 80 *Working Decoys…*, 88–89, 91, 96–97 *Flights of Fancy*, 8 "Delaware River," 126, 131, 133 *Decoys: A North American…*, 56 *Decoy Magazine*, March–April 2001, 8–11	1891–1943	Burlington, NJ
Homer Hobbs	*Floating Sculpture*, 76	1923–	Edgely, PA
John Holloway	*Decoys: Sixty Living and Outstanding…* *Floating Sculpture*, 76–77, 81 *Decoy Magazine*, July–August 1995, 18–20	1935–	Florence, NJ West Creek, NJ

Appendix IV

Carver	Reference(s)	Lifespan	Hometown
William C. Kemble	*Floating Sculpture*, 135, 151 "Delaware River," 126 *Decoys: A North American…*, 58	1885–1975	Trenton, NJ
Samuel Kershaw	*Floating Sculpture*, 135		
John S. Kimble	*New Jersey Decoys*, 186, 249 *Floating Sculpture*, 145 *Decoys: A North American…*, 58	1900–	Columbia, NJ Trenton, NJ
Joseph King	*New Jersey Decoys*, 186, 207, 227 *Floating Sculpture*, 78, 83, 131 *Working Decoys…*, 89 "Delaware River," 126, 134 *Decoy Magazine*, January–February 1998, 8–11 *Decoy Magazine*, January–February 1995, 8–10	1905–1972	Edgely, PA Manahawkin, NJ
Charlie Kovacs III	*Decoy Magazine*, July–August 1998, 36–39	1948–	Roebling, NJ
William Kuhn	*Floating Sculpture*, 136, 139	1910–1981	Tullytown, PA
Robert "Turk" Libensperger	*New Jersey Decoys*, 186, 201, 225, 248 *Floating Sculpture*, 82–84 *Decoy Magazine*, July–August 2003, 16–18	1931–2012	Levittown, PA Trenton, NJ
Harry Lynns			Bristol, PA
Clark Madera	*New Jersey Decoys*, 186–87, 201, 258 *Working Decoys…*, 109		Pitman, NJ
John Marinkos	*New Jersey Decoys*, 187, 194, 226	1915–98	Florence, NJ

APPENDIX IV

Carver	Reference(s)	Lifespan	Hometown
George Marshall	*Decoy Magazine*, November–December 2008, 36–38		Forked River, NJ
Caleb Ridgeway "Ridge" Marter Sr.	*New Jersey Decoys*, 187–88, 196, 214, 217 *Floating Sculpture*, 85–87, 95 *Working Decoys…*, 88–89, 91, 96–97, 105 "Delaware River," 126, 133, 134 *Decoys: A North American…*, 57 *Decoy Magazine*, November–December 1999, 16–18 *Burlington County Historical Society Newsletter* Spring–Summer 1996, 1–3	1893–1977	Burlington, NJ Beverly, NJ
Jay May		1936–2008	Langhorne, PA
Bob McGuire			Point Pleasant, NJ
Lawrence C. "Larry" McLaughlin	*New Jersey Decoys*, 187, 224, 248, 255 *Floating Sculpture*, 88–89, 96 *Flights of Fancy*, 10 *The Decoy Artist*, 125, 127, 129 "Delaware River," 126	1911–	Edgely, PA
Clint McLoughlin			Bordentown, NJ

APPENDIX IV

Carver	Reference(s)	Lifespan	Hometown
John "Mickey" McLoughlin	*New Jersey Decoys*, 187, 203–4, 223, 229–30 *Floating Sculpture*, 90–91, 97 *Working Decoys...*, 88, 98, 100, 102–3, 106–7, 108–9 *Flights of Fancy*, 9 "Delaware River," 126, 133, 134 *Decoys: A North American...*, 55, 61 *Decoy Magazine*, September–October 1996, 8–11 *Decoy Magazine*, Winter 1986, 30–33 *Decoy Collectors Guide*, 1966–67 Annual, 40–45	1911–1985	Bordentown, NJ Tucson, AZ
Terry McNulty			Trenton, NJ
Herb Miller	*Floating Sculpture*, 92–93 *Decoy Magazine*, September–October 1995, 32–33	1935–	Beach Haven, NJ Roebling, NJ
Joseph Morgan	*Floating Sculpture*, 94, 98 *Working Decoys...*, 103 "Delaware River," 126 *Decoy Magazine*, May–June 1998, 33–35	1924–2001	Holland, PA Tullytown, PA
Paul Murray			Bristol, PA
Charles F. "Pete" Pitman	*New Jersey Decoys*, 187, 215, 222, 260–61		Trenton, NJ

Appendix IV

Carver	Reference(s)	Lifespan	Hometown
William "Bill" Quinn	*New Jersey Decoys*, 187, 190–91, 219, 233 *Floating Sculpture*, 98–101, 109 *Working Decoys…*, 88, 91, 94–95, 107 "Delaware River," 126, 134–35 *Decoys: A North American…*, 62 *Decoy Magazine*, July–August 1993, 8–10	1915–1969	Yardley, PA
Al Reitz	*New Jersey Decoys*, 187 *Floating Sculpture*, 101, 110 *Working Decoys…*, 85, 88 "Delaware River," 126 *Decoys: A North American…*, 63 *Decoy Magazine*, November–December 2004, 13–15	1905–1994	Tullytown, PA Croydon, PA
Peter Roboy		1887–	Bordentown, NJ
George Runyan	*Floating Sculpture*, 102, 141, 150 "Delaware River," 126 *Decoys: A North American…*, 56	1860–1943	Bordentown, NJ
Pat Sabatini	*New Jersey Decoys*, 187		Levittown, PA
Ron Sabatini			Levittown, PA
Nick Sachi		1927–1996	Bristol, PA
Nick Saedin			Bristol, PA
Dominic Salvatore	*New Jersey Decoys*, 187		Paulsboro, NJ
Joseph Savko	*New Jersey Decoys*, 187, 247 *Floating Sculpture*, 103 "Delaware River," 126	1880–1940	Trenton, NJ
William "Sonny" Schnoor	*Decoy Magazine*, January–February 2004, 32–34	1913–	Bordentown, NJ

Appendix IV

Carver	Reference(s)	Lifespan	Hometown
T. Scott Mahlon Schuyler		1912–1994	Bristol, PA
Frank Sidebottom	*New Jersey Decoys*, 187 *Floating Sculpture*, 141, 150		Andalusia, PA
Ed Sitko			Trenton, NJ
Charles Strunfels		1884–1918	Bristol, PA
George Strunk	*Decoys: Sixty Living and Outstanding…* *Decoy Magazine*, May–June 1993, 36–38 *Hunting & Fishing Collectibles Magazine*, July–August 2011, 54–55 *Hunting & Fishing Collectibles Magazine*, May–June 2008, 16–22 *Hunting & Fishing Collectibles Magazine*, July–August 2007, 38–42 *Hunting & Fishing Collectibles Magazine*, May–June 2005, 12–17		Glendora, NJ
Robert Sean Sutton	*Decoys: Sixty Living and Outstanding…* *Decoy Magazine*, November–December 2004, 32–34		Paulsboro, NJ
Ronald Swiderski	*Floating Sculpture*, 136, 139, 142, 146		Burlington, NJ
Claude Edgerton Trader Sr.	*New Jersey Decoys*, 187–88, 205–6 *Floating Sculpture*, 104–5, 110 *Working Decoys…*, 88 *Flights of Fancy*, 7 "Delaware River," 126 *Decoy Magazine*, May–June 1992, 36–38	1902–1972	Florence, NJ

APPENDIX IV

Carver	Reference(s)	Lifespan	Hometown
John "Jack" Updike	*Floating Sculpture*, 106 "Delaware River," 126	1886–1955	Tullytown, PA
Arthur Bartholomew Vance		1818–1989	Philadelphia, PA
James Vogerman	*New Jersey Decoys*, 188, 228		Delanco, NJ
George W. Walker		1914–1992	Trenton, NJ
Charles Wargo			Florence, NJ
James R. Warrington Jr.			
William Welker		1909–1985	Edgely, PA
J.C. West			Manahawkin, NJ Bordentown, NJ
"J.J." West	*Decoy Collector's Guide*, July–September 1964, 15–18, 28–29		Bordentown, NJ
James West	*New Jersey Decoys*, 188, 239, 255 *Floating Sculpture*, 107–8, 111 *Flights of Fancy*, 9	1937–2000	Bordentown, NJ
Joseph C. West	*New Jersey Decoys*, 188 *Floating Sculpture*, 107–8, 111, 130, 132 *Flights of Fancy*, 9 "Delaware River," 126 *Decoy Magazine*, May–June 1997, 32–33	1907–1986	Bordentown, NJ
Kevin Wharton	*Decoy Magazine*, September–October 2013, 30–32 *Hunting & Fishing Collectibles Magazine*, May–June, 53–54 *Hunting & Fishing Collectibles Magazine*, November–December 2008, 28–30		Springfield, PA

Appendix IV

Carver	Reference(s)	Lifespan	Hometown
Robert L. "Bob" White	*New Jersey Decoys*, 188, 202, 216, 222–23, 229 *Decoys: Sixty Living and Outstanding…* *Floating Sculpture*, 112–14 *Decoy Magazine*, September–October 1990, 16–18 *Decoy Magazine*, Fall 1989, 22–29 *Hunting & Fishing Collectibles Magazine*, September–October 2005, 10–20 *Hunting & Fishing Collectibles Magazine*, November–December 2005, 10–19 *Decoy Collector's Guide*, 1968 Annual, 91–95 *Colonial Homes*, January–February 1986, 110–13	1939–	Tullytown, PA Trenton, NJ
John M. "Jack" Wood	*Decoys: Sixty Living and Outstanding…* *Decoy Magazine*, January–February 2002, 40–41 *Hunting & Fishing Collectibles Magazine*, May–June 2013, 16–17 *Skylands Visitor*, Spring 2008, 4–7	1949–	Trenton, NJ Hamilton, NJ

Appendix V
CONTEMPORARY CARVERS

The list of carvers here goes beyond what the "purists" will accept. These decoy carvers do not belong to what is considered the Delaware River tradition of carving; nevertheless, they have demonstrated both interest and skill in utilizing carving techniques that result in decoys that have all the characteristics of traditional Delaware River decoys carved by the masters. These carvers may be a source of Delaware River–style decoys for the interested collector.

Carver	Reference(s)	Hometown
Carl R. Becker		Fair Haven, NJ
Frederick C. Brown Jr.		Point Pleasant, NJ
Pete Butler	*Decoy Magazine*, May–June 2016, 17	
Lisa Byrd		
Bartis Church		Fieldsboro, NJ
Thomas Church		
Edward Clark		
D. Cobb		
Dale Dalrymple		

Appendix V

Carver	Reference(s)	Hometown
Lonn Deeter		
Paul Dobrosky		Little Silver, NJ
Mark English	*Working Decoys...*, 107 *Decoy Magazine*, September–October 2016, 32–35	Pitman, NJ
Alfred G. Evans		Normandy Beach, NJ
David F. Giannetto	*The Decoy Artist*, 11, 152–53, 175, 197–98	Beverly, NJ
Richard V. Giannetto	*The Decoy Artist*, 117–19, 149–53, 175–79, 197–98	Beverly, NJ
Bill Gibian	*Decoy Magazine*, November–December 1992, 36–38	
John Hanson		Fair Haven, NJ
Jode Hillman	*Decoy Magazine*, May–June 2006, 28–30 *Hunting & Fishing Collectibles Magazine*, September–October 2011, 37 *Hunting & Fishing Collectibles Magazine*, January–February 2007, 29–31 *Hunting & Fishing Collectibles Magazine*, May–June 2007, 45–48	Mullica Hill, NJ
John Hillman	*Decoy Magazine*, May–June 1993, 24	
Charles Huff		Shrewsbury, NJ

Appendix V

Carver	Reference(s)	Hometown
Forrest "Bud" Jennings	*Decoy Magazine*, July–August 1999, 36–38; *Hunting & Fishing Collectibles Magazine*, July–August 2008, 46–50	Shamong, NJ
Lloyd Johnson	*Decoy Magazine*, July–August 1997, 36–39	Bay Head, NJ
Joseph Liener		
Harry Lynns		Bristol, PA
Eugene "Gene" Marshall	*Decoy Magazine*, November–December 2008, 36–38	Forked River, NJ
Cyril E. Moore		
Jack Musgrove		
William W. Oler		Beach Haven, NJ
J.C. Overs		
Jay Polite		New Castle, DE
John Potts		Princeton, NJ
Larry Ricca		Stockton, NJ
Joan Siekert		Cape May, NJ
Larry Tawes Jr.		Hebron, MD
Charles Van Note		Manasquan, NJ

Appendix VI
Sources of Delaware River Decoys

Auction Houses
Frank and Frank Sporting Collectibles
422 Lakewood Farmingdale Road
Howell, NJ 07731
www.frankandfrankdecoys.com
732-938-2988
afrank1807rh@cs.com

Decoys Unlimited Inc.
PO Box 206
West Barnstable, MA 02668
www.decoysunlimitedinc.net
508-362-2766

Guyette & Deeter Inc.
PO Box 1170
St. Michaels, MD 21663
www.guyetteanddeeter.com
410-745-0485

Appendix VI

Guyette & Deeter Inc.
Retail Store
4 School Street
Freeport, ME 04063
www.decoysforsale.com (weekly auction)
207-869-6004
 Gallery
 Zac Cote
 410-253-8616
 Retail/Appraisals

Decoys & Wildlife Gallery
55 Bridge Street
Frenchtown, NJ 08825
www.decoyswildlife.com
908-996-6501; 888-996-6501
Ron Kobli, Director

NOTES

Preface

1. Mya: million years ago.
2. Justin Worland, "The Anthropocence Should Bring Awe—and Act as a Warning," T*ime*, September 12–19, 2016, 10.
3. Ibid.

Introduction

4. Steve J. Tambini and Bob Martin, *Administrative Agreement between the Delaware River Basin Commissions and the New Jersey Department of Environmental Protection* (Trenton, NJ: DRBC and NJDEP, March 2015).
5. Mgd: million gallons per day.
6. 2010 census, in Gerald J. Kauffman, "Socioeconomic Value of the Delaware River Basin in Delaware, New Jersey, New York and Pennsylvania," final draft, May 25, 2011 (Newark: University of Delaware, 2011).
7. Kauffman, "Socioeconomic Value of the Delaware River Basin."

Chapter 1

8. Jerry Bergman, "James Ussher and His Chronology: Reasonable or Ridiculous?," Institute for Creation Research, 2016, www.icr.org.

9. Ibid.
10. CE: years before the common era beginning during the fifth century BC.
11. Robert M. Hazen, *The Story of Earth* (New York: Penguin Books, 2012).
12. Chris Stassen, "The Age of the Earth," TalkOrigins Archive: Exploring the Creation/Evolution Controversy, September 10, 2005, www.talkorigins.org/faqs/faq-age-of-earth.html.
13. Ibid.
14. Ibid.
15. Plate tectonics, volcanism and erosion.
16. USGS, "Age of the Earth," July 9, 2007, www.pubs.usgs.gov/gip/geotime/age.html.
17. Wolfgang Frisch, Martin Meschede and Ronald Blakey, *Plate Tectonics: Continental Drift and Mountain Building* (London: Springer, 2011).
18. Peter Molnar, *Plate Tectonics* (Oxford, UK: Oxford University Press, 2015).
19. Stephen Marshak, *Earth: Portrait of a Planet*, 4th ed. (New York: W.W. Norton & Company, 2012).
20. Ibid.
21. Frisch, Meschede and Blakey, *Plate Tectonics*.
22. Billion years ago.
23. This list is written in reverse chronological order—most recent first.
24. Frisch, Meschede and Blakey, *Plate Tectonics*.
25. Carl S. Oplinger and Robert Halma, *The Poconos: An Illustrated Natural History Guide* (New Brunswick, NJ: Rutgers University Press, 2006).
26. Frisch, Meschede and Blakey, *Plate Tectonics*.
27. Bradford B. Van Diver, *Roadside Geology of Pennsylvania* (Brattleboro, VT: Echo Point Books & Media, 2014).
28. Peter E. Wolfe, *The Geology and Landscapes of New Jersey* (New York: Crane, Russak & Company Inc., 1977).
29. Kent C. Condie, *Plate Tectonics & Crustal Evolution*, 2nd ed. (New York: Pergamon Press, 1982).
30. Roger T. Faill, "A Geologic History of the North-Central Appalachians—Part I: Orogenesis from the Mesoproterozoic through the Taconic Orogeny," *American Journal of Science* (June 1997), www.ajsonline.org.
31. Wolfe, *Geology and Landscapes of New Jersey*.
32. Anticlines are folds in the layers of rock in which each half of the fold dips away from the crest, forming an "A" shape. Synclines are folds in the rock layers in which each half of the fold dips toward a trough of the fold, forming the bottom of an "S" shape. Monocline is a step-like fold

in the rock strata, consisting of a zone of steep dip within an otherwise horizontal or gently dipping sequence of rock layers.
33. Wolfe, *Geology and Landscapes of New Jersey*.
34. Tambini and Martin, *Administrative Agreement*.
35. George W. Stose, "Age of the Schooley Peneplain," *American Journal of Science* (July 1940): 461–76.
36. C.P. Yoder, *Delaware Canal Journal: A Definitive History* (Bethlehem, PA: Canal Press Inc., 1972).
37. Richard C. Albert, *Damming the Delaware: The Rise and Fall of Tocks Island Dam* (University Park: Pennsylvania State University Press, 1987).
38. Wolfe, *Geology and Landscapes of New Jersey*.
39. Rollin D. Salisbury, *The Glacial Geology of New Jersey: The Final Report of the State Geologist*, vol. 5 (Trenton: Geological Survey of New Jersey, 1902).
40. Ibid.
41. Ibid.
42. Ibid.
43. David P. Harper, *Roadside Geology of New Jersey* (Missoula, MT: Mountain Press Publishing Company, 2013).
44. "Dip" refers to the orientation or attitude of a geological feature such as a rock layer or a fault; it provides the steepest angle of descent of a tilted bed of rocks or other feature relative to a horizontal plane as measured by a Brunton compass.
45. Jack B. Epstein, "Structural Control of Wind Gaps and Water Gaps and of Stream Capture in the Stroudsburg Area, Pennsylvania and New Jersey," U.S. Geological Survey Paper 550-B, 1966.
46. Ibid.
47. "Strike" refers to a line representing the intersection of that particular rock sequence or other geological feature with a horizontal plane as measured by a Brunton compass.
48. Warren F. Lee, *Down Along the Old Bel-Del: The History of the Belvidere Delaware Railroad Company: A Pennsylvania Railroad Company* (Albuquerque, NM: Bel-Del Enterprises Ltd., 1987); Yoder, *Delaware Canal Journal*.
49. Epstein, "Structural Control."
50. "Peneplane" is a term used to name an ancient surface similar to a plain, although with small elevations that would interrupt the uniformity of a plain. The physiognomy of the peneplane line would depend on the consequences of erosion; therefore, a peneplane is a plain that lacks uniformity due to the action of erosion and hydrography.

51. Freeman Ward, "Recent Geological History of the Delaware Valley Below the Water Gap," General Geology Report 10 (Harrisburg, PA: Topographic and Geologic Survey, 1938), dcnr.state.pa.us/topogeo/publications/pqspub/general/index.htm.
52. Van Diver, *Roadside Geology*.
53. Charles H. Shultz, ed., *The Geology of Pennsylvania* (Harrisburg: Pennsylvania Geological Survey, 2002).
54. Kemble Widmer, *The Geology and Geography of New Jersey* (New York: D. Van Nostrand Company Inc., 1964).
55. Jack B. Epstein and Anita G. Epstein, *Geology in the Region of the Delaware to Lehigh Gaps* (East Stroudsburg, PA: 32nd Annual Field Conference of Pennsylvania Geologists Guidebook, 1967).
56. Richard C. Albert and Carrie E. Albert, *Along the Delaware River* (Charleston, SC: Arcadia Publishing, 2002).

Chapter 2

57. Vernon Leslie, *Faces in Clay: The Archaeology and Early History of the Red Man in the Upper Delaware Valley* (Middletown, NY: Emmett Henderson Publisher, 1973.)
58. Ibid.
59. Epstein and Epstein, *Geology in the Region of the Delaware to Lehigh Gaps*.
60. Ibid.
61. C.A. Weslager, *The English on the Delaware, 1610–1682* (New Brunswick, NJ: Rutgers University Press, 1969).
62. Ibid.
63. Ibid.
64. Ibid.
65. Ibid.
66. L.W. Brodhead, *Delaware Water Gap: Its Legends and Early History* (Philadelphia, PA: Sherman & Company, Printers, 1870, Cornell University Library Digital Reprint).
67. "The compound word Lenni Lenape signifies '*original people*,' a race of beings who are the same that they were from the beginning, acknowledged by near forty Indian tribes as being their grandfathers. All these tribes, derived from the same stock, recognize each other as *Wapanachki* or *Lenape*, which among them is a generic name." Reverend Heckewelder in Brodhead, *Delaware Water Gap.*

68. It is a well-established fact that "signal lights" were used by the Indians and that important intelligence was communicated from one eminence to another, hundreds of miles away, with the certainty, and almost the celerity, of electricity. The adoption of a similar system proved of great importance to our army in the late rebellion.
69. These mines were worked to a considerable extent, but with what success is not known. They are situated near the base of the Kittatinny Mountain, eight miles above the Delaware Water Gap, on the New Jersey side of the river. A company was organized, about twenty years ago in New York, for the purpose of reworking them but failed of success. When they commenced operations, they found large trees growing on places where excavations had been made nearly two hundred years before. The place is now called *Pahaquarri*, a corruption of "Pahaqualong," the original name.
70. There is scarcely a doubt remaining that these islands in the Delaware, as well as the adjacent main land, were under cultivation by the Indians. The evidence of the early settlers on the subject is confirmed by the discovery on Shawnee Island a few years ago of a dozen or more articles of the Stone Age, differing from those ordinarily found, which, on being submitted to Mr. Franklin Peale of Philadelphia—perhaps the best authority on this subject in the country—were unhesitatingly pronounced implements of agriculture, answering the purpose of our common hoe.
71. It was the custom of the Indians to bury distinguished persons of their own tribe with the head elevated to nearly a sitting posture and to encase the body in a stone box.
72. *Kitochtanemin*, *Kittatinny*, endless mountain.
73. The "Gap" was called by the Indians *Pohoqualin*, a word that signifies the termination of two mountains with a stream passing between them. The river was called *Lenapewihittuck*, the river of the Lenape. *Mack er iskiskan* seems to have been a place in the river and not the name of the river itself.
74. On the expedition fitted out by the English government that captured New Netherland (New York) from the Dutch, the writer's great-great-great-grandfather was a captain.
75. Some stone beads, of the described material, have been obtained from Indian graves along the river of such finished workmanship as almost to baffle modern skill, assisted by modern appliances.

Chapter 3

76. Please note there exists disagreement concerning the number of genera and living species, depending on the source, in the family *Anatidae*.
77. Bradley C. Livezey, "A Phylogenetic Analysis of Recent Anseriform Genera Using Morphological Characters," *AUK* 103, no. 4 (1986): 737–54.
78. M. Srami, L. Christidis, S. Easteal, P. Horn and C. Collet, "Molecular Relationships within Australasian Waterfowl (Anseriformes)," *Australian Journal of Zoology* 44, no. 1 (1996): 47–58; Kevin P. Johnson and Michael D. Sorenson, "Phylogeny and Biography of Dabbling Ducks: A Comparison of Molecular and Morphological Evidence," *AUK* 116, no. 3 (1999): 792–805.
79. Lester L. Short, "A New Anseriform Genus and Species from the Nebraska Pliscene," *AUK* 87, no. 3 (1970): 537–43.
80. Note that the ruddy duck, a diving duck, is a stiff-tailed duck of the subfamily *Oxyurinae*.
81. Edward O. Wilson, *Half-Earth: Our Planet's Fight for Life* (New York: Liveright Publishing Corporation, 2016).
82. John Long and Peter Schouten, *Feathered Dinosaurs: The Origin of Birds* (New York: Oxford University Press, 2008).
83. John Pickrell, *Flying Dinosaurs: How Fearsome Reptiles Became Birds* (New York: Columbia University Press, 2014).
84. Wilson, *Half-Earth*.
85. Carl Zimmer, "Evolution of Feathers," *National Geographic*, May 2016, www.nationalgeographic.com.
86. Ibid.
87. Ibid.
88. Matthew P. Martyniuk, *A Field Guide to Mesozoic Birds and Other Winged Dinosaurs* (Vernon, NJ: Pan Aves, 2012).
89. Pickrell, *Flying Dinosaurs*.
90. Stephen J. Bodio, "They Had Feathers," *Living Bird* 35, no. 2 (Spring 2016); Stephen J. Bodio, "They Had Feathers: Is the World Ready to See Dinosaurs as They Really Were?" Cornell Lab of Ornithology, May 10, 2016, http://www.allaboutbirds.org.
91. Pickrell, *Flying Dinosaurs*.
92. A violent, ugly period in the history of fossil hunting, driven by greed.
93. Pickrell, *Flying Dinosaurs*.
94. Ibid.
95. Ibid.

96. Ibid.
97. Alan Feduccia, *The Origin and Evolution of Birds*, 2nd ed. (New Haven, CT: Yale University Press, 1999).
98. Ibid.
99. Ibid.
100. Martyniuk, *Field Guide*.
101. Ibid.
102. Long and Schouten, *Feathered Dinosaurs*.
103. Ibid.
104. Ibid.
105. Martyniuk, *Field Guide*.
106. Ibid.
107. Feduccia, *Origin and Evolution of Birds*.
108. Ibid.
109. Ibid.
110. Ibid.

Chapter 4

111. Charles A. Stansfield Jr., *An Ecological History of New Jersey* (Trenton: New Jersey Historical Commission, 1996).
112. Gene Kangas and Linda Kangas, *Decoys* (Paducah, KY: Schroeder Publishing Company Inc., 1992).
113. Robert Cantwell, *Alexander Wilson Naturalist and Pioneer* (Philadelphia, PA: J.B. Lippincott Company, 1961).
114. Chad Tragakis, "Chesapeake on the Delaware: Decoys from the McKeag, Hildebrand and Brummett Rigs," *Decoy Magazine* (November/December 2015): 8–13.
115. For those readers eager to pursue more detailed biographical and technical information regarding individual carvers, a research guide resource has been provided in Appendix V of this book.
116. Ed Muderlak, ed., "Duck Shooting on Delaware Bay," *When Ducks Were Plenty: The Golden Age of Duck Hunting* (Long Beach, CA: Safari Press Inc., 2000), 167–74.
117. Robert Shaw, *Bird Decoys of North America: Nature, History and Art* (New York: Sterling Publishing, 2010).
118. Kenneth L. Gosner, *Working Decoys of the Jersey Coast and Delaware Valley* (Philadelphia, PA: Art Alliance Press, 1985).

119. Weslager, *English on the Delaware*.
120. Albert, *Damming the Delaware*.
121. U.S. Army Corps of Engineers, *Delaware River Dredging Disposal Study June 1984* (Philadelphia, PA, 1984).
122. Ibid.
123. Ibid.
124. Ibid.
125. David F. Giannetto, *The Decoy Artist: America's Last Hunter-Carver* (Gretna, LA: Pelican Publishing Inc., 2010).
126. Hal Sorenson, "The Blair Mystery," *Decoy Collector's Guide*, 1977 Annual, 70–77.
127. H. Harrison Huster and Doug Knight, *Floating Sculpture: The Decoys of the Delaware River* (Spanish Fork, UT: Hillcrest Publications, 1982).
128. Deborah F. Starker and Peter Rothenberg, *Flights of Fancy: New Jersey Waterfowl Decoys* (Madison, NJ: Museum of Early Trades and Crafts, June 19, 2004–January 16, 2005).
129. Gosner, *Working Decoys*.
130. Ibid.
131. Huster and Knight, *Floating Sculpture*.
132. Ibid.
133. Ibid.
134. Gosner, *Working Decoys*.
135. Ibid.
136. Tragakis, "Chesapeake on the Delaware."
137. Gene Kangas, "Jay Cooke—The Banker from Philadelphia," *Decoy Magazine* (September/October 2002): 8–12; Gene Kangas and Linda Kangas, "Jay Cooke—The Banker from Philadelphia: The Real Story Behind the Blair Decoys," Creekside Art Gallery Blog, January 10, 2009, www.creeksideartgallery.com/blog/kangas-articles-books-2.html.
138. Allen Linkchorst and many collectors support this second theory. Linkchorst is a noted Delaware River Decoy historian, speaker and contributing writer to *Decoy Magazine* (2017).
139. Tragakis, "Chesapeake on the Delaware."
140. Ibid.
141. Huster and Knight, *Floating Sculpture*; Allen Linkchorst, "John English: The Innovator of the Delaware River Decoy," *Decoy Magazine* (March/April 2000): 8–12.
142. Mahlon W. Schuyler, "The Delaware River Decoy and Its Carvers," *Decoy Collector's Guide* (July–September, 1964): 2–5.

143. Huster and Knight, *Floating Sculpture*.
144. Gosner, *Working Decoys*; Starker and Rothenberg, *Flights of Fancy*.
145. Huster and Knight, *Floating Sculpture*.
146. Schuyler, "Delaware River Decoy and Its Carvers."
147. Gosner, *Working Decoys*; Schuyler, "The Delaware River Decoy and Its Carvers."
148. Gosner, *Working Decoys*.
149. Huster and Knight, *Floating Sculpture*.
150. Muderlak, "Duck Shooting on Delaware Bay."
151. Gosner, *Working Decoys*.
152. Ibid.
153. Ibid.
154. Kirkland Marter, "The Delaware River: Bushwacking on Shedaker Flats," *Decoy Magazine* (September/October 1990): 8–14.
155. Giannetto, *Decoy Artist*.

A Chronological Human and Environmental History of the Delaware River and Estuary

156. J. Volney Lewis, *The Geology of New Jersey* (Trenton: New Jersey Department of Conservation and Development, Geologic Series, 1940).
157. Shaun Bailey, ed., "State of the Delaware Estuary 2012," *Estuary News* 22, no. 4 (Summer 2012), Wilmington, Delaware, Partnership for the Delaware Estuary.
158. John T. Cunningham, *Colonial New Jersey* (New York: Thomas Nelson Inc., 1971).
159. Tambini and Martin, *Administrative Agreement*.
160. Weslager, *English on the Delaware*.
161. Bailey, "State of the Delaware Estuary 2012."
162. Weslager, *English on the Delaware*.
163. Martin Wilson, *A History of Delaware Water Gap and Its Resorts* (Delaware Water Gap, PA: Antoine Dutot Museum and Galley, 1984), http://www.dutotmuseum.com/history.htm.
164. C.A. Weslager and A.R. Dunlap, *Dutch Explorers, Traders and Settlers in the Delaware Valley 1609–1664* (Philadelphia: University of Pennsylvania Press, 1965).
165. Weslager, *English on the Delaware*.
166. Ibid.

167. Cunningham, *Colonial New Jersey*.
168. Tambini and Martin, *Administrative Agreement*.
169. Ibid.
170. Weslager and Dunlap, *Dutch Explorers*.
171. Robert S. Grumet, *The Lenapes* (New York: Chelsea House Publishers, 1989).
172. Weslager and Dunlap, *Dutch Explorers*.
173. Weslager, *English on the Delaware*.
174. C.A. Weslager, *The Delaware Indians: A History* (New Brunswick, NJ: Rutgers University Press, 2008).
175. Grumet, *Lenapes*.
176. Frank Dale, *Delaware Diary: Episodes in the Life of a River* (New Brunswick, NJ: Rutgers University Press, 1996).
177. Weslager, *Delaware Indians*.
178. Weslager and Dunlap, *Dutch Explorers*.
179. C.A. Weslager, *New Sweden on the Delaware, 1638–1655* (Wilmington, DE: Middle Atlantic Press, 1988).
180. Ibid.
181. Ibid.
182. Frank S. Kelland and Marylin C. Kelland, *New Jersey: Garden or Suburbs* (Dubuque, IA: Kendall/Hunt Publishing Company, 1978).
183. Weslager and Dunlap, *Dutch Explorers*.
184. Grumet, *Lenapes*.
185. Weslager, *English on the Delaware*.
186. Ibid., *New Sweden on the Delaware*.
187. Ibid.
188. Kelland and Kelland, *New Jersey*.
189. Weslager, *English on the Delaware*.
190. Ibid., *New Sweden on the Delaware*.
191. Cunningham, *Colonial New Jersey*.
192. Kelland and Kelland, *New Jersey*.
193. Weslager, *English on the Delaware*.
194. Ibid., *New Sweden on the Delaware*.
195. Ibid.
196. Tambini and Martin, *Administrative Agreement*.
197. Weslager, *English on the Delaware*.
198. Ibid.
199. Weslager and Dunlap, *Dutch Explorers*.
200. Weslager, *New Sweden on the Delaware*.

201. Kelland and Kelland, *New Jersey*.
202. Stansfield, *Ecological History of New Jersey*.
203. Weslager, *New Sweden on the Delaware*.
204. Ibid.
205. Weslager and Dunlap, *Dutch Explorers*.
206. Kelland and Kelland, *New Jersey*.
207. Weslager, *English on the Delaware*.
208. Weslager and Dunlap, *Dutch Explorers*.
209. Ibid.
210. Cunningham, *Colonial New Jersey*.
211. Marion M. Kyde, Edith S. Sharp, Stephanie Fox and Keith Strunk, *Delaware River Scenic Byway* (Charleston, SC: Arcadia Publishing, 2014).
212. Ivy Jackson Bank, *Banks of the Delaware: The Life and Times of Frederick Banks, 1898–1964* (Trenton, NJ: Trenton Historical Society, 1967).
213. Cunningham, *Colonial New Jersey*.
214. Weslager, *English on the Delaware*.
215. Ibid., *Delaware Indians*.
216. Ibid.
217. Kelland and Kelland, *New Jersey*.
218. Cunningham, *Colonial New Jersey*.
219. Wilson, *History of Delaware Water Gap and Its Resorts*.
220. Ibid.
221. Kyde et al., *Delaware River Scenic Byway*.
222. William F. Henn, *The Story of the River Road: Life Along the Delaware from Bushkill to Milford, Pike County, PA* (Dingmans Ferry, PA: self-published, 1975).
223. Marie J. Summa, Frank D. Summa and Arthur Garris Jr., *Eastern Poconos: Delaware Water Gap to Bushkill* (Charleston, SC: Arcadia Publishing, 2005).
224. Ibid.
225. Durham Historical Society, "History of the Durham Boat."
226. Grumet, *Lenapes*.
227. Albert and Albert, *Along the Delaware River*.
228. Weslager, *Delaware Indians*.
229. Ibid.
230. Ibid.
231. Ibid.
232. Grumet, *Lenapes*.
233. Weslager, *Delaware Indians*.
234. Dale, *Delaware Diary*; Weslager, *Delaware Indians*.

235. Dale, *Delaware Diary*.
236. Albert, *Damming the Delaware*.
237. Ian W. Toll, *Six Frigates: The Epic Story of the Founding of the U.S. Navy* (New York: W.W. Norton & Company Inc., 2006).
238. Tambini and Martin, *Administrative Agreement*.
239. Kelland and Kelland, *New Jersey*.
240. Dale, *Delaware Diary*.
241. Bailey, "State of the Delaware Estuary 2012."
242. Dale, *Delaware Diary*.
243. Kelland and Kelland, *New Jersey*.
244. Dale, *Delaware Diary*.
245. Kelland and Kelland, *New Jersey*.
246. Henn, *Story of the River Road*.
247. Toll, *Six Frigates*.
248. Kelland and Kelland, *New Jersey*.
249. Albert, *Damming the Delaware*.
250. Albert and Albert, *Along the Delaware River*.
251. Dale, *Delaware Diary*.
252. Albert, *Damming the Delaware*.
253. Dale, *Delaware Diary*.
254. Wilson, *History of Delaware Water Gap and Its Resorts*.
255. Francis R. Drake, *The Borough of Delaware Water Gap: A Centennial Study* (Gainesville, FL: Elsa Drake, 1992).
256. Toll, *Six Frigates*.
257. Ibid.
258. Ibid.
259. Weslager, *Delaware Indians*.
260. Wilson, *History of Delaware Water Gap and Its Resorts*.
261. Toll, *Six Frigates*.
262. Bailey, "State of the Delaware Estuary 2012."
263. Robert Elman, *The Atlantic Flyway* (Tulsa, OK: Winchester Press, 1980).
264. Kyde et al., *Delaware River Scenic Byway*.
265. Albert and Albert, *Along the Delaware River*.
266. Summa, Summa and Garris, *Eastern Poconos*.
267. Toll, *Six Frigates*.
268. Albert and Albert, *Along the Delaware River*.
269. Brodhead, *Delaware Water Gap*.
270. Bailey, "State of the Delaware Estuary 2012."
271. Albert, *Damming the Delaware*.

272. Dale, *Delaware Diary*.
273. C.G. Hine, *The Old Mine Road* (New Brunswick, NJ: Rutgers University Press, 1985).
274. Wilson, *History of Delaware Water Gap and Its Resorts*.
275. Yoder, *Delaware Canal Journal*.
276. Ibid.
277. Lawrence Squeri, *Better in the Poconos* (University Park: Pennsylvania State University Press, 2002).
278. Dale, *Delaware Diary*.
279. Albert and Albert, *Along the Delaware River*.
280. Stansfield, *Ecological History of New Jersey*.
281. Sorenson, "Blair Mystery."
282. Dale, *Delaware Diary*.
283. Albert and Albert, *Along the Delaware River*.
284. Lee, *Down Along the Old Bel-Del*.
285. Albert, *Damming the Delaware*.
286. Lee, *Down Along the Old Bel-Del*.
287. Bailey, "State of the Delaware Estuary 2012."
288. Wilson, *History of Delaware Water Gap and Its Resorts*.
289. Brodhead, *Delaware Water Gap*.
290. Wilson, *History of Delaware Water Gap and Its Resorts*.
291. Dale, *Delaware Diary*.
292. Brodhead, *Delaware Water Gap*.
293. Albert and Albert, *Along the Delaware River*.
294. Dale, *Delaware Diary*.
295. James Lee, *The Morris Canal: A Photographic History* (Easton, PA: Delaware Press, 1983).
296. Albert and Albert, *Along the Delaware River*.
297. Wilson, *History of Delaware Water Gap and Its Resorts*.
298. Ibid.
299. Albert and Albert, *Along the Delaware River*.
300. Squeri, *Better in the Poconos*.
301. Yoder, *Delaware Canal Journal*.
302. Dale, *Delaware Diary*.
303. Lee, *Down Along the Old Bel-Del*.
304. Dale, *Delaware Diary*.
305. Albert and Albert, *Along the Delaware River*.
306. Bailey, "State of the Delaware Estuary 2012."
307. Albert, *Damming the Delaware*.

308. Bank, *Banks of the Delaware*.
309. Lee, *Down Along the Old Bel-Del*.
310. Ibid.
311. Bank, *Banks of the Delaware*.
312. Bailey, "State of the Delaware Estuary 2012."
313. Wilson, *History of Delaware Water Gap and Its Resorts*.
314. Lee, *Down Along the Old Bel-Del*.
315. Albert and Albert, *Along the Delaware River*.
316. Ibid.
317. Albert, *Damming the Delaware*.
318. Albert and Albert, *Along the Delaware River*.
319. Ibid.
320. Ibid.
321. Bailey, "State of the Delaware Estuary 2012."
322. Albert and Albert, *Along the Delaware River*.
323. Dale, *Delaware Diary*.
324. Albert and Albert, *Along the Delaware River*.
325. Albert, *Damming the Delaware*.
326. Dale, *Delaware Diary*.
327. Lee, *Down Along the Old Bel-Del*.
328. Albert, *Damming the Delaware*.
329. Bank, *Banks of the Delaware*.
330. Albert, *Damming the Delaware*.
331. Wilson, *History of Delaware Water Gap and Its Resorts*.
332. Ibid.
333. Squeri, *Better in the Poconos*.
334. Albert and Albert, *Along the Delaware River*.
335. Wilson, *History of Delaware Water Gap and Its Resorts*.
336. Lee, *Down Along the Old Bel-Del*.
337. Albert, *Damming the Delaware*.
338. Marie J. Summa, Frank D. Summa and Leonard Buscemi Sr., *Historic Easton* (Charleston, SC: Arcadia Publishing, 2000).
339. Albert, *Damming the Delaware*.
340. Ibid.
341. Wilson, *History of Delaware Water Gap and Its Resorts*.
342. Albert, *Damming the Delaware*.
343. Lee, *Down Along the Old Bel-Del*.
344. Tambini and Martin, *Administrative Agreement*.
345. Ibid.

346. Albert and Albert, *Along the Delaware River*.
347. Yoder, *Delaware Canal Journal*.
348. Ibid.
349. Albert, *Damming the Delaware*.
350. Ibid.
351. DRBC, "Delaware River Water Quality: A Brief Recap," Delaware River Basin Commission website, 2016.
352. Albert, *Damming the Delaware*.
353. Ibid.
354. Ibid.
355. Bailey, "State of the Delaware Estuary 2012."
356. Albert, *Damming the Delaware*.
357. Ibid.
358. Ibid.
359. Albert and Albert, *Along the Delaware River*.
360. Dale, *Delaware Diary*.
361. Lee, *Down Along the Old Bel-Del*.
362. Albert, *Damming the Delaware*.
363. Ibid.
364. Ibid.
365. Ibid.
366. Tambini and Martin, *Administrative Agreement*.
367. Albert, *Damming the Delaware*.
368. Ibid.
369. Ibid.
370. Ibid.
371. Ibid.
372. Ibid.
373. Ibid.
374. DRBC, "Delaware River Water Quality: A Brief Recap."
375. Albert, *Damming the Delaware*.
376. Ibid.
377. Ibid.
378. Dale, *Delaware Diary*.
379. Albert, *Damming the Delaware*.
380. Ibid.
381. Ibid.
382. DRBC, "Delaware River Water Quality: A Brief Recap."
383. Ibid.

384. Albert, *Damming the Delaware*.
385. Ibid.
386. Stansfield, *Ecological History of New Jersey*.
387. Albert, *Damming the Delaware*.
388. Ibid.
389. Bailey, "State of the Delaware Estuary 2012."
390. Albert, *Damming the Delaware*.
391. Ibid.
392. Ibid.
393. Ibid.
394. DRBC, "Delaware River Water Quality: A Brief Recap."
395. Albert, *Damming the Delaware*.
396. Dale, *Delaware Diary*.
397. Albert, *Damming the Delaware*.
398. Bailey, "State of the Delaware Estuary 2012."
399. Albert, *Damming the Delaware*.
400. Tambini and Martin, *Administrative Agreement*.
401. DRBC, "Delaware River Water Quality: A Brief Recap."
402. Ibid.
403. Bailey, "State of the Delaware Estuary 2012."
404. DRBC, "Delaware River Water Quality: A Brief Recap."
405. Bailey, "State of the Delaware Estuary 2012."
406. Ibid.
407. Kyde et al., *Delaware River Scenic Byway*.
408. Ibid.
409. DRBC, "Delaware River Water Quality: A Brief Recap."
410. Ibid.
411. Ibid.

ADDITIONAL SOURCES CONSULTED

Ackerman, Jennifer. *The Genus of Birds*. New York: Penguin Press, 2016.

Albert, Richard C., and Carrie E. Albert. *Along the Delaware River*. Charleston, SC: Arcadia Publishing, 2002.

Arndt, Harold H., and Gordon H. Wood. *Late Paleozoic Orogeny in Eastern Pennsylvania Consists of Five Progressive Stages*. U.S. Geological Survey, 1960. Professional Paper 400-B.

Backes, Pamela, Richard Backes and Chester Richards. *150th Town Celebration Phillipsburg, NJ 1861–2011*. Easton, PA: Harmony Press and Phillipsburg Area Historical Society, 2011.

Barber, Joel. *Wildfowl Decoys*. New York: Windward House, 1934.

Bertland, Dennis N., Patricia M. Valence and Russell J. Wooding. *The Minisink: A Chronicle of One of America's First and Last Frontiers*. Four-County Task Force on the Tocks Island Dam Project. July 1975.

Bill, Alfred Hoyt. *New Jersey and the Revolutionary War*. New Brunswick, NJ: Rutgers University Press, 1964.

Boyer, Charles. *Early Forges and Furnaces in New Jersey*. Philadelphia: University of Pennsylvania Press, 1931.

Brusatte, Stephen, and Zhe-Xi Luo. "Ascent of the Mammals." *Scientific American* (June 2016): 28–35.

Burtt, Edward H., Jr., and William E. Davis Jr. *Alexander Wilson: The Scot Who Founded American Ornithology*. Cambridge, MA: Belknap Press of Harvard University Press, 2013.

Additional Sources Consulted

Buscemi, Leonard, Sr. *Phillipsburg*. Charleston, SC: Arcadia Publishing, 2001.
Camp, Raymond R. *Duck Boats: Blinds: Decoys and Eastern Seaboard Waterfowling*. New York: Alfred A. Knopf, 1952.
Cary, John. *Historical Study of the Proposed Tocks Island Recreation Area*. Bethlehem, PA: Lehigh University, n.d.
Chambers, T.F. *The Early Germans of New Jersey*. Dover, NJ: Dover Printing Company, 1895.
Chance, H.M. *Special Survey of the Delaware Water Gap*. Pennsylvania Geological Survey, 1882.
Collum, Laura. "Delaware River Decoys Differ from Their Coastal Brethren." Worthpoint. www.worthpoint.com/blog-entry/delaware-rivers-decoys-differ-costal.
Colonial Homes. "Carver's Craft" (January–February 1986): 110–13.
Crowl, G.H. "Pleistocene Geology and Unconsolidated Deposits of the Delaware Valley, Matamoras to Shawnee on Delaware, Pennsylvania." General Geology Report 60. Harrisburg: Pennsylvania Geological Survey, 1971. dcnr.state.pa.us/topogeo/publications/pgspub/general/index.htm.
Crowl, G.H., and W.D. Sevon. "Glacial Border Deposits of Late Wisconsinan Age in Northern Pennsylvania." General Geology Report 71. Harrisburg: Pennsylvania Geological Survey, 1980. dcnr.state.pa.us/topogeo/publications/pqspub/general/index.htm.
Cummings, George Wyckoff. *History of Warren County, New Jersey—Primary Source Edition*. New York: Lewis Historical Publishing Company, 1911.
Cunningham, John T. *This Is New Jersey*. 4th ed. New Brunswick, NJ: Rutgers University Press, 1999.
Curtis, Charles T. *Rafting on the Delaware*. Ithaca, NY: Dewitt Historical Society of Tompkins County, 1957.
Dandelion, Pink. *The Quakers*. Oxford, UK: Oxford University Press, 2008.
Davis, William Morris. "Rivers and Valleys of Pennsylvania." *National Geographic Magazine* 1 (1889): 183–253.
———. "The Rivers of Northern New Jersey with Notes on the Classification of Rivers in General." *National Geographic Magazine* 2 (1890): 81–110.
Decoy Magazine. "Index of Master Carvers."
Delaware Water Gap. "How the Gap Was Founded." Delaware Water Gap National Park Service, U.S. Department of the Interior. Brochure.
Dorflinger, Don, and Marietta Dorflinger. *River Towns of the Delaware Water Gap*. Charleston, SC: Arcadia Publishing, 2009.

Additional Sources Consulted

Drake, A.A., Jr., R.E. Davies and D.C. Alvord. *Taconic and Post-Taconic Folds in Eastern Pennsylvania and Western New Jersey.* U.S. Geological Survey, 1960.

DRBC. *Delaware River State of the Basin Report 2008.* West Trenton, NJ: Delaware River Basin Commission, 2008. www.nj.gov/drbc.

Duess, Marie Murphy. *The Delaware Canal: From Stone Coal Highway to Historical Landmark.* Charleston, SC: The History Press, 2008.

Engers, Joe, ed. *The Great Book of Wildfowl Decoys.* San Diego, CA: Thunder Bay Press Inc., 1990.

Epstein, J.B. *The Shawangunk Formation in Eastern Pennsylvania.* U.S. Geological Survey Professional Paper 744, 1972.

———. *Structural Geology of the Delaware Water Gap National Recreation Area.* A Delaware Odyssey, 66th Field Conference of Pennsylvania Geologists, 2001.

Epstein, Jack B. "Geology of Delaware Water Gap National Recreation Area, New Jersey–Pennsylvania." Reston, VA: U.S. Geological Survey, Field Guide 8, 2006.

Epstein, Jack B., and Anita G. Epstein. *The Shawangunk Formation (Upper Ordovician to Middle Silurian) in Eastern Pennsylvania.* Washington, D.C.: U.S. Geological Survey, 1972.

Fagan, Brian M. *Ancient North America.* 4th ed. New York: Thames & Hudson Inc., 2005.

Ferris, Benjamin. *A History of the Original Settlements of the Delaware, from Its Discovery by Hudson to the Colonization Under William Penn with an Account of the Swedish Settlers, and a History of Wilmington.* British Library, Historical Print Edition. Wilmington, DE, 1846.

Fleckenstein, Henry A., Jr. *New Jersey Decoys.* Exton, PA: Schiffer Publishing Ltd., 1983.

Fried, Johannes. *The Middle Ages.* Cambridge, MA: Harvard University Press, 2015.

Fulcomer, Kathleen, and Roger Corbett. *The Delaware River: A Resource and Guidebook to the River and the Valley.* Springfield, VA: Seneca Press, 1981.

Gonzalez, Robbie. "How Did Dinosaurs Become Birds?" February 18, 2015. www.audubon.com.

Goudarzi, Sara. "Modern Birds Existed Before Dinosaur Die-Off." *National Geographic News,* February 8, 2008.

Gruzlovic, Hope, and Amy Cradic. *Natural Wonders of New Jersey: A Guide to Parks, Preserves & Wild Places.* Castine, ME: County Roads Press, 1994.

Halsey, Frances W., ed. *A Tour of Four Great Rivers, the Hudson, Mohawk, Susquehanna and Delaware in 1769: Being the Journal of Richard Smith of Burlington, New Jersey.* New York: Charles Scribner's Sons, 1906.

Additional Sources Consulted

Harper, John A., ed. *Journey Along the Taconic Unconformity, Northeastern Pennsylvania, New Jersey, and Southeastern New York*. 77th Annual Conference of Pennsylvania Geologists. Shawnee-on-Delaware, PA, October 18–20, 2012. http://fcopg.org.

Harrell, Loy S., Jr. *Decoys: North America's One Hundred Greatest*. Iola, WI: Krause Publications, 2000.

———. *Decoys: Sixty Living and Outstanding North American Carvers*. East Petersburg, PA: Fox Chapel Publishing, 2007.

Hecht, M.K., J.H. Ostrom, G. Viohl and P. Wellahofer, eds. *The Beginnings of Birds: Proceedings of the International Archaeopteryx Conference*. Eichstätt, Germany: Freunde des Jura-Museums Eichstätt, 1985.

Honeyman, A. Van Doren, ed. *Northwestern New Jersey: A History of Somerset, Morris, Hunterdon, Warren and Sussex Counties*. 5 vols. New York: Lewis Historical Publishing Company, 1927.

Hope, Richard F. *Easton, PA: A History*. Bloomington, IN: Authorhouse, 2006.

Hunter, Clark. *The Life and Letters of Alexander Wilson*. Philadelphia, PA: American Philosophical Society, 1983.

Jacobs, Jaap. *The Colony of New Netherland: A Dutch Settlement in Seventeenth-Century America*. Ithaca, NY: Cornell University Press, 2009.

Johnson, Amandus. *The Swedish Settlements on the Delaware 1638–1664*. 2 vols. Baltimore, MD: Genealogical Publishing Company, 1969.

Johnson, Douglas W. *Stream Sculpture on the Atlantic Slope: A Study in the Evolution of Appalachian Rivers*. New York: Columbia University Press, 1931.

Just Collecting. "List of Notable Bird Decoy Artists." https://www.justcollecting.com/misclanious/list-of-notable-decoy-artists.

Kangas, Gene, and Linda Kangas. *Decoys: A North American Survey*. Spanish Fork, UT: Hillcrest Publications, 1983.

Keith, Arthur. "Outlines of Appalachian Structure." *Geological Society of America Bulletin* 34 (1923).

Kious, W., and R.I. Tilling. *This Dynamic Earth: The Story of Plate Tectonics*. U.S. Geological Survey, 1996.

Kraft, Herbert C. *The Archaeology of the Tock's Island Area*. South Orange, NJ: Seton Hall University Museum, 1975.

Kummel, H.B. *Geology of New Jersey*. Bulletin 50, Geological Series, State Department of Conservation and Economic Development, 1940.

Kyriakodis, Harry. *Philadelphia's Lost Waterfront*. Charleston, SC: The History Press, 2011.

Lane, Wheaton J. *From Indian Trail to Iron Horse: Travel and Transportation in New Jersey, 1620–1860*. Princeton, NJ: Princeton University Press, 1939.

Additional Sources Consulted

Leiby, Adrian. C. *The Early Dutch and Swedish Settlers of New Jersey*. Princeton, NJ: D. Van Nostrand Inc., 1964.

Leiser, Amy. *The Legend of Lover's Leap*. Stroudsburg, PA: Monroe County Historical Association, February 2010.

Lender, Mark Edward. *The River War: The Fight for the Delaware, 1777*. Trenton: New Jersey Historical Commission, 1979.

Lesher, Peter. "New Additions to the R.W. Davis Rig." *Decoy Magazine* (November/December 2016): 32–33.

Lewis, Joseph Volney, and Henry Barnard Kummel. *The Geology of New Jersey*. Bulletin 14. Union Hill, NJ: Dispatch Printing Company, 1915.

Lewis, Russell E. *Warman's Duck Decoys: Identification and Price Guide*. Iola, WI: Krause Publications, 2006.

Lincoln, Frederick C. *Migration of Birds*. Circular 16. Washington, D.C.: United States Department of the Interior, Fish and Wildlife Service, 1950.

Lincoln, Frederick Charles, Steven R. Peterson, Peter A. Anastosi and Bob Hines. *Migration of Birds*. Reprint, Washington, D.C.: Office of Conservation Education, U.S. Fish and Wildlife Service.

Luckey, Carl F., and Russell E. Lewis. *Collecting Antique Bird Decoys and Duck Calls: An Identification and Price Guide*. 3rd ed. Iola, WI: Krause Publications, 2003.

Lurie, Maxine N., and Marc Mappen, eds. *Encyclopedia of New Jersey*. New Brunswick, NJ: Rutgers University Press, 2004.

Mackey, William J., Jr. *American Bird Decoys*. New York: E.P. Dutton & Company Inc., 1965.

Marshak, Stephen. *Essentials of Geology*. 4th ed. New York: W.W. Norton & Company, 2013.

McCormick, Richard P. *New Jersey from Colony to State, 1609–1789*. New Brunswick, NJ: Rutgers University Press, 1964.

Menzies, Elizabeth G.C. *Before the Waters: The Upper Delaware Valley*. New Brunswick, NJ: Rutgers University Press, 1966.

Miller, B.L., C.M. Fraser and R.L. Miller. *Northampton County, Pennsylvania, Geology and Geography*. Pennsylvania Geological Survey Bulletin C48, 1939.

Miller, Stephen M. *Early American Waterfowling, 1700s–1930*. Piscataway, NJ: Winchester Press, New Century Publishers Inc., 1986.

National Park Service. *Delaware River Basin National Wild and Scenic River Values*. Washington, D.C.: U.S. Department of the Interior, 2012.

Newberry, Lida, ed. *New Jersey: A Guide to Its Present and Past*. New York: Hastings House, 1977.

Obiso, Laura. *Delaware Water Gap National Recreation Area*. Charleston, SC: Arcadia Publishing, 2008.

Palmer, Tim. *Rivers of Pennsylvania*. University Park: Pennsylvania State University Press, 1980.
Partnership for the Delaware Estuary. *Estuary News* 22, no. 4 (Summer 2012).
Pernot, M.M. "The Bob and Pauline White Decoy Collection." Burlington, NJ: Burlington County Historical Society, November 1996–May 1997.
Price, Martin F. *Mountains*. Oxford, UK: Oxford University Press, 2015.
Redfern, Ron. *Origins: The Evolution of Continents, Oceans and Life*. Norman: University of Oklahoma Press, 2001.
Ridges, Bob. *Duck Decoys*. New York: Gallery Books, W.H. Smith Publishers Inc., 1988.
Rubin, Miri. *The Middle Ages*. Oxford, UK: Oxford University Press, 2014.
Sanderson, Dorothy H. *The Delaware and Hudson Canal Way*. Ellenville, NY: Roundout Valley Publishing Company, 1965.
Singer, Emily. "How Dinosaurs Shrank and Became Birds." *Quanta Magazine* (n.d.).
Stokes, A.F. *Indian History and Legends of Pennsylvania's Picturesque Playground*. Stroudsburg, PA: A.B. Wyckoff, n.d.
Stutz, Bruce. *Natural Lives—Modern Times: People and Places of the Delaware River*. New York: Crown Publishers Inc., 1992.
Summa, Marie J., Frank D. Summa and Leonard Buscemi Sr. *Historic Easton*. Charleston, SC: Arcadia Publishing, 2000.
Taylor, Hal. *The Illustrated Delaware River*. Atglen, PA: Schiffer Publishing Ltd., 2015.
Theisen, J.P. "Is There a Fault in Our Gap?" *Pennsylvania Geology* 14, no. 3 (1983): 5–11.
Thompson, H.D. "Drainage Evolution in the Appalachians of Pennsylvania." *New York Academy of Science Annals* 52 (1949): 31–62.
Tiner, R.W., Jr. *Mid-Atlantic Wetlands: A Disappearing Treasure*. U.S. Fish and Wildlife Service and U.S. Environmental Protection Agency, 1987.
Tradition from a Woman's Hand. Tuckerton, NJ: Tuckerton Seaport & Baymen's Museum, 2012.
U.S. Army Corps of Engineers. "Delaware Estuary Historical Timeline." *Compilation of Delaware Estuary Use Attainability Project Reports*. Philadelphia, PA: USACE, n.d.
———. *The Delaware River: A Brief History of Its Improvement*. Philadelphia, PA, 1950.
———. *Long Range Disposal Study*. Part I: *General Data for the Delaware River*. Philadelphia, PA, n.d.

Additional Sources Consulted

Veit, Richard. *The Old Canals of New Jersey*. Little Falls: New Jersey Geographical Press, 1963.

Vergano, Dan. "Birds Evolved from Dinosaurs Slowly—Then Took Off." *National Geographic*. http://news.nationalgeographic.com/news/2014/09/140925-bird-dinosaur-evolution-burst-scenic.html.

Wacker, Peter. *The Musconetcong Valley of New Jersey*. New Brunswick, NJ: Rutgers Universty Press, 1968.

Wacker, Peter O. *Land & People: A Cultural Geography of Preindustrial New Jersey Origins and Settlement Patterns*. New Brunswick, NJ: Rutgers University Press, 1975.

Ward, Christopher. *The Dutch & Swedes on the Delaware, 1609–64*. Philadelphia: University of Pennsylvania Press, 1931.

Wildes, Harry Emerson. *The Delaware*. New York: Farrar & Rhinehart Inc., 1940.

Willard, Bradford. *A Paleozoic Section at Delaware Water Gap*. General Geology Report. Harrisburg, PA: Topographic and Geologic Survey, 1938. dcnr.state.pa.us/topogeo/publications/pqsbub/general/index.htm.

Wilson, Edward O. *The Social Conquest of Earth*. New York: Liveright Publishing Corporation, 2012.

Woodward, Jamie. *The Ice Age*. Oxford, UK: Oxford University Press, 2014.

Wuorinen, John H. *The Finns on the Delaware, 1638–1655*. New York: Columbia University Press, 1938.

Wynkoop, Ronald W., Sr. *Forks of the Delaware: A Picture Album*. Phillipsburg, NJ: self-published, 1966.

———. *The Golden Years: Old Time Easton & Phillipsburg*. Phillipsburg, NJ: self-published, 1970.

———. *It Seems Like Yesterday: Forks of the Delaware, 1902*. Phillipsburg, NJ: self-published, 1989.

———. *The Old Home Town*. Phillipsburg, NJ: self-published, 1977.

———. *A Time to Remember*. Phillipsburg, NJ: self-published, 1985.

INDEX

A

Acadian Orogeny 45, 51
accretion 47, 50
adaptive radiation 107, 113, 116
Adirondack Mountains 48
age-of-Earth 33, 34, 35
Age of Reptiles 103
Algonquin 73
Alleghanian 45, 52
Alleghanian Orogeny 45, 52
Allegheny Mountains 48, 52
Alps Mountains 46
American Revolution 21, 133, 152
American shad 24, 25, 162
Anatidae 93, 94, 95, 116, 226
Anatinae 93, 94, 95
ancestral Delaware 28, 54, 55, 56, 57, 58
Anser 96
Anseriformes 93, 96, 114, 116
Anserinae 93, 94, 96
anthracite coal 21, 22, 150, 151, 156, 157, 164

Anthropocene Epoch 11
Appalachian Basin 50
Appalachian Mountains 44, 45, 47, 48, 49, 50, 51, 52, 54, 55, 68, 117
Appalachian Orogeny 52
arboreal archosaurs 106
Archaeopteryx 98, 99, 100, 101, 102, 103, 104, 106, 107
Archaic Period 117
Archean Epoch 47
Archean Era 44
Archosaur 106
Argall, Samuel 20, 76, 144
asthenosphere 39, 40, 41
asymmetrical 99, 101, 102, 109
Atlantic sturgeon 24, 155
Auimimus portentosus 105
Avalonia 44, 45, 51
Avialae 99
Aythyinae 94, 95

INDEX

B

Bacon, Francis 36
Baltica 44, 45
Barnegat Bay 120, 121, 126, 136
basalt 42, 53, 97
Battle of Raymonskill 153
Becquerel, Henri 33
Belvidere 53, 57, 58, 59, 60, 62, 71, 159, 164, 167, 196
Best Management Practices 181
Big Bang theory (birds) 107, 116
bird-hipped 106
Black, Charles 134
Blackett, P.M.S. 38
Blair, John, Jr. 126, 202
Blair, John, Sr. 119, 120, 125, 126, 127, 201
Blair School 125
Blair, Walter 126, 202
Bloomsburg formation 57
blue crabs 24, 180
Blue Mountains 22, 55, 64, 66, 71
Boltwood, Bertram B. 33
Bone Wars 104
Borden, Joseph 132
Bordentown 21, 119, 120, 132, 133, 135, 136, 156, 184, 200, 201, 202, 204, 205, 206, 208, 209, 210, 212
Bordentown School 119, 134, 135
boundary 39, 40, 50, 54, 62
Brandywine Creek 151
Branta 96
Brotherton 151, 154
buffer zone 76, 143, 144, 148
Buffon, Conte du 32
Byrne, Brendan T. 26
Byrne, Governor Branden T. 176

C

Cabeza de Vaca, Álvar Núñez 47
Cabot, John 143
Cahill, Governor William T. 176
Cambrian Period 44, 50
canal 22, 147, 150, 153, 156, 161, 162, 179, 184, 185, 188
Carboniferous Period 44, 52
Carr, Sir Robert 148
Carter, President Jimmy 27, 177
Catskill-Delaware Supply System 19
Catskill Mountains 15, 18, 19, 51, 73
Cenozoic Era 107, 111, 114
Charadriiformes 111
Charles II, King 148
Chesapeake and Delaware Canal 156
Chesapeake Bay 119, 127, 128
Chestnut Hill 71, 167
Chicxulub 98
cholera 153, 157, 160
Clean Water Act 19, 24, 25, 176
Clean Water Council of New Jersey 174
coal arks 121, 152
coelurosaurian 97
Comprehensive Conservation and Management Plan for the Delaware Estuary 179
Comprehensive Environmental Response, Compensation, and Liability Act 178
compressive mountain building 48, 50
Compsognathus 103
Confuciusornis 112
Coniornis 103

Index

Connecticut River 54
continental crust 39, 44, 47
continental drift 36, 37, 38, 39, 40, 42, 47
Cooke, Joy 127
Cooper, Alan 114
cordonts 104, 105
core 35, 36, 39, 42
Cretaceous Period 11, 46, 54, 58, 97, 98, 102, 103, 104, 105, 107, 108, 109, 110, 111, 112, 113, 114, 116
crocodiles 105, 106
crust 32, 33, 35, 39, 40, 42, 52, 69
Curie, Marie and Pierre 33
Cygninaic 93

D

dabbling ducks 93, 94, 95
Darby Field 77
Darwin, Charles 32, 98, 103
Darwin, George H. 32
Dawson, John 119, 131, 203
DDT 166, 168, 176
Deccan Traps 97, 98
Deinonychus 105
Delaware and Raritan Canal 18, 21, 156, 167, 170
Delaware Bay 15, 18, 20, 24, 58, 73, 76, 118, 119, 120, 122, 125, 136, 143, 144, 146, 147, 148, 155, 175, 176, 177, 178, 179
Delaware Canal 21, 156, 165, 167
Delaware Ducker 135
Delaware Estuary 19, 25, 143, 147, 149, 162, 172, 178, 179, 180, 187
Delaware Estuary Toxics Management Program 178
Delaware National Wild and Scenic River System 180
Delaware River 15, 16, 18, 19, 21, 22, 24, 25, 27, 28, 29, 52, 53, 54, 55, 57, 62, 66, 68, 69, 70, 71, 73, 76, 116, 117, 118, 119, 120, 121, 122, 123, 125, 126, 128, 129, 131, 132, 134, 136, 137, 143, 144, 145, 148, 150, 152, 153, 155, 157, 158, 159, 161, 162, 163, 164, 165, 166, 167, 168, 169, 170, 171, 172, 174, 176, 177, 178, 179, 180, 181, 185, 186, 199, 200, 201, 202, 203, 204, 205, 206, 207, 208, 209, 210, 211, 212, 215, 228
Delaware River 308 Report 167
Delaware River and Bay Authority 173
Delaware River Basin 18, 19, 167, 171, 172, 181
Delaware River Basin Advisory Committee 171
Delaware River Basin Commission 19, 172
Delaware River Basin Survey Commission 171
Delaware River decoys 117, 215, 219
Delaware River Development Corporation 169
Delaware Riverkeeper Network 178
Delaware River Scenic Byway 181
Delawares 81, 82, 118, 150, 151, 154
Delaware Supply System 19
Delaware Valley 21, 22, 25, 59, 62, 71, 73, 75, 147, 151, 158, 170, 174, 199

INDEX

Delaware Water Gap 22, 25, 26, 27, 28, 54, 55, 56, 57, 59, 63, 64, 66, 67, 68, 69, 70, 71, 73, 74, 75, 77, 87, 151, 153, 156, 158, 159, 160, 161, 166, 168, 173, 177, 180, 196, 225
Delaware Water Gap National Recreation Area 173
De La Warre, Lord 20, 76
De Narváez, Pánfilo 47
Dendrochen 116
deposition 48, 50, 51, 52, 58, 59, 62
Depui, Nicholas 149
Dermer, Thomas 144
De Soto, Hernando 47
Devonian Period 44, 45, 49, 51
Dietz, Robert 39
dinosaurs 97, 98, 99, 100, 102, 103, 105, 106, 107, 110, 111, 112
dip 223
diving ducks 93, 94, 95, 120, 125
Dormer, Thomas 77
double-ended boats 136
downcutting 70
dredging 24, 120, 121, 122, 123, 124, 161, 168, 169
Durham boats 57, 121, 150, 152
Dutch 20, 76, 77, 88, 118, 121, 143, 144, 145, 146, 147, 148, 225
Dutot, Antoine 154, 156

E

East Africa Rift Valley 47
East Branch 15, 16, 54, 167, 170, 186

Easton 21, 26, 57, 60, 71, 81, 150, 151, 155, 156, 157, 158, 159, 161, 163, 165, 167, 171, 186, 196
Edison, Thomas 163
Endangered Species Act 176
English 20, 36, 68, 76, 77, 81, 88, 103, 118, 120, 121, 128, 132, 134, 143, 144, 145, 146, 147, 148, 151, 216, 225
English, Daniel 131, 203
English/Dawson decoys 131
English, Jack 132, 204
English, John 119, 130, 131, 132
Environmental Defense Fund 176
Environmental Protection Agency 19, 175
Eocene Epoch 114
Epidexipteryx 100
Epstein, Jack B. 67
erosion 28, 48, 50, 51, 52, 53, 54, 55, 57, 58, 59, 61, 62, 69, 70, 97, 179, 222, 223
estuary 18, 19, 21, 24, 25, 29, 57, 58, 73, 118, 122, 123, 136, 143, 152, 155, 156, 163, 168, 177
eugeosyncline 49, 52
Euroamerica 44, 52

F

falls 20, 21, 57, 58, 62, 77, 87, 118, 121, 145, 148, 149, 153
Farnsworth, Thomas 132
faulting 45, 48, 50, 52
Feduccia, John Alan 106
Finns 118, 121

flexure zone 67
Flood Control Act of 1936 167
Flood Control Act of 1962 172
Florence 119, 120, 129, 132, 135, 203, 204, 206, 207, 211, 212
Florence City Company 129
Florence School 119, 130, 132, 134
folding 45, 48, 49, 50, 52, 66
Fort Christine 146
Fort Delaware 159
Fort Mercer 152
Fort Mufflin 152
Fort Nassau 144, 146, 147
Foul Rift 57, 121, 192
Fox Gap 66
fracking 24
fracture zones 38
Franklin, Benjamin 21, 150, 165, 195
French and Indian War 150, 151

G

Gauthier, Jacques 111
Gondwana 42, 44, 45, 51
Good Faith Negotiations 177
gorge 59, 60, 62, 68, 70, 89
Gorges, Sir Fernando 77
Graculavidae 107
Graculavids 107, 113
granite 42, 49
Great Valley 48
Great Wagon Road 80
Grenville collision 49
Grenville Orogeny 49
"ground up" hypothesis 99
Gutierrez, Diego 48

H

hactenus inculta 145, 147
Hancock, New York 15, 28, 54
Hauser, Ned John 127
Heezen, Bruce 38
Heilmann, Gerhard 104
Heisler, Jess 132, 136, 206
Hendrickson, Cornelius 144
Hess, Harry 39, 40
Highlands Province 55
Himalayan Mountains 41, 46
Hobart 15, 54
Holmes, Arthur 34
Holmes, Justice Oliver Wendell 167
Holocene Epoch 11
Homo sapiens 11
Horner, Jack 105
Hudson, Henry 20, 143
Hudson River 18, 21, 54, 76, 80, 144, 157
Huxley, Thomas H. 32, 103

I

Ichthyornis 104, 108
igneous 49
Industrial Revolution 21, 150, 155, 156
intermontane trough 55
Interstate Commission on the Delaware River Basin 167
Iroquois 73

J

James I, King 143
James River 54, 76, 159, 165

INDEX

Jay, John 33
Jurassic Period 43, 53, 98, 99, 101, 102

K

kitchen gardens 118
Kitochtanemin 74, 225
Kittatinny Mountain Pump-Storage Project 172
Kittatinny Mountains 26, 51, 52, 53, 54, 55, 58, 63, 66, 67, 70, 73, 74, 75, 80, 147, 225
Kittatinny Valley 67, 118
K-T boundary 97, 107, 111, 113, 114
Kurzamov, Sergei 104

L

Lackawaxen 16, 156, 160, 162, 186, 197
Lackawaxen Dam 158
Lake Laconia 76, 77, 121, 145
Lake Sciota 71, 75
Late Woodlands Period 73
Laurasia 42, 45
Laurentia 44, 45, 47, 51
Lehigh River 16, 19, 54, 57, 60
Lehigh Valley 21, 22, 157, 159, 190, 196
Leni-Lenapes 66, 73, 74, 76, 78, 79, 80, 81, 83, 90, 118, 119, 143, 144, 145, 146, 150, 151, 174, 224, 225
Liaoning Lake 100, 111, 112
lithosphere 39, 40, 41
lizard-hipped 106
Llaoninqornis 107

log rafts 121
Lomonosov, Mikhail 32
Lower Delaware National Wild and Scenic River System 28
lumber rafts 152, 165
Lyell, Charles 32

M

magma 39, 50
Manatamany 78, 81, 82, 84
maniraptoran theropods 97, 106, 111
mantle 33, 35, 39, 40, 42, 50, 98
Marathon Mountains 48
Marble Mountain 71
Marsh, Othniel Charles 103
Martynuik, Matthew P. 114
Mason, Captain John 77
May, Cornelius Jacobsen 144
Medgea, Benjamin 104
Mei Long 112
Mesozoic Era 43, 52, 58, 97, 99, 103, 104, 106, 107, 113
Mesozoic radiation 113
metamorphism 50, 51
mid-ocean ridges 38, 39, 40, 41
Milankovic, Milutin 36
minisink 73
Minisink Valley 56, 60, 73, 74, 75, 144, 149, 153
Minsis 73, 81, 118, 165
Miocene Epoch 116
miogeosyncline 52
Moho 39
Montague Formula 170
moraine dam 71
Morris Canal 21, 157, 158, 161
Mount Minsi 66, 67, 68, 73, 89

Index

Mount Mitchell 48
Mount Tammary 66, 73
Munsees 73, 76, 118
Munseys 118

N

National Environmental Policy Act 175
National Estuary Program 19, 178
National Parks and Recreation Act 177
National Park Service 27, 68, 174
National Recreation Area 27, 63, 68, 177, 180
National Wild and Scenic River System 25, 26, 27, 28, 29, 177
Newark Rift System 53
Newcomb, Simon 32
New Jersey and Pennsylvania Treaty of 1783 170
New Sweden 146, 147
Nockarmixon Rocks 57
non-tidal 15, 25, 29, 62, 171, 172
North River 76, 144
Northwest Passage 77, 118, 121, 143, 144, 145
Nova Caesarea (New Jersey) 148

O

oceanic crust 39, 41
Old Mine Road 147
Oligocene Epoch 113, 116
Ordovician Period 44, 45
Ortelius, Abraham 36
Ostrun, John 104, 105
Otsego Lake 76

Ouachita Mountains 48
oyster 24, 165, 171

P

Pahaqualong 79, 80, 225
Pahaquarry mine 147
Paleocene Epoch 113, 114
Paleo-Indians 73, 76, 117, 143
paleomagnetism 38
Paleozoic Era 43, 45
Pangaea 37, 41, 42, 43, 44, 45, 46, 47, 50, 52, 53, 54, 63, 67, 70
peneplane 52, 67, 223
Penn, Thomas 149
Penn, William 21, 82, 149, 150
Penny, David 114
Permian Period 45, 52
Perry, John 33
Philadelphia 18, 21, 22, 26, 58, 62, 63, 70, 81, 119, 120, 121, 122, 123, 125, 126, 127, 128, 130, 132, 136, 149, 150, 151, 152, 153, 154, 155, 156, 157, 158, 159, 161, 162, 163, 164, 165, 166, 168, 169, 170, 171, 173, 177, 178, 179, 180, 184, 185, 186, 188, 189, 190, 201, 202, 212, 225
Philadelphia Navy Yard 22
Philadelphia School 119, 125, 128
Phillipsburg 21, 59, 60, 71, 155, 157, 158, 159, 161, 163, 164, 167, 170, 171, 188
Phillips, John 32
Piedmont 28, 50, 52, 56, 57, 58
Piedmont Province 56
placodes 101

Pleistocene 11
plutonic intrusion 51
Pocono Plateau 54, 55, 73
Port Delaware 157, 161
Port Jervis 15, 27, 28, 54, 55, 60, 157, 159, 160, 164, 170, 177, 196
post-glacial erosion 62
Potomac Orogeny 50
Precambrian Era 49
Presbyornis 113
Presbyornithids 113, 114
Printz, Governor Johan 146
Protoavis 107
protofeathers 100, 101
Prum, Richard 101
Pterodactyl 98

Q

Quarternary Period 58
quill-knobs 105, 107

R

radiometric dating techniques 34
Ramsey, William 34
Reigel, John 159
Renaissance 31
reservoirs 15, 18, 19, 29, 62, 167
Resource Conservation and Recovery Act 177
Ridge and Valley Providence 48
Roebling, John A. 158
Roxbury 54
Runcorn, S.K. 38
Rutherford, Ernest 33

S

Safe Drinking Water Act 176
saurischian dinosaurs 106
Schooley Penneplain 54
Schooley's Mountain 54
Schuylkill River 19, 28, 54, 57, 146, 167, 176, 189
scouring 48
sculling 121, 135, 136, 137, 140, 141
sculling boat 121, 136, 137, 140
sea-floor spreading 39, 40
Septuagint 31
1783 anti-dam treaty 164, 165
Shawangunk conglomerate 51, 55, 64
Shawangunk Mountains 51, 54, 55, 64
Shawano Island 82, 83
shipbuilding industry 22
shorebirds 107, 108, 110, 113, 114, 158
Silurian Period 51, 66
Silurian Shawangunk conglomerate 64
Sinosauropteryx 100
Six Nations 81
Sixth Extinction 11
Skinner, Daniel 151
Smith, Captain John 76
Smith, William 32
Soddy, Frederick 33, 34
South River 76, 144
Special Protection Waters 25, 179
squatters 175
strike 54, 67, 98, 223
Stuyvesant 88, 147

INDEX

subduction 40, 41, 47, 50, 51
subsequent valley 54
Sunfish Pond 26, 172, 175
supercontinent 43, 44, 45, 47, 48, 49, 51, 53
Susquehanna River 54, 76, 78
Susquehanna Valley 118, 150, 151
swans 93, 94, 95, 96, 114, 116
Swedes 20, 118, 121, 145, 146, 147, 153
symmetrical 99, 101

T

Taconic Orogeny 45, 50
Talmud 31
Tamanend, Chief 66
tanneries 150, 154, 160
tectonic plates 35, 46
telegraph 158
terraces 58, 59, 60, 61, 62
terrane 50
Tertiary Period 98
Tharp, Marie 38
theropod dinosaurs 97, 99, 101, 105, 106, 112
Thompson, William 32
thrusting 51
tidal 15, 25, 32, 55, 56, 62, 120, 121, 123, 136, 168, 171, 172, 180
till bench 59
timber rafting 151, 160
Tocks Island 26, 27, 56, 75, 163, 166, 168, 169, 171, 172, 174, 175, 176, 177, 180, 193
Totts Gap 66, 70
Toxics Management Program 25
Toxic Substances Control Act 177

transitional shorebirds 107, 113, 114, 116
transition (dinosaurs to birds) 99
transverse fault 66
Treaty of 1783 122
Treaty of Westminster 148
"trees down" hypothesis 99
Trenton 15, 18, 20, 21, 25, 28, 29, 55, 56, 57, 58, 59, 62, 69, 77, 118, 119, 120, 121, 122, 123, 130, 131, 132, 133, 135, 136, 145, 149, 152, 153, 154, 155, 158, 161, 162, 163, 164, 166, 178, 181, 184, 195, 201, 203, 206, 207, 209, 210, 211, 212, 213
Trent, William 149
T. rex 101, 102
Triassic Period 46, 53, 102, 106

U

Unalichtigos 118
Unannis 118
uplifting 36, 48, 49, 50, 51, 52, 53, 54, 55, 57, 70
Upper Delaware Wild and Scenic River 28
Urvogel 98
U.S. Army Corps of Engineers 19, 22, 26, 122, 153, 167
Ussher, James 31

V

Valley and Ridge Province 52, 55
Valley Forge 152, 153
Van Allen, Hendrick 77, 79, 88

INDEX

Vance, Arthur Bartholomew 119, 128, 212
Vegavis iaai 114
Velociraptor 100, 105
Verrazzano, Giovanni da 118, 143
Von Helmholtz, Herman 32

W

Walking Purchase Treaty 150
Wallpack Bend 28, 54, 71, 165, 167, 168, 170, 171
wastewater treatment 25, 177, 179
waterfowl 93, 108, 113, 118, 119, 123, 125, 127, 140
water quality 19, 25, 29, 167, 175, 178, 180
Water Quality Act of 1965 173
Water Quality Improvement Act of 1970 173
Wegener, Alfred Luthar 36
West Branch 15, 16, 19, 54, 163, 167
West Indian Company 147
Weygadt Gap 71
White, Bob 126, 137
White Mountains 77
wildfowl 117, 118, 119, 120
Wilson, Alexander 119
Wind Gap 66, 70
Winona 74, 77, 78, 79, 80, 82, 83, 84, 85, 86, 87, 88, 89, 90, 91
Wisconsin 53, 58, 71, 75
Wisconsin continental glacial 58
Wisconsin glaciation 71
wishbones 104

Wissinoming, Chief 77, 78, 80, 81, 82, 83
Woodland Period 117
Worthington, Charles C. 164

Y

yellow fever 154, 155
Yong, Thomas 76, 145
York, Duke of 148, 149

Z

zircon 35

ABOUT THE AUTHOR

Frank Harris Moyer grew up along the Delaware River and continues hunting, fishing and boating on its waters today. A retired educator, Moyer is a collector of Delaware River duck decoys. He is a member of the New Jersey Geography Alliance and resides in Phillipsburg, New Jersey.

Visit us at
www.historypress.com